RECONSTRUCTING THE SUBJECT

RECONSTRUCTING THE SUBJECT

MODERNIST PAINTING IN WESTERN GERMANY, 1945–1950

YULE F. HEIBEL

PRINCETON UNIVERSITY PRESS

PRINCETON, NEW JERSEY

Library of Congress Cataloging-in-Publication Data

Heibel, Yule F., 1956–
Reconstructing the subject : modernist painting in Western Germany, 1945–1950 / Yule
F. Heibel.
p. cm.
Includes bibliographical references and index.
ISBN 0-691-03646-2
1. Painting, Abstract—Germany (West) 2. Painting, German—Germany
(West) 3. Painting, Modern—20th century—Germany (West) I. Title.
ND568.5.A13H45 1995
759.3'09'044—dc20 94-28054
 CIP

This book has been composed in Linotron Palatino

Princeton University Press books are printed on acid-free paper
and meet the guidelines for permanence and durability of the
Committee on Production Guidelines for Book Longevity of the
Council of Library Resources

Printed in the United States of America

10 9 8 7 6 5 4 3 2 1

CONTENTS

ACKNOWLEDGMENTS

I T IS OFTEN DIFFICULT to name precisely what sustains one during the writing of a book. In my case, the past was certainly a factor: my interest in this period is intricately bound up with my personal history. I was born in Germany, raised in Canada, and in my late teens I returned to Germany for several years—to a country I found closed, confounding, hard to understand. I recall reading *Dialektik der Aufklärung* by Theodor Adorno and Max Horkheimer during that period and feeling my eyes open. Years later, as an art historian, paintings became another factor. I hope the reader will come to understand why I consider Ernst Wilhelm Nay's work intriguing aesthetically and historically, and how my interest in Western individuality and subjectivity sustained both my choice of topic and my approach.

I am happy to acknowledge the material support of the Social Sciences and Humanities Research Council of Canada Doctoral Fellowship (1987–90) and the Social Science Research Council's Berlin Program for Advanced German and European Studies Dissertation Fellowship (1989–90). Beyond financial support, the Berlin Program at the Freie Universität Berlin provided a collegial, interdisciplinary atmosphere. I thank the staff and my colleagues for their interest in my work, in particular Monika Medick-Krakau, Patty Davis, Matt Levinger, Brigitte Young, and the late Bernard Bellon.

I began work on this topic in 1985. I owe a great intellectual debt to Serge Guilbaut and T. J. Clark for relentlessly asking me to clarify and rethink particularly obscure or vague passages. John Czaplicka also gave very generously of his time to respond critically to earlier versions of this text. My thanks also go to Serge Guilbaut and to Ann Gibson for giving me opportunities to test my analyses in public lectures.

Friends and colleagues—Nancy Locke, Karyn Esielonis, Johanna Drucker, to name just three who were always ready to listen to an earful of lament over the state of the work, life, the universe, and everything—are part of the vital circuits that kept me feeling connected to life beyond my own Wall. And a special thanks to that small (but growing) group of academics who are also parents of small children for listening and advising on the problems and delights of

birthing and nursing and rearing and teaching not just courses, dissertations, or books, but new-born human beings, too.

Most of all, I thank my husband Werner Bahlke, without whose support I would never have even begun work. This book is dedicated to him and to our children, Adam and Emma.

LIST OF ILLUSTRATIONS

COLOR PLATES

BLACK-AND-WHITE FIGURES

RECONSTRUCTING THE SUBJECT

Introduction

SUBJECTS AND OBJECTS

Fate, myth's bondage to nature, comes from total social
tutelage, from an age in which no eyes had yet been
opened by self-reflexion, an age in which subject did not
yet exist. Instead of a collective practice conjuring that
age to return, the spell of the old undifferentiatedness
should be obliterated. Its prolongation is the sense of
identity of a mind that repressively shapes its Other in its
own image. If speculation on the state of reconciliation
were permitted, neither the undistinguished unity of
subject and object nor their antithetical hostility would be
conceivable in it; rather, the communication of what was
distinguished. Not until then would the concept of
communication, as an objective concept, come into its
own. The present one [concept of communication] is so
infamous because the best there is, the potential of an
agreement between people and things, is betrayed to an
interchange between subjects according to the
requirements of subjective reason. In its proper place,
even epistemologically, the relationship between subject
and object would lie in the realization of peace among
men as well as between men and their Other. Peace is
the state of distinctness without domination, with the
distinct participating in each other.

(Theodor W. Adorno, "Subject and Object")

B Y THE mid-twentieth century subjectivity had found its Scylla
and Charybdis, and Adorno apprises us of the terrain. "Collec-
tive practice" represents one obstacle that threatens the sub-
ject. Collective practice comes about when society is tribalized, either
through totalitarianism, of which Nazism is an extreme example, or
through the enthrallment to various religious or irrational "explana-
tions" of the world. These practices threaten to return the subject to a
primordial "oneness," a potentially terrifying bondage to fate, and to
an embeddedness in a nature bereft of reason, calculation, and critical

self-reflexion. And without this ability for self-reflexion the modern (western) subject disappears.

The other, equally dangerous, obstacle on which the subject runs aground is the very logic of modern (western) rationality itself. The subject, asserting itself against what it perceives as the threatening array posed against it—its "others": nature, objects, the world, woman, and eventually, of course, society and other men—refuses, in a bid for survival and supremacy, to accept difference. It will not accept difference in any way but by ingesting it, assimilating it, and thereby making it the same as itself. Adorno's "interchange between subjects according to the requirements of subjective reason" is but a subtle way of describing the social Darwinism of modern capitalist society. Thus, the subject's Scylla and Charybdis are totalitarianism (whether fascist, irrational, or "scientific") and capitalism: in both its guises, the threat has a specifically post-1945—indeed, post-Holocaust—form, making the question of the subject at mid-century, because of this particular historical constellation, thoroughly acute and critical.

What effect does the state of the subject have on the development of modern abstract painting in Western Germany after 1945? By analyzing the terms of art's reception in the immediate postwar period, and interpreting some of the key paintings produced, this book attempts to answer that question. From 1945 to the 1950s there were at least two distinct styles of abstract art in Germany, yet these styles were not distinguished by postwar audiences as being different.[1] But why were postwar audiences seemingly not ready to distinguish stylistic differences in abstract painting? The argument I will advance here is tied to an investigation of what subjectivity could be after 1945, after World War II and the Holocaust: in the post-1945 climate of reconstruction, subjectivity had to be regrounded on a secure basis, safe from harm. It had to be regrounded because the twelve-year Hitlerian assault on the "image of man"[2] had provoked a crisis of belief in what constituted safe or normal or acceptable behavior. Such a regrounding meant, however, that subjectivity's affective and expressive potential had to wither. This development is social and, as such, affected not only the painters who grappled with the problem of what to paint after 1945, but also the critics and viewers who tried to make sense of art.

The climate of reconstruction in the immediate postwar period stigmatized previous expressive modes—such affective phenomena as Romanticism and Expressionism, as well as the tradition of philo-

sophical inquiry initiated by Nietzsche. These now became associated with social ruination and the cultural bankruptcy brought about by Nazism, but more insistently with the dangers posed by "Eastern"-style totalitarianism, that is, Soviet and East German communism. The combination of these two overriding factors—a desire to secure the subject on a stable ground and the willingness to project onto "the East" the dangerous qualities one is seeking to escape—set the terms for art's reception in the postwar period.

These factors also helped determine what art would be produced, what would be viable. The dominant mode of abstraction, which helped eclipse other, different kinds of abstract work, was an absolutist, metaphysically oriented painting style associated most prominently with a group of painters known as ZEN49.[3] Many in the group were heavily invested in Heidegger's philosophy,[4] which points to an additional facet of the postwar reconstruction of the subject: while Nietzschean excess, for example, could be avoided for its seemingly dangerous proximity to Nazism, irrationality itself could continue to thrive in the form of Heideggerian metaphysics. Ontology could be hailed as scientific, technological, reasonable, and right, because it eschewed the outward markers of more blatantly "vitalistic" philosophies—now associated with instability and rupture.

If the abstract painters in ZEN49 followed a metaphysical orientation, what did their work look like? Was there any other kind of abstraction around as a counterproposal? And did audiences see it as distinct or alike? The painters associated with ZEN49 include Fritz Winter and Theodor Werner, as well as Willi Baumeister[5] (pls. I–III). Both Werner and Baumeister are of the generation born in the second half of the 1880s—Werner in 1886, Baumeister in 1889—thus already in their early sixties in the period under discussion here. Fritz Winter was born in 1905, hence a younger forty-five years of age by 1950. Ernst Wilhelm Nay, the painter on whom my main focus falls, was born in 1902, more or less a strict contemporary of the younger ZEN49 painters. But Nay held himself very much aloof from ZEN49,[6] and despite the postwar critical inability—or refusal?—to differentiate between Nay and, for example, Winter, their work could not be more different (fig. 1).

Winter did not return from a Russian prisoner-of-war camp until 1949, and, as a result, there is a five-year gap in his oeuvre, from 1944 to 1949. Whether he would have been a stronger, more individual force in ZEN49 if he had not been absent from the German art scene

between the end of the war and his release in 1949 is impossible to say, but it does seem clear that ZEN49's agenda was predominantly determined by the older, reputable painters such as Baumeister and Werner. One of their key allies in the art historical and critical camp was Franz Roh, of the same 1880s generation. The absence of young men—as well as the virtual absence of women—in the forging of a postwar cultural identity should alert us to some key postwar problems. The most obvious problem is that an entire male generation, that which was born between 1915 and 1925, grew up under Nazi indoctrination and hence was now considered unfit to assume the task of reconstructing a non-Nazi subject.[7] This indoctrination also meant that they were ignorant of modern art, which in turn predicated an overreliance on older German modernists for guidance.

Common to all ZEN49 members in the early years of the group's existence was an often-declared adherence to spiritualist or metaphysical ideas. The painters explicitly strove to eliminate that which could be "optically perceived" in order to "reveal" that which was universal, transcendent, creative, and true. Optical reality was seen as a veil that obscured true reality.[8] Painterly elements independent of optical reality were invested with supernatural power: "Derealized" colors and forms were vessels for "magical powers" capable of opening "the gates to the realm of the supernatural, to the world of the unconscious."[9] At best, "pictorial forms were thus optical apparitions of originary feelings."[10] And while a painter might state that "the basic element and reality of the pictorial is the surface," he was quick to add that everything that happens on that surface could be traced "back to a law of motion that underlies the Cosmos."[11]

The painter was thus not performing or acting on the surface, he was the antenna that properly broadcast onto that surface a cosmic, transcendent reality independent of "mere" physical and, therefore, crude optical reality. These painters took abstraction to be absolute, to be a transcription of the absolute. Painting was thus elevated, bearing affinities to the disembodied sister art of music, borrowing from the language of the unconscious only enough to declare its proximity to religion. Abstraction was painting's guarantee against the nether regions.

This insistence on making painting be about something "better" than the world perceived by ordinary human eyes found its way into the style of these painters. Typically, the work of Fritz Winter and Theodor Werner is characterized by floating forms, sometimes

biomorphic, sometimes quasi-geometric, on a ground that is never clearly defined (pls. I–II). Invariably this creates an illusion of space unlike Cubist space, or the post-Cubist pictorial spaces of Abstract Expressionism. Both the surface (what Rolf Cavael called "the basic element and reality of the pictorial") and the forms created on it strive to shed the signs of physicality, and hence of resistance to the Idea. The painter claims to reveal, but is this not an exercise in bad faith, since the painter determines the conditions and the outcome of this revelation? The traces of the surface's unamenable nature to illusionism and the undisputable presence of paint *material* as carrier of significant color are absent.

Ernst Wilhelm Nay's work differs from ZEN49 painting precisely because it does allow these resistances to enter into the very activity of his picture making. Whether the work in question is *Sibylle* of 1945 (pl. IV) or the late *Aequinoctien* of 1963 (pl. V), the painting's space is not treated as an illusory field entirely at the ready disposal of the painter's metaphysical trajectory. It retains a physical aspect that the metaphysical subjectivism of absolute abstraction discards. These factors signal important differences in the postwar meanings of the subject and its objects, meanings that in turn are implicated in the direction that postwar cultural reconstruction took.

The terms for art's reception can be understood through the discourse surrounding social and cultural reconstruction in postwar cultural and general interest journals, as well as in letters, catalogs, and archival materials.[12] Critical theory informs my interpretation of this material. Max Horkheimer and Theodor Wiesengrund Adorno wrote the incisive *Dialektik der Aufklärung* in the 1940s, publishing it in 1947—at the height of our period. What Adorno and Horkheimer put forward is a critique of rationality that shows how irrationality—and its most extreme historical occurrence in Nazism—is already implied in rationality itself. The illusion that the two may be neatly separated they expose as wishful thinking that ends in repression.[13] Adorno's later work, such as "Subjekt und Objekt"[14] and *Negative Dialektik*,[15] forms the theoretical backbone of my analysis, in ways that I hope will become clear throughout this inquiry.

Delineating the differences between various types of modern abstract art produced between circa 1944 and the early 1950s is crucial to understanding the elaboration of a restorative set of terms for subjectivity, which had been nearly demolished by the excesses of National Socialism. The ability to perceive these differences dimmed after

World War II because certain affective or expressive elements in art were progressively stigmatized in the wake of the war. A "new," absolute abstraction, which bracketed out the question of affect and expression, instead dominated the field. The critical aspect of affective or expressive abstraction in this postwar context of restructuring the subject can best be seen by analyzing the work of E. W. Nay, though I also touch on the work of non-abstract modernists such as Werner Heldt and Carl Hofer.

Nay's work managed to show "development," i.e., convey a sense of ever-new forays into untested formal territory—from the early postwar work (pl. IV) to the late work (pl. V), with many and varied formal innovations between—while Winter's work arrived at its set vocabulary before 1945 and essentially remained unperturbed by subsequent postwar developments. A work such as *Vital Drives of the Earth*, 1944 (fig. 2) does not markedly differ from 1949's *Sounds* or from subsequent works painted throughout the 1950s; in all these works, Winter manipulated a set of abstract, somewhat biomorphic shapes across an undefined ground that allows, first, the shapes to "float" and, second, the illusion of an open abstract space unfettered by the objective restraints of either the medium or the surface support on which this illusion is engineered.

Most of all, however, there seems to be a deliberate removal from these works of the (expressive) subject, accounting perhaps for the quality of sameness that permeates not just Winter's work, but that of others such as Werner and Baumeister as well. What caused the avoidance of this "subject problem"—and why such an avoidance should have had resonance in postwar Western German society—constitutes the main thread of this inquiry.

To combat the obscuring generalizations sometimes found in summaries of this period, I have relied almost entirely on contemporary German sources, rather than secondary source material. A 1948 analysis of the usefulness of Marxism for Western society, as disseminated in the German press, is more instructive for what Marxism meant to a 1940s reading public than a secondary summary analysis of Marxism in Western Germany.[16] By using various material that is not strictly art-related, I hope to provide a more lively, vivid sense of this period than previous histories have been able to convey. This approach entails some sacrifices: the reader will not find a narrative approach, nor a biographical one, nor a strict, progressive chronology from 1945 to

the early 1950s, nor a discussion of the merits or faults of other sec-
ondary sources.[17]

Certain personages figured more prominently than others in deter-
mining the postwar climate for cultural reception. Franz Roh and Will
Grohmann are two well-known German art historians and critics who
greatly contributed to propagating modern art in Western Germany
after 1945. Ottomar Domnick, a practicing psychiatrist, helped create,
together with Willi Baumeister, a hub of abstractionist activity in Stutt-
gart in the immediate postwar period. Beside E. W. Nay, Baumeister,
Winter, and Werner, other painters—well known in Germany, but
less known abroad—will make an occasional appearance: Werner
Heldt, an outsider by most standards, restricted himself to a reper-
toire of themes centering on Berlin, the city of his birth; the painter
Heinz Trökes, also a Berliner, championed surrealism and contributed
several important essays on the postwar art scene to *Das Kunstwerk*,
the Baden-Baden based art magazine; and Carl Hofer, another Berlin
painter, defended figurative painting against both the growing he-
gemony of abstraction in Western Germany and the restrictions of
realism in Eastern Germany. My analysis does not extend to figura-
tive realism, whether of the kind practiced in the West or the Social
Realism of the East, but the East-West dimension is brought out dis-
cursively in analyses of what certain terms such as "Eastern" came to
mean in the West. I also want to stress that nineteen forty-five was
never a "zero hour" in German cultural history; concepts such as ar-
tistic autonomy, realism, and expression had to be subjected to pain-
ful reappraisal, but this did not amount to an entirely new beginning
that the term Zero Hour suggests is possible.

Chapter One is devoted to explaining the problems of expression in
the postwar period, particularly in relation to the *Menschenbild* ("the
image of man"). Nay's work is the main focus, followed by a discus-
sion of how ZEN49-type abstraction, rooted in a metaphysical ap-
proach and ontology, as popularized by Heidegger, contributed to
setting the terms for a new, postwar "expressionless" subject. I do not
offer a conclusive assessment of the use of expression and of artists'
relationship to it, but suggest that this issue's reception set the stage
for art's ability either to exist and thrive or to wither in society; the
conditions for which are then examined in subsequent chapters.

Chapter Two examines the conditions that politicized the issues of
individual expression and action. In particular, resistance to the status

quo in relation to the destabilized image of man, of (male) subjectivity, as well as expression and action vis-à-vis concepts of "Eastern" in a Cold War context, were in large measure a *German* affair that cannot be explained only by superpower rivalry. Werner Heldt is introduced as a counterpoint to the belief that artistic issues revolved only around a "bloc" of abstraction on the one hand, which was opposed by a similarly "homogeneous" realism on the other.

Chapter Three, by analyzing expression's non-reception, offers another explanation of why the postwar art scene became so fossilized, why the younger generation, once it had found an ability to begin articulating a non-Nazi subject, was so unheard. The critical discourse, the critical failure to see differences amongst the older and middle generation of abstract painters and the insistence on creating "harmony," "synthesis," and sameness on the modernist front contributed to a climate of stagnation in the 1950s. This desire for harmony and synthesis was not simply the desire for the triumph of one style over another but the desire to be sheltered from dissent, difference, and decision: this more than anything contributed to a climate of high cultural torpor as the fifties progressed in Western Germany.

Chapter Four explicitly deals with the American contribution to Western Germany's reconstruction of modernism. The American model became the key for Western Germany's solution to the social management of violence. This liberal model attributes social violence to totalitarian or otherwise recalcitrant social systems, and assumes that the liberal individual, in a liberal constitutionalist society, can be engendered without the aid of state violence. The new *Menschenbild* in Western Germany, modelled in part on liberal constitutionalism, was generated without questioning whether some forms of social violence are necessary for individualism to exist. Because any kind of recognition of individualism's occult marriage to violence is rendered impossible, yet another affective, expressive dimension in art withered.

It is my hope that the four chapters, when taken together, will offer a deeper and more incisive account of both modern painting in the immediate postwar period in Western Germany as well as of the role of social forces rooted in the historical experience of Nazism and modernity. It has become necessary since 1945 to speak more frequently of the death of the author—of agency and the subject—as a direct result of indictments of those western metaphysics that underpin notions of individuality and subjectivity. We now see more readily that questions of power determine relations previously thought to be natural.

Perhaps this book, insofar as it is a cultural history of a period of extreme crisis of subjectivity, will enable the reader to think historically about the recent past. Perhaps this investigation of the German situation in 1945 will allow for a comparative analysis of abstract art in other contexts. Have we really done with the expressive, affective dimension in art, or does it only get resurrected periodically as a more or less effective market phenomenon? And in whose interest, finally, is the subject spoken, according to what pressures interpellated?

Chapter I

FIRST VOICES, INITIAL ASSESSMENTS
1945 TO 1949

> I yearn to come over sometime and see all the
> splendours; would also die reluctantly before having
> experienced the land of our forefathers, for by now
> things have gotten so that the old Europe has
> wandered across the ocean and we are the neophytes,
> primitive as immigrants, at least in Germany.
>
> *(Will Grohmann to Curt Valentin,*
> *letter dated 23 November 1951)*

A SIBYL, according to standard dictionary definitions, is one of a number of women of antiquity believed to possess powers of prophecy or divination; as a prophetess, she sometimes is also defined as a witch or fortune-teller.

Prophecy, fortune-telling, and divination: an unusual set of concerns at the end of a cataclysm? *Sibylle* was, however, the title given by Ernst Wilhelm Nay to a painting of 1945 (pl. IV).[1] It was unusual for its time: large, at 104 by 71.5 cm, when canvas was scarce; densely worked, when oil paint was rare. As an oracle should be, it is difficult to read, to understand. In its way, *Sibylle* announced an expansive and complex set of ambitions, which, together with its contexts, is the subject of this chapter.

One wonders how a German painter could have had any ambitions at all in a period such as this. *Sibylle* shall stand as a centerpiece for an analysis of the early, immediate postwar period and its contradictions, since it contains or points to most of the relevant issues of the postwar discourse: the image of the human body and the crisis-riddled issue of the image of "man" in society; the alternate proposals of critical theory as well as the renewed claims of ontology; and concerns peculiar to art itself, centering on realism, autonomy, and expression.

The figure of the sibyl is visible from the loins up, and, posed with

splayed fingers and one arm akimbo, she possesses the central area of the canvas, filling it almost completely. The visible portion of the legs would suggest that she is striding forward; her torso is slightly arched and tensed; her left arm angles outward while the hand is placed in the area in front of the hip. The other arm reaches up and out, arching back over the head to cradle what appears to be a load of some kind—wood kindlings or a basket.

There is, however, much more to the painting than this limited, sober assessment of what the painting depicts suggests. The affective charge of the painting actually claims the viewer's attention first, before she has figured out what is shown. It is difficult to find the figure as a whole, because the way it is rendered—in primitivist, slightly cubist reductions to triangles and oblongs, painted in thick, rough layers—is more or less identical to the way the background is rendered. The struggle to represent form—an image of a woman, in this case—is manifest in the application of the paint; the painting refuses to resolve clearly the elements of a figure against the ground, to create clearly the illusion of plasticity.

For the art public of the first half of the twentieth century, this refusal to represent an object clearly signified a sometimes exhilarating, sometimes offensive tendency usually characterized as "abstract" or "modernistic." In order to understand what Nay was drawing on in this painting, the reader is asked to recall some of the prior claims of modern painting. For centuries in the West, painting had pursued perfection in the rendering of the visible three-dimensional world on the flat surface of the painting support, resulting in an increasingly perfect illusionism. To achieve this, painting to an extent had to hide the marks of its materiality; while painterly qualities such as visible brushstroke or impasto were periodically prized, academic painting was valued for its highly resolved finish, for the clear differentiation between the plasticity of the figures and the atmospherically or perspectivally receding background. This type of painting also had traditionally the greatest appeal to non-specialist consumers of art, and thus cemented a social contract between the public at large and the producers of culture. To be acceptable to the largest number of people, paint had to become something else (an illusion of something), it was not allowed to stand alone or signify too clearly a critical difference between itself and the object it represented.

By the nineteenth century, the use of painterliness became freighted with social meanings tied not only to conceptions of good taste and

style, but social stability.[2] Around mid-century, non- or even anti-academic styles of painting had become fused with choices of subject matter that challenged the academy's hierarchy of genres. And by the turn of the century, the field was broken open to the extent that the term "avant-garde" was used to describe styles of painting that pushed, in what must have appeared as convulsions, the medium's limits further and further beyond the accepted status quo. This was not, however, a question of form alone, for arguably no nineteenth- or twentieth-century avant-garde style failed to try to imbue itself with content-related and contested significance. Modern painting's rich and varied history comes from this interaction between formal and social concerns.

During the nineteenth century, Germany lagged far behind France in these developments, but by the beginning of the twentieth century, painters and sculptors joined with a vengeance with a style vaguely characterized as "Expressionism."[3] It was this style, coupled with insights derived from Cubism, that Nay drew upon for his *Sibylle*, implicitly exploiting an appeal to affective responses in the viewer, while building on the previous decades of detachment from the academy.[4] Nay reduced the figure to elemental building blocks, such as wedge-shapes for breasts and nose; an oval, reaching from the loins to top of the breastcage, that signifies "womb" or female torso (here as well as in later paintings usually marked by a line of dots that signify vertebrae as well as a large central dot signifying the umbilicus); and eyes derived from elements of African masks. Most of all, however, Nay relied on color to challenge the viewer: a heavy, blood red dominates not only the charged area of the figure's torso, arms, and head, but also her immediate surroundings: she is integrally a part of the surface that surrounds her, differences between background and foreground are destabilized by the dominating use of red and ocher earth tones for both.

The painting operates crucially with several concerns: the image of the human body and the possibility for *Ausdruck* or "expression." It is appropriate that Nay should have immediately set out in 1945, when most other German males were either marching into POW camps, trickling back into their bombed home towns, emerging from the many prisons of the National Socialist regime, or finding their way uncertainly as refugees, to paint a work that is striking for its refusal to illustrate the postwar reality. He had already become, several years before the beginning of the Hitler regime, one of the younger artists

to watch. As a young man with a solid middle class background, who had attended the most prestigious Gymnasium in Weimar Germany[5] and had graduated first in his class, Nay could have chosen any number of secure, bourgeois careers. But he must have been convinced quite early on of his ability to meet his ambitions.

In an autobiographical sketch written in 1958, he recalled that 1925 was a turning point, marked by the demise of Cubism: Picasso's and Braque's paths had separated, Gris was admired, and in Paris the "great era" was over. As he put it, there was no point in combing the anthropological collections for exotic inspiration, and thus "one's own life had to try to yield that which could become art."[6] With tenacity, Nay pursued his path, as the following anecdote well illustrates. In the spring of 1925 he returned for a year to his mother's residence, worked in a bookstore during the day, and painted at night. The son was not on best terms with his mother; "she was indeed cold and domineering, I painted her for the duration of an entire Sunday— 8 hours, then in a faint she fell from her chair and so did I. Surely both not just from the exertion of painting, but from the other tension."[7] He remained determined to expose himself to "tension" and to paint to the point of collapse.[8] In the mid-1930s, when he was effectively painter non grata to the regime, he again managed to pursue a strong-willed course. Through personal contacts, he succeeded in obtaining funding in 1937 that allowed him to travel to Norway to meet Edvard Munch, and to spend a period of time there painting.[9] While the regime's curtailment of his ability to make a living inevitably pushed him into a sort of "inner emigration," it did not entirely cut him off from the world beyond Germany (something that "inner emigration" entailed for most others).

When the war broke out and he was drafted, he did not endanger his pursuit of a painting career by resisting the draft, but instead made several contacts within the German army who did their best to ensure that his postings would be relatively free from danger. He was eventually assigned to cartography duties in France, and was in at least one posting treated by the local population as a guest, not an occupier: he had a studio to work in and secretly continued making his "degenerate" paintings (all very small format, often watercolors on cardboard).[10] Even war service, rather than cutting him off from the world beyond Germany, provided him with important contacts.[11] When the war ended, his division had already retreated to Germany, and after capture he was immediately released and sent home by the

Allies, never spending time as a prisoner of war: his record was clean and clear.

But Nay was always an elitist, which initially makes one suspect him of a certain affinity with the propagators of the ideology of the "master race." The architects of the "thousand year realm," however, were for Nay a low, uncultured rabble, and it was certainly neither a left-wing nor a traditionalist conservative political position that determined Nay's repugnance for Nazism. Rather, his utter contempt was for its propagandistic instrumentalization of German culture and its denigration and perversion of internationalism (derogatorily termed "cosmopolitanism" by Hitler's propagandists), along with its demagogic manipulation of the masses' disapproval or resentment of elite or "incomprehensible" art.[12]

Nay, a Berliner, did not return after the war to that city; his home and studio had been bombed, and he instead used his contacts to secure a studio-dwelling in the countryside near Frankfurt.[13] Relatively primitive, it was still more than what most city-dwellers could count on, and Nay settled into a prolonged period of relative isolation, consisting of feverish work on painting, interrupted only by correspondence and visits from others interested in art. Perhaps someone less willful and convinced of his ability would have failed to muster the ambition to paint after Hitler, after genocide and Holocaust, after total cultural and social bankruptcy. It is a curious and at times irritating paradox that Nay, whose ambition was appropriate to the scale of the calamity, never once made that calamity the express subject of his art.

In the midst of the war, 1942–44, Nay experienced the "decisive years of my development as a human being and as an artist,"[14] as he wrote to his friend Erich Meyer in 1946. "I experienced a very rare unity of life and art there, in the course of which the main part was played by an extraordinary woman who is at present unattainably far away."[15] What did this development entail?

Blissful paintings came to light, far from all the mundane and wartime concerns, but also not idyllic. What the world wants to know least of all—goodness and love—became refuge and poetics. I just simply didn't comprehend many things, they didn't reach my ears, didn't enter my soul. This was protection for me. A startled individualist, who was masked. I anyway don't like to uncover myself. The mask is a constant part of me. But in this way I overcome the cynicism in me and remain natural.[16]

The paintings from this period show the change. Around 1943, Nay's style changed from a splotchy, Fauve-Expressionist way of painting to one more concerned with structure, quasi-geometric reductions, and, consequently, greater attention to the flat painting surface's contradiction—its resistance—to the illusion of the painted object. Compare, for example, *The Female Acrobat* from 1942 (fig. 3), with its summarily defined figures rendered in broad strokes of paint, to *Composition with Four Women* from 1943 (pl. VI), where a wholly different use of faceting structures the relationship between figures and ground, and where, despite greater detail and definition, the sense of tension between canvas surface and representation seems heightened. *The Female Acrobat* is still closer to the "Lofoten"-series,[17] as comparison to *People in the Lofoten*, 1938 (fig. 4), shows. In the earlier picture, the drama is conveyed through the jagged forms of the landscape and the people in it, through the crow-like black shapes in the sky, the threatening thrust of the three pink-colored bathers' breasts, and the way the brown figures, men who are barely visible as they blend directly into the rock formations behind, absorb as well as set apart the females in front. While formal tension is created through the use of color and shape, it is due mainly to the harsh, aggressive outline of the shapes. In *Acrobat*, that harshness is gone, replaced by mere crudity of shape. In *Composition* we are not dealing with harshness of shape, or crudity per se, but with a deliberate reduction of the human figure to elemental details. This is combined with far more careful attention to how these figural aspects interact with background elements, and the result is a painting with greater structural tension. The tension Nay always sought—illustrated so well in the incident of maternal-filial combat resulting in a mutual temporary annihilation, the prelude to renewed battle—that tension he now tried to put into and onto the canvas itself, in a way that departed markedly from his previous efforts. And as a battle of wills, it is also bound up with the larger collapse of another, pretended, "triumph of the will."

A large part of what these paintings are about is the search for a formally coherent expression of drama—human drama—albeit increasingly stripped of theatricality or illustration of narrative action, features appropriate to some pre-Nazi, as well as all Nazi culture. The latter, stupendously summarized by Nürnberg spectacles, parades, and mass rallies, was bombastic, threatening, and often *kitschig*. Human drama was thoroughly orchestrated, co-ordinated, and controlled

as spectacle.[18] Within the context of postwar reality, expression and human drama came to resonate among a whole set of crucial social concerns. There was now a deep crisis over "the image of man," as well as the related question of *Ausdruck* (expression).

There are at least two issues involved in the use of the word "expression," which I take to revolve around the problem of "authenticity" and affect. On the one hand, we are dealing with "self-expression" in art, while on the other we face the question of an expression of national, cultural identity. These two aspects bear a relationship to prior cultural traditions, which in Germany include the varied and fractured history of Romanticism in the nineteenth century and Expressionism in the twentieth century. These issues are also implicated in the tradition of modern art, which by the end of World War I attempted an international validity: while Futurism, Expressionism, Cubism, and Constructivism, for example, were associated with national particularity, they were also held to be evidence of a move toward a "universal" (non-national) modern spirit.

In this situation the individual subject might try to find ways of expressing affect or conviction in art authentically, without resorting to clichés. This positioning of the self vis-à-vis a notion of authenticity is particularly dangerous territory. German intellectuals regarded this concept cynically, believing it died with Romanticism in the nineteenth century. They generally suspected that the *Kleinbürgertum* (the middle to lower middle class) is addicted to some belief in the possibility of authenticity, but their addiction only produces an endless stream of kitsch. In Germany, the alienation of the intellectuals from the bourgeoisie was heightened as the cynicism of the intellectuals turned the expression of affect—as that which "authentically" belongs to the individual—into a position of irony (nineteenth-century Romanticism's own strategy), or, in the twentieth century, into an either-or position of desperation, as could be seen in many examples of German Expressionism. And, following Expressionism's decline in the 1920s, this cynicism damned the expression of affect entirely, revoking even irony, and instead sought refuge in New Sobriety.

The problem of expression, in any case, continues to fester as a difficulty that is individual-personal as well as national-cultural, particularly when the individual artist faces the task of situating him- or herself in relation to the national tradition as well as to the seemingly separate issue of modern art removed from a national context. In post-World War II Germany this problem was further compounded by

The paintings from this period show the change. Around 1943, Nay's style changed from a splotchy, Fauve-Expressionist way of painting to one more concerned with structure, quasi-geometric reductions, and, consequently, greater attention to the flat painting surface's contradiction—its resistance—to the illusion of the painted object. Compare, for example, *The Female Acrobat* from 1942 (fig. 3), with its summarily defined figures rendered in broad strokes of paint, to *Composition with Four Women* from 1943 (pl. VI), where a wholly different use of faceting structures the relationship between figures and ground, and where, despite greater detail and definition, the sense of tension between canvas surface and representation seems heightened. *The Female Acrobat* is still closer to the "Lofoten"-series,[17] as comparison to *People in the Lofoten*, 1938 (fig. 4), shows. In the earlier picture, the drama is conveyed through the jagged forms of the landscape and the people in it, through the crow-like black shapes in the sky, the threatening thrust of the three pink-colored bathers' breasts, and the way the brown figures, men who are barely visible as they blend directly into the rock formations behind, absorb as well as set apart the females in front. While formal tension is created through the use of color and shape, it is due mainly to the harsh, aggressive outline of the shapes. In *Acrobat*, that harshness is gone, replaced by mere crudity of shape. In *Composition* we are not dealing with harshness of shape, or crudity per se, but with a deliberate reduction of the human figure to elemental details. This is combined with far more careful attention to how these figural aspects interact with background elements, and the result is a painting with greater structural tension. The tension Nay always sought—illustrated so well in the incident of maternal-filial combat resulting in a mutual temporary annihilation, the prelude to renewed battle—that tension he now tried to put into and onto the canvas itself, in a way that departed markedly from his previous efforts. And as a battle of wills, it is also bound up with the larger collapse of another, pretended, "triumph of the will."

A large part of what these paintings are about is the search for a formally coherent expression of drama—human drama—albeit increasingly stripped of theatricality or illustration of narrative action, features appropriate to some pre-Nazi, as well as all Nazi culture. The latter, stupendously summarized by Nürnberg spectacles, parades, and mass rallies, was bombastic, threatening, and often *kitschig*. Human drama was thoroughly orchestrated, co-ordinated, and controlled

as spectacle.[18] Within the context of postwar reality, expression and human drama came to resonate among a whole set of crucial social concerns. There was now a deep crisis over "the image of man," as well as the related question of *Ausdruck* (expression).

There are at least two issues involved in the use of the word "expression," which I take to revolve around the problem of "authenticity" and affect. On the one hand, we are dealing with "self-expression" in art, while on the other we face the question of an expression of national, cultural identity. These two aspects bear a relationship to prior cultural traditions, which in Germany include the varied and fractured history of Romanticism in the nineteenth century and Expressionism in the twentieth century. These issues are also implicated in the tradition of modern art, which by the end of World War I attempted an international validity: while Futurism, Expressionism, Cubism, and Constructivism, for example, were associated with national particularity, they were also held to be evidence of a move toward a "universal" (non-national) modern spirit.

In this situation the individual subject might try to find ways of expressing affect or conviction in art authentically, without resorting to clichés. This positioning of the self vis-à-vis a notion of authenticity is particularly dangerous territory. German intellectuals regarded this concept cynically, believing it died with Romanticism in the nineteenth century. They generally suspected that the *Kleinbürgertum* (the middle to lower middle class) is addicted to some belief in the possibility of authenticity, but their addiction only produces an endless stream of kitsch. In Germany, the alienation of the intellectuals from the bourgeoisie was heightened as the cynicism of the intellectuals turned the expression of affect—as that which "authentically" belongs to the individual—into a position of irony (nineteenth-century Romanticism's own strategy), or, in the twentieth century, into an either-or position of desperation, as could be seen in many examples of German Expressionism. And, following Expressionism's decline in the 1920s, this cynicism damned the expression of affect entirely, revoking even irony, and instead sought refuge in New Sobriety.

The problem of expression, in any case, continues to fester as a difficulty that is individual-personal as well as national-cultural, particularly when the individual artist faces the task of situating him- or herself in relation to the national tradition as well as to the seemingly separate issue of modern art removed from a national context. In post-World War II Germany this problem was further compounded by

the legacy of Nazism and the crime of genocide. Expression as a mat-
ter of "subjects of the artist" then raised questions: who has the right
to express anything (and how?) in this situation; what meaning can
an individual's affective charge possibly have; and how can there be
even the possibility of expressing anything on an individual level in
relation to a national, cultural tradition that included Nazism and
genocide?

In the post-1945 period, the problem of affect and "authenticity"
massively inflected the crisis over the "image of man," with dire im-
plications for the realm of history (how to teach it, write it, conceive
it). The crisis called into question all cultural traditions and severely
disrupted received notions of subjectivity. It provoked several at-
tempts to reground the *Menschenbild* (the image of man), attempts
that roughly fall into two categories: restorative and progressive-
critical. "The Image of Man in Our Times" ran the title of a sympo-
sium held in Darmstadt in 1950,[19] indicating that by 1950 the issue
had achieved "academic" status and had become the subject of schol-
arly debate. But much had happened in the preceding years, between
1945 and 1949. Restorative attempts, for example, were not all conser-
vative; some were in fact closely linked to modern, abstract art. The
progressive-critical attempt, on the other hand, was difficult, hard to
communicate to more than a very few people, almost hermetic in its
refusals: in many ways the polar opposite of the (Nazi) spectacle, al-
though it, like the latter, concerned itself with the issue of expression.
Nay eventually moved between what I shall define as a progressive-
critical view and the pro-abstract, but ultimately restorative, view,
characterized by an enthrallment to strange fusions of mythic think-
ing and ontology. This issue of "the image of man" was fraught ter-
rain, and an analysis of its early articulation is absolutely necessary to
understand the later, largely academic, debates of the 1950s.

The image of man had been fundamentally damaged by twelve
years of Nazi rule. Previous rules and traditions no longer applied.
Military men, for example, who had traditionally sworn allegiance to
their country, were required to swear allegiance to their leader, Hitler.
The individual was required to identify completely with the figure of
the leader, who in turn claimed to embody values of patriotism and
discipline. In this way Hitler, on the surface, occupied traditional
values when in reality Nazism represented an extreme subjugation of
conventional expectations and values.[20] This revolution extended into
civilian and family life as well; it encouraged citizens to denounce

their neighbors, children to denounce their parents. Within this system of denunciation, traditional loyalties counted for very little, and bit by bit the image of man was restructured to suit the Nazi ideal.[21]

Men and women in concentration camps, Jews, Gypsies, and Gentiles, Germans and foreigners, experienced a brutal encounter with Nazi force. Men in German armies—and most men were affected by the militarization of the country—encountered Nazi force on another level. Almost all of Germany's postwar modernists were male and had been affected directly by militarization.[22] When it became clear after the battle at Stalingrad in 1943 that Germany was losing on the Russian front, the military leadership was confronted with the phenomenon of soldier suicide. As the beginning of 1944 saw a repeat of the defeats at Stalingrad, both German and Soviet resistance movements tried to fortify their gains in the propaganda war for the German soldier's mind. One such group was known as the Nationalkomitee Freies Deutschland (NKFD).[23] Its goal was to convince German soldiers to capitulate and defect to the Soviet side.

Suicide, practiced by an increasing number of German soldiers, appeared to the NKFD as proof of a deep crisis in individualism and self-conception. In one of their propaganda leaflets dropped behind the German lines, the officers tried to analyze the causes for suicide.[24] Why was suicide preferable to capitulation? According to the leaflet, Hitler's demand for total and unwavering identification with his causes, concerns, and paranoias provoked this response. This total identification with Hitler, most effective with the generation born around 1920–25, left an enormous vacuum once Nazism was defeated, and provided the basis for the subsequent crisis in "the image of man."

The response by the Party Chancellery on 17 July 1944 exposes the cynical attitude toward human life endorsed by the Nazi leadership: suicide is not dishonorable "in those cases, in which no further exertion for the people is any longer possible, or when impending Soviet imprisonment could make the continuation of [one's] life into a danger for one's own people."[25] What is implied is that "man" is to be made over as "Nazi," fully and completely, and that individuality is relinquished in favor of total identification with the leader. One is provided with a ready-made "image of man" that claims totality, to know all the answers and define all the questions.[26]

This identification was successful particularly with the younger generation that had grown up under the regime, and for whom the

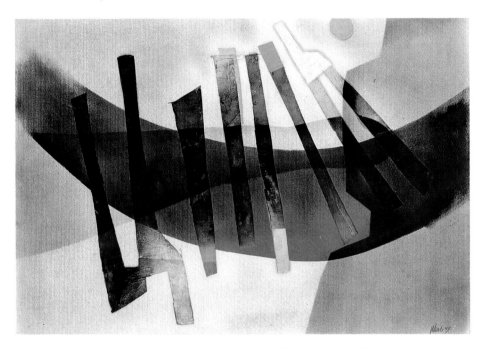

I. Fritz Winter, *Sounds*, 1949, oil on carton. Munich, Bayerische Staatsgemäldesamm-lungen. Staatsgalerie moderner Kunst.

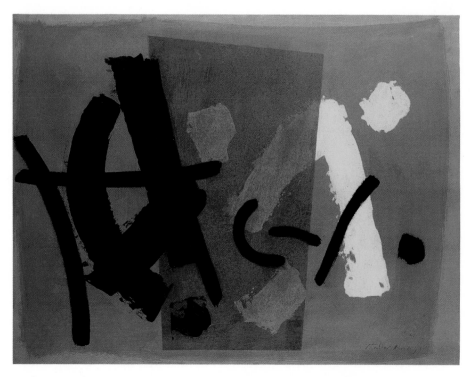

II. Theodor Werner, *Annunciation,* 1952, tempera on carton. Berlin, Galerie Pels-Leusden.

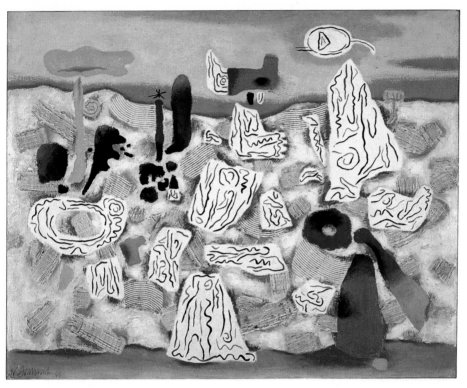

III. Willi Baumeister, *Growth of Crystals II*, 1947/52, oil on carton. Stuttgart, Archiv Baumeister.

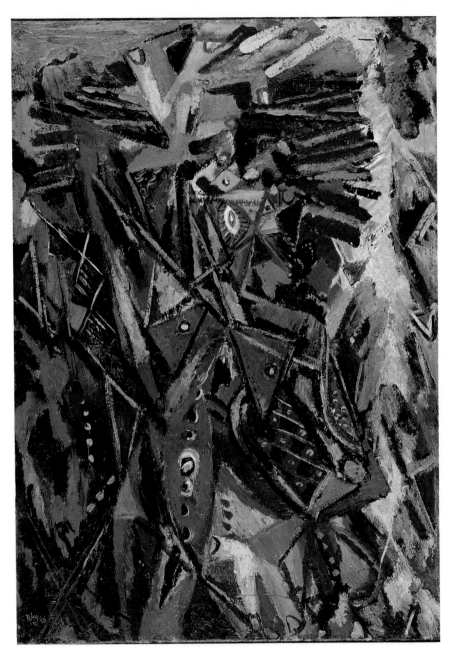

IV. E. W. Nay, *Sibylle*, 1945, oil on canvas. Priv. coll.

V. E. W. Nay, *Aequinoctien*, 1963, oil on canvas. Priv. coll.

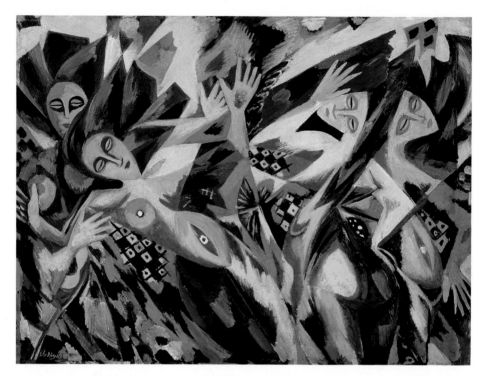

VI. E. W. Nay, *Composition with Four Women*, 1943/44, oil on canvas. Priv. coll.

VII. Werner Heldt, *Une Gifle aux Nazis (Still Life)*, 1952, oil on canvas. Priv. coll.

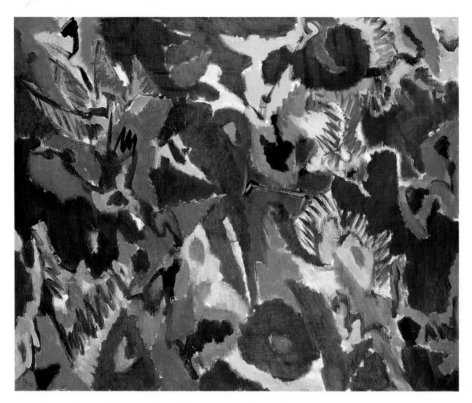

VIII. E. W. Nay, *Oasis*, 1952, oil on canvas. Mannheim, Kunsthalle.

end of the war—capitulation—brought not just physical and material displacement, but mental confusion as well. The immediate postwar "cynicism" and intractable Nazism of the younger generation was of concern for most older critical thinkers who, having already developed a strong sense of individuality before Hitler's system was established, were bewildered by this "new" youth.[27]

For the world beyond the walls of the prison that Germany had become, as well as for those within the country who could find the energy to encompass events not immediately impinging on their daily existence, the worst, most singular, and unnamable legacy of the war was the system of concentration and deathcamps, and: the Holocaust. As the Thomas Mann character Serenus Zeitblom puts it in *Dr. Faustus*:

> Germany had become a thick-walled underground torture-chamber, converted into one by a profligate dictatorship vowed to nihilism from its beginnings on. Now the torture-chamber has been broken open, open lies our shame before the eyes of the world. Foreign commissions inspect those incredible photographs everywhere displayed, and tell their countrymen that what they have seen surpasses in horribleness anything the human imagination can conceive. I say our shame. For is it mere hypochondria to say to oneself that everything German, even the German mind and spirit, German thought, the German Word, is involved in this scandalous exposure and made subject to the same distrust? Is the sense of guilt quite morbid which makes one ask oneself the question how Germany, whatever her future manifestations, can ever presume to open her mouth in human affairs?[28]

If Mann—as a German—could find no adequate words to describe it, neither could the Allied victors: no one had the moral distance, the breadth of horizon to encompass this. It was unheard of, unbelievable, incomparable.

Initially, the Americans tried to meet the challenge by addressing the Germans as a mass (a strategy not unlike the one they were accustomed to under Hitler): everywhere in towns and cities in the American Zone of Occupation, civilians were faced with posters showing the liberated Bergen-Belsen concentration camp, with the one-sentence caption, "This is your fault."[29] Likewise, the Allies attempted to "educate" the German citizenry that lived in the vicinity of death camps by forcing them to tour the camp and march past the mounds of bodies.[30] The reactions were often not the desired ones: a hardening of the emotional armor more often ensued than an emotional outburst, but in

neither case was there a meaningful assimilation or acceptance of what was shown.

When individuals allow their singularity to be extinguished and instead function as cogs in a machine, moral and ethical taboos dissolve; death camps and factories become interchangeable. Genocide, mass-produced death, raises, among other things, issues of quantity. And the emphasis on sheer quantity had raised this war—its German form, its crimes—beyond the realm of what could be mentally assimilated.[31] The quantity of killings posed the danger of not being able to find a punishment adequate to the crime, that is, a punishment that would in itself not "tip over" into a new quality: barbarism.[32] As Adorno put it in 1944,

> The idea that after this war life would be able to continue "normally" or that culture could even be "reconstructed"—as if the reconstruction of culture itself was not already its negation—is idiotic. Millions of Jews have been murdered, and this is supposed to be but an intermezzo and not catastrophe itself. What is this culture actually still waiting for? And even if countless people find reprieve, could one imagine that what has occurred in Europe will not have consequences, that the quantity of victims won't turn over into a new quality—barbarism—of society itself? As long as things continue blow by blow, the catastrophe is perpetuated. One only has to think of vengeance for the murdered. If as many of the other side are killed, then the horror is institutionalized and the precapitalist schema of the blood feud, which since time immemorial has reigned only in isolated mountain regions, will be reintroduced in more expanded form, with entire nations in the role of subjectless subject. If, however, the dead are not avenged and mercy reigns, then unpunished fascism will have its victory after all, and after it has shown how easy it is, it will continue elsewhere. The logic of history is as destructive as the people it produces: wherever its center of gravity falls, it reproduces the equivalent of past disaster. Death is normal.[33]

For most Germans, unconditional capitulation—the end of the regime as well as the war's end—had been both unthinkable and longed-for. But after it finally happened, the Western world in its entirety also faced the incomparable disaster of its civilization. If "precapitalist" vengeance (an eye for an eye, . . .) is exacted, the horror will be perpetuated; if the dead are not avenged, if mercy reigns, fascism (the expendability of individualism) will have proven its victory, will have shown how easy it is "to get away with it," and will con-

tinue elsewhere. Within Germany, withdrawing from a narcotic powerful enough to convince those under its spell of the "rightness" of inhumanity, of fighting to the death, and of suicide, the loss of a closed, ready-made fascist "image of man" compounded the matter.

Damage done to the image of man was not confined to Germany alone; it was read by many as a European-wide phenomenon, insofar as it signalled a crisis in Western culture. It was a topic debated at length in German postwar journals, which, despite the incredible destruction and ruin of the country, sprang up almost immediately,[34] and it became the topic of popular books. In Max Picard's *Hitler in uns Selbst*, published in 1946 and already in its third edition by 1949,[35] indictment of Nazism was conservative, as Picard eventually unveiled a desire to include the entire post-Baroque modern era in his critique. But his emphasis on the *non*-humanness of Nazism—on its destruction of all one associates with the image of man as well as on Nazism's co-ordination of affect—is basically similar to critiques coming from a significantly more progressive quarter.[36]

> It is completely wrong to think that the Nazi crimes are sexual repressions, and to say that a vehement sadism raged in the Nazi crimes. These crimes are bound to nothing sexual, nor to any perversion; they are bound to nothing human at all, and exactly for this reason they are so uninhibited and monstrous. They are so monstrous that one cannot at all explain them through any human cause that still acts as a cause within human order.
>
> That is what is new and thoroughly terrifying about Nazi cruelty: it no longer has human measure, but rather the measure of something beyond the human, of an apparatus of factories and laboratories. Even the cruelty of Nero and Caligula at least was tied to these *humans*, was tied to their wild flesh and their corrupted senses, the human ruins were still in the crimes, a relationship to the human was still present; the crime still emanated immediately from the human being. Nazi cruelty emanates from a factory apparatus, or from a human who has become a total apparatus.
>
> When the human being wants to overstep the human measure of evil, he has to stop being human; he must become an apparatus: the latter is without measure because it is adjusted only to the quantitative, it can be intensified to the most monstrous.[37]

With "man" turned into an apparatus—a machine—he gave up human form (spiritually speaking), and was geared to the quantitative, and thus could become anything at all. Unmoored from divine origins

(which bound him to a preordained code, to law), he did not, how-ever, achieve the post-enlightenment utopia of Zarasthrustian free-dom, but rather came to be haunted by that old, "precapitalist" (and premodern) fear of the demonic, now in a post-machine age guise: he became the automaton, the marionette without a soul, the worshipper of idols, the non-human human.

Also implied in this schema is a loss of focus or hierarchy, which might sound like a contradiction in view of Nazism's "leader"-cult. Recall, however, that while the "leader" arrogated to himself all power, *all* else was ex- or interchangeable. This lack of "true" leadership—of a leadership with the "real" spiritual legitimacy capable of meaningfully fixing moral significance in all spheres of human society—is, in the conservative view, symptomatic of modernity itself. The indictment of the "apparatus" is essentially an indictment of the machine age's loss of "spiritual" values; the result is assembly-line culture, and assembly-line cruelty.

> The Nazi abominations . . . are executed as if they were incidental: ex-actly as if executed by apparatuses that could also produce something else. One moment the apparatus is set on crimes, the next moment on welfare or on a concert by Bach or on child rearing; the abominations are as if for play or for experimentation. That is why they are as mani-fold in their way, but not as manifold as nature; rather, manifold in the way of experiments. One manifoldly experiments in cruelty. And this is why everything is so monstrous, because everything is without hu-man measure; it has the measure of the apparatus, and it is boundless.[38]

Again, the loss of the measure of man—the image of man—is linked to the boundary-destroying hubris of Nazism, while the emphasis on the "apparatus" is indicative of a perception that the problem has not been solved with the "defeat" of Nazism. At the same time, it is clear that the phenomenon of Nazism had set in motion a massive cultural critique: massive because it came from all sides, from the anti-modernity camp of Picard and others, from communist-utopic and communist-totalitarian camps, as well as from independent, radical thinkers like those of the Frankfurt School.

As the number of printings of Picard's book indicates, the critique put forward by conservative writers had greater resonance than leftist or radical critiques. This is certainly due to the overriding conserva-tism in dominant German culture. By identifying Nazism as a product of the industrial revolution, and as fundamentally different from the

supposedly secure Christian authoritarianism of that favoured conservative German historical touchstone, the Baroque era, this critique obscures Nazism's affinities to more traditional right-wing thinking. In this way, traditional conservative authoritarianism could absolve itself of affiliation with Nazism.

The references to assembly-line crime and cruelty raised the question of quantity, which was so acute that, as Adorno put it in 1944, it could "tip over" into quality. Basic epistemological assumptions were affected. It is part of modern culture to quantify the world, and, by measuring objective reality, to gain control over it. But in the process the subject doing the controlling is altered; he does not remain unchanged, despite his belief to the contrary. Adorno's later opus, *Negative Dialektik* (1966), addresses the issue precisely: "Corresponding to the quantifying tendency on the subjective side was the reduction of the knower to a purely logical universal without qualities."[39] In rational science, the dominant epistemology of modernity, the subject is exhorted to be "objective," which amounts, however, to making the subject into a generality, a "logos" separate from his or her objective bodily existence. Meanwhile, the emphasis on quantity silences the rights of quality; quality can only be cognized by a subject who is mindful of difference and who does not instantiate him- or herself as autonomous of the determining qualities of the objective world. What is needed is a subject capable of interacting with his or her objects.

> The ideal of discrimination, of the nuance—an ideal which in cognition, including the latest developments, has never been quite forgotten, despite all "Science is measurement"—refers not only to an individual faculty which objectivity can do without. . . . [It] provides a haven for the mimetic element of knowledge, for the element of elective affinity between knower and the known.
>
> In the total process of enlightenment this element gradually crumbles. But it cannot vanish completely if the process is not to annul itself. Even in the conception of rational knowledge, devoid of all affinity, there survives a groping for that concordance which the magical delusion used to place beyond doubt. If this moment were extinguished altogether, it would be flatly incomprehensible that a subject can know an object; the unleashed rationality would be irrational. In being secularized, however, the mimetic element in turn blends with the rational one. The word for this process is discrimination.[40]

For Adorno, "elective affinity," the "mimetic moment," is crucial, but it is marginalized in the age of practical reason. It is the one moment,

however, in which the subject learns to recognize the difference be-
tween the levelling demands of quantification ("science as measure-
ment"), learns to recall his or her fundamental difference from the
dictates of logos, and instead perceives an elective affinity with the
object, that is, allows the object the right of determination. In the more
strictly rational quantification scheme, the subject determines the ob-
ject, the object world. Usually the object's (Other) qualities are erased
or subsumed to the functional-rational demands at hand. In recogniz-
ing difference, the subject paradoxically allows him- or herself, in a
transformative moment, to separate from the demands of quantifica-
tion by perceiving an affinity with the (Other) object. In this way, the
subject perceives quality, and—this being the larger implication—
offers a critique of *ratio*. Differentiation from "pure logos," the elec-
tive affinity or mimetic identification with the object, is defined as a
relic from cultic practices ("magical delusion"), but no longer bound to
archaic, cultic rituals. In the modern period, the mimetic moment has
"melded" with the rational moment in a process of secularization:
"The word for this process is discrimination." For Adorno, this is a
critical *and* elitist activity.

Such a critical-progressive approach to understanding modern cul-
ture, an understanding of the mimetic moment, can have direct appli-
cation to the kind of art produced in the postwar period, as well as to
its reception. It seems clear that Adorno's critique, opposed to the
apotheosis of quantification, which is the "democratic" mode of cog-
nition (i.e., an epistemological tool most easily transmitted to the
largest number of people), readily becomes elitist or even hermetic:
arguing for quality, in an environment geared to quantity, his way of
thinking is sure to reach the smallest, not the largest, number of
people, and to be the most difficult to assimilate. Yet art must have
intercourse with precisely this question of quality[41] versus quantity,
as well as with expression.

On a considerably more prosaic level than the complex ruminations
of negative dialectics, postwar art criticism meanwhile applied itself
to addressing the current malaise of the *Menschenbild*. By 1946, the
press once again had art exhibitions, even major ones, to discuss, and
the question of subjectivity and its interaction with objective reality
took center stage. The first major postwar art exhibition, brought
about through Franco-German cooperation, with assistance from
Switzerland, took place in Konstanz in 1946. As the reviewer for *Aus-
saat*, another of the many postwar journals devoted to art, culture,

and intellectual matters, noted, the emphasis was given to finding new definitions for "man": "But—and this was the key—the merely aesthetic did not at all stand in the forefront. What was enjoyed in the presentations, what all the lectures expressed, what was typical in many expert discussions was the search for a human center. Perhaps no other expression came up as often in these days as the word 'man.'"[42] Critics agreed; in many ways the problem was one of form.

By analyzing the extent to which contents—values—had been degraded and perverted, writers again and again struck upon the problem of their form, although this was usually more readily seen in cultural critiques dealing with language. In art criticism the terms were less well clarified, perhaps due to visual art's many—and confusing —formal permutations in the twentieth century. The more specific analyses thus focused on language, and they were pervasive throughout the period.[43] Form (particularly language) stands, I would argue, for a kind of objective reality, and it had become crucial to understand to what extent the subject determined this objective reality or was determined by it. While one could argue the same formal importance for the material realities of painting—the flatness of the canvas, the properties of paint—contemporary art criticism rarely strayed into this territory. Most art criticism in this period remained at a vague, general level of discourse about "man," but the specific analyses of language at this time bear useful parallels to analogous problems in the visual arts. The more astute conservative critics in art, as in language, sometimes found themselves in basic agreement with radical critics on this issue of form,[44] and while they drew markedly different conclusions from their analyses, there was a common interest in formal issues. On the other hand, those critics who were more utopic or optimistic (for whom art was a specific world apart from quotidian reality), as well as those with a still-intact political totality or world view (for whom art was an illustration of appropriate commitment), focused more on the problem of content, without overly troubling themselves with formal issues. For the time being, I will offer an account of the criticism relating to form, particularly as it relates to language and society.

The American journal for Germany, *Amerikanische Rundschau*, usually published articles by American authors about America, its domestic policy and its culture. It generally avoided existentialist or nihilistic-sounding analyses of culture—unlike its French counterpart *Quelle*, which occasionally offered articles on existentialism—and it

only occasionally offered analyses of European or German culture it-self, preferring instead to report on American subjects that served to inform a German public. But it struck a very familiar chord when it published excerpts from the recently deceased German émigré Ernst Cassirer's book, *Myth of the State*, echoing critiques that had appeared in all the other major journals.[45] It is noteworthy how Cassirer and Picard, whom we encountered already as the popular-conservative author of "Hitler in Ourselves," echo similar views about the modern age and its new methods of production.

> One has always assumed that myths derive from the unconscious and that they are the free products of imagination. They do not grow, they are not, as in ancient times, the wild impulses of an overactive imagina-tion. They are, rather, artificially fabricated by skillful and clever ex-perts. It was left to the twentieth-century, our great age of technology, also to discover a new technique of myths. From now on, myths can be manufactured in the same sense and with the same methods as machine guns and airplanes. This is what is completely new, and a matter of great significance. The form of our entire social life is hereby altered.[46]

Cassirer locates two bewildering "perversions" here: first, the catalyz-ing of "myth" from a passive, cultural context—a sort of content— into a formal instrument of manipulation; and second, the utilizing of modern means of production, of "know-how," to create these new formal structures that allow content to become virulent in a culture. *The form in effect determines the content*:

> With closer inspection of our political myths and the use one makes of them, we discover—to our great surprise—a revaluation not only of all of our ethical values, but also of language. The semantic word yields priority to the magical. . . . One is now in fact using formerly descrip-tive, logical—in short: semantic—words like magical ones which can have effects and are supposed to excite emotions. Our everyday words *mean* something; the new-fangled ones, however, are charged with feelings and passions. The men who coined these expressions were masters in the art of political propaganda. They achieved their goal— to excite vehement political passions—with the simplest means. A sin-gle word, or even the alteration of a syllable, was often enough to achieve the desired effect. The entire scale of human emotion resounds in these new words: hatred, rage, arrogance, contempt, pretention, and disdain.[47]

Finally, of greatest significance in this alteration, or even perversion, of form is that the destruction of language is linked to the creation of new rituals that serve to destroy the distinction between the public and the private sphere, that serve radically to remake civil life; and by extension and implication, this destruction of difference— which is, in plain terms, nothing less than the destruction of the ability to perceive quality—also destroys individuality.

> But the magical word requires completion through new rites if it is to have its full effect. This task, too, was solved as thoroughly as it was methodically by the political leaders. Every political action was surrounded by its own ritual. And since there is no private sphere independent of political life in the totalitarian state, the entire life of people was suddenly flooded with new rites. They were as regular, strict, and unrelenting as the rites of primitive societies. There was a special rite for every age and every sex, for every class. One could not even go into the street and greet one's friend and neighbour without undergoing a political rite. [Cassirer refers to the rule that one was always required to greet with "Heil Hitler."] And exactly as in primitive societies, the negligent ones were threatened with death and wretchedness.[48]

The effect of all of this is to eradicate the subject's sense of self, of individuality. And in the final analysis, this amounts to an alteration of the concept—or the image—of man itself.

> The effect of the new rites is apparent. Nothing is more suited to crippling our power to act, to discern, and critically to differentiate, as well as to robbing us of our sense of personality and individual responsibility, than the steady, uniform, monotone exercise of the same rites. Just as there is only collective, but not individual, responsibility in primitive societies in which the rite dominates everything. Not the individual, but the group, is the "moral subject." The family, the clan, and the entire tribe are responsible for the deeds of its members.[49]

It is striking that Cassirer, who had died before the end of the war, should have formulated so accurately the charge of "collective guilt," and link it so convincingly to the social form, not just the actual crime committed.

Collective guilt is an appropriate verdict, insofar as it assesses Nazi strategies of "tribalizing" society. It does not offer an accurate assessment of responsibility, however, as Cassirer's comparison to the Odyssey indicates.

We have learned that modern man, despite—or perhaps as a result of—his inner turmoil has not really elevated himself above the savage. When he is exposed to the same powers that held the savage enthralled, he compliantly returns to the old condition of malleability. He ceases to maintain a critical relationship to his environment, and instead accepts it as a given.

Of all the terrible experiences of the last twelve years, this might be the worst. One could compare it to Odysseus's experience on Circe's island. But it is even more horrifying. The friends and companions of Odysseus were turned into animals by Circe; but here there were intelligent and educated people, honest and upright men, who, of their own volition, threw away the highest privilege of man: to be sovereign persons. By carrying out the same rites, they soon also had the same feelings and thoughts, and began to speak the same language. Even if their gestures were lively and even vehement, they actually only led a shadow existence. They were marionettes—and did not even know that those pulling the strings in this theatre were their own political leaders.

This circumstance is of decisive significance for understanding the problem at hand. Political methods have always employed force and oppression. But they mostly pursued material goals. . . . The modern political myths achieve their effect in a totally different manner. They did not start by dictating man's ability to do or not do. Rather, they undertook in the first instance to alter man himself, in order then to regulate and control his actions.[50]

Again, the theme was sounded: "man" had been altered; there was no longer a fixed image, whether biblical, classical, or rational-enlightened. "Man" is mutable. Ironically enough, this realization was brought home by an ideology that had pretended to give "man" a fixed, eternal contour, namely phallic, German, "hard as Krupp steel": an ideology willing to exterminate or enslave all other men and women who failed to fit the mold. And with this realization of mutability, an entire social tradition and structure began to come undone.

In fact, history itself becomes unlodged when the image of man is insecure, a concern that worried the staffers in the Office of Military Government for Germany United States—Education and Cultural Relations Division (OMGUS-ECR).[51] Interested in gathering German opinion as well as in furthering a constructive, democratic policy in postwar Germany, OMGUS-ECR kept, for internal use, a document written in English by a German, Joseph H. Pfister, entitled "Educational Goals in the Teaching of History." It began with the statement,

"Education is always the transmittal of tradition."[52] Early in the report, Pfister succinctly defines our problem.

> *Every* form of history instruction proceeds consciously or unconsciously from some sort of principle of selection or evaluation according to which the overwhelming mass of events is organized and judged. The first principle of the by no means unprincipled science of history is, however, the current picture of man. If we wish to discuss the teaching of history as it has been conducted in Germany up until now, we must as a matter of method examine the various conceptions of man which were used as guiding images.[53]

Insofar as the image of man is necessary to constructing a *narrative* (history), and insofar as this image is currently unstable or simply "barbaric," Germany in particular and Western culture in general is threatened by total chaos.[54]

What were the proposals offered in the realm of art and culture that addressed this crisis? Here we again face the interesting (and difficult) task of differentiating critiques that, while reaching similar assessments, derive from opposite poles, conservative or progressive ("progressive" not necessarily equated with the politically left or pro-Soviet). Most assessments of visual art seem less incisive than those in the area of language or critical theory, and in general most were either too optimistic or too conservative.[55]

An expression of an optimistic view that carried a progressive note was the propagation of art previously repressed by Nazism, as if furthering what was forcibly repressed would amount to answering the disintegration of the image of man and all it implied socially. The move to abstract art, which was suppressed during the National Socialist period, was sometimes touted as a move to a "new" expression of "man," but this answer often erased the original question. Thus, the magazine *Prisma* addressed modern art in its first volume (1946/47) as follows:

> In accordance with the premise of this magazine, to avoid prejudgements, and also to do everything to eliminate prejudices, we in this issue present various voices on one of the most significant themes of modern culture. The problem of individualism is the point of departure, to arrive where the most decisive turning point of our times is manifested: in abstract painting. It is not enough to ascertain the difficulty of understanding—or the incomprehensibility of—an artwork; nor to call the one who produces the apparently incomprehensible a

fool. Likewise, clichés like "degenerate," "psychopathic," "stiltedly modernistic" unexpectedly fall back on the one who unthinkingly uses them. . . . Many younger people, who seek the quiet and the comprehensible after they have experienced far too much noise and incomprehensibility, will easily be drawn into the pull of a Hitlerian conception of art and of "Foto-Hoffmann" [this refers to a National-Socialist, ultra-realist painting style] ideologues. They should beware of the insinuating prejudice that comes from those quarters. It sounds convincing enough to observe that a pine tree is green; and it is easy enough to affirm such platitudes. The vulgar strength of conviction of Hitlerian cultural politics was based on this recipe.[56]

The optimistic solution suggested here is simple, and even simplistic: since conventionalism—what Cassirer described as the creation of collective rites to which everyone had to say yes and to which everyone had to adhere—destroyed individuality, then art that throws overboard the agreed-upon conventions of representation will therefore be most resonant with the project of recreating individualism. And abstract art, being, according to the author, the most difficult to understand and the most unconventional, is thus most appropriate to the expression of individuality. A real understanding of the crisis of individuality, of "authenticity," and of the image of man is simply circumvented in favor of easy solutions, without any differentiation between different kinds of "abstract" art. *Prisma*'s discussions were thus limited to generalizing lists of historically significant artists (Klee, Kandinsky), as well as unanalyzed contemporary practioners, often not even named.

At the same time, French modern art, which had traditionally provided inspiration for artists and publics, was also being touted in a simplistic and conservative manner, this time at the official level of the French occupation: in October 1946 the French government-sponsored exhibition, *Peinture française moderne*, was shown in Berlin, the capital of the Occupation. The catalog text, written by Jean Cassou, Conservateur en Chef du Musée d'Art Moderne, was published in French, German, English, and Russian: it laid claim to international reception. The very first sentences are telling, however, of an inadequate understanding of the depth of the crisis.

Painting is a form of expression to which France has never ceased to have recourse; it belongs to her genius; it suits her perfectly. For it is a comprehensive form of expression that accounts for exterior reality and which, at the same time, registers the effort of intelligence to assimilate

this reality and to reduce it to one figure, to one cipher, to a comprehensible language. There, reality and reason each find themselves realized.[57]

In the wake of what has happened to the image of "man" in the twentieth century, claims are still expressed that man is primarily a rational being who can "reduce" exterior reality and expression to "a figure," "a sign," to "a comprehensible language." Yet how could he? Would any such singular "reduction"—via man's wonderful ability to synthesize reality and reason—not simply flatten and distort and in the end lie about both reality and reason?

In effect, this conservative claim for culture—admirable in its defense of reason, however blind that defense might be—refuses to allow that which might now most radically question reason's ability to play any role in art. The criticism insists on harmony, on claims to great, unbroken, rupture-free traditions. Yet harmony is precisely what has disappeared from the postwar landscape, and much contemporary art refuses harmony. Conservative criticism, whether pro- or anti-modern or abstract art, denies the existence of disharmony, and thereby denies the expression of riven, disharmonious aspects.[58] The question of *Ausdruck* or expression is in this way tied to conceptions of history/tradition, to conceptions of history as a continuum, or as punctured by ruptures.

I want to argue that in this context expression comes to figure as reason's radical critique. That is, whether in the schizophrenic denial of the existence of disharmony (the optimistic view) or in the fearful jeremiad concerning the reduction of humanity to factory automatons (the conservative indictment of modernity), the subject's expressive capabilities are pre-tailored according to certain requirements. Hence, expression—particularly in the sense of Adorno's "mimetic moment"—is controlled or suppressed. The "mimetic moment" is supposed to recall the subject's fundamental difference from language, from form, or from the object. The rational, use-oriented subject assimilates (and distorts) the object, uses form or language in a game of false transparency and immediacy, and thus levels difference. The "mimetic moment," an archaic remnant of more primitive, magical thinking, instead suggests to the subject that the object or form or language cannot be assimilated or manipulated completely. The "mimetic moment," as magical relic, now surviving in the ability to discriminate, asks the subject to experience his or her elective affin-

ity with the object, thus allowing the object some rights of determination over the subject. This allows the subject to "escape" (temporarily) the requirements of rational quantification, and thus to perceive quality. What this also obviously suggests is a recourse to an earlier Romantic notion of critical authenticity: in the realm of quality, the subject can be expressive without domination, and he or she can locate a different relationship to self-identity, as well as to the national culture and the modernist tradition. This program cannot be sustained, however, for more than fleeting—or hermetic—moments: it is useless. A restorative cultural program, whether optimistic or conservative, has no use for such an unstable expressive moment.

Expression, and hence its need to be suppressed, came to be, in the postwar discourse, an important crux on which conceptions of art, occidentalism (belonging to the Western tradition), and "the image of man" turned. E. W. Nay's work is of paradigmatic importance here as he is one of the only modern painters who set himself an expressive agenda, one that relates to formal issues similar to the criticism of language as form. The question then arises whether Nay worked toward some version of the mimetic moment, and if so, how this was perceived in the postwar world, and furthermore, whether differences between the various kinds of abstract, modern art produced in Germany were perceived in art criticism.

In 1942, when Nay fortunately secured a posting as cartographer and subsequently found time to paint again, certain "mythic" conceptions determined his work. For Nay, "myth" signified man's fateful ties to nature, the natural—"original" in man, prior to civilization's rational influence.[59] He worked as a driven man, mostly on watercolors —landscapes, figure groups, lovers. Above all, he strove for *Ausdruck*, expression, as a letter of 10 February 1943 from Nay to the gallery owner and Nay's personal friend Günther Franke makes clear.

And I, too, well believe that here, amidst the agonies of tempestuous times, the new European painting is being born. Logically *in* war, logically amidst sacrifices and exigencies, logically amidst flaming chaos. I believe that beyond any idea of human labor, which articulates itself in my art, it [my art] is the first in a long time *to express itself with all of painting's forms of expressions* and to no longer need to renounce anything. The surface as imaginary space, the colored, dynamic construction, the ornament, the relief, the *light* from absolute color. Out of this radiates the picture of mythic reality, fed by the sources from which spring religions.[60]

Note that Nay clearly planned to operate with the expressive formal means of painting, and that he states a desire to experience the qualities of color, light, flatness as imaginary space. His desire for expression is tied to formal qualities, which in turn are imbued with mythic significance. But as his friend Heinz Lühdorf later recalled, Nay's interest in "mythic" ties was not religiously determined or even a matter of a *Weltanschauung*, as Nay did not believe that modern man could follow any dogmatically formulated religion, nor that he was subject to determinism.[61] If myth was embeddedness in nature—that which escapes *logos*—and if formal qualities could express nature/myth, then the painter's task was to show his elective affinity to the "mythic."

For Nay, the reality of his time's rivenness ("agonies of tempestuous times," "*in* war," etc.) is furthermore a crucial, significant, and even welcome component of his art's authenticity. He does not suggest creating an alternate harmony in art. But Nay's desire to find expression for the human drama was cloaked in a language that can be traced to a venerable German tradition ultimately identified with Nietzsche, and—despite its perversion of Nietzsche—to Nazism itself. One wonders whether *Drang*'s guilt-by-association made it almost taboo after 1945, for Nay's unabashed espousal of will is rare in this period. There is certainly a lack of humility in statements such as the following, made in another letter to Günther Franke, 27 February 1943: "I know that I paint the painting of the future, some already recognize it—and I believe that the future is no longer all too far. That a new European measure is here at hand is no longer to be doubted."[62]

In *Composition with Four Women* (pl. VI), painted at the time of Nay's letter to Franke, some of the same formal devices used in *Sibylle* (pl. IV) occur: the womb-umbilicus-eye symbol and a reduction to certain geometric structures. *Four Women* is also the first of Nay's paintings in which structural and expressive interests are joined in a dynamic play of forms bound to the flat canvas surface. The figures of the four women are interwoven, making the figure-ground relationship deliberately chaotic. Even as everything is brought to the surface, the use of ornamental motifs such as the checkerboard patterning serves to suggest a Byzantine richness which differs from works of the 1930s, or even from those of the previous year. This approach had been announced in drawings that preceded the painting, as Lühdorf recalled.

Nay had the feeling of having started something decisively new, that is what he explained to me while working on the following sketches, *Sleeping Woman* and *Watching Knight*. The drawing of the figures, which up to now had a kind of schematic quality, suddenly acquired three-dimensional volume. With increasing abstraction, he now also formed the background, which had been landscapes before, with abstract ornaments and patterns. One could say that Nay achieved a new disciplining of his art through this newly won freedom.[63]

In other words, the background is brought forward, and newly volumetric figures enter into this heightened dynamic surface play to create a reconfigured space, not necessarily a reduced one. Note, for example, how the diagonally placed figure on the left moves in and out of flatness and volume, and how the background is manipulated to this end: while the torso (primarily breast and womb-umbilicus) is volumetrically modelled, arms, head, and thighs are merely patterned in crude brush strokes, pushing these "volumes" back. The checkerboard background below the breast meanwhile emphasizes ornamental flatness (as well as the torso's volume), but directly below this, the background matches the rendering of the thighs. A deliberately rich and gaudy interaction ensues to make the surface as dynamic, as well as expressive, as possible—even at the risk of overloading, pushing too far. Above all, it is the placement of color that activates the painting, particularly the use of red and green; red had, for Nay, immediate connotations of the bodily, as in the color of blood.[64] But this expressivity is achieved deliberately on primarily formal terms, not on the basis of content.

In Hofheim, his new studio locale immediately after the war, Nay pursued this "expressive" path which came to be known as the "Hekate period."[65] And as the response from friends and collectors indicates, these works were appreciated for the expressive vein they tapped. In a letter from Berlin, dated 17 February 1946, Nay's friend Erich Meyer reacted as follows upon seeing photographs of Nay's most recent works: "If we had 'peace,' I probably soon would show up in Hofheim to satisfy my unbearable curiosity."[66] Immediately following this, he comments on the paintings themselves.

I can't, by the way, even define why I actually feel so compelled. I only know that "something's up" in your pictures. *Tays [sic] and Anna* (oil) excites me in every way, followed by *Daughters [sic] of Hecate*, *Sybille* [sic], and *Pastorale*. This time above all the oil paintings. They fascinate me more as painted surface and seem to me looser, freer. The less one

is reminded of natural forms, the more I like them. *Tays and Anna* is perhaps the fleshliest and most temperamental. Do you still have it?? I believe I would exert myself very much to abduct it if I could see it.[67]

Of particular interest is Meyer's inability to name precisely what excites him—he resorts to typical Berliner jargon: *"es tut sich was"* ("something's up") in these paintings—but whatever it is, it has to do with their formal qualities (the "painted surface," the lack of reference to naturalism), and their expressive quality: *"fleischlich"* (literally "fleshly" or corporeal) and *"temperamentvoll."* According to Meyer, the paintings refer neither to naturalism, nor to *"geistige"* ("spiritual") or metaphysical concerns as they then would not have such corporeal, somatic affinities.

In the same letter, Meyer comments on the condition of Expressionism, which in the 1920s had political associations.[68] It is obvious that Nay is not to be associated with this historical style.

There are, by the way, many debates on Expressionism—"canned art" [literally: "art in a preserve (or pickle) jar"], as the *Horizont*, of all things the youth magazine, calls it. In almost all the discussions it is said that Expressionism is to be dug up again. That strikes me as droll when I think of you.[69]

In view of Nay's latest works, Meyer found it droll to call for "resuscitating" Expressionism, though one can also infer that he finds the Expressionism of the 1910s and 1920s anachronistic in the present time.

On this last point, Nay would have agreed absolutely, not only because he considered himself a pathbreaker who avoided getting trapped by past styles, but also because the issue of form took priority over content and because the old Expressionism was no longer *expressive*, in his view. In September 1948 Nay responded to an artist who had sent him examples of his work; his answer encapsulates in miniature his philosophy, his own likes and dislikes.

I am glad that you have the basics, above all that you have understood that the picture is always the issue, never tendencies of an extra-formal type, never feelings, but always the picture-form. The Cubism of Juan Gris must combine with the new style, the modern vitalism. Stay as disciplined in this as your beginnings indicate; and beware of the modern enthusiasts [*Schwarmgeister*, pejorative] like Baumeister, Nolde, *et al*. The latter are *Jugendstil* tendencies, one side only, which later developed vitalism; but it is nothing without the other side, form. *Their* pic-

tures float—a sure sign of formlessness. Placed between these two poles that signify the future are all the modern or less modern academics and fantasts—Kokoschka, Hofer, the Surrealists, *et al.* While I can't discern anything in your woodcuts, I find your sketchbook on the right track. Because your woodcut is two-dimensional, and that's a dead end, except for some sort of literary tendency. And we don't want that.[70]

Note that Nay expresses the desire to combine Cubism with a "new vitalism": the Cubist "grid" prevents the painting from swimming or floating, "a sure sign of formlessness." Form comes from adherence to, and understanding of, the painting surface, the objective reality that resists willful or literary deformation. But simultaneously, it is vitalism—the expressive, the bodily, somatic, corporeal—that Nay seeks to encounter.

He also warns the young painter against *"Schwarmgeister"* such as Baumeister, who at this time was consolidating a successful center of abstract art in Stuttgart. Baumeister's influence, along with that of the collector Ottomar Domnick, represents the opposite in the realm of modern abstract art of the time to that of Nay. Nay's postwar exhibitions, when reviewed by a sympathetic critic, were sometimes seen in terms resonant with Nay's desiderata of combining form and expression. Thus Will Grohmann's review of the 1947 exhibition at the Galerie Franz in Berlin repeats the theme of the "vitalist" combined with form. His paintings are:

> Formations of visions, processes of the subconscious that lead to archaicisms. This means that Nay touches on depths from which arise mythologemes. Hence also some of the titles: *Orpheus, Daughter of Hecate.* They are not high school reminiscences, but rather the symptoms of human memory, forgotten heritages, atavisms. The color allows one to recall forgotten demons, often functions as a protest of the nonconformed; the delineation has something rather metamorphic, changing. . . . A submerging in worlds that also dwell in us, a search after common traits across time and nations, an understanding of the ambiguity of all things and occurences, all forms and aspects.
>
> The question, how something like this is made. One can also do it in the manner of a dilettante, or approximated to the infantile or primitive or schizophrenic. Nothing of the sort can be found in Nay; everything is capable, convincing, because he himself is convinced.[71]

His "mythologizing" is not puerile (it does not derive from high school reminiscences), and technically, Nay is a professional, not a

dilettante: "primitivism" is not the aim, the paintings do not try to be regressive, even as they utilize so-called "atavisms" to catalyze form. Despite Grohmann's adoption of Nay's basic terms, it is telling that as elegant and erudite a committed modernist critic as Will Grohmann had such difficulty forming complete sentences to describe Nay's work. The lapses in syntax are telling, as is the fact that criticism in this vein was very rare.

One might also wonder whether Grohmann had a specific kind of painting in mind when he referred to dilettantism. I would argue that it was the visionary or zealous tendency indicted also by Nay, namely the orientation crystallized around Baumeister's southwest German group. The major enthusiast of this circle, who was not himself a painter, was Dr. Ottomar Domnick. A psychiatrist, he and his wife (also a psychiatrist) were ardent collectors of abstract art, which they viewed as entry points to the subconscious. Domnick achieved a measure of fame when he began organizing abstract art exhibitions, and publishing his views on the subject; his major work was the 1947 book, *Die schöpferischen Kräfte in der abstrakten Malerei.*[72] Like Nay, Grohmann entertained reservations about amateur enthusiasts, as his 16 February 1949 letter to Hans Hartung indicates.[73] Domnick collected Hartung's work, and the latter was eventually persuaded to exhibit in a group show of ZEN49 artists.[74] Grohmann, who had known Hartung for years, wrote to him after Hartung returned to France from a visit to Stuttgart on the occasion of a Domnick-organized exhibition of French abstract art.

> I was a little worried about you in Stuttgart, since for us "initiates" it's always somewhat irritating when enthusiasts like Domnick from one day to the next jump, so to speak, from a hobby horse to abstract art. One has to be generous here, and in America it probably happens frequently, [but] here less often.[75]

The previous year, Grohmann had successfully avoided reviewing Domnick's book in the *Neue Zeitung*,[76] something that provoked at least two letters of inquiry from Domnick.[77]

While on the surface Grohmann's rejection of Domnick can be explained as one of professional jealousy, it is apparent that Grohmann's perception of what art does is quite different from Domnick's. The latter accorded it therapeutic value and believed in what seemed to him its metaphysical powers of direct transcription. Grohmann was far more interested in questions of form, unrelated to enthusiastic

spiritual claims. Nay fully agreed, linking his formal inquiries to expressive aims. Expression, in the sense of articulating the riven, unreconciled, and somatic experiences of the individual, could not in his view play a significant role in metaphysically oriented agendas for abstract art, as these usually are geared toward spiritual or therapeutic "reconciliation." Nay, despite the suspect Nietzschean language, openly addressed himself to the "tempestuous," unharmonic times. The therapy-oriented approach, on the other hand, looked for continuities, archetypes, reconciliations.

This issue of expression came to figure in the postwar cultural discussions that often laid claim to larger, idealistic truths, though sometimes figuring as an absence, not a presence. In 1949, for example, the prestigious art journal *Das Kunstwerk* reviewed the show of French abstract art in Stuttgart organized by Dr. Domnick. The exhibition, which included Hans Hartung as well as Pierre Soulages and other painters from the Parisian "Salon des Réalités Nouvelles"—but not Wols—subsequently travelled to other German cities. Kurt Leonhard, the reviewer, alternates between criticizing the lack of "power of expression and [lack of] fantasy of form," which had at least been traits of German and Russian abstract art,[78] and elevating this absence of expressive power to a new historical good—or at least a tolerable status quo.

> On the whole, one hardly—except with Hartung—finds anything fundamentally revolutionary. This may perhaps be what speaks for the argument that abstract painting is not a passing fashion that needs to insist on its newness, but rather a by now forty year organically developed, fertile tradition.[79]

Now, Leonhard here makes the point that when abstract art no longer shocks, it is removed from the particularity of its time and is instead elevated into historical tradition. When analyzed one could deduce that it is now dehistoricized, in a manner of speaking, that it is only the "shock" that allows rupture and hence specificity—which is history—to enter the picture.

The "shock" or radically new is crucial to the renewal of form, but in the name of historical tradition (continuity), it is praised as absence. The radically new is like striking a different ground than the familiar one of quantifying logic. It is like falling, but a fall that is constantly obliterated—or cushioned by the idea of modernity and modernism.[80] It is subversive, creaturely, and anti-idealistic. As an

expression of subjective confrontation with objective limits, it holds the potential for delimitation, and hence the creation of new limits and new forms. Far from "illustrations" of "the unknown," the "fourth dimension," the "unseen creative powers," or other metaphysical-idealist positivities espoused by ZEN49, abstract art that mobilizes the mimetic-expressive (the affective) rather than represent what materially does not exist, represents what, as being pre-language, has no name. This is supposed to be a negativity. The trick is in making it into a carrier (of meaning), something that perforce requires contact with "language."

However—and this is the point where idealism reclaimed its footing in the radically new—as Adorno repeatedly pointed out, there is no a priori identity between what is communicated and the communication itself. They are *different*, despite the *Menschenbild*'s self-flattery of being the locus of identity between *what* is thought or felt, and *how* s/he thinks or feels it.[81] The "shock" (of falling, of losing the familiar bearings of logic) recalls this difference that idealism wanted to erase. This critical stance is not arguing for the priority of subjectivism;[82] it attempts instead to return to the bodily the significance it has been denied by the dictates of progress: reason "instrumentalizes" everything in its name in order to claim its autonomy from bodily existence. Yet, without the "somatic moment," there can be no perception.[83]

The somatic nature of the subject's ways of knowing irritates both the philosophical claims structuring the relations between subject and object, as well as the desire to believe in the dignity of the corporeal itself.[84] In accordance with western epistemology, Adorno points out, we delude ourselves into believing that the body is constituted according to a law of relationships between perceptions and acts. Implied is the assumption that the body is subordinate to the mind, that without the mind's guidance, the body would not exist.[85] This means that perception is thus always already screened by the mind, the mental censor, and yet we lay claim to the belief that we perceive directly.[86] The somatic moment, however, is the fly in the ointment: it is irreducible, it cannot be assimilated or subordinated to the mind and hence irritates the mental image of bodily dignity. To conceive, on the other hand, of the bodily as subservient to laws intelligible to cognition is to repeat the subjectivist fallacy of creating identity where none exists, namely between what the body does or expresses and what logos can formulate about it. The "freedom" won by this idealism is thus a temporary, forced one.

This formulation also tells us nothing about will, which is after all intimately bound up with desire and freedom. To find a way of speaking of will without distorting it as an identification with reason, Adorno invented the term *"das Hinzutretende,"* the supplement, which appears irrational when seen through the rational rules of the game. The supplement is an impulse, "the rudiment of a phase" in which dualism had not yet consolidated its categories.[87] The supplement is both of the mind (intramental) and of the body (extramental); dualism cannot assign it to an either-or position and hence denies its existence. But as an impulse that exists all the same, it inflects the will, pushing toward a "concept of freedom as a state that would no more be blind nature than it would be oppressed nature."[88]

This concept of freedom's phantasm is the reconciliation of mind and nature. At first glance, it might seem that such a concept of will is in line with a Kantian version of practical reason, where will and reason are equated. But in the idealist scheme, where will is only an abstraction, the supplement has no role: "To philosophical reflection it [the supplement] appears as downright otherness because the will that has been reduced to pure practical reason is an abstraction."[89] The supplement, then, "is the name for that which was eliminated in this abstraction; without it, there would be no real will at all."[90] Here an attempt is made to snatch the remaining vestiges of spontaneity[91] and freedom from the maws of *both* rationality and irrationality.

For Adorno, intense theorizing on these questions was crucial work toward stemming barbarism: "A will detached from reason and proclaimed as an end in itself, like the will whose triumph the Nazis certified in the official title of their party congresses—such a will, like all ideals that rebel against reason, stands ready for every misdeed."[92] While reason fundamentally was criticized by Adorno, it was also held up—particularly in the form of the "most advanced state of theory"—as the only cognitive counterprinciple to barbarism: "For the right practice, and for the good itself, there really is no other authority than the most advanced state of theory."[93]

Although Adorno's proposals did not necessarily carry weight in the general postwar society or in the specialized discourse of the postwar art world,[94] it is necessary to understand his criticism of ontological thinking because so much of it was directed—obliquely or directly —against the very influential Martin Heidegger.

Heidegger himself had a cogent, even forceful critique of rationality and subjectivism,[95] and it is one that many postwar artists re-

sponded to positively.[96] But was this attraction perhaps due mainly to what Adorno analyzed as Heidegger's ability to present nihilism as a positivity? Within postwar society, there was a general sense among intellectuals that something was wrong with the very notion of progress and rationality, and it manifested itself at every level in discussions surrounding the image of man. But what if a philosopher could turn this potentially nihilistic summing up of Western culture into a positivity, as Adorno suggests Heidegger does?

> Heidegger's realism turns a somersault: his aim is to philosophize formlessly, so to speak, purely on the ground of things, with the result that things evaporate for him. Weary of the subjective jail of cognition, he becomes convinced that what is transcendent to subjectivity is immediate for subjectivity, without being conceptually stained by subjectivity. . . . Because we are neither to think speculatively, to have any thoughts that posit anything whatever, nor the other way round to admit an entity—a bit of the world, which would compromise the precedence of Being—we really dare not think anything but a complete vacuum, a capital X far emptier than the ancient transcendental subject which always carried "egoity," the memory of a consciousness in being, as its unit of consciousness.
>
> This new X, absolutely ineffable and removed from all predicates, becomes the *ens realissimum* under the name of Being. In the inevitability of aporetical concept formation the philosophy of Being becomes the unwilling victim of Hegel's judgment about Being: it is indistinguishably one with nothingness. Heidegger did not deceive himself about this. But what should be held against existential ontology is not the nihilism which the left-wing Existentialists later interpreted into it, to its own horror; to be held against that ontology is its positive presentation of the downright nihility of its supreme word.[97]

The return to elemental factors is made programmatic, recalling some of Nay's own ambitions. The "subjective prison of epistemology" is "overcome" with a warlike effort. And nihilism, which, as the previous discussion of the loss of an intact *Menschenbild* showed, had deep and lasting claims on postwar culture, is presented as a positivity, a way to go on.

Heidegger had also asked how "the subject" came into being in the first place, in this way addressing the modern conundrum of subject-object relations. He saw that modern subjectivity was primarily a new phenomenon, but, along with modernity itself, gave short shrift to the striving for social emancipation embodied by the subject. Heideg-

ger seized, as did Adorno, on the problem of the domination of na-
ture. That is, once man begins subjugating the world to language, he
begins representing the world to himself: he makes "world pictures,"
representations of the world, which are taken for the real thing and
constitute his ideology. With ideology and such mediated representa-
tions of the world, the domination of nature thus begins: the subject
puts his stamp on the world of objects, on nature.[98] In German, this is
referred to by the shorthand term *Naturbeherrschung*, or "nature domi-
nation," which I will use to refer to the process explained above. For
Heidegger, this is the key evil of modernity.

Newness was fundamentally distasteful to Heidegger; to him,
modernity was a plague that had "de-essentialized" the world, and
placed blind, subjectivist man in its stead. Heidegger put the blame
for modernity's propensity to think historically and its hostility to es-
sentialist thinking largely on Hegel, who "names the 'feeling on
which rests the religion of the modern period—the feeling God him-
self is dead.'"[99] Heidegger's anti-modernity attempted in effect to del-
egitimize historical thinking. Although both Heidegger and Adorno
criticized subjectivity and rationality, particularly for their role in "na-
ture domination," they were worlds apart on the question of history
and essentialism.

The desire to essentialize existence in turn had great resonance for
the agenda of ZEN49, for example, and its desire to formulate a style
of abstract painting. While both Heidegger and Adorno address vi-
sion and representation, the differences are significant. First, Adorno,
at the 1950 Darmstadt symposium: "all visible things are tied to resem-
blances to the visible world, because the eye, which constitutes the
picture, is figuratively and literally identical to the one that perceives
space and that because of its nature can be controlled tendentially by
the human being."[100] By stating that man controls how he sees, he
thereby linked vision to rationality and "nature domination." Vision
is something the artist—and viewer—can choose to control and ex-
press according to subjective needs. But Adorno's agenda, the even-
tual promise of his realism, was "the highest aesthetically possible
reconciliation of subject and object," not the "eradication of the sub-
ject, [or] the triumph of crude, violent objectivity, in which the I can-
cels itself out."[101] Clearly, the subject-object dialectic should not be
abandoned.

The case looks different for Heidegger, where visibility is linked to

the will to power by the Cartesian subject. He writes: "The essence of value lies in its being a point-of-view. Value means that upon which the eye is fixed . . . as a point-of-view, value is posited at any given time by a seeing and for a seeing."[102] The rational aspect of vision, its "nature domination," is implicated in the very structuring of values, which, being modern, are wrong. Deeply antithetical positions are espoused here. Adorno, despite his critique of rationality, refuses to stigmatize the modern era, or to reduce it to one thing, arguing instead that rationality is a complex, differentiated way of dealing with the world; reduction to only one of its aspects would be absurd. Heidegger is also critical of rationality, yet while he would have us live in a technological world, he opposes modernity. He denies ruptures, and the idea that humans can understand what they have made, the idea that underlies the belief in the intelligibility of history, is simply discounted as a mirage. The key problem for Heidegger is the subject, something that should be dethroned, but not in Adorno's sense of a reconciliation with that which is heterogeneous but rather by elimination. While Heidegger expresses a distrust of subjectivism and of "world pictures," he simultaneously villifies rationality as well as modernity.

Expression, to return to our theme, is a factor tied to human subjectivity, and at the same time very much a question of form. For some postwar critics, form was not an issue, provided that the content was politically or morally correct.[103] Other writers and cultural critics recognized that form, not merely subject matter, was a problem to be addressed in the postwar period. The majority of critics, however, refused to acknowledge the tremendous lack of available forms, much less the difficulty of formulating the radically new. The lack of form, and the concomitant crisis of subjectivity, resulted in a nihilism which, at least by Heidegger, was transformed into a combative positivity. The liquidation of subjectivity in its way completes the fake apotheosis of the will—the "co-ordination" of subjectivity—characteristic of the National Socialist regime.

Access to usable forms implies access to a tradition, which is linked to history. As these concepts were unstable, the result was a lack of form. Conservative critics wanted to "re-establish" tradition—usually meaning humanism—and failed to see that access to tradition, contingent on so many other factors, was not readily possible. Heidegger openly proclaimed his hostility to humanism,[104] and thus touched a

resonant chord in modernist and avant-garde culture. Once expression is eliminated, it is no longer a problem in this paradigm and ontology offers a "solution" to the problem of expression. But art seemingly cannot thrive without this "problem," and in the following chapters I will analyze this situation from several perspectives.

Chapter II

THE MARGINALIZATION OF EXPRESSION

A sharp attempt to come to order, to order the picture
with a method whose syntax is the surface as that which
is to be formed. An order deriving from the immanent
value of the number, and hence toward a self-evident
expression. [An order] Of formative color and its
subdivisions: chromatics, dynamics, rhythm,
volume to hieratic color.

(E. W. Nay to Will Grohmann, 8 October 1954)

I F CONCEPTIONS of history, including historical continuity or
narrative, are as intimately tied to conceptions of the "image of
man" as I suggested in the first chapter, does the lack of involve-
ment of *Germans* in the destruction of Nazism, which in the postwar
period is universally stigmatized as evil, then inflect the possibilities
for German self-expression and self-imaging? What sorts of political
venues will people adopt, what kind of image of culture, or of publics
for culture, will they generate?

While we must differentiate between what happens at the level of
political organization and at the level of painting, which takes place in
a small world of special interests and which hardly reaches a mass
audience, we may also assume that artists imagine a social world that
both imbues their work and is shaped by the existing social world.
Thus, even artists without political agendas partake in the terms of
the social field in which they exist. None of the living modernist art-
ists of the postwar period—including those who had become famous
before the war, such as Max Beckmann and Otto Dix, or Willi Bau-
meister, as well as younger ones, such as Nay, Heldt, Winter, and
others—were expressly committed to a clearly defined political ideol-
ogy.[1] Why not? Was it because they were too "bourgeois," or were
they silenced by the polarizing demands of the Cold War, or are art-
ists inept as political thinkers?

None of these "answers" could possibly satisfy the real demands of
the social field, which, in the initial months after war's end, was char-

acterized by the total absence of co-ordinates, as well as the inversion of previous social values, as the letters and other documents from this period illustrate. Werner Gilles, a moderately well-known postwar artist,[2] spent this initial period drifting from region to region; he was looking for a set of co-ordinates by which to reconstruct his life. In a 13 June 1946 letter to his friend Werner Heldt,[3] who had returned to Berlin to attempt a resumption of painting, we get a sense of how dislocated—but also heady and "free"—things could be.

> I travelled around constantly in the last weeks in an attempt to come to a decision. In Düsseldorf it was especially lively. Festivity on top of rubble—people find rubble their real home, with creased pants and spit-polished shoes; and on top, alcohol as plentiful as water in the Rhine. In Munich I sensed the fortunate air from Italy, and would soon have desired also to stay there. Here, near Stuttgart, a studio waited for me, but it was located in a mountain fold and I surely wouldn't have felt at home there. The only thing that's left for me is a trip to the French zone. There's supposed to be an exhibition now opened in Konstanz with a thousand pictures by Frenchmen and Germans. Matisse, Nolde, Hofer, et al. Hans Kuhn and Georg Becker are also nearby, and I would be really pleased to see them again. Well, yesterday I decided to move near Hof in the Fichtelgebirge. The painter Schumacher lives there and he's keeping a room ready for me which one can supposedly also heat in winter. I want to paint big pictures; the past year was rich for me, and I don't want to lose my new energy for life. Since I hung in the "Degenerate," the Americans have recognized me as politically persecute [sic]. Has one a bit more luck with this document! Actually I have to stay in the American zone, because my brother in America wants to send me packages. Please drop me a line at my new address. When I've got some more time, I'll write you in detail and at length.[4]

Whereas previously, attachment to a place—even rapidly evolving, unstable, and changing places such as Berlin (or New York, for that matter), places where modernity itself was being staked out—helped inform the artist's ability to lay claim to some image of world, some mediation between the private sphere of painting a particular painting and the public sphere it was imagined for, the artist was now a nomad, a wanderer in the husks of bombed cities (fig. 5), observing the natives constructing strange new rituals with new elements: patent leather shoes and Rhine wine, mountains of rubble against vast empty spaces, prostitution for basic necessities, the family heirloom for a half pound of butter. Cigarettes were currency, as good as gold,

and the Allied soldiers were the real nouveau riches of this strange new world.

Gilles and Heldt exemplify this in their work.[5] Of the two, Heldt is by far the more interesting. His prewar paintings are firmly attached not only to a place—Berlin—but to a specific milieu as well—the neighborhood around the *Altstadt*, which a work such as *Cloister Church* of 1928–29 (fig. 6) typically represents. But Heldt, a homosexual who felt increasingly threatened by Hitler's rise to power, as his ink drawing *Deployment of the Zeros* of 1933–34 (fig. 7) shows, withdrew from the depictions of his familiar neighborhood and its denizens, depictions he had favoured a decade earlier. The neighborhood was now an altered, "Nazified" milieu. Heldt instead cultivated a limited set of subjects which he treated with variations: the still-life (fig. 8), the view of the street (fig. 9). Figural references would occasionally intrude in an uncanny way, as in the 1952 *Une gifle aux Nazis (Still-life)* (pl. VII), in which the pink triangle foisted on homosexuals during the Third Reich is treated as a still-life element amongst many, but is juxtaposed to the unmistakable black, shadow profile of Adolf Hitler.[6]

Heldt himself never wore the pink triangle, even though it would seem that everyone in his very large and supportive circle of friends was aware of his orientation. Instead, Heldt was drafted, as suitable soldiering material, and had, like Nay, to serve time in the army. His postwar works continue the thematic repertoire from the thirties and forties: what is depicted are the trappings of a world that is thoroughly intimate to Heldt, it is *his* view from *his* window, but always with the estranged distance of one who is nonetheless not fully a habitué of that world. The part of him that this world excludes—an absence—is what determines the tone, feel, and treatment of these paintings. Heldt unfortunately died in 1954 just as he was attempting to move further into abstraction.

When we ponder what, beside the actual physical destruction of cities, had contributed to this new world to which painters in one way or another responded, we again have to consider what had happened to the *Menschenbild* during this period. Individual ability to act comes about only, I would argue, from allowing difference to manifest itself—a claim that has direct applicability to Heldt, as his paintings are the struggle of individual action in the face of social disallowance of difference. As soon as difference is denied, individual action—or any notion of "autonomy," for that matter—is severely compromised, even eradicated. Regression is the result.

Michel Foucault has examined the differences between regimes that exercise power (or domination) and those that exercise government,[7] a distinction that is useful for our case as well. Foucault traced a shift from medieval notions of government as exercise of power, in which power is more or less tautological: the point is to get and to have power, to maintain it, and proof of its maintenance is the allegiance and subservience of one's subalterns (the people). A newer model began to take hold in the eighteenth century, with forms of government that incorporate notions of economic management: things, and this includes the nation's people, should be managed according to their purposes and uses. Frederick II, according to Foucault, is exemplary of this shift when he noted that it is no longer a matter of territory per se that determines power, as Holland was far greater and wealthier than Russia: it was rather the things (including populace) in a territory, and their "wise" management, that mattered.[8]

To succeed, capitalist management (of the sort described by Foucault as a modern development) requires far more individual action and participation than older models based on power and territorial expansion. Nazism, however, was an express attempt to regress to "state forms" valid in the Middle Ages, based on territory, not modern "economic regimes" (despite German capital's tacit support of Hitler). As Hitler himself put it:

> Germany will either be a world power or it will not be at all. But to be a world power it needs that stature [size] which will give it the necessary significance in today's times and will give its citizens life.
>
> We National Socialists in this way consciously put an end to the foreign policy tendency of our prewar period. We begin where things ended six hundred years ago. We halt the eternal trek of the Germans to the south and the west of Europe, and point the gaze to the land in the east. We finally bring to a close the colonial and trade policy of the prewar period and move to the land policy of the future.
>
> When today we in Europe speak of new ground and land, we can in the first place think only of Russia and its subordinated satellites.[9]

Of course the *Volk* is the instrument of this regression to territorial-expansionist government: it is to ensure the "relentless Germanization" of the conquered territories. And this "Germanization" is of course again the expression of infantile dreams of omnipotence, of eradicating difference, of making everything the same and hence bringing it under one's control: denial of difference is the psychological equivalent of territorial conquest and of regression. It also effects closure, homogeneity.[10]

The insistence on exactly this kind of regression—in all spheres of public and private life—made Nazism a system in which resistance, for individuals, became increasingly impossible and dialogue became life-threatening.[11] In the "total" world created by Nazism, as in all fascist worlds, whether "hard" or "soft," differentiation and related critical faculties are increasingly dimmed. Actual attempts at criticism or opposition are ruthlessly eliminated and silenced. I suspect, furthermore, that this dynamic can only succeed if the majority of the populace *want* to abdicate their individual ability to act, *want* to be "seduced" by total thinking, because the instrument of seduction is appealing: the National Socialists offered jobs to the unemployed, goods and property (stolen from German Jews) to the career-minded, and careers to those otherwise incapable of achievement in Weimar Germany. Because it stood to gain, this "seduced" populace willingly —and virulently—contributed to the suppression of critical voices amidst their ranks.

As a closed, homogeneous monolith, the Nazi state had become seemingly impossible to defeat from within. Germany never developed a large-scale or popular resistance movement to Nazism, but opposition did exist in splintered, isolated groups. It was, however, impossible for them to come together or unify.[12] Why? An obvious reason was the system of denunciation and the threat of punishment. We must recall that once the war started, a Nazi law went into effect that defined a statement made to another person or persons—i.e., to one single other person, or to two or more—anywhere and anytime as an "address to the public," so that even private, cautious statements such as, "I think we're going to lose this war" or "Hitler's policies are designed to provoke world hatred," could therefore be considered public speeches falling under the rubric of high treason.[13] Those groups that did openly promote treason—namely, struggle against the state, capitulation to the enemy—were villified by Nazi propaganda, unless of course it was possible to deny their existence outright.[14]

For most of these groups the Allied demand for unconditional surrender compounded their problems in an unexpected way. One case in point is a group discussed in the previous chapter, the ultra-conservative and nationalist officers' corps of the German Army, who attempted to flood the German army with anti-Nazi propaganda. They did so with the aid of Soviet counter-intelligence, but the Western Allies, unlike the Russians, were far more unwilling to deal with German resistance, and sometimes even sabotaged its efforts.[15] In

large measure this was because the Western Allies hoped to secure a long-lasting peace through their strategy of unconditional surrender; allowing a resistance to represent the "good" Germany would have meant exempting it from unconditional surrender. By insisting on the unconditional surrender strategy, the Western Allies believed they could avoid the formation of a *Dolchstosslegende* such as developed after the First World War,[16] and it is indeed true that the aftermath of the Second World War did not see the rise of resentment-fueled myths of this sort.[17]

From the beginning, the actions of organized resistance groups were interpreted in terms of power-bloc interests. The right-wing conservative Nationalkomitee Freies Deutschland (NKFD), for example, produced leaflets detailing the Holocaust taking place in the East, from the first recognizing the unique characteristic of this genocide.[18] The official paper of this group, *Freies Deutschland*, was most probably the first to publish German accounts of the horrors perpetrated in death and concentration camps.[19] After Lublin was taken by the Russians, *Freies Deutschland* on 10 September 1944 published reports of genocide by the National Socialists, as well as an eyewitness account on 15 October 1944 by Luitpold Steidle that stressed the assembly-line quality of this genocide, an aspect that had already particularly horrified people and led to denial or repression.[20] But tragically, some reports, if they were perceived as coming from Soviet-supported German sources, were rejected by the Western media because of suspicion that they might be Soviet propaganda.[21]

The West valued a group's allegiance—in the case of the NKFD an allegiance to ultra-conservative nationalism and support from Soviet Russia—over truth—in part, because clearly the Cold War was already underway. The founding of the NKFD, as a case in point, provoked panic in the West, as it indicated that the Soviet Union was now willing to negotiate with a German leadership that pledged to end the war and overthrow Hitler; this, clearly, put the doctrine of unqualified capitulation into danger.[22] Bringing German opposition into play could be interpreted by the Western Allies as a Soviet plot, which makes some sense in view of the fact that, the NKFD notwithstanding, most opposition was leftist.

Furthermore, within the oppositional groups, there were great ideological rifts that prevented cohesive work. The Western Allies wanted an unconditional surrender because they wanted to deal neither with a communist-run Germany nor with a Junker military leadership, as the

Junkers represented a reactionary conservatism and nationalism that was as repugnant to the West as the Soviet-Communist proposals for social organization.[23] In this the Western Allies were supported by the leadership of the German Social Democratic Party (SPD), which exercised some influence in exile in England, particularly in supporting British distrust of the military, semi-aristocratic leadership proposed by the Junkers, while the SPD itself was furthermore deeply suspicious of the NKFD's support from Stalin, whom they detested.[24]

As a result, much of the NKFD activity was downplayed, if mentioned at all, or was sabotaged in the Western Allied propaganda aimed at Germany, particularly by the Office of Strategic Services (OSS) under Allen Dulles.[25] By 1952 the NKFD was again stigmatized as a band of traitors, this time by the West Germans: they were supposedly the "germ-cell" of the communist Soviet Zone of Occupation, the future German Democratic Republic,[26] a clear case of making a resistance movement that disagreed with Western values the scapegoat for German partition, despite the fact that this group had nothing in common with communism, except for an "anachronistic" distrust of modern capitalism.[27]

In terms of providing a forum for difference and individual action, the fate of resistance from the left—in a climate of Cold War distrust —was not much better. The term "Freies Deutschland" was taken up by groups of wildly opposed political views, but was originally used in the Manifesto of the Kommunistische Partei Deutschland (KPD) conference in Brussels in October 1935.[28] Next, it was used by a committee exiled in Paris that was preparing a German united front.[29] In Mexico, where many German émigrés had fled, the political-cultural magazine of the KPD-Mexiko was founded in 1941 with the title *Freies Deutschland*.[30]

The "Bewegung Freies Deutschland für den Westen" (BFDW) was the largest and strongest leftist opposition, operating in France and the Benelux countries. The (illegal) German Communist Party had already been distributing leaflets in France among the occupying German troops, and the BFDW was formed in August/September 1943; in October their manifesto appeared.[31] While they enjoyed close relations with the Parti Communiste Français (PCF), their relations with de Gaulle's Comité Français de Libération Nationale (CFLN)— seemingly comparable in some ideological respects to the NKFD, at least in terms of its basic conservatism and nationalism—were strained. But in April 1944 de Gaulle's CFLN did recognize the BFDW as part of

the résistance, and as a result the BFDW received considerable official power, enabling it to negotiate, to send its people into both army hospitals and POW camps, and to train its members "maquis-style." But their participation in French radio was unexplainably eliminated in October 1944 and, suddenly, in December 1944, their organization was forbidden.

> The intention, after the Allied invasion, to train German partisans in the manner of French maquis fighters and to sluice them into Germany to give emphasis to the rallying cry "Cross over to the Free Germany Movement's side" found no favor with the Allies. A protest note, in January 1945, to Great Britain and the USA over the injunction, put out by the authorities of liberated France, of radio and camp propaganda also was not listened to. These restrictions and injunctions were among the reasons why, despite all attempts, efforts to fan an anti-fascist mass movement within the Wehrmacht were unsuccessful.[32]

Insofar as German resistance groups already represented political and cultural interests—nationalism, communism, anti-capitalism, pro-Junker aristocratic interests, anti-modernity views, etc.—their suppression or marginal reception according to Soviet or Western desiderata implies that a Cold War, both politically and culturally, was well underway by at least 1943.

This use and misuse of resistance groups was not, however, a tactic only of the Western Allies. The German Communists, who would eventually found the German Democratic Republic (GDR), from the start worked hard to extirpate, with whatever violence was necessary, any opposition to Hitler that did not fit the precise mold dictated by party politics. Walter Ulbricht, shortly after May 1945, decreed the elimination of the NKFD in Berlin because it was a "cover organization of the Nazis [that] would sap valuable strength from the administration."[33] The same party also immediately took over the existing Nazi concentration camps in the area of the Soviet Zone of Occupation and turned them into concentration camps for critics of orthodox Stalinism (of which the German Party was one of the most ardent admirers).[34]

Admittedly, the Western press did cover the "German resistance" with some interest for a while after the war's end, but by the late 1940s, it simply was not mentioned at all. The reasons for this, I would argue, lie in the various groups' ideologically conflicting positions, which were already expressions of Cold War rivalries. At the

same time, however, coverage of the resistance could easily have become a "myth" of resistance (as it did in several European countries, particularly Austria, and even France), which would have allowed for an honorable reassertion of national identity. That this was quelled in Germany was in part due to the sheer burden of guilt Germans bore, but it was also due to the country's peculiar situation between East and West. Both factors determine the possibility of reconstituting the subject in Germany.

One of the last times the *Amerikanische Rundschau* broached the subject was in late 1947, when it published a translation of an article that had first appeared in the *American Historical Review* that year. The article is by Franklin L. Ford, identified in the notes on contributors as being

> currently twenty-five years old. During the war he was a First Lieutenant assigned to the Office of Strategic Services. During the course of his activities he had the opportunity to amass the material for his article, "The Twentieth of July," which first appeared in the quarterly *The American Historical Review*. On the strength of a fellowship, Ford is currently continuing his studies at Harvard University.[35]

Ford's analysis turns in part on this ideological conflict between the ultra-conservative opposition and the demands of the Social Democrats, who in many ways were far more in accord with the Western Allies' notions of postwar German development than any of the other political groups. The British and the Americans never felt comfortable around either the Communist or the conservative-nationalist groups, nor around any radical sector whatsoever. The French could tolerate the German Communists, but they were overruled. For the Anglo-American forces, the Social Democrats represented the only reasonable alternative, at least until under Adenauer the Christian Democrats shed the remaining vestiges of their Catholic socialism.[36]

Ford argues that it is precisely the organized leftist movement that fell most thoroughly victim to the Nazi terror: organized mass movements after all have membership lists, union support, and so forth, and it was almost child's play for the Nazis to round up or at least severely intimidate every single registered member. But the conservatives were from the start more individualistic, belonging only to traditionally "apolitical" organizations of their class, and hence were less easy to grasp. This proved to their advantage later, when the leftist opposition was either exiled or imprisoned in concentration camps,

as they could then claim to represent the only alternative to Hitler. This made the Social Democrats (and the Anglo-Americans, one might add) very nervous, and rightly so. As Ford notes:

> Despite the observer's easy assertion that Hitler's was the most ruthlessly efficient police state in history, the political implications of those police methods become clear only in their demonstrated effect on potential opposition. In a population reduced to almost complete formlessness except for the form imposed by the government and infiltrated with enough *agents provocateurs* to make perilous even the most privy expression of doubt in the regime, oppositional alignments necessarily fell into the pattern of old associations and official organizations which still retained some measure of freedom from party domination. To Hitler's counterrevolutionary regime the traditional mass organization of the Left, such as the trade unions, were at once the most obviously dangerous and the most easily crushed by ruthless police action. The groupings of the Right, on the other hand, relying less upon numerical power than upon the individual influence of relatively few members, were less easily controlled even after their old alliance with the Nazis could no longer be relied upon by the regime. *In this sense the Nazi measures drove active resistance increasingly into the hands of conservatives."* [37]

Ford argues that the nature of the National Socialist police state itself forced oppositional forces to come from conservative groups, since leftist mass organizations were either summarily extirpated or refunctionalized by the regime.

This put the left in a difficult predicament, as its post-National Socialist saviours would be conservative-nationalist reactionaries who had few sympathies for modernity or for socialist goals. As Ford notes in his analysis, the defeat of the Nazis was, in the left's view, obviously necessary for liberating the oppressed masses. Conditions were at the same time such that defeat was possible only with the help of the army and upper echelon bureaucrats, two traditionally right-wing bodies. Hope for liberation, in other words, was paired with fear of a takeover by reactionaries. And there was yet another complication: the left could actively support the conservative-reactionary attempts to defeat Nazism, or it could bide its time and hope for the unconditional breakdown of the country, a breakdown that would cripple the right wing and allow a moderate Allied government to take control. [38] This implies that the Western Allies and the Social Democrats were, for better or for worse, in agreement, that unconditional surrender

was preferable to letting conservative-nationalists, i.e., reactionaries, gain power.[39] It also illuminates the democratic left's inability to act.

Given the previous description of the death of individual action, this review of some of the real, existing resistance groups might seem like a contradiction. While these were individuals-in-action, the problems faced by even these people, the most powerful or influential, the least brainwashed (in terms of social standing where the reactionaries are concerned and a structure of organizational support in the case of the left), basically underscores the reduction to inaction of "a population reduced to almost complete formlessness," as Ford characterizes them.[40] If opposition or resistance was already enmeshed in a Cold War dynamic, it would amount to a massive restriction of individual ability to act, further hampered by the willingness to be manipulated, to abdicate individual responsibility. It instead predicated a "ticket" mentality.[41] And if the organized opposition faced such problems, what would the "average citizen," with no organizational model to endow him or her with strength, be willing to burden himself with? Most of those same average citizens had stood in the streets and cheered when things had gone well, but for those who had doubted from the start, there was no venue. And when things became obvious, when the National Socialist police state was so firmly entrenched that Hitler decided he did not have to lie to the German populace any longer about desiring only peace, it was too late.

In this sense, despite the average citizen's complicity with Nazism —a complicity determined both by his or her desire to be seduced, to abdicate responsibility, and a lack of active opposition—it was not *Heuchelei* (hypocrisy, a charge levelled easily at the Germans after the war) when many of these same average citizens claimed to experience the end of Nazism as a liberation. But a liberation *into* what?

Into a world without readily available co-ordinates, but one in which an immediate, intense competition for staking out new (or often old) terms ensued. The East had its own view of what was to be done: it had a seemingly secure model of history, including an image of man—a subject—in that history. As the earlier quoted Josef Pfister noted for OMGUS-ECR, in the Soviet Zone of Occupation the Germans were already working on a new image of man based on "historical dialectical materialism," as outlined in their "Directives for the Teaching of German History" published by the German Administration for Public Education in Berlin.[42]

This secure image would eventually be transcribed by the dictates of socialist realism in art, where individual action is depicted strictly as the performance of mandated collective desire. In regard to the *Menschenbild*, Pfister noted that "in the western zones it has to date only been established that the education authorities do not want it 'that way.'"[43] But neither had alternatives been presented, and the West stood in danger of slipping behind the Soviets. Nor could the West's prewar model be accepted by postwar youth.

> The older generation is in the weak position of having in the large majority lost their right to authority and example. However, in spite of all this the connection between generations must be revitalized to preserve the unity of the nation and to protect the youth from new aberrations of extremism.[44]

Before the war, the "ethical imperatives"[45] of this generation had been

> practically and idealogocially [sic] oriented to the most powerful pressure groups which were the deciding influences in the history of their times. It was first bourgeoisie-idealistic (with certain limited confessional christian overtones), then marxian materialistic, and finally national socialistic.[46]

A notion of history, and an image of man in that history, was crucial for "preserving the unity of the nation"[47] as well as for providing guidance to today's youth. However, Pfister notes that both history and its subjects are determined by the political principle that happens to rule.

To have recourse to the "transitional" history books of the Weimar period, first eliminating any references to militarism, could only be a stop-gap measure, for "all those books belong to the 'bourgeois idealistic' tendency which was already out of fashion after 1918"; and furthermore this important caveat is added: However it does not matter how often you wash a leopard you cannot change its spots—and a 'bourgeois' history book no matter now disguised does not become 'democratic' in the positive ethical sense of a new way of living."[48] Thus, if the Western zone was not going to copy the Eastern zone's model of history (along with the image of man that goes with that model), and if at the same time some liberal voices noted that the old *bürgerliche* models were inherently authoritarian and likely to provoke further radicalization of the country's youth, then it would seem

merely logical that only a new model of citizenship, of *Bürgertum*, would stand a good chance of gaining officially sanctioned popularity and adherents. Locating this new model—one basically sympathetic to Western values, and in the coming years increasingly determined by specific American values—was the real purpose of re-education.[49]

Before this new model could be located, however, the West's position remained quite volatile compared to the East's. The subject of Western history is the (male) citizen, the *Bürger*, and it was precisely the image of the *Bürger* that was being contested and was in doubt. The whole concept of individualism tied to the specific circumstance of the nation-state had failed, or at least shown a fatal flaw. The most powerful Western ally had already perceived it by 1945 as, perhaps not a failure, but certainly a calamity:

> The German people must come to understand that the Nazi repudiation of those [universally valid] principles [of justice] destroyed all *individual rights* in the Nazi state, made the effort at world tyranny inevitable and brought Germany to its present disaster.[50]

It is the destruction of individual rights and of individual life—the enmeshing of all aspects of private life into public ritual—that enabled the Nazi machine to effect its destruction of civil life.

In 1945, the date of this secret long-range directive, the United States still believed that the situation could be corrected, or treated therapeutically, by calling upon as many oppositional forces as possible, as though agreement, rather than bitter disagreement, reigned among these forces as to what constituted a "good" image of man, a valid alternative to Nazism.

> The occupation authorities will bear in mind that permanent cultural changes can be effected only as they are developed and maintained by the Germans them-selves [sic]. Having first eliminated the Nazi elements, they will seek to effect the progressive transfer of authority in re-education to responsible Germans as rapidly as conditions permit. The most obvious evidences of anti-Nazi resources will be found in specific religious, intellectual, trade union and political resistance to Nazism. A further source of anti-Nazism should be considered; that springing from the resistance of the family, particularly of the women, to the Nazi state. Similar resources must also be looked for in members of welfare and teaching organizations who remained unpolitical and thus possibly avoided the taint of Nazism. The occupation authorities will encourage the revival of educational and other cultural activities of

those groups and organizations (such as the family, the churches, trade unions and welfare organizations) many of which have suffered under Nazism and which form a natural basis for the realization of the principles formulated above.[51]

The list indicates a certain problematic regarding consensus: women are cited as a specific source of individual non-conformity to the Nazi state (whether this belief was determined by fact or by the conditioned thinking that equates the female sphere with the private sphere is open to question), along with trade unions, for example. Yet one immediately wonders why there should be any point of agreement between these two besides an opposition to Nazi control.[52]

The earliest directives, along with later documents, indicate the significance attached in the Western camp to addressing the problem of individualism, civil life, and its specific political and institutional forms.[53] For our purposes the question of art's relationship to this fractured concept of individualism and civil life immediately presents itself: whether art could have a direct, formative role in the creation of new proposals, or whether it was totally "autonomous" to these concerns; whether it was a reflection of the current state of affairs, or whether it was the "badge" of identification of particular social trends (democracy, socialism, communism); or whether it forms a relationship of another, more mediated kind. And furthermore, how did the state of affairs described in the previous pages inflect the *possibilities* for art's reception in the postwar period?

Older liberals, like the writer Erich Kästner, were troubled by the climate in which art was seen and commented on in the immediate postwar period. Reviewing an exhibition held in Augsburg in 1946,[54] Kästner puzzles over the harsh, violent outbursts that the most modern and abstract art provoked. The work of a minor artist, Ernst Geitlinger, came in for especially vituperative treatment by the public. The most negative reactions came from young people, who openly advocated that abstract artists should be "stuck into concentration camps" or "gunned down."[55] This situation was particularly disastrous, since an important source of feed-back, namely the supportive response of the younger generation, was taken away from those artists who dared to be unconventional: "For even if productive youth, even if young talents themselves find their way—in spite of the influence of the past twelve years—in what sort of vacuum will they end up without the company of their contemporary [same-aged] publics?

Without the latter's fanaticism for the new? Without the latter's exultation and enthusiasm?"[56] The danger that Kästner does not address is that the avant-garde is more likely to find its audience among the educated elderly rather than rebellious youngsters (who have spent all their "fanaticism for the new" on Hitler), and that the former will move into a position of power, as they have the best chance of fulfilling the "democratization" charge of re-education.[57]

The charge of re-education included the creation of a tolerance for modern art, but it is only too clear that the most avant-garde art would find no favor whatsoever among the public at large. This made art into a not-very-flexible tool for democratization: it remained unamenable to mass dissemination, remained a specialized, elitist "marker." When the German press was decontrolled in 1949, the Americans, too, became acquainted with this fact. In a memo of 16 August 1949, Sam H. Linch, the Acting Chief of the Cultural Affairs Branch, was informed of the following developments.

In every age the taste of the average citizen lags behind that of the avant-garde among the artists and art lovers. After the Nazi regime had collapsed it was only too natural that the group of artists hitherto labelled as 'degenerate' should come to the fore. They found strong support from many of the progressive art critics who, writing for a controlled press, had to pay little attention to the likes and dislikes of the average reader. Since the controls were lifted this situation is undergoing remarkable changes. People are now writing letters of protest to the paper that deviates too strongly from the prevalent taste. A well-known art critic, who regularly contributes to 'Die Zeit', a weekly of high intellectual level, was recently advised by the editor to tone down his praise of modern art. In this case the harmless and playful art of Paul Klee had aroused the indignation of enough readers to cause the editor's concern. This incident shows the gap between popular and advanced taste, a gap which Nazi intolerance has purposely widened and which only patient visual education can hope to narrow down. Taken by itself, the protest is a healthy sign of the functioning of a free, democratic press.

Related symptoms can be noticed in the field of exhibitions. In the Haus der Kunst, built by Hitler to replace the destroyed Glaspalast, the 'Secessionists' are at present preparing their first post-war show. Once the revolutionary avant-garde, the Secessionists have in time taken over the place of the academicians. In the coming show one can expect to see the art of the day before yesterday, technically well-made paintings, conventional, unoffending, with strong nationalistic potentialities. The

Secessionists have their counterpart in Stuttgart, where the avant-garde under the leadership of the excellent Willi Baumeister now occupies the key positions in the Art Academy, forcing reactionaries and conservatives among the artists to form their own organization, which, with involuntary irony, calls itself 'Sezession'.[58]

Thus, while the press was controlled, the "avant-garde" critics could write without heed to public taste; now, in 1949, the tide is turning and the public is demanding an art to its liking: innocuous, not avant-garde, familiar, not strange. For the United States, the most interesting upshot, as the 1949 memo puts it, is that: "the conclusion to be drawn from the above is that we must be aware of the prevalent trend in German taste, when we circulate exhibitions of contemporary American art in the US Zone. Predominance of abstract and surrealist art had better be avoided."[59]

Two things are of interest here: first, that the period between 1945 to 1949 was indeed a controlled period in which the general condition of the "German mind" was taken into account, but, as it was held to be too warped by Nazism, the reins of control in art re-education were passed to an elite, a German group of writers, intellectuals, critics, and artists who for the most part belonged to a generation born before 1905–1910, who shared the ideals of the Western Allies, and who, while trying to "re-educate" German youth, had few sympathies for its thoroughly philistine character.[60] Second, that the United States was not going to jeopardize its position in Germany by "infiltrating" it with art that had no popular resonance: just as no Wols could be seen in Germany for many years after the war (although Hartung and Soulages were), so no Pollock or other Abstract Expressionist painter could be seen in Germany in these early years. We are dealing with a situation in which the desiderata of the victorious Allies had a general determining power, but in which the specifics of art and culture were worked out by the Germans themselves, and the image of culture shaped thereby was the result of internal maneuvering.

In Berlin, the "Kulturbund zur demokratischen Erneuerung Deutschlands," a heavily pro-Soviet umbrella organization for various writers and intellectuals, was formed on 4 July 1945. Its founding address to the public, made by the actor Kai Moeller in the Grosse Sendesaal of the Berliner Rundfunk,[61] was indicative of the clear image of man that the Soviet model inspired—here in its most idealistic form. Interestingly enough, this model was inextricably bound to an old-fashioned idea of

nationalism, patriotism, and German national identity, values about which, however, many must have been deeply confused in this period. But even though it called for "German" ideals, its lesson was heavily negative in the sense that it pointed more to what the "new German" was to hate, rather than to what he was to love: his new identity was to be formed through this loathing of the previous regime's ideals.

> A national hatred, of a passion the like of which has never before in Germany been enflamed, must strike all those who still show themselves to be recalcitrant and who pursue a prolongation and perpetuation of the Hitler outrage. Love for Germany and national disposition must be measured according to the extent to which a German is ready to become a new German man, a free German man, the extent to which he self-critically participates in the destruction of the Nazi ideology, the imperialist and militarist ideology, and the extent to which he shows initiative for reparations.[62]

The problem was that the Kulturbund expected to arouse the same kinds of violent, vehement feelings as the Nazis had aroused, only now the object of those feelings was altered. But the language— and the devotion to Germany—remained uncannily familiar: now the war criminals were stigmatized as "enemies of Germany, traitors to the fatherland, and corrupters of the people"; that is, they were characterized by the same misanthropic language used by the Nazis to designate their enemies. The format of the pro-Soviet defense of "German" culture all too often assumed a similar shape to the Nazi ideal.[63]

By 1948, the deep divisions between the two competing worldviews of East and West made the partition of Germany a de facto reality. The East Berlin art magazine *Bildende Kunst*, which in the coming year would increasingly absent itself from discussions of contemporary art but which in 1948 pursued an optimistic and idealistic line, emphasized contemporary art's social embeddedness.

> The year 1948 stands under the sign of remembrance of the revolutionary struggle for unification by the German people split into countless little fatherlands. Today, German unity is again endangered. *Bildende Kunst* would like to help preserve it by serving, in its specialized area, German culture as an indivisible whole within the framework of a world culture.[64]

Art is here given a role: that of unifying the nation. The magazine intends to help bring about "that the people find their way back to art and art find its way back to the people, that the fatal split be closed

which today separates a painting and sculpture struggling for new contents and new forms from the public at large."[65] At this point, it was not yet *Bildende Kunst* policy to ignore the various types of abstract art. But how was the magazine to present the latter without having it contribute to the ever-widening rift between art and public, a rift in turn interpreted as symptomatic of a lack of national unity?

One such attempt was made by Adolf Behne, one of the older generation now in the position of instructing the young in the principles of unconventionalism.[66] Behne's "Was will die moderne Kunst?," published in the same issue of *Bildende Kunst*, is a brief, but rhetorically clever attempt to make viewers understand "abstract" art—this being the avowed goal of the article—while at the same time trying to make them comprehend formal or artistic autonomy. His article begins by noting twentieth-century developments in science, which had served as a standard defense ploy for abstraction since the discovery of the atom. But Behne puts an interesting twist on this: he maintains that as science is becoming increasingly abstract, art, appropriately enough, becomes increasingly *anschaulich*, i.e., "demonstrably visible," specific, material.[67] Aware of how his proposal contradicts the more prevalent view, he asks polemically whether he has not just given up a wonderful argument for abstract art, namely, that as science becomes more abstract, so does art. But this, he quickly adds, would be missing the truth: art is not the illustration of physics; art is a matter of visibility, of *Anschauung*. Even abstract art is not an illustration of "ideas" or "speculations" or "thoughts."[68] But what, Behne wants to know, does modern art put before our eyes for our *Anschauung*, considering that it avoids naturalism? His answer indicts the equation of conventionalism and idealism and instead champions the liberating effect of unconventional materialism: "Well—are really only objects demonstrably visible? Or do we cheat ourselves of all the pleasures of looking by quickly degrading every optical marvel to a known 'object,' that is, to a convention?"[69] He continues his questioning: is red only red if it represents an apple, yellow only yellow *if* . . . ? No, because the colors themselves, as physical properties, are *Gegebenheiten*, i.e., givens, and if they address us, it is not as adjectival qualities (red apple), but as substantives: "Colors and forms are free forces, not house painters,"[70] a clear denigration of the art philosophy advocated under Hitler, whose failed career as an artist and architect had taken him temporarily to the profession of house painting.

From here, however, Behne proceeds to his real purpose: a frontal attack on the corrupt relationship of the *Bürger* to nature, his degrada-

tion and corruption of it. Behne's modern art is to provide a maieutic model for a different relationship with nature, with that which the *Bürger* is not. Modern art, Behne argues from a standpoint deeply embedded in the appreciation of French Impressionism, wants to give viewers a pure and elemental relation to nature—which might, he adds, seem queer considering it does not represent nature "naturalistically."[71] But it does not really turn its back on nature at all, as simply copying it merely allows us to continue lazy visual habits that prevent us from ever truly looking at or seeing nature itself. The most enchanting object is seen only as "object," as "the copy of a well-known schema,"[72] a habit that allows only the "intellectual apparatus" to function.[73]

> Living nature scoffs at these small puny bodies, their limits which only human inertia continues to drag along. "Aha, an apple!"—this we note, just to avoid having to see, to look. Apple, tree, swan, cloud: they are conceptually registered, recognized as objects. What a miracle each individual branch of the tree, each leaf of the branch is—this we now no longer have to see. "Objectiveness" is the barrier between nature and the citizen.[74]

Like Adorno, Behne attacks, albeit on a very different level, the *Bürger*'s ingrained habit of quantification, as well as his concommitant neglect of quality. Deriving from a study of Impressionism, an older-generation critic is attempting to sketch out for a younger generation a proposal, based on quality, not quantity, for linking seeing with cognition, with social habits and norms.[75] Of interest is the recourse to elementals, the belief that somehow going back to primary, elemental cognitive and experiential states will be beneficial, in a concrete way, for society and culture, as it will undermine the habit of schematic quantification.

Of course this program could lead easily to arbitrariness and subjectivism, and Behne tries to incorporate a warning to this effect.

> The new art is a call to creative daring and to elemental human being [*elementaren Menschentum*]. It does not culminate—except in the case of some insignificant followers—in an egocentric subjectivism, in arbitrariness, in products that finally are only comprehensible to their author. On the contrary: it allies itself to the objective, which to be sure is sought at a new depth.[76]

This call for binding to something "objective" (left undefined, however) was probably the aspect that allowed this article to appear in *Bildende Kunst*, which in numerous articles was dedicated to locating

this objective quality in a new social reality predicated on communism.[77] The important question for *Bildende Kunst* really was whether the new order would not of itself allow a new, vital, socially embedded art to ensue, a question *Bildende Kunst* usually answered affirmatively. Thus, even though 67.5 percent of those who filled out a questionnaire while visiting the First Dresden Art Congress in 1946 rejected modern art, "and namely particularly because of expressionist and abstract art,"[78] art should not resign itself to pandering to the lowest instincts of the people's fascist deformity. As Carl-Ernst Matthias, the author of this article, exhorts: "No cultural pessimism! Rather: fanatical optimism is appropriate. Only the art of a particular social order is declining. What counts now is to engage with tremendous passion all efforts toward a different order."[79]

The autonomy issue here becomes acute. Art, even Matthias seems to agree, does not quite work as a mass consumer product nor mass re-education tool. The masses will often reject difficult or ambitious art—although Matthias quickly adds that once the new order is established, art of quality (yet to be defined, but at any rate opposed to the art correlating to fascist deformity) will be embraced. But the burden of proof remains for this assumption. And the old problem remains: Who would take on the task of shaping art's progressive form if the masses, in the form of a new order, continued to refuse the task? A small elite? Who defines what is art, or what is "progressive" about it? It is clear that in the East the dictates of Socialist Realism quickly usurped the role of defining art. It is less clear how in the West this issue of art's autonomy, which keeps it aloof from totalitarian dictates as well as from mass consumption requirements, became enervated. In the West, "autonomy" became a kind of fetish, the talismanic proof of art's critical quality of opposition to the given established status quo as well as to the habit of quantification. To varying degrees, autonomy instead became a reified concept venerated by the (re)new(ed) apostles of being, of "elemental *Menschentum*"[80] posited as ontological a priori. It simply "is," opaquely and inexplicably, and it thereby assumes the same veiled mysticism as some ontological searches into the origins of being.

We could dissect the fetishization of autonomy on yet another level, in relation to truth and subjectivity, a topos Adorno addressed in *Negative Dialektik*. He pointed to the tautology inherent in idealistic thinking: "If truth were indeed [only] subjectivity, if a thought were nothing but a repetition of the subject, the thought would be null and

void."[81] When I think, for example, I can be aware that my thought is different from myself as subject, or I can insist that there is identity between myself and my thought as medium and as content. If thought, in other words, just *reproduced* the subject ("myself"), versus expressing its difference from both its subject and its object,[82] it would be a tautology and hence void; this is a critique also levelled by Wittgenstein against the metaphysicians, notably Heidegger. This tautological mode, in which thought is reproduction, not difference or negation, is in fact a kind of imperialism, for through an "existential exaltation of the subject" it "eliminates, for the subject's sake, what might become clear to the subject," namely differential, even contradictory experience.[83] Instead, everything is relativized in the name of homogenizing it to being.[84] Critical thinking is incapacitated, and this, I will argue, entails the real "restoration" aspect of modernism's turn in Germany. Autonomy, with these maneuverings, became a fetish, not a critical concept. And nowhere is this more clearly expressed than in the art and the discourse surrounding the ZEN49 group of abstractionists.

ZEN49 from the start sought independence from agendas such as *Bildende Kunst*'s: art had a role resolutely apart from "ordinary" social life. As Franz Roh formulated it in the catalog of the group's first exhibition in 1950:

> THESIS The new art is unsensual, a mere play of thought or concepts. COUNTER-THESIS It does not have anything to do with thoughts or concepts, for every line and color is here to be enjoyed sensually. "Sensual-moral [or: "material-moral"] value of color" (Goethe). THESIS Is it not objectionable to circumvent the creaturely world that surrounds us? COUNTER-THESIS If we did this in social life, it would be highly questionable. In the arts, however, every ethos can reveal itself beyond the world of things.[85]

Here, art is not the unifier of the nation, nor should it agonize needlessly over the ever-widening rift between painting and its publics. Roh defined three dominant strains of painting in 1949/50, which were usually presented pell-mell in collective exhibitions at this time (a tendency ZEN49 was trying to escape).[86] The first type is Realism, which includes Surrealism and "Magic Realism"; second, an art that abstracts from real objects, or in which real objects serve as the inspiring force: here, Roh cites Beckmann, Braque, and Picasso; finally, there is the new painting, which does not abstract in this sense at

all.[87] ZEN49 abstraction, independent of social ethos and objective reality, is absolute, and this absoluteness is somehow to be enjoyed sensually (*"sinnlich genossen"*) as Idea.

While Roh would maintain that absolute values in art—pure, elemental color or line, for example—could be enjoyed through the senses (as of course they would of necessity, something Roh's contemporary Behne would have agreed with), the artists and their spokesmen could not help but freight this agenda with metaphysical speculation, making this project quite different from Behne's attempt to understand painting's formal qualities. Theodor Werner, well known by the beginning of the 1950s for works such as *Annunciation*, 1952 (pl. II), published his clearly Heideggerian philosophy of painting in a 1955 article for the *Frankfurter Allgemeine Zeitung*.

> To quote Lao-Tse: signs are not the essence of the picture, but the empty gaps between the signs, that is the essence of the picture.
>
> Modern reality—a reality caused by elemental forces, which no longer projects through the senses from outside to inside, but rather is sent and placed deductively from inside. . . . The creative man gazes upon the aura of beingness. Being-creative means: to be capable of a conception of being that revalorizes every seeming-world [presumably worlds of appearances or phenomenality] to world.[88]

By painting philosophy, the artists committed to ZEN49 perhaps even believed they were contributing to "saving" the world: "The gift of occidental technology and civilization to the rest of the world is like a virus without the vaccine [*wie Gift ohne die Mitgift*, a play on words that literally translates as "like a poison without the dowry"] without the key to its *aesthetic justification*. What responsibility!"[89] The new, absolute painting, in other words, was to be the "aesthetic justification" for occidental civilization's triumphal march across the rest of the world.

One wonders what has happened to the insecurities about the *Menschenbild* and history here, and if this is perhaps the "boastful affirmation of the way it is" [*auftrumpfende Affirmation des Soseins*],[90] and one also realizes what a leap has been effected between the doubts of the *Umbruchsjahre* (1945–49) and the upswing of the fifties' *Wirtschaftswunder* in the West. My concern, however, is less the indictment of 1950s self-assuredness about the "rightness" of affirmative thinking, whether feigned or real, but rather with tracing what had to die to allow affirmation to occur in the first place.[91] As early as 1948,

E. W. Nay denounced what he termed "abstract snobbism"[92] which had gripped the artworld, even though he himself was hardly immune to charges of elitism. But despite some similarities, the differences between Nay and the program of ZEN49 elucidate a subtle change in attitude toward expression and Expressionism—recall Roh's neat split between the new, absolute abstract art and the object-derived (as well as obviously expressive) "abstraction" of Beckmann or Picasso—which points us to what had to die in postwar art.

Behne, who developed his views through an appreciation and study of French Impressionism, still clearly defended artistic autonomy, but from an "expressionist"-informed stand: that art can alter the way we go about cognizing our social, material, and spiritual worlds because of the way it acts immediately—materially and sensually, not intellectually—on our ability to perceive. ZEN49's program, on the other hand, believes it possible to circumvent this material sensual aspect. If we compare works by Werner and Nay, for example, the differences are clear (pl. II and fig. 10). Nay's work can easily be traced to earlier motifs such as the oval womb-breast-eye shape that, despite present abstraction, are charged with a vital, sexual interest, while Werner's work elicits a more cerebral reading. We are clearly not meant to read Werner's work as deriving from any object-particulars: its lines and colors are "autonomous" even of "vitalism," something Nay incorporated into his most abstracted as well as his late works. Werner relied on another kind of prewar modernism, one that assigned to visual art the quality of script, of writing, even of language.[93] Werner's abstraction moves into the orbit of "writing"; its meaning is in its indecipherability as hieroglyph.

While "writing" indeed also lays claim to an expressive dimension —if only because, by virtue of it being a sign, it is supposed to mean something—the elimination of object-particulars leads to a different construction of subjectivity, which in this particular historical situation (late 1940s, early 1950s) has a specific resonance. The attempt to make art "autonomous" by separating it from "vitalism," or any other object-derived expressivity, amounted to instantiating a new image of man, one whose relation to history was idealized, universal or general, but never particular or concrete: a subject of history who speaks with authority and affirmation about the mystery of life and the secondary relevance of history. This new image of man, which appeared via the absolute or "autonomous" abstraction of ZEN49 in the early 1950s, circumvents the issue of subjectivity. Metaphysical idealization

eliminates the need for hard thinking about the possibilities for individual action, and thus a restorative link is forged between the totalitarian extirpation of individualism during the National Socialist years and the restorative climate of the 1950s.[94] We can find a persistent desire for restorative thinking in the great interest after the war in Greek antiquity. It was usually presented in terms of "humanism," linked to a recourse to Goethe and classicism, but when we recall Heidegger's infatuation with the ancient Greeks as well as his indictment of humanism, we should understand that the fascination with things Greek does not end with traditional humanism. It can lend itself as well to an idealization that obliterates particularity, that asks us to bury both body and action in favour of "*geistige Taten*" ("mental or spiritual deeds") which amount to "affirmation of the way it is."

Of the numerous articles dealing with Greek antiquity or classicism in postwar journals, the question of art—usually framed in terms of sculpture or drama—found especial favour. Thus, Joseph Fink's 1947 "Das griechische Antlitz"[95] devotes itself to portraiture. Of interest here, however, is that this article expresses anxieties about the form-versus-content issue that are clearly determined by the general postwar search for solutions. Greek portraiture was not, according to Fink, a formal problem, but rather the expression of an humanistic ideal that deliberately ignored concrete physiognomy to express an abstract ideal. This is obviously a projection: we do not really know whether Greek portraiture was normatively "beautiful" for formal or idealistic reasons. Once claimed, however, this position seeks to expand to the universally, and most emphatically transcendentally and ahistorically, valid.

> One must not demand a Greek iconography. The Greek store of images denies such a demand. But each Greek statue has something impressive of the Greek countenance: the high, the elevated, the affinity to the gods. But is this not the core of man, and the image of it his most noble, intimate feature? Understood thus, the Greeks, in their unrelenting efforts around the image of man and in the masterful perfection they have given to it, are the discoverers of the human portrait in a spiritualized sense. Not human physiognomy, but rather the human countenance had to be discovered and coined. Recall the goggle-eyed faces of early, non-Greek artists. . . . Their conquest was the spiritual deed of the Greek artists.[96]

Fink claims that "spiritual deeds"—a kind of autonomy of the spirit—can "overcome" base, physical ugliness. That is, not physiognomy

(reality), but "countenance" (the original, the essence) had to be portrayed. What dies is the body—so that *Geist* may "live."

While it may seem that articles on Greek portraiture are of small concern to analyses of modern art's reception, I would argue that articles like Fink's are relevant precisely because they articulate an ideological position that fully regains dominance in this period: the valorization of generality, preferably idealist and essentialist, over specificity, over base, somatic particularity. If the trauma of the body had maintained an equal weight, if the essentialist stand had not returned to its position of dominance, the West would not have been able to cement its *Menschenbild* successfully and in accordance with the values of western liberal constitutionalism. Postwar readings of expression, Expressionism, and the body show that these factors were associated with "dirty," dangerous, unsavoury things that could only threaten the closed contour of a stable image of man.

The military state of Nazism usurped a masculinist expressivity for its own ends, which in the postwar period resulted in a distrust of (but perhaps also lingering fascination with) such displays. The well-known Romance languages scholar Werner Krauss analyzed this phenomenon in a 1947 article for *Die Gegenwart*.[97] Quoting a passage from a short story used in a National Socialist school textbook, Krauss examines how and why this passage, full of animistic, vitalist argot, has more "authenticity" and appeal than the sterile, official flood of slogans of the Hitler regime. First, the passage from the short story about a fighter pilot:

> When the pilot has a forced landing, he just plops down or loses it if he bangs up. . . . Emil guns the throttle and zooms off. A fighter gets on top of him, shoots for what he's worth and blows him full of holes. When one of his [Emil's] own fighters comes along, the Brit gets cold feet. He takes his backside out fast and hightails it to avoid getting snuffed. By now we've laid our eggs and go home. That's when the right motor chokes up, gags, and finally croaks.[98]

The story leads Krauss to examine its language and its connection to a base, lower-class existence exemplified by argot. He observes that one of the most peculiar effects of the story is the "not to be denied impression that here indeed something authentic is happening."[99] Despite the technical milieu, it gives "a correct picture of the real live language that millions of German privates spoke on a daily basis."[100] The representation of their "base" argot, in other words, is a form of realism that more pristine language cannot begin to approximate.

At the same time, this naturalist realism is not mere reproduction; it is a formal strategy that actually molds or shapes thoughts, events, actions.

> Argot does not replace language for anyone. Certain expressive tendencies, however, which are strongly tied up in slang figures of speech, are transferred in creative speech acts to new situations. In this way, argot can become the frame for new language behaviour. Precisely because of the acuteness of its stylistic means, argot forces its world view on all those who speak it. As long as one spoke the language of the infantryman, he was bound to the infantryman's faith.[101]

This form of language, in other words, has a compelling, and hence even dangerous, quality to it.

In large part its compelling aspect is due to its reliance on "animistic" metaphor, its out and out devotion to "thinking" through the body—a strategy, however, that leaves the subject with too little critical distance.

> In the rapt attention to the events of an occurence, reflexion stays thoroughly disengaged. Through the dense deployment of bodily related metaphors, the event moves into almost oppressive nearness. Shot off airplane parts become amputated limbs, weapons and men gag and choke and act like organisms charged with gigantic impulses. . . . In the animalistic [animistic] events, a general principle for explaining one's own life experiences seems to intrude. Even the human being is after all nothing but the stage for these unceasingly recurring processes. . . . Unswerving identification of all life processes with one's own body-experience may also be observed in other collective states that produce argot: here, the accumulation of animistic metaphors is a characteristic phenomenon.[102]

"Reflection"—the ability to distance oneself, to assess—is cancelled by this too-close, too bound-to-the-body representation: the discrete, separate image of man is here just as endangered as by the authoritarian make-over of enforced collectivization via propaganda. This time it is not the coercive force of denunciation and concentration camps, but that of "primal warmth" or "tribal belonging" (all-male), of regressing willingly to a pre—"I" state.

Krauss has here also described what happens to the base or bodily under the National Socialist regime, which was in all ways prudish and hostile to liberal enjoyment of the body. The National Socialist regime practiced a grim idealization of the mother (the "original"

body) and expected German men to be "hard as Krupp steel." From Krauss' observations it seems that under these conditions the bodily has nowhere to go but the obscene, to drift off into argot, slang, pornography. And if this is where *Ausdruck* (expression) now takes place, we cannot be surprised if it was regarded sceptically after the war.[103]

Thus, E. W. Nay's commentary on his paintings, written for the first postwar exhibition of the "Deutscher Künstlerbund 1950" in 1951, stands isolated in its specific references to the body.[104] None of the other artists stressed this; at most, they reiterated the necessity of artistic freedom, as Fritz Winter (pl. I) did, particularly in the wake of recent history.[105] Nay, however, tries to extricate painting from all concerns unrelated to form, expression, and affect, and thereby locates it instead in relation to *somatic* experience.

> Our time exhibits the tendency to make painting the object of psychology. The corporeality of the picture is hereby denied, and as a result, the form-picture. It seems to me that our time, however, is beginning to discover the dynamic-rhythmic form of the picture expressed in the aperspectival three-dimensionality of the corporeal form-picture. The operative force of this picture is color as formative value. Pictures that withdraw from the disruption of psychology's speculative elements, of reflexion, of intellectualism, require the cabala of the language of form. To create the latter is the artist's business; to recognize it, that of the viewer who wants to experience the pictures. To experience the pictures does not mean, however, remaining at the basic level of modern man, of emotion that encompasses feeling and instinct, but rather [to experience them] in affect, in excitement and shock, in order to arrive also at the corporeal experience of the picture.[106]

Note how closely Nay orbits the "secrecy" Krauss described as characteristic of expressive argot: painting is to have its "cabala," and reflexive, self-conscious, "psychologizing" thinking is banished—here he could have had in mind both the self-conscious surrealism of current German practitioners like Heinz Trökes or the pathos-charged pictures of Carl Hofer. And experience of painting has little to do with modern emotion (which includes feeling and instinct), but rather with (primal?) affect, excitement, shock, which leads to a corporeal experience of the painting. Yet this sort of unabashed devotion to things irrevocably recognized as dangerous and terrifying, things that in the post-National Socialist period were also associated—via "barbarism" —with Nazism itself, is rare by 1950.

But not only "barbarism" was associated with Nazism; Romanti-

cism and Hegelian conceptions of history, along with Nietzsche's radicalism, were all seen as precursors by 1945/46. J. A. von Rantzau's "Geschichte und Politik im deutschen Denken"[107] is typical of this conflation. Romanticism—excess, radicalism, "irrationalism"—is linked explicitly to "Eastern," that is, anti-occidental, tendencies. Not only is the connection between pro-Western attitudes and rationality established, but also between "Eastern" thought and the opposition to reason: i.e., a geographical basis for ideological preferences. In a scheme such as Rantzau's, it is perfectly "natural" that Expressionism should have "originated" in Dresden—i.e., in the East. That even Expressionism is, however, heavily indebted to "Western" Fauvism can presumably be ignored. Rantzau's main thesis is that Germany is characterized by East-West "tension" determined by the historical migration of Germans from West to East. He sees the East as progressively usurping the "real"—namely "Western"—Germany. The worst development was Romanticism—Eastern, he claims, and entirely "independent" of the West.[108] It is furthermore Romanticism's fault that post-18th-century constructions of history are determined by so-called "Eastern" prejudices: Herder and Hegel come in for special criticism. Their historicizing thinking is responsible for resistance to the West's reason-based conceptions of history. German history "thereby derives a tendency toward the suprareasonable, the irrational" and distinguishes itself markedly from the thinking of Kant, who is West-oriented and reason-bound.[109]

It is intriguing how pro-Western attitudes are equated with pro-reason ones, so that, given the political context, anti-East attitudes will easily ally with anti-irrationalism and anti-communism. As with the discourse on Greek art, these first postwar analyses of historical and cultural issues illustrate the climate of reception for art and the difficulties it faced. On the one hand, art is supposed to be "subjective," or at least "individual," versus collectivist or totalitarian. On the other hand, art's implication in the aesthetics of history, sketched out by these articles, are manifest and profound. The demands on art are unclear and contradictory.

The point at which art perhaps most forcefully removes itself from rational consensus is when it pursues ugliness, not beauty. Affect, in Nay's sense, after all implies loss of composure, of harmony, and results in extreme reactions—against work that may appear "ugly," unbeautiful—that could themselves be characterized as ugly, repulsive. And Nay is the only painter who seemed, for a period in 1946,

deliberately to pursue ugliness in his work: *Daughter of Hekate I* (fig. 11) of 1945 or *Woman's Head* (fig. 12) of 1946 are botched and inelegant, but deliberately so, as though the painter desired to pass through ugliness to a greater depth and understanding of the physical, somatic nature of affect. Ugliness finally is unreadable, unspeakable, unrepresentable, and the body is ugliness' site. Beauty's site is the mind, apart from daily life and disharmony.

> The entire higher possibility of our existence enters into where we create or experience beauty; only that here there comes into blessed, lived and not conceptualized, unity what in the noise of daily life and for our moral existence always remains struggle and opposition and hateful tension.[110]

But expression in art is of course not necessarily beautiful or harmonious, often not *geistig*, and instead somatic: in a word, "ugly" when measured by the standard of "beauty."

In addition, expression—particularly in the guise of historical Expressionism—had assumed a political dimension irrespective of content. Repeating the categorization of painting styles developed by Wilhelm Worringer's *Abstraction and Empathy*,[111] which in turn were based to some extent on Heinrich Wölfflin's distinctions, but now imbued with non-formalist, ideological resonance, the editor of the powerful art magazine *Das Kunstwerk*, Leopold Zahn, in 1946 set out the "geographical" (as well as geopolitical) affinities of linear and painterly painting.[112] "Linear" painting, as Worringer had postulated, was of course considered typical of Expressionism. "Painterly" painting, according to Zahn, "constitutes the most precious essence of *occidental* art."[113] Thus,

> While the formal equivalents of surface and line are the constitutive characteristics of Eastern art, the plastic and spatial values count as essential to occidental art. To assert these values against the planimetric nature of the picture surface was the task solved by the occident in a centuries-long process.[114]

A tidy schema of "East = line + flatness" and "West = plasticity + space" is articulated in a period when crises of Western self-definition abound and the East can only mean "the Asiatic," non-European, and Soviet.

Zahn specifically links painterly painting with the virtues of leisure and reflection: "Painterly painting is spiritualized sensuality, spirit-

infused nature, dreamt reality. . . . The indefinite is dear to its heart, that is why it loves twilit times: morning and evening."[115] Painterly painting, in a word, is linked to the "luxury" of time not spent working; it is reserved for deep leisure. In this sense, it is a specifically bourgeois product, and associated with a specific cultural tradition: "Will there ever again be a painterly painting? One could also ask if there will ever again be the European *homo humanus*."[116] This closing statement again underscores the link to a European, that is: occidental tradition, which excludes both the Soviet world ("Asian") as well as the American—at least for the time being.

As for "Eastern" painting, it is characterized by the lack of ability to handle broken or modulated colors, by a preference instead for pure colors.[117] By 1948, à propos of Emil Nolde, *Das Kunstwerk*'s Egon Vietta locates the threatening quality of Expressionism more precisely.

> The retrospective on Nolde, celebrated in northern Germany as the founder of the flowing landscape picture formed with dense spots of color, was confirmation that so-called Expressionism may be called an Impressionism of introverted means. Atmosphere and color are often enflamed to such intensity that the control of the objectively seen picture must make way for the control of the inwardly seen picture. Never did Nolde incorporate the construction of the picture like Cézanne did; from him there leads no way to abstraction. There exist watercolors by him—and unfortunately, too few were exhibited; thus the valuable material in the possession of Prof. Berg in Hamburg was missing—in which color runs across the entire picture in a darkening red-heat ecstacy, where nature and sky unite in an act of creation. And here, to be sure, he succeeds in creating visions that are marked by the demonics of second sight. He is the ghost rider of northern painting, no legislator like Cézanne, but rather a medieval visionary who in his Biblical legends has pushed to the limit the abject, man the mask. Here he is the brother of Barlach, masters the dramatics that are at home in north-western Germany. He is uninhibited, far from the south German, and never has he passed through netherlandish humanism. In him there still exists a core of real barbarism.[118]

Nolde does not grade or modulate his colors well, a clear sign that he is "out of control" in terms of a more humanist view of culture. But this humanism in Vietta's criticism of Nolde amounts to the culture of a particular class—one that can afford leisure—and although Vietta

brackets the issue of class out, it is obvious that Expressionism is associated with the lower, even peasant, orders, with the less educated.

"Humanism" is something for the rich and educated: Cézanne was a banker's son; Nolde a peasant's. Vietta's references to the Middle Ages also point to something backward, a socio-economic backwardness. When the Russians are termed "Asiatic" or "Eastern" or even "barbarian," it is their social backwardness, their lack of a ruling, rational male *Bürgertum* that is being named. And this is what Expressionism is tied to. It is clear that for *Das Kunstwerk* and related critics, the issue of abstract art is one of recuperating it into a "humanistic" model, into the middle and ruling classes, and separating it from the non-occidental. Hence Vietta's assertion that an out-of-control peasant like Nolde could never provide a "way" to abstraction, while Cézanne, supposedly calm, regulated, and even legislative, could. Yet this teleological and inflexible view of modern art can never generate an art criticism adequate to the actual range and permutations of "linear" and "painterly" painting, of abstraction that is "humanistic" or one that mixes "barbarism" with "harmony," regardless of discursive preferences.

Instead, critics complained about the hodge-podge variety of group exhibitions—Vietta's plaint, "the lively profusion of our exhibitions makes it difficult to ascertain something like an overview based on the one-man or the group exhibition,"[119] is typical—and artists began to cling to philosophical agendas like ZEN49's as justification for their work. Nay was an exception insofar as he not only continued to explore the "vitalist" forces of expression in his abstraction—a sort of marriage between Cézanne-derived structure and Expressionism—but also in terms of refusing to join any groups devoted to "higher" agendas.

While ZEN49 was founded in Munich by local artists, its strongest orientation was to the "school of abstraction" based in Stuttgart around Willi Baumeister and Dr. Ottomar Domnick. The south-west German area in fact developed a distinct modernist identity determined almost exclusively by these abstractionists. Thus, even though Otto Dix lived in this region, his biographer found ample reason to complain in letters to Dix about the abstractionist stronghold that prevented Dix from achieving the exposure he deserved after the war.[120] Dix's supporters also perceived a distinct rivalry between Dix and Beckmann, exemplified by the "partisan" exhibition practice of Gün-

ther Franke, a powerful Munich art dealer and Beckmann collector: Dix and his biographer saw Beckmannesque expressionism (or formalism, as they might have put it) pointing the way to abstraction.[121] Franke, however, was never associated with ZEN49, despite his avid support of modern art, but instead was E. W. Nay's single most important gallery supporter, while Nay in turn also shunned ZEN49.[122] On the other hand, Nay, Theodor Werner of ZEN49, and even Dix turn out to have been readers of Heidegger, pointing to the deep hold that this south-west German philosopher had on modernists of truly varied stylistic persuasion.[123]

In other words, this region, partly in the French and partly in the American zone of occupation, generated a significant theoretical discourse on both painting and philosophy, without necessarily achieving instant stylistic homogeneity in art. For the latter to take hold in any way required some additional factors, such as critical support from a powerful art magazine like *Das Kunstwerk*. Based in Baden-Baden, which was headquarters of the French zone of occupation, *Das Kunstwerk* enjoyed especial proximity to Stuttgart, home of Baumeister and Domnick, a fact that appears reflected in the critical bias of its discussions of abstract art. Both Baumeister and Domnick vigorously propagated abstraction, which for them seemed to be a kind of transcription of archetypes, albeit stripped of the animistic references still found in Nay. Baumeister's book, written secretly during the war and published in 1947, *Das Unbekannte in der Kunst* ("The Unknown in Art"), reveals its credo in its title.[124] Thus, paintings such as *Archaic Dialog with Plastic Lines* of 1944 (fig. 13) recall "Ur" origins via their titles and suggest hieratic, totem-like figures captured in a surrealistic shadow box: apparitions, the figures in this instance look like part of an arcane electrical circuitry. At other times, the figures—or shapes— become more rounded, as in *Monturi* of 1953 (fig. 14), recalling the biomorphic or gestural abstraction of 1930s and 40s surrealism: see Hans Hartung's *Composition "G 1336–10"* of 1936 (fig. 15).

Baumeister's work stays close to this paradigm, always suggesting a hint of spatial illusion, a realm of unconscious dreams. Invariably, there is an element of "floating" shapes in his work; the formal problems of painting—its treatment of line, color, and space in relation to one another as building blocks of the picture—are de-emphasized in favor of painting's function as a revelation of the "unknown." Like Werner's hieroglyphic writing, Baumeister's pictograms suggest a reference to a deeper meaning, with perhaps therapeutic significance for

the beholder. Domnick held similar views. By 1948 Nay, installed in the Frankfurt region and separated from Stuttgart by zones of military occupation, bemoaned the hold of *"Schwarmgeister"* like Baumeister on the German art scene. It is worth quoting once again his 1948 comments to a young artist in the Soviet zone of occupation:

> beware of the modern enthusiasts [*Schwarmgeister*, pejorative] like Baumeister, Nolde, et al. The latter are *Jugendstil* tendencies, one side only, which later developed vitalism; but it is nothing without the other side, form. *Their* pictures float—a sure sign of formlessness. Placed inbetween these two poles that signify the future are all the modern or less modern academics and fantasts—Kokoschka, Hofer, the Surrealists, et al.[125]

Note that Nay, too, includes Nolde in the group of unproductive artistic styles, but not for reasons of his expressionism or vitalism alone, rather for his lack of structure—a quality Beckmann certainly had and which Nay pursued relentlessly as well. Without this structure or form, "vitalism" is unproductive. But even without "vitalism," abstract art can "float," can fail to be anchored by form, and when this happens, academicism results, as the indictment of "surrealists" suggests.

But this ambition—to combine "vitalism" and form—tended to be downplayed, particularly by *Das Kunstwerk*, which continued to support the agenda of what I am tempted to call the "higher formlessness" of Baumeister, Domnick, and ZEN49. By 1948, Nay and Baumeister were even defined as polar opposites in *Das Kunstwerk*, à propos of an exhibition planned by Hanna Becker vom Rath's gallery: "This active gallery, a center in Frankfurt's art life, will this fall show in its new rooms the opposing poles of modern German painting, Baumeister and Nay."[126] This is followed by a discussion of art happenings in Munich that accurately reflects the range of things currently on view, from Paul Klee to Karl Hofer, Otto Dix, and an exhibition of American abstract art organized by the theosophist Hilla von Rebay for Solomon Guggenheim.[127]

This exhibition, the first show of modern American art in postwar Germany, consisted entirely of the geometric abstraction we associate with Ilya Bolotowsky, Reichmann Lewis, or von Rebay herself. It was not very well received in Germany. At this point, we should observe that the American art shown in Germany was incapable of providing a model along the lines striven for by Nay. Not only were the Ameri-

can Abstract Expressionists not shown in Germany until the Fifties, they were either not even mentioned or else at best heavily downplayed in the German press. *Die Amerikanische Rundschau* as late as 1949 published surveys on "Contemporary American Painting"[128] without once mentioning Jackson Pollock.

And Pollock is only mentioned in *Das Kunstwerk*—to my knowledge this being the only magazine to do so—for the first time in 1948, à propos of Egon Vietta's review of the Venice Biennale. He is listed in a string of names cited to underscore Baumeister's significance.

> The only countervailing force would be Willi Baumeister, represented honorably amongst the German painters with his *EIDOS III*—the prehistoric form of an abstract vision. He is supported by Henry Moore, who dominates the English pavilion, by Georges Braque, who along with Matisse has in Paris dropped considerably in importance, and the abstractionists of Peggy Guggenheim's collection, such as Kandinsky, Calder, Leger, Lissitzky, Lipchitz, Juan Gris, Giacometti, Antoine Pevsner, Joan Miro, Mondrian, Francis Picabia, Jackson Pollock, Vordemberge-Gildewart, Ozenfant, Tangerloo [sic].[129]

While Pollock is grafted onto an unlikely family tree here, Nay is not even mentioned. But most significantly, Vietta goes on to pit "the abstracts" (meaning the artists named above) against the "anxious" surrealists Ernst and Tanguy, who were also included in Peggy Guggenheim's collection. Vietta concludes that between the two there is a confrontation of spiritual continents, "here the anxiety, the horror, the subconscious demonics of the contemporary European, there [i.e., with "the abstracts"] the spiritual transfiguration or letting-go of any sort of materiality."[130] The "spiritual" agenda of abstraction was thus also a way of escaping the "anxious" confines of the "contemporary European," and this "spiritual" dimension is the one into which Baumeister is discursively incorporated, while Nay, at least for now, was absent and excluded. In the critical reviews there is also not the slightest understanding yet that Americans like Pollock were far from rejecting European "anxiety" (or "barbarism" in the guise of what the American art critic Clement Greenberg derided as "gothicism").[131]

Instead, attempts are made again and again to ground abstract painting in science, and thereby to make it modern and simultaneously removed from anxiety, whereby anxiety is often another word for vitalism. Thus, articles called on a supposedly "unquestionable" view of science for support, as does the following argument, from 1948, about the appropriateness of still life.

Science reveals the daily relations between man and his surrounding world to be sensory delusions and turns its attentions only to the ideal instances of phenomena that are independent of man: to laws.

Both the art of still life as well as the natural sciences are based in their subjective and objective interpretation of the surrounding world on a loosening of phenomena from the life-context. Both of their spheres of activity are only seemingly identical with the reality that surrounds us on a daily basis; but basically, it is purely spiritual or theoretical—still, as the German form, derived from the Netherlandish, for this type of painting puts it, or dead, as the more factual, French interpretation, names it.[132]

Modern science has no interest in the contextual connectedness between humans and their environment, according to this argument, and neither does still life, as its adjectival *morte* suggests. And since science is most modern, so is the anti-vitalist agenda of still life as here defined.

This argument is of a piece with similar ones made for other aspects of art, such as arguments for Greek antiquity or classicism, or for humanism over baser forms of expression. They all have the effect of inching art away from "expression," "vitalism," and "anxiety" in a fantastic bid to define a culture safe from harm. Formaldehyde could have the same preservative effect—or, as Nay put it, the Fifties were "anaesthesized."

> The general restoration—particularly in anaesthesized West Germany —is the bourgeois world's defensive position against this openness and self-creation. Since the bourgeois world does not want to reject outright—to avoid exposing itself—it tries to amalgamate.[133]

Nay suggests that bourgeois society "amalgamates"—or co-opts— openness and self-creation or expressive subjectivity. In this dynamic, art loses its dialogic quality and its audience; it becomes a "safe" consumer good instead.

While in the Soviet zone of occupation, questions about culture were cleared up via an increasingly rigid and authoritarian image of man, of history, and of a subject in that history, resulting in prescribed subject matter (work, heroics) and style (so-called Socialist Realism), the West went about its redefinition more tentatively, but as rigidly. The West offered a (new) essentialist and masculinist ontology to painting that promised to remove contextual anxiety: "Absolute painting (the absolute = complete, unconditional) creates the abso-

lute art work from pure forms, many angles, circles, lines, and pure colors—creates a new thing, so to speak, a picture that is nothing but a picture-in-itself."[134] The confident (?) assessment of "absolute" painting as an "in-itself" in *Das Kunstwerk* in 1948 was countered by *Bildende Kunst* in East Berlin that same year by increasing charges that abstract art was *"blutleer"* (anemic) and that formalism was not enough.[135] Given the arguments made by the West *for* abstraction, one could hardly blame them for no longer defending it in their magazine. By 1948 both sides were furthermore under increasing outside pressure to define their "world pictures" as the Cold War became more ferocious. The unilateral Currency Reform, the Berlin Blockade, the Air Lift, and the final partition of the country in 1949 into two states "justified" abandoning "anxious" modernism, whether Eastern or Western, in favor of a "scientific" one.

Yet the struggles over definitions of modernism did not stand still in the West, in part due to its openness to international trends, both French and American, and *Das Kunstwerk*'s and ZEN49's views of abstract art did not remain uncontested, particularly by art critics like Will Grohmann, a strong supporter of Nay. While the East tended to solve its problems by decree, the West was increasingly beholden to an ontological bedazzlement that crippled critical thinking. As Adorno philosophized it, the truth of the subject is brought out in its relationship with that which it is not, and if truth were just subjectivity, then thought would be the mere reproduction or repetition of the subject, and hence a mere tautology.[136] But the new defenders of abstract art attempted to create a "reproduction"-theory to justify abstract art—which is in some ways strikingly similar in its simplemindedness to the East's reproduction theory of art—when they argue that abstract art is *like* science, or that it looks *like* nature seen through a microscope or *like* nature's rock formations.[137] Art, which I would argue is a form of thought (but not a "language" in the usual sense), is brought into identity with something else, rather than having its productive difference from everything else stressed. And in this reduction and even denial of difference, we find encoded the new image of man for the postwar era in Germany, a subject in enforced hibernation, but one that remains one-dimensionally male, uninterested in difference, and in uneasy reconciliation with its lack of expressive resistance to the status quo.

Chapter III

AGENDAS FOR RE-ENGAGING THE WEST

The vast majority of Germans was neither so narrow-minded nor so evil that they would have with conviction sanctioned the ruinous deception. The verdict must give judgment on moral dullness due to psychic paralysis. One must not, however, wait for great external changes to shake off the paralysis. The process of production can no longer be turned back, the machine grows ever more powerful, scientific discoveries follow one another daily. The task at hand is thus to raise a human being who does not succumb to the conditions of existence laid down by technology and economy like the older generation, which to a certain extent was still overcome by them. The start will have to be made in the higher and highest levels of education. When the better educated one is his own man and is free, then the more independent impulses and ideas will be able to spread among the people, and will counter mass-slavery and mass depravity. Within the internal tension, in the daily resistance to everything that is machine and apparatus, the new man has to assert himself today, and to whomever it is still granted to work for spiritual values shall show others the way.

(Gu [Bernhard Guttmann], "Der Wert des Einzelnen")

I F EXTERNAL COERCION by the occupying forces was not the determining factor that caused Western Germany to turn away from an art of *Ausdruck* or expression in the postwar period, what or who facilitated this move? Were there critics who helped shape or direct a more discerning reception for painting, or was society's overall perception of the problems besetting "the image of man" also a key factor? How did artists and critics deal with the seemingly conflicting demands of cultural nationalism, internationalism, and historical responsibility? To answer the questions we have to take another look at the ideological resonance of "the East" and "the Eastern" in Germany,

and the ways in which it alluded to dangerous, and no doubt "anti-occidental," tendencies, to "irrationalism," and, by implication, to "the dark years" of Nazism. Because Germany's unique regionalism means that an in-depth look at all areas of the country is beyond the scope of this text, my focus will be on Berlin. Its status as the former capital of both Imperial and Nazi Germany is of importance here. Some of the battles, both artistic and political, fought in Berlin simply were not relevant in, say, Baden-Baden. Yet these battles nonetheless set a *tone* of reception for all of Germany, both West and East, and thus offer an insight into what the regional centers were reacting to and provide us with a setting that the West, in its attempts at cultural and political definition, was reacting to.

In Berlin, more so than in other cities, cultural activity was immediately put under official sponsorship after the war's end. As early as 11 June 1945, the *Magistrat*, or city government, formed a Chamber of Art Workers (*Kammer der Kunstschaffenden*) as part of the Section for People's Education (*Abteilung für Volksbildung*).[1] The *Magistrat* was firmly controlled by the city's Communist Party (KPD) and Socialist Unity Party (SED),[2] a fact that caused increasing friction and hostility in city government, particularly after the first free elections in October 1946, which had a voter turnout of 92.3 percent and in which all of the city's twenty districts, from middle class areas like Wilmersdorf to working class areas like Wedding, overwhelmingly voted for the Social Democratic Party against all other parties, but particularly against the SED under Wilhelm Pieck and Otto Grotewohl.[3] In no city in the Western zones of occupation could the KPD/SED have held onto power after a defeat such as the Berliners dealt this party in 1946, yet Berlin was a special case: of the city's twenty districts, almost half belonged to the Soviet zone of occupation, and this meant that effectively speaking the Communist Party did not lose its stature.

If anything it "proved" to its supporters (almost 20 percent of the voting population)[4] the tremendous odds faced by the SED: according to the Party's post-election statement, the SPD victory was the result of "petit-bourgeois" and "dangerous chauvinist" attitudes:[5] the SPD, according to the SED's Pieck and Grotewohl, refused to carry on "the struggle against fascism and militarism" and instead made promises of socialism and democracy designed to extricate Germany from historical responsibility.[6] Of particular interest here is the SED's reluctance to relinquish the old prewar language of what I would call civil war priorities: defeating the "socialist rival" often seemed as important, if not more so, in KPD rhetoric—and certainly took pride of

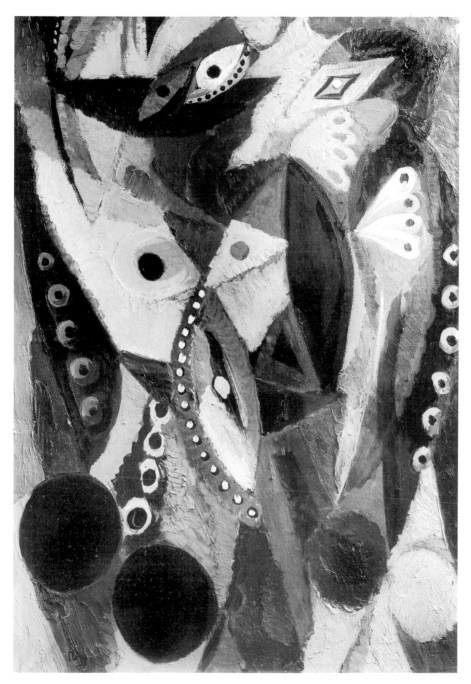

1. E. W. Nay, *Moorish Girl*, 1948, gouache. Priv. coll.

2. Fritz Winter, *Vital Drives of the Earth*, 1944, aquarell. Priv. coll.

3. E. W. Nay, *The Female Acrobat*, 1942, aquarell. Stuttgart, Staatsgalerie, Graphische Sammlung.

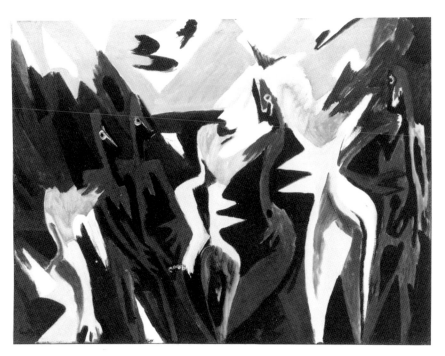

4. E. W. Nay, *People in the Lofoten*, 1938, oil on canvas. Priv. coll.

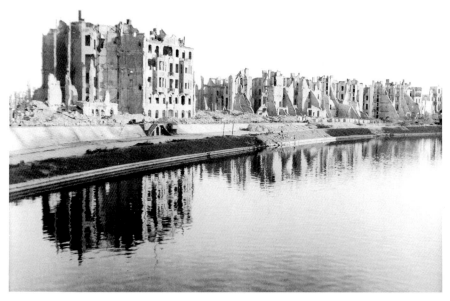

5. Friedrich Seidenstücker, *Destroyed Houses on the Banks of the Spree, Berlin*, 1946, photograph. Berlin, Bildarchiv Preussischer Kulturbesitz.

6. Werner Heldt, *Cloister Church*, c.1928/29, oil on canvas. Berlin, Berlin Museum.

7. Werner Heldt, *Deployment of the Zeros*, c.1933/34, charcoal on paper. Berlin, Berlinische Galerie.

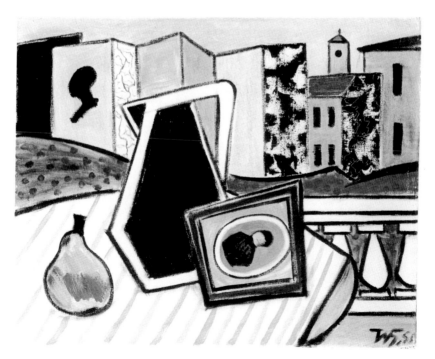

8. Werner Heldt, *Still Life on Balcony*, 1951, oil on canvas. Cologne, Museum Ludwig.

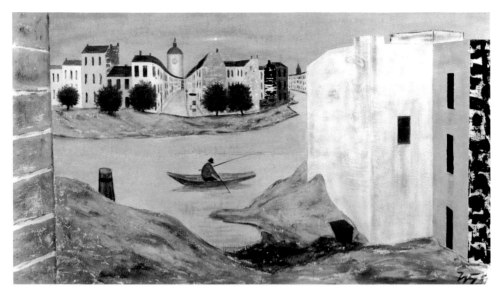

9. Werner Heldt, *Before the Rain*, 1951, oil on canvas. Berlin, Staatliche Museen Preussischer Kulturbesitz, Nationalgalerie.

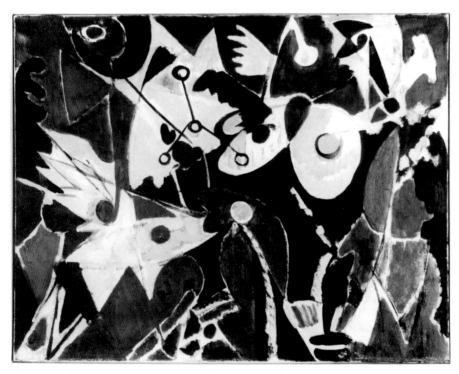

10. E. W. Nay, *Purple Rhythms and Black*, 1951, oil on canvas. Stuttgart, Galerie Dr. F. C. Valentien.

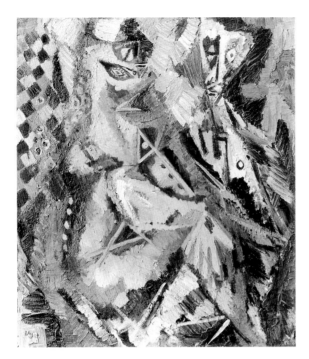

11. E. W. Nay, *Daughter of Hecate I*, 1945, oil on canvas. Priv. coll.

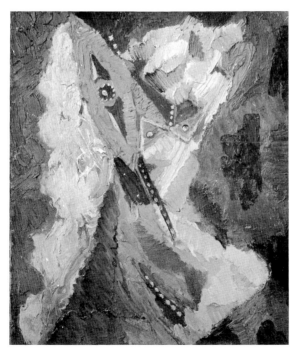

12. E. W. Nay, *Woman's Head*, 1946, oil on canvas. Priv. coll.

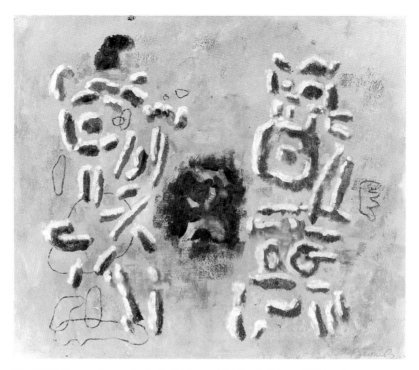

13. Willi Baumeister, *Archaic Dialog with Plastic Lines*, 1944, oil on carton. Stuttgart, Archiv Baumeister.

14. Willi Baumeister, *Monturi with Red and Blue*, 1953, oil with sand on carton. Stuttgart, Archiv Baumeister.

15. Hans Hartung, *Composition "G 1336-10,"* 1936, egg tempera on canvas. Essen, Museum Folkwang.

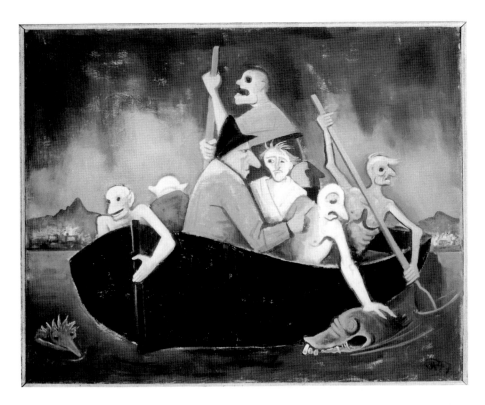

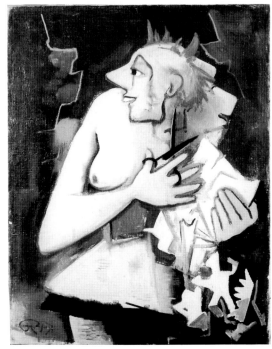

16. Carl Hofer, *Voyage through Hell*, 1947, oil on canvas. Hofer Estate, Cologne.

17. Carl Hofer, *The Insane Woman*, 1947. Ettlingen, Schlossmuseum.

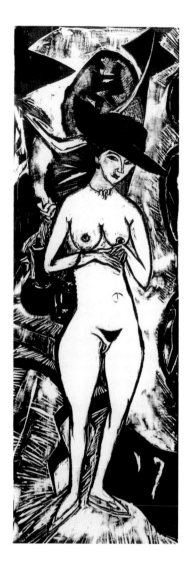

18. Ernst Ludwig Kirchner, *Woman with a Hat*, 1911/13, woodcut. Frankfurt, Städelsches Kunstinstitut.

19. E. W. Nay, *Dark Pink-Orange*, 1965, felt pen drawing. Priv. coll.

20. E. W. Nay, *Shepherd I*, 1948, oil on canvas. Priv. coll.

21. E. W. Nay, *Night (Large Reclining Woman)*, 1950, oil on canvas. Priv. coll.

22. E. W. Nay, *Stellar Composition in Gray*, 1955, oil on canvas. Priv. coll.

23. E. W. Nay, *Figurine*, 1951, oil on canvas. Priv. coll.

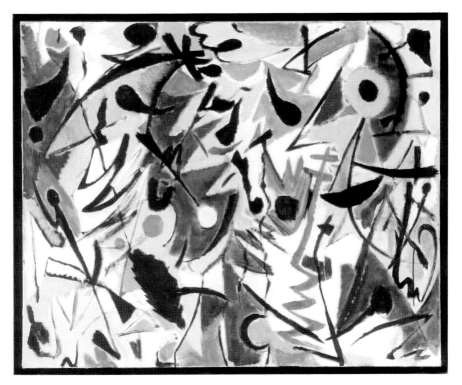

24. E. W. Nay, *In Black Bars*, 1952, oil on canvas. Priv. coll.

25. Wols (Alfred Otto Wolfgang Schulze), *Composition*, 1946, oil on canvas. Stuttgart, Staatsgalerie.

place in SED rhetoric—as defeating the fascist one. Because the Communists lacked the power base they had in Berlin and in Eastern Germany, this continuation of nearly civil war rivalry between the two competing socialist parties did not exist to the same extent in other Western German cities. The Berlin SPD, meanwhile, propagated a strategy that would eventually be popularized in the United States by new liberals such as Arthur Schlesinger, Jr., whose book *The Vital Center*[7] is a mirror of what the SPD had identified as its credo in 1946: the election was "a rejection of all claims to totality."[8] The SPD elaborated on this rejection of totalitarianism as follows: "We will also in our work unerringly continue the path laid down in our voting campaign, to look neither to the right nor to the left, neither to the East nor to the West."[9]

While the SED continued to exploit a pre-1945 rhetoric of "civil war," namely the argument that vanquishing the SPD variant of socialism was crucial for conquering Nazism, more reactionary elements in the West exploited—at times subtly and at other times crudely— the Nazi claim that the war had been not about Nazi world domination, but rather about "defending" Europe against Bolshevism. And in these ideological battles Berlin was the front line; for Nazis as well as reactionaries, it was the front to "Asia." Hitler had declared Berlin a *Festung* (fortress) during the war, and the last remaining directives from the *Führerhauptquartier*, Hitler's bunker headquarters, to German soldiers in the spring of 1945 stressed the city's "historic" role.

> This time the Bolshevist will experience Asia's ancient fate: he must and he will bleed to death before the capital city of the German realm. . . . If in the coming days and weeks every soldier on the Eastern front fulfills his duty, the final Asian assault will break apart, exactly as the invasion of our enemies in the West will fail after all.
>
> Berlin remains German, Vienna will again be German, and Europe will never be Russian.
>
> Form a conspiratorial community for the defense not only of an empty concept of a fatherland, but for the defense of our homeland, your wives, your children, and thus your future.
>
> In this hour the entire German people look on you, my East front fighters, and only hope that through your steadfastness, your fanaticism, through your weapons, and under your leadership the bolshevist assault will be choked in a bloodbath.[10]

As another propaganda item twelve days later spelled out, "Sacred Word: Berlin": "In Berlin holy war was declared on the bolshevist world menace. In Berlin this war will be decided."[11] When the battle

for control over Germany reached its most acute stage, Berlin came to stand for Germany in the same way that Paris stands for France. The city had never really had this kind of status before, as Germany, unlike France, is splintered by varying claims to regional autonomy, but in this issue of "Germans" against "Asians/Bolsheviks"—or "West" against "East"—it was invested with this sort of capital significance. And although the representation of Nazism as primarily a "struggle" against communism is a myth, it was deeply ingrained by relentless propaganda and would have an effect on postwar perceptions.[12]

While hardly "Asianized" at the end of the war, Berlin was quickly dominated by the KPD, which in its administrative methodology duplicated many aspects of civil life under Nazism, thereby earning the immediate dislike particularly of the American occupation. Recall that a key concern for both American and German liberals had been the extirpation of individuality under the National Socialist regime: that Nazism had sought to control both public and private life and had attempted to eradicate the civil sphere as it was known in the occidental world. The *Magistrat* of Berlin continued along similar anti-civil libertarian lines when, faced with the chaotic conditions of postwar Berlin—hunger, homelessness, crime, black markets—it instituted a system of "house and street (or block) supervisors."[13] Each apartment house and each street was assigned a supervisor—often an SED party member—who was responsible for each inhabitant's comportment, his or her allotment of rations, the number of boarders he or she would have to accept (the housing crisis obliged everyone to share existing accomodations), and so forth. While it brought administrative benefits, it also quickly became apparent that unpleasant supervisors could act as mini-dictators vis-à-vis their "charges," and that the individual citizen, once again entrusting his or her welfare to a caretaker/supervisor, would not learn to exercise his or her rights under such a system.

Thus, the American commander of the city district Neukölln ordered the elimination of this system in his jurisdiction as early as 6 September 1945. When Berlin's *Oberbürgermeister* (chief mayor) sent out a protest, detailing the system's advantages, the American commander published the following rebuttal in the *Allgemeine Zeitung*, the United States Military Government newspaper, on 9 September 1945:

> The system of house, street, and apartment-block supervisors is based on the system of the Nazi period, and it gave many the opportunity to

play the tyrant and to oppress those who disagreed with them. In this way, many people experienced injustice. In short, the system is in no way democratic, and Berlin is probably the only German city which today still has such a system. Despite the fact that a new system will further burden the city financially, it must be readily apparent that personal freedom cannot be measured in monetary terms. Under Hitler's regime, the German people had much money, but no freedom. The effects of the Nazi tyranny must be clear to everyone. No house, street, and apartment-block supervisors existed in Germany before 1933. There is today also no valid reason for their existence. The inconvenience to the populace due to this change will be more than compensated for by the democratic freedom that will be given in the future. Like their Allies, the United States fought this war to crush National Socialism and fascism. We can no longer tolerate the existence of such tutelary figures—under no pretext and no circumstances.[14]

As is clear from the rebuttal, the Allies registered similarities between the totalitarianisms of Nazism and communism. These similarities consisted first in the reduction of the individual, as (more or less) free agent, to tutelage. It is not a contradiction for modern capitalism, at a liberal stage of its development, to want citizens to be free agents, provided their individual activity goes toward enriching the overall apparatus of production—which, the communists would rightly argue, is owned, however, not by the people, but by an elite few. While Soviet-style communism could try to circumvent the significance of the individual to the overall social health, the "West," i.e., the occidental tradition, could not, precisely because its very ratio and raison d'être was and is rooted in the development of the discrete, nuclear (male) individual.[15] Hence, no matter how heated the debates over political systems became as the Cold War deepened, central to the possibilities for painting and the climate for its reception was a violent collision of ideological conceptions of "the image of man." At the same time, it should be clear that the Western Allies' willingness to identify Nazism and Communism as totalitarianisms brought with it ample possibility for general German opportunism: had they not been told all along they were front line fighters against Bolshevism? Now they would continue to be just that, this time, conveniently forgetting that the previous fight had been in the name of Hitler, they embraced—at least in name—the current cause of democracy.

In other words, the perception of similarity between Nazism and communism contributed to the West's stigmatization of "the East":

onto it were projected many of the unassimilated contradictions in the West's reconstruction of an appropriate, and above all rational, image of man. Many of the contradictions were either remnants of modernity's tumultuous progress in twentieth-century Germany, or parts of the "mythic" structure built by Nazi self-glorification, but insofar as they all related to concrete German history, their projection onto an Other or their repression amounted to a distortion of history. And Berlin was the site where these contradictions could be most vehemently played out.

As the political landscape in Berlin showed an almost instant hardening of positions, often along prewar lines, so did the visual arts in Berlin take on overt political meanings which failed to materialize in quite as succinct a form elsewhere in Western Germany. The well-known painter Carl Hofer came to represent the most conflicted aspects of polarization. Known for a style that combined aspects of Expressionism with some New Sobriety realism, with a subject matter that often addressed the quotidien reality of working class life, Hofer's art, in an attempt to deal with this new reality, took on more pronounced allegorical aspects after the war, as in *Vogage through Hell* of 1947 (fig. 16). Despite Hofer's committed engagement with the plight facing the postwar rubble-dweller, his paintings offer no new way of thinking about any of these dilemmas. *Voyage through Hell* innocuously draws on the Dantean theme of a trip to Hades, and even evokes some aspects of early nineteenth-century Romanticism via its compositional similarity with Delacroix's *Dante Crossing the Styx*. Particularly around the figures in the barque and their relation to the background, the work is painted in a thin, almost sloppy manner, betraying the painter's greater interest in making a pathos-charged, content-based statement than in finding a way for painting to go on in any form at all in view of present circumstances.

Hofer's commitment to social justice—along with his aloofness from specific party allegiances—made him the logical choice to head up the *Magistrat*'s newly created Chamber of Art Workers (*Kammer der Kunstschaffenden*), formed on 11 June 1945. From the *Magistrat*'s session, it would seem that Hofer's election to this post was dependent on his political stance, not on his artistic renown: "After discussions with representatives of the fine arts, Carl Hofer, a painter who was disciplined by the Academy of Arts for his political convictions and then periodically put in an insane asylum, will become a member of the presiding board."[16] The *Kammer*'s objective was closely linked to a

re-educative agenda: "After 12 years of spiritual deformation and stunting, we stand before the tremendous task of re-educating the German people."[17] The goal of the *Magistrat* was thus the same, in principle, as that of both the Western Allies and the Soviet occupation: art was to serve as a tool in re-education.

Of interest here, as in the manifesto of the *Kulturbund zur demokratischen Erneuerung* is the *Magistrat*'s focus on German culture: "An institution must be created in the Berlin Magistrate whose task it is to spread the freedom-oriented progressive traditions of German cultural life to the broad mass of the people."[18] What this implies is that despite communism's "image of man" based on dialectical materialism—an image that projects, after all, into the future in an almost messianic way—it needs a construction of history that will somehow justify the present projection. For the messianic image to be compelling, it needs to promise a healing of the rift between the masses and what had heretofore passed for culture: the two are to be reconciled. And to ground this promise of reconciliation, communist rhetoric, despite its vision of an international brotherhood of man, will have frequent recourse to the binding ties of "true" and "good" (versus merely "elite") indigenous national culture.[19] Hence the recurrent inferences to German culture and its role in "educating" and unifying the masses.

Ironically, the communist proposals here, in the name of a future internationalism, trade on an idealization of the past (the "good history") in ways that, methodologically at least, bear affinities to the Nazi glorificaton of German culture.[20] Capitalism, meanwhile, most often bypasses this problem of establishing a taxonomy of the "good tradition" (with the exception of creating a certain classical literary canon, which then again becomes the property of a cultural conservative elite) because it has no need to justify its existence with a messianic image of a future where all rifts are healed. Its promise is not delayed, but rather almost instant gratification (or at least the possibility of such). Its search for historical roots will be less searching, and in fact one of the charges levelled against our society is that it has no sense of history, no roots. Here again we find the path laid down that would later lead to charges that Western Germany "forgot" or repressed its history: if it did so for opportunist reasons, it is also clear that such a strategy is inherent in the Western capitalist model.

This is not to imply that the American occupying forces disregarded German national culture in their quest to pacify the country.

But note that German national culture was not to be reinterpreted to serve as a re-educative tool, but rather to ensure a kind of continuity and stability conducive to pacification, as General Clay, in an 18 July 1947 directive entitled "Subject: Objectives of Military Government," put it:

> CULTURAL OBJECTIVES
>
> Your government holds that reeducation of the German people is an integral part of policies intended to help develop a democratic form of government and to restore a stable and peaceful aconomy [sic]; it believes that there should be no forcible break in the cultural unity of Germany, but recognizes the spiritual value of the regional traditions of Germany and wishes to foster them; it is convinced that the manner and purposes of the reconstruction of the national German culture have a vital significance for the future of Germany.
>
> It is therefore, [sic] of the highest importance that you make every effort to secure maximum coordination between the occupying powers of cultural objectives designed to serve the cause of peace. You will encourage German initiative and responsible participation in this work of cultural reconstruction and you will expedite the establishment of these international cultural relations which will overcome the spiritual isolation imposed by National Socialism on Germany and further the assimilation of the German people into the world community of nations.[21]

There is, I would argue, a crucial difference between the two approaches: in the United States Military Government example, national culture is left to the petit-bourgeois consumer of folkloric traditions in the hope of reconciling him to the sufficiency of his culture, while in the German communist case, national culture is to be re-interpreted to serve as an exemplary image of ancestry designed to spur the useful social member to ever greater heights of sacrifice.

Yet in the realm of high art, which cannot be defined either as regional folklore tradition nor as idealist reinterpretation of history, it is the East that fell into an astonishing provincialism,[22] while the West "ahistorically" and "anationally" measures itself against internationalism. Reorientation to the West and to internationalism was left largely in German hands, however, and was not "directed" by OMGUS (the Office of Military Government for Germany—United States), as the extensive, detailed report of OMGUS's Education and Cultural Relation Division's first art expert, not commissioned until 1949, makes clear. William Constable, then of Boston's Museum of

Fine Arts, in 1949 produced a document entitled "Art and Orientation"[23] which among other things reiterates a liberal argument for international—versus national—cultural contacts.

> Foreign affairs and foreign trade and exchange are among the subjects specifically reserved to the occupying powers under the Occupation Statute. As foreign cultural relations are part of foreign affairs, and involve foreign trade and exchange, it seems as though ECR is under formal obligation to concern itself with them. Apart from this, foreign cultural relations can play a part in re-orienting the German mind. It may be noted that in a directive to the Military Governor, dated July 15, 1947, he is bidden "to expedite the establishment of those international cultural relations which will overcome the spiritual isolation imposed by National Socialism on Germany and further the assimilation of the German people into the world community of nations." One of the effects of the isolation of the last ten to fifteen years, was to stimulate the idea of German self-sufficiency and of German superiority in every branch of cultural matters, and to feed a militant nationalism. To have Germans in free communication with colleagues elsewhere; to have them associated with learned bodies other than German; and to have them measure their work against that of others, is likely to prove a useful corrective to such an attitude.[24]

Constable's analysis points out that too great a sense of sufficiency will lead to chauvinism, which is precisely what had happened under Nazism in all areas of learning and culture. But this caveat is aimed primarily at high culture and does not imply that Germans in general should find a "good" national history that, as German communism would suggest, will contribute to strengthening a messianic image of man.

Constable's concern was almost exclusively with institutions, not with contemporary artists. While the latter were, in Constable's view, supposed to fend for themselves, his report describes how little official support institutions were actually receiving.

> The situation is, however, that owing to the general confusion in the museum, academic and art world of Germany; to deaths, disappearances, and drastic changes in staffs; and to the separation of the Eastern zone from those of the West, people abroad do not know where to address themselves to get information about cultural matters, or to get such things as photographs, microfilms, etc. An example of what may happen is that when recently a national institution of the highest standing in the United States made enquiries from Washington

as to how it could assist, financially or otherwise, Military Government in sending Germans to the United States, it ultimately received a series of reports from a minor official about youth activities in a corner of Hesse! It may be suggested that through such bodies as the American Council of Learned Societies and the American Museum Association, ECR should let it be known that it will undertake to answer enquiries on cultural matters, or forward them to the right quarters, giving an address to which such enquiries may be sent.[25]

While the report encouraged support for institutions, individual artists were far more vulnerable, moving through the domestic political landscape at their own peril.

Hofer was an individualist, contemporary painter whose appointment in 1945 was supposed to signify institutional changes. His mandate, in the eyes of German communist idealists, was to validate a different, democratic historical tradition and thereby lay a foundation for future work the masses could embrace. Current high art, a product of excess wealth unmoored from utilitarian ends, maintained the rift, so the communist left argued, between the masses and culture. This culture did not speak to the masses; if art were again to serve an ideal, as it had when it was religion's tool, then it would regain relevance in the eyes of the common man. An art that served the ideal of democracy and communist idealism would signal the return of a golden age in which art would once again be integrated into the life of the masses.

In the "internationalist" view of Westerners committed to high modernism, however, painting should not have such a role, particularly if this role implied limiting art to the utilitarian. This approach, they argued, raises art's *Gesinnung* (its social conviction) above formal concerns. An art form's self-reflexivity and internal development— i.e., how issues such as paint handling, color, and drawing articulate aesthetic issues, and how, in turn, these issues have developed within a tradition—were given at least as much weight as its propagandistic or programmatic meaning. A clinical separation of content and conviction on the one hand and form and aesthetics on the other is not really possible, but in the immediate postwar period these issues were polarized, and Hofer was one of the more high-profile artists to become caught in the middle.

With support from the Soviet Military Government, the Academy of Fine Arts was opened on 18 June 1945; its teachers were committed to re-education, as the Academy's founding directive makes clear:

We need new foundations for bringing up our youth, a clear and conscious setting of goals. Art is not just a means of enjoyment, it is an instrument, a weapon in the struggle, a stone in rebuilding, a many-sided help to the community. The teaching faculty must be inspired by this task.[26]

Carl Hofer, the Academy's new director, reiterated this credo: new foundations, refusal of connection with the bourgeois imperialist or Nazi past.[27] But by 1948, when the Soviet Zone of Occupation, soon to become German Democratic Republic, launched into a massive official offensive against "formalism" and particularly abstract art, Hofer was defamed as "decadent," a representative of bourgeois art. Despite Hofer's continued dedication to an image repertoire that was historically and figuratively referential, his refusal to let his art be completely guided by "extra-artistic demands"[28] was seen as a betrayal of political conviction to the correct cause. The director of the Soviet equivalent of Education and Cultural Relations, Major Dymshitz, accordingly illustrated his November 1948 attack on "abstract" art, published in the military occupation's official paper, *Die Tägliche Rundschau*, with Hofer's paintings, which stood as examples of "subjectivist fantasy" and "falsification of reality."[29]

In the West, German students[30] attacked Hofer in 1949 after his signature appeared beneath a salutation to the World Peace Congress published in the communist *Vorwärts*. The Western press, decontrolled and readily responsive to the Western German populace's intense dislike of bolshevism, was fully in a Cold War fury by 1949 and accused Hofer of being pro-communist.[31] The issue of his art, meanwhile, was never seriously analyzed or addressed.[32] Hofer, in Western eyes, had at least two major liabilities: he was associated with Expressionism (but not abstraction), which looked increasingly provincial, and he was inextricably linked to the polarized, politicized climate of Berlin, the divided city.

Most surveys of this period regard Hofer as a casualty of the struggle between abstract painters and realists, and hence a victim of the Cold War struggle between Western internationalism and Eastern Socialist Realism. But Hofer's eery postwar themes fall far short of Socialist Realism, and I would argue instead that Hofer was a liability in the West, because, while certainly his style, subject matter, and conviction were old-fashioned and burdensome in the sense of being less concerned with formal issues than with content, he betrayed an embarrassing insistence on a kind of Expressionism unamenable to

international assimilation. For if we take a closer look at a work such as *The Insane Woman* of 1947 (fig. 17), it is its haunting pathos that strikes us first. Paintings such as these clearly drew on a Northern European tradition, recalling Munch as well as Ensor, working with a repertoire of gestures and facial expressions rooted in the significance of the grotesque.[33]

That Hofer has an Expressionist dimension which was recognized as such by postwar audiences is underlined by the fact that Günther Franke, the Munich art dealer who was Max Beckmann's as well as E. W. Nay's most important gallery supporter, in 1948 showed Hofer in honor of his seventieth birthday.[34] While Hofer's Expressionism is by no means as vitalistic as that of its earlier practioners, it nonetheless resonated with meanings that had become, in the West, highly suspect and unpalatable. Even Franke, who stands as the only significant modernist supporter of Expressionism in the postwar scene, increasingly satisfied his interest in this form with shows of the 1910s and 1920s Expressionists (Beckmann, Kirchner, Schmidt-Rottluff, et al.), while turning to more abstract painters for his contemporary stable, including Nay, Conrad Westphal, Hans Hartung, and Emilio Vedova among others—all of whom incorporated Expressionism into their abstraction. But this later Expressionism was no longer tied to the subject matter of the earlier Expressionists—the urban prostitute and the pastoral "free love" idyll, to name the two extremes between which Expressionism's subjects oscillated. Nor was its style still beholden to *die Brücke*'s manipulation of overt markers of Germanness and lack of sophistication—the Gothic factura, for example, or the reproduction in oil paint of woodcut print effects.

The Expressionism of Franke's younger modernists was encoded: it could not have existed without the heritage of *die Brücke*'s rough edges, but neither did it reproduce the subject matter or the formal devices of Kirchner, Schmidt-Rottluff, or Beckmann. Yet whether we focus on Westphal's jagged, gestural brushwork as a legacy of Expressionism, or compare Kirchner's 1912 *Woman with a Hat* (fig. 18) to Nay's late felt-pen drawing of 1965, *Dark Pink-Orange* (fig. 19), and register the similarity in both artists of erotic interest, format, and tendency to simplify, it is clear that there was a segment of the post-1945 generation that owed a heavy debt to Expressionism. It was, however, never explicit, and one wonders whether the political climate contributed to its altered form, or at least to the possibilities for its reception. "Encoded" Expressionism was more international

because it could, in Western Germany, be more easily dissociated from the vexing political meanings that Expressionism and the Eastern had absorbed.

As the 1946 Berlin election results showed, the two main political contenders in that volatile city were the communist SED and its social democratic rival, the SPD. In terms of *Kulturpolitik*, it was also clear that there were divisions along party lines: while SED-influenced platforms, such as the magazine *Bildende Kunst* and the Academy of Fine Arts, wracked their collective brains over the issue of art's social role, its content, and its proximity to "the people"—or its alienation from them—the SPD, more thoroughly modern, pursued a relatively straightforward path of support for modern art. The cultural battle lines between the two were, by 1948 at any rate, clearly drawn.

> Blockade, currency reform, and the enforced division of the magistrate, the three most decisive events of the year 1948, have also had a detrimental effect on Berlin's cultural life. But they have also sharpened the outlook and the conscience of Berliners—and beyond that of the entire German people—for our cultural-political situation. It was not empty rhetoric to celebrate and commemorate in word and text the 100th anniversary of the ideas of 18 March 1848. In close contact with the power in the East, in the disguise of progress both democratic and expansive, we know only too well what political freedom means, and we also know that the cultural goods of the occident and of humanity can only maintain themselves and continue to unfold on the ground of this political freedom. When we reject the ordered participation of teachers and pupils in communist demonstrations, and when we reject a one-sided "alignment" [*Ausrichtung*, a word with totalitarian resonance to both Nazism and Communism] of pupils through a course of instruction colored by party politics, when we resist the foreign infiltration of Berlin's theatres with Soviet bias plays and leave Soviet films unattended, when we find parallels between the bias reports of the Berlin Radio and the falsehoods-propaganda of a Goebbels, when we do not let our universities be debased to party schools, then we do so in the knowledge that we in Berlin have to maintain a freedom of the spirit and that we have to defend a cultural heritage as the final and most precious good of our people.[35]

Thus began the first page of the Annual Report of the Bureau for *Volksbildung* (Popular or Continuing Education) in Berlin's Western sectors, compiled by Dr. Walter May (SPD). But rather than ground explicit counterproposals to their communist enemies' strategies, the

SPD developed alternatives by supporting modern art in a typically liberal, non-partisan manner.[36] In general terms, support for cultural activity in the area of painting or sculpture was not spectacular— probably due to lack of funds as much as anything—but it was consistent and sincere.[37] Most often, support for modern art came from far-sighted individuals such as Dr. Karl Ludwig Skutsch, who directed the West-sector "Haus am Waldsee," a community-based *Kunstamt* (bureau for art).[38] Initially directed after the war by Robert Büchner, the Haus am Waldsee began by exhibiting artists who had been suppressed during the Nazi period. But Skutsch, who took over in 1946, soon devoted the *Haus am Waldsee* to exhibiting local artists from Zehlendorf (the Berlin district it served), as well as more widely known modernist artists such as Schmidt-Rottluff (1948), Picasso (1949), Schlemmer (1950), Rouault (1950), and Moore (1951), to name a few. Skutsch was independent of direct political allegiances, but he was well respected by the SPD members of the *Magistrat*'s cultural section, particularly its principal director, Dr. Jannasch.[39]

Berlin's prewar standing as a center of German Expressionism prevented it from drifting into provincialism. Expressionism was the one internationally viable modernist style Germany had produced, and therefore Berlin's status as capital city and the hegemony of an art style are symbolically linked. This linkage, however, helped push Berlin into a ghetto of another sort, since Expressionism was now seen as too political and too German in a period when both the political and the German (and especially the German political) were murky, suspect, and shifting. And Berlin itself, like German Expressionism, was now challenged: regional autonomy reasserted its rights against Berlin rule, political conceptions as well as conditions for the reception of culture. This culture would not be shaped by German Expressionism, no matter how internationally recognized this style might have been.

While questions surrounding "the image of man" made German Expressionism seem unknowing and simplistic, the rise of regional autonomy also made this style unfit for the new federalism. Federalist aspirations wanted autonomy from Berlin, to which an especially shameful and painful national history was now tied. On 20 April 1946—the symbolically important date of the Führer's birthday—the writer Otto Flake, based in Baden-Baden, published his thoughts on Berlin and federalism in the *Badener Tagblatt*:

The Germany of tomorrow constructs itself under the rule of division into zones, no longer deriving from a center, but from the peripheries, from the previously bordering lands . . . a federalist movement can be seen. This is entirely natural. The capital city of the kingdom of Prussia also became the capital of the German federal state after 1870. Because of too much imperial realm, the federal character of the German state was forgotten. We merely continue logically the basis when we once again examine the two words, confederacy and state, to the possibility of joining them. . . . May the Berliners make their efforts, we will make ours. In Munich, Tübingen, Freiburg, Baden-Baden, Mainz, Frankfurt, Wiesbaden, Koblenz, and Hamburg, in Stuttgart, Augsburg, Kassel and elsewhere, the initiatives for a new life started almost automatically since last summer. . . . No artificial programs were necessary, no appeals of dangerous totalism, that hitlerian inheritance. Total governing by the Berliners—no. They take on too much, their city lies in ruins . . . we are federalistic . . . reconstruction can only proceed from the region.[40]

Flake only names regional centers in the West: Eastern cities such as Weimar, Halle a.d. Saale, Leipzig, or Dresden are not cited. Berlin is clearly not just an imperialist and Nazi capital, but also the capital of Eastern Germany—of Prussia—now behind the Iron Curtain. Germany's partition and Berlin's destruction as *Grossdeutschland*'s ("Greater Germany"'s) capital signify Eastern Germany's amputation from the occident.[41] But while some commentators worried about this, most— and Flake is representative here—welcomed it: it must, after all, have been a relief to erase from Western regionalism Germany's own "Eastern," anti-occidental elements and project them onto a separate entity (Eastern Germany).

The "loss" of Eastern Germany came to be accepted in cultural terms as well. Although not explicitly named as a loss, the implication is clear: Flake's political argument echoes contemporary cultural ones:

For if indeed Expressionism accords, since 1900, with the spiritual/ intellectual structure of this first half of the century, we should, however, consider it well before, with gentle pressure, we undertake to re-educate our youth to this art. German youth's rejection of Expressionism can, if it is a universal phenomenon, well derive from the correct instinct that we must not burden ourselves, in our difficult struggle to find a new life-concept and world-concept, with the problematics of not at all good old times.[42]

Note the similarity of tone; the promise that "overcoming" the Prussian or centralized state and "overcoming" the Expressionist legacy will somehow translate into a more anxiety-free future. The rejection of Expressionism, which usually carried a messianic urgency, a reminder of dissatisfaction with the present, was no longer simply a stylistic matter. Its rejection instead became a matter of allegiance: to the future (but not to the messianic or utopic future), to the non-Eastern, to the Western. Rhetorically, Expressionism still carried a notion of "Germanness," but this was now too historically burdened. And in view of the "new" beginning or "zero hour," it needed to be relinquished.[43]

While Expressionism, the child of Romanticism, had previously been viewed as one of the most individualistic of forms, opposed to the cold schematics of classicism, arguments could now be heard that turned this idea on its head. For one thing, Romanticism had shown its supposedly true, dangerous side: irrational, potentially barbaric, primitive, and hence crypto-Nazi. As *Die Gegenwart* pointed out in 1948:

> Like 'le lied,' so does 'le Reich' count as one of the necessary foreign words in the French language. They aim at the untranslatable, at the whole and complete otherness of the German. They refer to a danger. The danger of seductive, unbounded sensibility, and the danger of the colossal, the violent. A French mouth utters 'le lied' but reluctantly and quietly; 'le Reich' is a cry of alarm.[44]

The German *Lied*, characteristic of nineteenth-century Romanticism in music, was so emblematic of the sentiment and promise of German Romanticism that it could not be translated into another language. Now, however, not just Romanticism, but also Nazism were termed as being specifically German. And if the war and Nazi atrocities had shown that the individual was no longer a closed entity, it was now high time to reconstruct him—for he is decidedly the male citizen—as clear and self-composed. It was time to make him classical and to wither his "romantic" aspect.

Thus, André Gide, French and not tainted by German Romanticism or Expressionism, was published in the 1946/47 volume of *Prisma* as the champion of classicism and individualism, putting to rest the earlier infatuation with Expressionism as the only—and excessive—road to experiencing the full spectrum of individuality.[45] The question of individualism was of course bound up with the question of the *Men-*

schenbild, and with the problem of countering *Vermassung* (collectiviz-ation) as it had been and was practiced under both Nazism and communism. Collectivization and *Unmenschlichkeit* (inhumanity) were now equated, as were individualism and humanity. Expressionism, which belongs to Romanticism and hence, in popular schematics is opposed to classicism, had to be repressed insofar as it threatened a return to *Menschlichkeit* (humanity) and individualism, which were held to guarantee the nation's healing. Gide's description of the cure reveals, however, the deeply masculinist nature of the "return to or-der" that now gripped Western Germany:

> In this matter it is important to keep in mind that the struggle between classicism and romanticism is played out within the spirit of everyone. And precisely out of this struggle the work must derive; the classic work of art tells of the triumph of order and measure over the inner romanticism. The work is all the more beautiful the more the finally overcome romanticism initially behaved rebelliously. Is the material subdued from the outset, then the work is cold and without charm. True classicism countenances no limitation or repression; it is not so much conservative as it is creative; it is averse to all quaintness and refuses to believe that everything has already been said. . . . The tri-umph of the individual coincides with the triumph of classicism. The triumph of individualism lies, however, solely in the renunciation of individuality, and thus there is not a single advantage on the part of the classical style that was not purchased at the cost of complacency.[46]

First, note that individuation is posed in masculinist terms, as a hand-to-hand combat between two opposing forces, as a battle. But second, note the rapist ideology this implies: the "weaker" element "resists," and the more it resists, the sweeter is the victory of the conqueror, the more beautiful the work created in the struggle's wake. In fact, there must be struggle, as co-operation leaves this virile discourse cold. What results is a triumph: success, closure, "safety," subjugation of the threatening "feminine" aspects of the heroic individual's person-ality. Romanticism, presumably, is the infertile half of something that is not whole.

It is of course absurd to accord this sort of analysis any real credence —neither "Classicism" nor "Romanticism" or "Expressionism" are on-tological entities with fixed meanings that signify outside of discursive practices. But it is the discursive practice that is of importance, pre-cisely because it claims to be an ontology. In this discourse, no matter how great the reduction of the individual to one-dimensionality the

reward is, first, a secure identity, and, second, the ability to make sense of the recent past.

This restrictive and reductive sort of agenda was however, propagated not only in the West, but in the East as well. Heinz Lüdecke, a critic for the magazine *Bildende Kunst*, by 1948 clearly championed a "thinking"/rational art, versus an art of dream, fantasy, or openness.[47] Citing Rimbaud as "the type of the irrational, 'non-thinking' artist," who was already equipped "with all the outlooks toward the parapsychological and paralogical,"[48] he indicted the entire Romantic tradition, this time not in the name of a normative and elitist classicism, but in the name of the rationalism of a new social order. Novalis' "the world becomes dream, the dream becomes world" results in nonsense of a "Baudelairian imprint,"[49] in which the artist is reduced to "babbling" because he refuses *ratio*'s ordering syntax. For Lüdecke, thought is key, even to art which had sought to escape those confines through a show of excess; art, too, should be harnessed to the greater task at hand: "The author therefore gives notice that for him, 'thinking' does not mean 'dreaming' nor 'registering subconscious psychic processes,' but rather it means thinking consciously, reasonably, cognitively, in an ordering fashion, and with a plan in mind."[50]

The extent to which the dream needs to be controlled in order to control society, to "normalize" it, is indicated by Lüdecke's caption accompanying Picasso's *Rape of Europa* (1946):

> This classical theme of European painting undergoes a formal metamorphosis with Picasso that can no longer be comprehended or explained in a literary manner. The barely suggested figuration is completely subordinated to a formal pictorial construction that has its own laws. The driving forces of Picasso's work are feeling, intellect, and fantasy. The mental and artistic process of creation occurs with him on such an individualistic level, however, that comprehension of his work is for most people only conditionally possible.[51]

The problem, in other words, is that even a good-intentioned (communist) artist like Picasso falls into the trap of making elitist art; elitist because it is individual, not a mass-consumer product, not instantly comprehensible by the greatest number of people, but rather only by a small fraction of initiates. This is also a clear indictment of the play or dream quality of art: the controlling factor is missing. "Thinking" is not play; it is supposed to be ordered so that as many adults as possible can immediately understand it, that is, identify with it and be

controlled by it. One does not want an art of real imagination or daring, since it escapes the parameters of social control.[52]

In attacking the dream element that opposes itself to instrumentalizing reason, Lüdecke unfortunately attacked the liberating potential of art; he furthermore proceeded to equate certain strands of mysticism with the dream element, betraying a lack of understanding of Romanticism's critical edge.[53] Of value in Lüdecke's indictment is his ability to link the proliferation of amorphous, mystical assertions about art with the decline of bourgeois society, instead of, as was common practice in the West, linking the need for "the unknown" to very allusive references to a crisis of "man." Thus, on the one hand his attack on modernism—including Constructivism, which he also (perversely) identifies as an irrationalism—is concise when he takes on Willi Baumeister's vague, mystical conclusions about art. Baumeister's statement, "the strength of the West [or occident] rests in its willing acknowledgement of the unknown"[54] is dissected as follows:

> In this statement lies buried the declaration of bankruptcy of bourgeois ideology which had as its point of departure a belief in the unrestrained might of reasonable, causal thinking. Its desertion of reason is so widespread that within western European culture, the artist, insofar as he does not rise above the process of decline through ideological decision, of necessity becomes a mystagogue. If he stays in the spell of decadence, then he cannot evade the pull of irrationality even through the attempt to flee into reason; he ends in a skewed, unreal relationship to social reality, and that means: in "not-thinking."
>
> Would a correct relationship to social reality, versus the shifting one of Baumeister's "creative corner," thus be the indispensable prerequisite of the thinking artist? This is indeed the problem's solution. For every thinking requires an objective content if it is not—in the manner of the pun coined by Heine—to resemble the monkey who stands at the stove and cooks his own tail. The abstract, constructivist artists make art the thought-content of art. Through this renunciation of objectivity they arrive ideologically at the same results as the "non-thinking" ultraromantics and surrealists.[55]

The key phrase here perhaps is "through ideological decision": the artist must choose an ideology and create with it in mind as the objective content of his or her art. Because of this faith that one can consciously choose and thereby "escape" ideologies, Lüdecke reiterates throughout his article a deep mistrust of psychoanalysis and of the dream.

One, however, could easily counter that the artists he names have chosen consciously—albeit "the wrong side," namely not "thinking" or rationality as defined by Lüdecke.[56] Meanwhile, the subversive element, the excess that escapes ordering *ratio* and the instrumental, is denied in both Eastern and Western restorative accounts of modern art. Lüdecke denies that the dream need not be completely irrational when he states that "abstract, constructivist artists make art the thought content of art," and thereby renounce all objective factors.[57] This means that the self-reflexive aspect of modern art—admittedly not a mass-consumer article—is denied any critical dimension. Communist demands for an art for the people cannot be an art of self-reflexive, critical thought since by definition this would escape the quantification logic necessary to making a product fit for mass consumption. Such demands become themselves irrational insofar as they attack the Enlightenment tradition (of which Romanticism is an integral part) of self-reflexive critique.

While Lüdecke castigated Baumeister's irrationality, Baumeister shared with Lüdecke an inability to understand the critical dimension of Romanticism—a dimension that expression in art could still occupy. For Baumeister, a key feature of modern art was that it "overcame" the subject-object dichotomy, an "observer position" that previous, rationalist and naturalist art had explored.

> As scientists and artists, Leonardo and Dürer based themselves on the observation of nature. . . . As another type of man they had left the unity with nature, had stepped outside of nature, and established the relationship between the observing subject and the observed object. . . . In today's science, at its cutting edge of research and discovery, the microscope no longer suffices. The processes at stake now are no longer to be grasped through observation.[58]

The recourse to science, unlike Behne's argument quoted earlier, is meant to validate abstraction. The latter ends up as the appropriate illustration of science and as an ordering principle in the new world.

> The discoveries made with refined measuring instruments inexorably demand that deep-rooted conceptions of observability be relinquished, and that they be replaced with new, abstract conceptual constructions for which the corresponding demonstrative forms must first still be sought and created. . . . new ideas do not come from calculating reason, but from artistically creative fantasy; but the value of a new idea is never determined by the degree of its demonstrability. . . . In view of

this new world picture, we may be permitted the following question: can the old, externally observing naturalism and its followers maintain a position of value within the new front line—or is non-objective (or predominantly non-objective) art the closer parallel to today's science?[59]

Thus, while Behne had argued for the material *Anschaulichkeit* (demonstrable visibility) of abstract painting, Baumeister has recourse to earlier twentieth-century models for abstraction that see it as analogous to science's lack of *Anschaulichkeit*.[60]

In conclusion, Baumeister posits an agenda that sounds similar to Lüdecke's: finding a new order:

> The pictures show forms, colors with clear contrasts and intermeshing, lines and rhythms, in order to arrive via these elements at a new order, to arrive at a so-called harmony. Through order, man can gain a point of view in a world of confusing multiplicity. The contemporary painter does not see that point of view through the copying of external phenomena of nature, but rather he forms from within himself. He does not form after nature, but like nature.[61]

The program aims for an identity between the painted product and its conceptual meaning, between the painting and the idea. This, however, is an agenda far removed from a critical conception of expression.

To understand the difference here, recall Nay's expressed desire to provoke and experience affect and shock with his art. Baumeister's art, along with that of most of the ZEN49 group, draws instead on mysticism in order to eliminate shock, and it does so, notwithstanding all theoretical rhetoric to the contrary, by denying the fundamental difference of the unassimilable aesthetic moment (Nay's "shock") from everything else. According to Romanticism's enemies, its mortal sin is a lack of *Begrifflichkeit* or conceptual definability,[62] a flaw that makes Romanticism's aesthetic the supreme enemy of ontology.[63] In addition, this incompatibility with ontological reconstruction of reality also makes Romanticism's aesthetic—which is one of affect, shock, and coincidence, as also formulated, for example, by surrealism —into a corrosive agent in those social sectors where conceptual definitions are more secure, namely religion, morals, politics, and economics.[64] And thus, Romanticism's enemies want representational art instead, an art that "reflects" positive content. Baumeister is

accommodating himself—as did many other practioners of abstract art in this period—to this restorative demand: abstract art's positive content, what it "reflects" according to its theoretical trappings, is the rule of science.

Romanticism can of course be interpreted as an arch-ontology, best summed up by the infatuation with the religious or profane symbol. But I am arguing for a critical version of Romanticism that refuses a handy reconciliation of Man and Nature, or an equally vacuous synthesis of subject and object. Aesthetics, unlike traditional philosophy, potentially allies itself with the critical view. Philosophy, the realm of thought, is a form of violence, as Adorno argued, because it implies control: over concepts, categories, judgments.[65] Philosophy traditionally turns on creating identity, not difference; but the "aesthetic moment"—something Adorno called "*das Schwindelerregende*"[66]—is the resistance, in Adorno's theory, to philosophy.

In this version of the Romantic aesthetic, idealism is subverted—or at least the claim is made for subverting it. In idealism, the subject is a concept, not a temporally existing changeable conglomerate, but a timeless entity.[67] Hence, too, the necessity, in idealist regimes, of conceiving of time as a smooth, rupture-free continuum of sameness. This basically amounts to a denial of time's existence, for if time were allowed to begin, it would shatter idealism: heterogeneity, not just homogeneity, would have to be taken into account. In a climate of reconstruction such as post-1945 Germany's, clinging to idealism not only countered the prevailing cynicism, but it also became the necessary philosophical underpinning of reconstruction. A corrosive aesthetic that offered views of heterogeneity provided little for the demands of the time.

There was a rapid return to idealisms of various kinds in the postwar period, manifesting themselves most often in fantasies of synthesis. One familiar scenario was the call for a synthesis between Romanticism and classicism as the cure for postwar rupture.[68] This talk of synthesis proved false and disingenuous, however, for consciousness was merely flattering itself by "synthesizing" what it had separated conceptually in the first place. Concepts invariably and unavoidably reproduce the difference between thought and what is thought, but the dream of synthesis—and liberalism is always haunted by it—is an idealism that refuses to analyze this fact.

Fear is the driving force behind this drive toward identification and homogenization. Adorno theorized that historically this fear derived

from the threat nature represents for unprotected man: the desire to be safe from harm produces an intolerance of that which escapes control, of that which is different and which may threaten.[69] Available social theories prove incapable of coming to terms with the consequences of identification, in part because they also misperceive the radical potential of Romanticism: "Even the theory of alienation,"—a key social theory of the late 19th and 20th centuries—"the ferment of dialectics, confuses the need to approach the heteronomous and thus irrational world—to be 'at home everywhere,' as Novalis put it—with the archaic barbarism that the longing subject cannot love what is alien and different, with the craving for incorporation and persecution. If the alien were no longer ostracized, there hardly would be any more alienation."[70] Thinking, conceptualization, is dual, is split, despite its attempts to claim totality, to ingest "the Other." Both subject and object are conceptual abstractions.

Unlike Baumeister's optimistic assessment that modern abstract art has escaped the subject-object dichotomy because it is no longer based on a "naturalistic" observer position, critical thinking remains wary of claims to synthesize the subject and object or to overcome their difference, for neither do subject and object "purely" exist, nor are they "pieced out of any third that transcends them."[71] Rationality has manufactured them, as concepts: it has arrayed them in its armament for appropriation. This duality or division "makes the object the alien thing to be mastered," but "no critique of [this division's] subjective origin will unify its parts, once they have split in reality."[72] If a theory or ideology posits "synthesis," it is merely evading the responsibility of critical thinking: "Consciousness boasts of uniting what it has arbitrarily divided first, into elements—hence the ideological overtone of all talk of synthesis. It serves to cover up an analysis that is concealed from itself and has increasingly become taboo."[73]

What makes it increasingly taboo is the climate of cold war, for analysis reveals the fundamental complicity between a rationality out of control—one that is superinvested in creating identity and denying difference—and a capitalist division of labor.

> The reason why a vulgar nobility of consciousness feels antipathetic to analysis is that the fragmentation for which the bourgeois spirit will upbraid its critics is that spirit's own unconscious work. The rational processes of labor are a model of that fragmentation. They need it as a condition of the production of goods, which resembles the conceptual procedure of synthesis.[74]

Synthesis, in other words, is the philosophy of rationalism that conceptually accommodates itself to capitalist division of labor and of products necessary for efficient commodity production. In this way, idealism is directly implicated in commodity economies. The aesthetic, however, for Adorno represents the unassimilatable difference to this logic. Hence the importance—the utopic hope, one might say—attached to it in Adorno's oeuvre.

I have spent some time analyzing this claim—rooted in Romanticism and expressionism—for the aesthetic's critical potential because I want to make the point that all abstract art is not the same; Baumeister and Nay, for example, are representatives, whether stellar or not, of two very different approaches to art. Thinkers and painters pondered these issues in the late 1940s and 1950s.[75] But expression was suppressed in the Federal Republic of Germany's restorative minded prototype, the Western zones of occupation, which were intent on reconnecting to a smooth, unruptured flow of (idealist) time. Expression was dangerous because it bore affinities to forbidden aspects of the recent past as well as to what generally came to be described as "the Eastern": "the barbaric," "the inhuman," and "the anti-individual."

It was not allowed to thrive, but was not summarily extirpated either. Picasso continued to loom large on the modern art scene, and his art was almost always discussed in terms of its expressive power. In a period when anarchy carried no positive political connotations in Western Germany, Picasso was praised as an anarchist: his refusal of the rules represented freedom.[76] While praising Picasso's "freedom from history" distorted freedom,[77] it presented Picasso as the embodiment of sovereign individuality, as someone who continued to be productive even in these traumatic years. In this way, reception of his art contributed to the maintenance of the model of the artist as quasi-Promethean creator, of author, in an age that began moving closer to the "death of the author."[78]

This latter aspect had a different connotation in Germany, where the demise of subjectivity was also tied to restorative conceptions of history, to repressions of recently engendered, supposedly Nietzschean "subjectivistic" assaults on normative rationality or objectivity. Generally speaking, the "death of the author" in France could signify the uncanny loosening of both objectivity's and subjectivity's grip on the mind and on the impossibility of narrative or of finding one's bearings: once the balance between objectivity and subjectivity is destroyed both concepts may be called into question. But in Germany,

"objectivity" was sufficiently destabilized to provoke calls for the demise of subjectivity in the name of reconfirming the priority of the (idealistically determined) "objective."

What was "objective"? History, tradition, political beliefs, religious values, authority: every concept, it seems, that in the postwar period was shaken to its foundations. Methodologies, too, were evaluated for their objectivity, and it was hoped that they might yield the correct cultural products. As *Prisma* formulated it in 1947:

> The old and ever again fertile dispute between Enlightenment and Romanticism, or, if you will, between realism and surrealism, today has become acute in the contentious question as to what best approximates reality: the fairy-tale or the statistic.[79]

The article creates a dichotomy between objectivity (Enlightenment and realism) and subjectivity (Romanticism and surrealism), and poses the now acute question: which of the two, methodologically, is more apropos to our current reality? The fairytale or the statistic? This is like asking, do we simply "chart" or "map" current reality (via statistics), or do we "interpret" it (veil and unveil it, via the discursive strategies of the *conte*, the fairytale). It did not occur to the writer that the statistic might be equally interpretative.

What the author suggests is a synthesis between the two supposedly opposing forces:

> We should accustom ourselves to seeing Romanticism and Classicism not as opposites, but in terms of a higher synthesis. Taken together, they are the counterpart and the accord of that polarity which in our times aims for the beginning forms of new syntheses. Classic calm and romantic dynamism today thus no longer need to be opposites just as the experimental avant-garde style of Romanticism and Classicism's sovereign consciousness of tradition need not be opposites.[80]

Enlightenment/realism and Romanticism/surrealism are posed as opposites, but in the name of striving for "synthesis," the favored postwar mode of overcoming cultural crisis. Abstract art, according to this and other writers, represents the desired "synthesis" insofar as it has learned to eschew "Expressionism": the phenomenon of synthesis was encountered in the literary works of Wilder, Kafka, Mann, and Hesse, but "even more clearly in modern painting which has overcome Expressionism without renouncing the elements of abstraction."[81] By representing the ideological panacea of synthesis, abstract art was burdened with showing the way out of the current crisis.

And Nay, too, speaks in terms of synthesis: rejecting the abstraction-realism dichotomy, he instead worked on synthesizing cubist forms with "spiritually vitalistic tendencies"[82] by focusing on the "*Menschenbild*," which, encoded and abstracted, became the carrier of expression. This was already clear in *Sibylle* of 1945 (pl. IV), but it is also the case in later, more abstract works.

Around 1948, Nay incorporated more geometrical forms, relying on circles, triangles, oblongs, as, for example, in *Shepherd I* of 1948 (fig. 20). But if one carefully reads the work, one can see parts of a human figure elaborated on the flat of the canvas: the row of dots on the left represents a spine; the circles with dots refer again to the umbilicus; while the oblong with a center dot refers to both the eye or head as well as the womb. What is specifically of importance here, however, is that Nay searches for a way to translate the human figure into rhythm: like a fugue, each circle, oblong, spine is meant to mesh with its neighboring element to offer an almost musical version of the body. It is important to keep in mind that this translation is expressionistic in the way that dance, movement, music—in short, the experiences of the bodily—are incorporated into painting. Even in 1950, when Nay's work became smoother, less tactile in its surface qualities, and the artist's "touch" through handling of paint was reduced, rhythm remained as the code of the body in abstraction. *Night (Large Reclining Woman)* (fig. 21) is such a work: the "woman" in the title can be found in the represented forms, rhythmically translated into the curves and sweeps of the lines that easily suggest a reclining female figure. But the sensuality of the figure is restricted to the rhythmic, interactive play of forms and colors, not to representational figuration or to tactile, brushstroke qualities.

In 1951–52, on the other hand, Nay did return once again to the gestural "scribble" to achieve similar results, as in *Purple Rhythms and Black* of 1951 (fig. 10). But he never stayed with this strategy for long, preferring instead to look for a more ordered, less vehement vehicle for expression; each recourse to a more violent gesture is like a prelude to a new "law." The one he became most famous for in the 1950s in Germany dates from the middle of the decade and is characterized by the so-called "disc-pictures," as for example *Stellar Composition in Gray* of 1955 (fig. 22). These innocuous-looking canvases were quite acceptable to many audiences, perhaps because their Expressionist ancestry was only visible with the previous works in mind. That the discs or circles always signify in Nay's formal repertoire the softest

part of the (usually female) human body—namely the belly, whose round shape in turn is repeated by the eyes that often appear in Nay's work—and that their rhythmic orchestration on the canvas surface suggests sensual bodily activity, would remain obscure to most viewers. Not until the mid-1960s did Nay return to a more vehement form, a move that simply revealed that he had never left behind the expressive agenda of what in 1948 he called "vitalism."

It is not the purpose of my investigation to analyze the artistic or discursive developments of the 1950s; I am primarily concerned with the immediate postwar period and the conditions it set for a future aesthetic and reception, what expression and abstraction meant in postwar Germany, what this meant in turn for art's reception, and how different kinds of abstraction could exist side by side without critical distinctions. If, as I have argued, Nay's work continued to be expressionistic, how did postwar criticism and audiences deal with it, and how could it have been identified with the abstraction of ZEN49, which pursued a decidedly non-bodily, non-expressive abstraction?

Expression became a painful and political issue, and it was in the interests of orderly restoration to seek alternative bases for the making of art. Expression in some quarters was linked to the Expressionism of the 1910s and 1920s and smacked of the failures of Germany, of Weimar, of the two World Wars, and, most recently, of the "East," of the "Asiatic" and the "barbaric." At the same time, there simply did not appear to be many art critics on the scene who could respond to the new situation with any breadth of scope. It was not empty propaganda when the OMGUS-ECR art expert, William Constable, bemoaned the results of twelve years of isolation from international developments and suggested that one task of OMGUS-ECR should be the facilitation of international contacts.[83] Furthermore, not many art magazines on the scene were capable of summarizing the situation in both East and West without immediately sharpening the ideological axe for their side. *Bildende Kunst* in the Eastern sector of Berlin and *Das Kunstwerk* in Baden-Baden, Western Germany, were the two main contenders for serious, consistent criticism, but although they dominated, they by no means furthered real critical dissent within their own pages,[84] and thus instead of fostering critical debate, they contributed to its suspension.[85]

Das Kunstwerk, Western Germany's most influential art magazine, devoted a famous double issue to abstract art in 1947, and thereby set some of the terms for its reception.[86] Heinz Trökes, the surrealist

painter from Berlin, was asked to contribute a survey of current modern art in Germany.[87] Trökes, who occasionally wrote for *Bildende Kunst* as well, defended modern art, but did so with his particular surrealist-influenced agenda in mind. His aim at an overview of the "avant-garde" in Germany overrated, however, the role of "the unconscious" without paying equal heed to formal or material issues. Trökes' view of modern art is fused in the pages of *Das Kunstwerk* to the editor's commitment to "mystical" and great "*geistige*" endeavours in modern art. As a result, a kind of absolutist view of abstraction was given priority by the magazine.

According to Trökes' summary, artists who represented "new intentions" were showing in the galleries in Konstanz, Augsburg, Dresden, Berlin, and Cologne, "which stand in *opposition* to expressionist painting."[88] These new painters included Gilles, Kuhn, C. G. Becker, Bargheer, Kunz, E. Ende, Geitlinger, Westphal, Fuhr, Paul Strecker, Peiffer-Watenphul, Purrmann, and—a rare mention in the pages of *Das Kunstwerk*—Nay.[89] A number of the painters mentioned were contributors to the magazine, several were surrealists and friends of Trökes, and a number of others—Westphal, especially, and of course Nay—were arguably expressionistic, despite Trökes' characterization.

As for the kind of avant-garde art produced as a result of this move away from Expressionism, Trökes gives high praise to the Stuttgart circle around Baumeister and especially Dr. Ottomar Domnick. Trökes manages to link his own surrealist interests to Domnick's passion for an abstract art of the unconscious mind by emphasizing the common bond of "fantasy" and even "irrationalism"—but an "irrationalism" divorced from expression and instead based on a mystical abstract *telos*, a "necessary development."

> In the house of Dr. Domnick a discussion cycle on abstract painting is taking place during which men and modern art meet once a month. This does not go into breadth, but into depth. Painters, sculptors, art historians, scientists, and friends of art illuminate the visual and problematic aspects of abstract painting from various sides. Pictures by the Bauhaus student Fritz Winter were shown, to which Rudolf Probst from Mannheim spoke; for the paintings by Otto Ritschl, a presentation by Dr. Lüdorf from Düsseldorf; and for Willi Baumeister's art, the introductory, explanatory, and pointing out the larger contexts exposition of Professor Hildebrandt of Stuttgart. The basic outline of Dr. Lüdorf's presentation was that abstract art is a logical necessity following Realism and Impressionism (Cubists, 'Blue Rider' from 1906–1914);

that abstract art is the necessary result of art historical development: Cézanne, *Jugendstil*; third, that it is an aesthetic necessity, everything aims toward a harmony of pure pictorial means subordinated to the laws of the surface and of color (parallels to music: the inner resonance of forms); and finally that it is necessary in terms of content: the philosophy of Franz Marc, the joy in life of August Macke, the mysticism of Jawlensky, and the new feeling of collectivity that finds expression in the pure and universally understood forms of all the abstractionists, also with Kandinsky.[90]

It is unclear, of course, whether Trökes himself fully endorsed Domnick's interests, but he at any rate repeats in a nutshell *Das Kunstwerk*'s guiding philosophy which reduces modern art and abstraction to an ontology, not a critical view of art. Perhaps Trökes' own view is better expressed in this surprising summary of Nay's achievement, one of the few times this painter got favorable mention in *Das Kunstwerk*:

> E. W. Nay, who comes out of Expressionism, has created out of this a new pictorial world, using strong color rhythms and clear, prismatic forms which are not simple decoration, but rather multilayered like our modern life, but which show the rupture without veiling it.[91]

This is the only time that Nay was singled out as showing rupture, but simultaneously working out of the idiom of Expressionism.

Das Kunstwerk's dominance on the Western German art scene considerably irritated the art historian and art critic Will Grohmann, who was one of the few writers whose interest in art in an international context outweighed the tendency to ascribe metaphysical meaning to art. His position in many respects illustrates the historical juncture reached by modernism in Germany. Grohmann's was the strongest— at times most controversial—voice for a particular kind of modern art in Germany: one that would be able to hold its own in an international, cosmopolitan context; one that would not be mired in regional or national specificity, even though it would, presumably, stand on the international scene as German. Yet, given the historical conditions, which included both the taint on everything German after Hitler and the negative cast on expression in art, now associated with "the Eastern," Grohmann's position is as contradictory and conflicted as Nay's in terms of its success in bringing to fruition an international as well as a national outlook.

Will Grohmann tried to encompass his dedication to Berlin[92] as well as to modern art at a time when Berlin was turning into a ghetto, if

not a marginalized non-entity, in the overall cultural life of the new state of West Germany. Paradoxically, Grohmann's insistence on international contacts contributed to restoring Germany on the European scene, even as the particularity of that presence was increasingly eroded by the new homogenized look of non-expressive abstraction. Insofar as abdication of historical specificity and expressive particularity contributed to this characteristic "fifties" style of European abstract painting, it should not be surprising that this kind of internationalism drifted into obscurity when eventually faced with the expressive, particular, yet rhetorically "universal" painting of American Abstract Expressionism, which after all competed on the international scene not by abdicating its own national specificity, but rather by asserting it. This American counterproposal of a "reconciliation" or synthesis of expressive particularity, national specificity, and international universality triumphed over European expressionisms such as COBRA's, precisely because, unlike the latter, European promoters and audiences did not see the American variant as mired in its own national/domestic struggles and contradictions.

At the same time, Americans were able to dazzle with the power of their money, which, in cultural matters after 1946/47, was more often not channelled via government financing but rather at the private level.[93] The Europeans, by comparison, operated on a shoe-string budget. Grohmann, who frequently complained, like every other supporter of modern art in Germany, of the tide of official and popular reactionary attitudes against modernism,[94] utilized his existing international contacts to drum up support for modern art both in Germany and abroad. He received no appreciable official support, as far as his letters testify, and although he was never a social outsider, Grohmann maintained a liberal ability to "float above" socio-political ties.

> Was in Paris and Switzerland for fourteen days, happened to meet all my friends from the period between the wars: Miro, H. Read, Sutherland, Georges Duthuit, McEwen, and those who came later. There was great arousal over the Unesco fight and san Paolo and Eluard's funeral. Picasso's new dove of peace proudly lifted its wings, the Garde Nationale was forbidden by the police prefect. You see, we again live in great times which we already knew when they were still small.[95]

Here Grohmann names a partial array of his international friends, but more significantly, he names his liberalism: while he would never

ally himself with the communism being suppressed by the official French reaction,[96] he was also unwilling to ally himself with its official suppression, as the ironic references to "great times," which he and Nay already knew when these same times were but babes— namely, the beginnings of Nazism and its rapid growth into full-blown totalitarianism—suggests.

As a liberal, Grohmann saw himself as cut off from official cultural policies, and he detected backroom politicking as the real reason for both his exclusion and the dismal showing of German modernists on the international scene.

> Yes, the world is crazy, the stupidest people get the most rewarding things. I recently wrote a short article in the NZ [Neue Zeitung]—'Art and Manegers' [sic]—which also appeared in the West-edition, to try to put a finger on who did the exhibition for Helsinki, who did the German exhibition for Canada, etc.?? This all flows through secret channels into secret offices and nothing is discussed publicly. The New Group here opened an exhibition with French guests. The Germans are for the most part frightful and I've got all sorts of trouble.[97]

And several months later, in a letter to Nay:

> Even worse is that the Germans always do everything so stupidly abroad with the big exhibitions everywhere in the world—and of whose coming into being and backgrounds one always only hears after the opening has taken place. I once wrote a column in the Neue Zeitung on 'Art and Managers' and in response received a query from Bonn, but naturally I haven't gotten around to talking with these people. Some of us just have less time than others—that's the depressing part. How the others do it, always politicking around everywhere, I don't know.[98]

To what extent Grohmann's complaint was justified is difficult to say, but it is clear that his ideal was to build up enlightened private support for modern art, and in that he both failed and succeeded. His contacts with friends such as Herbert Read and Christian Zervos brought him further personal connections to Alfred H. Barr and other New York Museum of Modern Art people,[99] as well as a platform for publishing German abstract art in Cahiers d'Art.[100] As Christian Zervos put it in 1949:

> Dear friend, I was very happy to see you again and to find that the terrible years we have all lived through have not dampened your artistic enthusiasm.

> I hope that hand in hand we will try again to undertake the spiritual collaboration between Germans and French.[101]

As for Grohmann, he was thrilled to have renewed contact with *Cahiers d'Art*, and did not fail to assure Zervos of the significance his magazine had for German artists.

> Here in Berlin the *Cahiers d'Art* enjoy an almost legendary renown: each issue is a precious object for which all friends of art envy me. . . . It is obvious that you have been right these twenty-four years, and I am very pleased to know myself so well in agreement with you.[102]

While Grohmann always cast a friendly eye on the Anglo-American world, his real interest well into the fifties remained with Paris.

> Paris was for me an exquisite impression. I have the feeling of having finally regained my footing and of having much more certainty in my work.[103]

In 1949, Grohmann still had plans for a Berlin MoMA, strictly separate from official government sponsorship or control.

> In particular, I am in the process of realizing some projects which, I believe, you will be interested in as well. Official artistic life being always more or less reactionary, I have had the idea of organizing a kind of 'Museum of Modern Art,' under the name of 'Institut fuer Neue Kunst,' first within a restrained framework and on a purely private basis, so that Berlin, isolated for these long years, finally again has the possibility to see international art. To begin with, I am thinking of showing works borrowed from private collections, of good exhibitions, of a small library with art journals, of discussions, etc. All of this will come into being during the course of this summer.[104]

The *Institut* never came into existence, probably for lack of funds, and Grohmann turned his energies to locating other platforms for the artists he meant to support. It was not to be America, as his efforts to visit that country were repeatedly thwarted, nor was America in the late forties yet weaned from its own dependence on French modern art.[105] The source of support was to come from innovative "joint-ventures" between new German industrialists looking to build up their contemporary art collections, and the needs of prestigious, but financially struggling, internationally read art magazines such as *Cahiers d'Art* to increase the number of their subscribers, as well as to offer foreign readers incentives by including surveys of, in this case,

recent German developments.[106] By December 1952, Grohmann noted, in a letter to Günther Franke:

> Getting subscriptions for *Cahiers d'Art* would of course be simpler with preprinted forms, but unfortunately Zervos didn't print any. The journal, as you can imagine, is of course always a subsidized enterprise, and thus he has to economize. But I think that *Cahiers d'Art* is well known enough so that everyone can get an approximate idea. In contrast to the last annual and semi-annual issues, Zervos wants to again return to single issues, like before. The next issue, which will however probably again be fat, has an essay by me on Nay and one on Camaro, each with one color and several black-and-white illustrations. The journal appears this week. In the issue after the next one, Winter and Woty Werner follow. The color plates are already finished. The thing is that Zervos also again wants to take Germany strongly into consideration, and that's very important for us. I was very happy that he asked me to introduce abroad the younger generation in Germany via *Cahiers d'Art*.[107]

What is perhaps most striking here is the attempt by Grohmann to build up a platform for modern art based entirely on private contacts, separate from official sponsorship.[108] But the basis for this kind of support system would nonetheless remain the existing German bourgeoisie, such as it was—such as it was again regrouping—and this social class elected precisely the reactionary government officials Grohmann and others objected to so strongly: the climate of reconstruction could not be eliminated by a clever mis-en-scène of modern abstract art. Art more often merely decorated it.[109]

The color plates for these issues of *Cahiers d'Art* were paid for by Karl Ströher, a cosmetics industrialist (Wella-Werke) from Darmstadt, in an ingenious scheme apparently thought out by Grohmann. In return for funding the costs of producing *Cahiers d'Art*'s color plate illustrations for Grohmann's articles on Nay, Winter, and the others, Ströher was able to acquire the paintings at a "friendly price," thus boosting his collection with works now lavishly illustrated in an internationally recognized art journal.[110] It is particularly interesting that Grohmann had to nudge Ströher into accepting Nay, as the patron found Nay too *derb* ("rough").

> We too were very impressed by Nay's pictures, but it would well have required your support to have made us in like manner feel enthusiastic, since coming from Baumeister, Winter, and the others, we did not yet quite understand Nay's somewhat rough color language. We also

would have preferred a personal engagement with you as to why the green picture should be preferable of the two.[111]

After noting that he does not (yet) completely understand Nay's "far-big derbe Sprache," a characterization that, particularly in comparison with Ströher's favorable assessment of the more subdued, perhaps harmoniously placed abstractions of Baumeister and Winter, clearly links Nay to an Expressionist heritage, he inserted this postscript:

> We have heard several voices among art friends and connoisseurs which were quite restrained in their judgment, occasionally also expressing the opinion that this period remained too close to the decorative. Many of the pictures were suitable for consumption and could provide good fabric patterns.[112]

It is a curious paradox that Nay could be deemed appropriate for fabric decoration, while the others remained exempt: is the expressive agenda too far from the lofty realm of the metaphysicians' claims, too close to the low art of decorators? Whatever the reason, several visits to Nay's studio managed to turn Ströher into an admirer; he not only bought a painting, but funded a prize (the Ströher Preis), which he made clear Nay should receive.[113]

Grohmann's failure as a critic and proponent of modern art was, in my view, his unwillingness to differentiate between the various strands of abstraction, and his willingness to support all modernists, regardless of direction, who fought against "reaction." This could well have been necessitated by the overall climate of reconstruction in Germany: it would have been too difficult on modern abstract art as a whole to have had internal strife in addition to the popular opposition it faced.[114] But simultaneously, this erasure of internal strife and disagreement in the abstractionists' camp contributed to the creation of a fossilized environment in which younger German artists could find no venue, while newer international developments were perceived late.[115] For Grohmann, the avoidance of open strife remained a top priority. To this end, he was willing to use existing artists' groups and turn them into vehicles for his own agendas, as, for example, in his wish to see ZEN49 develop into an alternative to the *Künstlerbund*.

> As concerns the ZEN-Group, I hope that they will be able to exhibit at the 'Haus am Waldsee,' our best exhibition space. I will write to you to let you know of possible dates. What would you think of expanding the ZEN-Group to include two young people: Bernard Schultze of

Frankfurt on the Main, Eschersheimer Landstrasse 565, and Otto Greis of Bad Soden. The two represent a matter apart, and I think ZEN should constantly encompass the new and the historical. [Literally, Grohmann says the group should expand forward and backward, presumably meaning that it should include both younger, newer artists as well as established modernists of previous years, although his meaning is not entirely clear.] I would prefer it best if a new *Künstlerbund* that included Baumeister, Nay, etc. evolved out of the ZEN-Group. But this will presumably remain a pious wish.[116]

Here he was clearly trying to promote Ursula Bluhm's husband Bernard Schultze, who, as Bluhm noted, was painting in an Abstract Expressionist manner—circumspectly characterized by Grohmann as "a matter apart." It amounted, however, to a tinkering with the existing framework to ask for the inclusion of one or two younger artists, not its revision.

A climate of something close to stagnation persisted until the 1960s and the second American "cultural offensive" on Europe known as Pop Art. It had a tremendous impact on German artists because, I would argue, it helped break up from outside the domestic stranglehold of what had basically become an undifferentiated and uncritical abstract style conglomerate. This conglomerate remained at heart a Western European, often Franco-German affair, and while it seemed sealed off from the turmoil of the Cold War, Eastern Europe, American expansionism, and changing social values, these factors in reality were very much its subtext.

Chapter IV

TOWARD THE SOCIAL MANAGEMENT
OF VIOLENCE

> Man as a mass or mob is the most unworthy and
> depressing phenomenon in this world. It is, however,
> also the most dangerous—that is something that we
> should all have learned by now—more dangerous than
> earthquakes and storms. Therefore, "un-massing" or
> individualization must be the chief aim of every attempt
> at reconstruction.
>
> (F. H. Rein, "De-Nazification and Science")

ONE of the more profound aspects of the breakdown of a secure *Menschenbild* is that it gives free reign to a rejection of systemic views of man, which in turn forms a basis for rejecting the proletarian image-of-man. This in turn then becomes a basis for rejecting the idea of class struggle. As the *Neues Abendland* put it in 1947: "The discussion surrounding the new image of man continues still."[1] What seems clear is that a re-orientation around the "image of man" was sought because the previous orientations appeared to have been systemic: collectivist, communist, national-socialist. And all of these solutions were seen as evil or bankrupt. Note how the rejection of systemic views of man accorded with the variants of a liberal ideology espoused to one degree or another by Europeans as varied as Nay and Grohmann, or, for that matter, the writers Max Frisch and Albert Camus. But note especially how well it expressed the rejection of class struggle as a motor of history, and hence facilitated the dissemination of the more flexible, pragmatic American ideology of postwar liberalism. If American liberalism to some extent triumphed intellectually in Germany and in much of Europe after World War II, it was not only because of brute imperialist force, economic expansionism, or any of the other realities of postwar American foreign and domestic policy, but also because its claims and explanations seemed more reasonable. In this chapter, I will look at

two related aspects: how the United States was seen by the (Western) Germans, and how the United States proposed to keep "its" Germany free of communism, as well as culturally oriented toward the West.

Despite good intent, such as that in Josef Pfister's analysis quoted in chapter Two, US support for cultural change often manifested a desire for restoration and continuity, not a mandate for change. As in so many other situations, an "old boy network" ensured that those in power remained in power. The art historian Edwin Redslob, who became in 1949 the first *Rektor* of the newly created Free University of Berlin, is a case in point. Redslob's career, while probably impeccable in terms of scholarly commitment, was, however, unfortunately symptomatic of acquiescence and adaptation to those in power. Thus, during the Allied bombing raids on Berlin in 1943, Redslob plied his Nazi connections to ensure speedier repairs of his villa, as well as to secure better access to the postal service.[2] As a way of ensuring a response, he never failed to stress his significance to the regime.

> Since October 1939 I have exerted myself in the war effort through my collaboration on the battle journal, *Bilder der Woche*, published by the Air Force's general staff; this work currently also continues. Since 1941, I have furthermore been engaged in a ten-year contract with the publishing house Reclam in Leipzig, as well as being at work on two large commissioned publication projects for the publisher Stalling Oldenburg. The activity of both publishers is acknowledged to be important to the war effort.[3]

Despite such blatant exploitation of his connections, Redslob's career continued its upward climb at the war's end.

For one thing, Redslob continued to advance his official contacts— now albeit no longer Nazi—for career gains, and he could rely on what appeared to be a network of German friends to champion his cause: which by the late 1940s was freedom. While the Office of Military Government for Germany, United States-Education and Cultural Relations Division (OMGUS-ECR Div., part of the US Military Occupation Authorities) had a significant program of cultural exchange, the tight money situation made it imperative that private sources be called upon for support. Here, too, Redslob was more successful than most, not least because by 1949 he could sell himself to anxious Americans as a defender of cultural and political freedom. His personal contacts, not government support *per se*, were again invaluable, as the

following letter from Hans Rosenberg, a German professor at New York's Brooklyn College, dated 5 October 1949, indicates:

> I personally consider it very important that you come to America, and in fact as soon as possible. Considering the thoroughly precarious situation of Berlin and of the Free University, you need American help. The transfer from OMGUS to HICOG unfortunately implies—among other things—that American *government* funds for direct subsidies of German organizations will very soon hardly be available much longer. Thus it becomes all the more important to direct the attention of local foundations here and other private organizations to the Free University, before other German universities beat you to it. All told, there will only be very limited means available for such purposes. If you come, it would be vital to bring along very precise proposals, along with the necessary written documents.[4]

Less than two months later, his contacts with the American Occupation also served him well, as Maxwell D. Taylor, Major General USA, the U.S. Commander of Berlin, wished the *Rektor* of the Free University all the best "on the eve" of his departure for the United States, adding:

> I am taking the liberty of attaching a letter of introduction to General Eisenhower at Columbia University in New York. I am sure that you will enjoy meeting the General, and that he will derive much pleasure from hearing about the Free University from you.
>
> When you return from the United States, I hope that you will have a chat with me and tell me about your visit.[5]

Why Redslob should receive such extensive, even hearty support is perhaps best summed up by a letter from Rosenberg to Mr. Elkinton, the Executive Director of the Carl Schurz Memorial Foundation in Philadelphia, one of the private organizations called upon to fund this cultural exchange:

> He is, therefore, the elected head of a unique school, fighting in splendid isolation against enormous odds. His university is the last remaining outpost of western learning in Europe beyond the eastern boundaries of the newly created west German state. By virtue of being free from the direct or indirect control of Soviet Communism his university lives up to its name. There simply does not exist any other 'free university', that is located within, or hemmed in on all sides by, the dangerously extended boundaries of the Russian sphere of domination in Europe

and elsewhere. It is no exaggeration to say that the Free University has a historic mission to perform, a mission, moreover, which is in accord with our American interests in Germany and in Europe. Significantly enough, the Free University came into being in close cooperation with American Military Government. This pioneering university, in my considered opinion, is in spirit and organization a more genuinely democratic institution of higher learning than any other German university at present. It deserves, therefore, special consideration and encouragement.[6]

Redslob's career exemplifies my earlier point that the Cold War germinated with anti-communist affinities between Nazism and United States policies during World War II.

It seems that it even became respectable in the postwar climate to propagate the racist charge of "Asianism" against the Soviet Union: not restricted to the realm of general paranoia, this characterization could be applied to the Soviet Union by scholars and officials of the highest credentials. Thus, when Edwin Redslob, as *Rektor* of the Free University, told his American audience in December 1949 that his Berlin university and all of West Berlin were a last stronghold of freedom in a sea of "Asiatic . . . mass-slavery," he was both articulating a general German resentment and telling his audience what they needed and wanted to hear.

> I hope, that, [sic] what I have said, will make clear to you the whole situation in Berlin, which is a result of the defeat of the blockade. I know that outside of Berlin, where people did not learn such a terrible lesson, communism and reaction have shown their heads. There will be great danger if both get together. But I trust in the common sense of the youth of the world. We are getting tired of totalitarianism in all forms. The world will go ahead and not go back. It seems impossible to think that the Asiatic form of mass-slavery will become the form of European life. Therefore, please help us. Do not leave the youth of Europe alone. Cultural relations with the Americans, communication through books and lectures, ties through the exchange between teachers and youth of our countries, will save democracy in our lands. Community in the spiritual life for all who follow the ideals of Christianity and humanism: Berlin has defended these ideals. The more the world understands, what Berlin has done, when it resisted the Russian pressure, the more real democracy and liberty will develop in Germany, the more assured will be the future of Europe, of the whole world, of all of us who are of good will.[7]

Humanism: the ideals of Christianity and humanism will bridge the chasm torn open by twentieth-century totalitarianisms, will erase the scars on occidental civilization's face.

Freedom was the sword of this belligerent humanism. Redslob, as could be expected, maintained close relations with the Congress for Cultural Freedom (CCF),[8] founded in 1950 in Berlin with secret CIA funds. Most members were ignorant of this funding connection, but their willingness to defend a rhetorical conception of freedom, incapable of reflecting critically on the source of its engendering, was exactly what the US required, given the Soviet Union's own aggressive attempts at expansion.[9] Karl Jaspers, honorary president of the CCF, fired the opening volley by stating: "Truth also has need of propaganda."[10] Clearly, more radical critical thinkers—for example, Adorno—who did not have positive agendas to offer, could not hope to secure either much support or even much understanding for their refusal to participate in "necessary propaganda" for something identified as "truth."

Aside from making the world safe from "Asiatic . . . mass-slavery,"[11] what constituted the major enticement of "freedom"? Americans were seen as individualists, still successful at the constitution of a feasible image of man, which in Europe had suffered serious blows. Individualism contributes to strengthening a non-systemic image of man, thereby countering what were perceived as the two key dangers of systemic views: collectivization and inhumanity. In the German discourse, the problem of totalitarianism—usually addressing Nazism directly, but already implicating the Soviet system as well—was initially addressed most often as one of inhumanity: "For where inhumanity reigns, the cry for vengeance is also not an argument. There exists no argument on earth for inhumanity."[12]

Writers were still at a loss, however, as regards finding a positive image of humanity. This was eventually located under the restorative aegis of individualism, freedom, and humanity. The smiling American was the "logical" opposite number of the grim totalitarian.

While there was no official program to plot the propagation of individualism as anti-communism and the restoration of pro-capitalist and pro-American power elites, an analysis of American self-representation in the press, as well as of OMGUS-ECR Division policies, shows this link to be real. The *Amerikanische Rundschau* by 1948 was making a cogent case not only for Schlesinger's "vital center" liberalism, but also against Marxism. Already at this point (1948), Marxism's claim to be a

method of explaining history and the present as a totality was under attack, as George J. Eliasberg, a German émigré, spelled out in an article entitled "Marx und die totalitäre Idee."[13] On the very first page, Eliasberg sets out the problem:

> No scientific theory is so comprehensive as to deliver behaviour codes for each concrete case; only a pseudo-scientific dogma can even appear to raise such a claim. That Marxism raised such a claim is the result of a basic error in its system: from the observation that the prerequisites for socialism are engendered in capitalist society, it was reasoned that the transition to socialism would of necessity follow out of the "dialectic of the historical process." The former is a scientific observation, the latter a utopian illusion. The extraordinary charismatic power of Marxism, as it was represented by the proletarian movement, can be explained precisely by the fact that science and utopia are interwoven in an inseparable unity in it.[14]

These two factors, one rational (scientific), the other a matter of faith or irrational in Eliasberg's words, are inseparable in Marxism, hence its great attraction. If Marxism had only been a rehash—without its rational-scientific claims—of old utopian ideas, it would not have held much attraction in an age enamoured with rationality. If it had been only rational, however, it would not have been charismatic.

Eliasberg goes on to trace this charismatic/irrational aspect to Hegel, who propagated a notion of telos in history.[15] The Soviet variant, on the other hand, he indicted not so much for its irrational totalization, but rather for its imperialism. As Eliasberg sees it, the Soviet Union is guilty not of communism, but of imperialism:

> The Communist International was not Marxist. During the course of its development, it ceased being Leninist. It finally turned into a weapon of Russian factional struggles and into an instrument of Russian power politics. The "Marxist" garb cloaked every phase of this metamorphosis because in reality all theories only existed for the Communists as a justification of their current practice.[16]

Wedged between these critiques of utopian and actual (power politics) communism is an attempt to salvage a socialism that, while surely anathema to conservatives and reactionaries, could be reconciled with the liberalism propagated by Schlesinger.

Key to Eliasberg's rescue of a democratic Marxism—embodied by Marx's own valorization of the 1871 Paris Commune[17] and Eliasberg's praise of Rosa Luxemburg[18]—is the rejection of totalizing in favor of

what we might call "mapping": Eliasberg believed that the latter would allow one to be aware of the determinants of one's activity so that one would be aware of distortions and could work with or around them. If one attempts to take a totalizing idea—such as "all history is the history of class struggle" or the assertion of the "primacy of foreign policy"—and make it the basis either of all historical explanation or of practical politics, one ends up with a distortion:

> Such theories pose quite similar problems as when one considers the different ways of projecting the earth's sphere onto a flat map. It is well known that there is no "true" projection, that is, none that would simultaneously fulfil all requirements and in which all the relationships would be accurate. One has to use different projections for different purposes if one wants to avoid reaching false conclusions. This does not mean that the well known Mercator map is "wrong"—as long as one does not make demands of it which it just cannot fulfil; for example: establishing the shortest flight line between two given points. Other projections provide us with a grotesquely distorted picture of entire continents—but yet are not "wrong" as long as one is conscious of the purposes to which these particular maps are supposed to be put and what their limitations are.[19]

While in mapping one can be aware—supposedly—of distortions, in totalizing one is in the distortions and cannot take an outside stance. One can read this as an endorsement of dialectics, since at its best dialectics attempts to bring to the surface of thought the inevitability of totalization in *all* thinking. But one might avoid this more difficult lesson and instead see a confirmation of a free consciousness capable of taking a defining stance. What is implied by this text is that this (reasonable) activity of mapping, insofar as mapping allows a viewed object/analysand relationship to exist, could rescue and restore the subject-object relationship, which is threatened with eradication in all totalizing regimes. Thus this thoughtful critique of Marxism, perhaps in spite of itself, contributes to securing the seemingly inevitable rightness and reasonableness of American "vital center" liberalism.

Arthur Schlesinger in the previous issue of *Amerikanische Rundschau* had projected the aims and benefits of just this pragmatic approach to capitalism and socialism.[20] He condemned both extremes, for they "[have] indulged in . . . the error of mistaking abstractions for concrete realities."[21] The primary question for Schlesinger was "Is democratic socialism possible?"[22] What Schlesinger of necessity simplifies,

however, is the phenomenon of violence, by defining it primarily as physical or brute coercion, without careful analysis of how violence inheres in epistemology—in thought—itself:

> The classical argument against gradualism was that the capitalist ruling class would resort to violence rather than surrender its prerogatives. Here, as elsewhere, the Marxists enormously overestimated the political courage and will of the capitalists. In fact, in the countries where capitalism really triumphed, it has yielded with far better grace (that is, displayed far more cowardice) than the Marxist schema predicted. The British experience is illuminating in this respect, and the American experience is not uninstructive. There is no sign in either nation that the capitalists are putting up a really determined fight. Liberal alarmists who feel that the clamor of a political campaign or the agitation of hired lobbyists constitutes a determined fight should read the history of Germany. In the United States an industrialist who turned a machine gun on a picket line would be disowned by the rest of the business community; in Britain he would be sent to an insane asylum. Fascism arises in countries like Germany and Italy, Spain and Argentina, where the bourgeois triumph was never complete enough to eradicate other elements who believe in what the bourgeoisie fears more than anything else—violence, and who then used violence to "protect" the bourgeoisie.[23]

Of greatest interest here is Schlesinger's proposal of a linkage between violence and the absence of a strong ruling bourgeoisie; only in this combination could fascism be possible. But this ignores the existence of "soft fascism" in democratic systems with a strong bourgeoisie, a scenario already considered by the Frankfurt School.[24]

Schlesinger was concerned with how the United States could pursue "any program of resistance to Soviet expansion without itself moving toward fascism."[25] For him, the United States should not make itself dependent on the right in its fight against communism, it must instead support "progressive capitalist democracies," for it was crucial to keep the United States from becoming fascist in its further development of capitalism.[26]

The prerequisite for preventing this drift was support for the Marshall Plan. This was where intellectuals needed to play a role, according to Schlesinger: they had to rally to this concept of co-opting capitalist strategies as the only way to guarantee that the United States would not go fascist. A "radical democracy" and an enlight-

ened capitalism had to be furthered, defended, fought for, against the intellectual treason of the "progressives" who believed in the abstract formulae of Marxism.

> The intellectual must not be deflected from his responsibility by inherited dogma. It is clear today that Marx's method was often better than his own application of it. Experience is a better master than any sacred text. The experience of a century has shown that neither the capitalists nor the workers are so tough and purposeful as Marx anticipated; that their mutual bewilderment and inertia leave the way open for some other group to serve as the instrument of change; that when the politician-manager-intellectual type—the New Dealer—is intelligent and decisive, he can get society to move just fast enough for it to escape breaking up under the weight of its own contradictions; but that, when no one provides intellectual leadership within the frame of gradualism, then the professional revolutionist will fill the vacuum and establish a harder and more ruthless regime than the decadent one he displaces; and that the Communist revolutionist is winning out over the fascist and is today in alliance with an expanding world power which will bring every kind of external pressure to block the movement toward democratic socialism.[27]

The intellectual, Schlesinger insisted, had to provide the leadership necessary for preventing a war with the Soviet Union. If this project failed, however, then the possibility for a "peaceful transition to a not undemocratic socialism" disappeared, and the fate of democracy, socialism, and everything else would be that of Hiroshima and Nagasaki.[28] For Schlesinger, the "vital center" ideally was a kind of democratic socialist mode of bourgeois management of social violence.

In Western Germany, these analyses must have been compelling, as the Nazi phenomenon was discussed in various publications as a failure of the middle class[29] and current cultural nihilism was seen as an expression of the bourgeoisie's loss of faith in some larger ideal.[30] The role of art and culture in this dynamic was recognized by various writers, as their linkage of the "problem of individualism" and abstract art indicates. While these linkages were not specific, art clearly was implicated; thus, *Prisma* as early as 1947 stated: "The problem of individualism is the point of departure, to arrive where the most decisive turning point of our times is manifested: in abstract painting."[31] That this was a generational problem—insofar as an entire generation's formative years were spent in Nazi indoctrination—is also reit-

erated by *Prisma*'s editor. The availability of banal platitudes were part of the problem. Their uncritical affirmation led to disaster:

> "Woman is born to be a mother"—of course! "A people is a blood community"—goes without saying. This was what was said. The next act was the official propagation of unwed motherhood, euthanasia for sick people, and proclaimed contempt for all peoples but one's own. The third act was war to the point of destruction of one's own people and placing the woman-born-to-be-a-mother behind a canon.[32]

Individualism as a problem is tied to "Abstract" art which clearly meant "modernist," i.e., anti-naturalist, art. "Abstraction," which meant "deformation" of natural, objective appearance, as well as the infusion of art with spiritual ideals beyond the scope of copying objects, allowed one to escape conventions. This was deemed good, since it was conventionalism of thought that allowed the individual to be transformed into mass man. Here, too, violence was ascribed to the aggression on individualism, but little thought was given to the violence required by "the individual" to counter it. The individual was posited as some kind of natural phenomenon that would exist as long as totalitarianism did not prevent him from doing so: a naive proposition shared by many in the liberal camp.

Liberal individualism was equated with simple heroics, even nobility (in the sense of man-as-individual being the crowning glory of nature), yet without organized state violence to support such individualism— i.e., a system that allows the individual to exist as a noble, vertical, cephalic, crowning achievement—this sort of liberal individualism was impotent. This is something the reviewer of Eric H. Boehm's *We Survived*[33] missed when he discussed the book in the last issue of *Amerikanische Rundschau* in 1950.[34]

> Here speak men and women—many of them simply liberals who demonstrated through their behaviour that liberalism cannot necessarily be equated with powerlessness and inability to act—who knew that torture and death waited for them around the corner, and that the best solace they could hope for was articulated by the lawyer of one of their own who, before sentence was passed, told his client, "don't worry unnecessarily—the worst they can do is condemn you to death!" This was not at all meant ironically, and in view of the bestiality of the Nazis, such words indeed seemed almost comforting.

In spite of all this, the illegals continued their struggle. They hid in basements, operated secret printing presses, distributed leaflets, went

about with suitcases that, when placed on the sidewalk, stamped anti-Nazi slogans, they made deliberate errors in radio broadcasts, and directed military convoys to the wrong destinations. It was an unequal struggle, this fight of weak people against monsters, but it was fought out with tenacity and heroism. Each one gave his best.[35]

Nazism was treated as an inexplicable system, as a sphinx, a totality thoroughly foreign to human values as espoused by Western bourgeois society, values that were derived from certain ancient traditions, but that were then also "universalized." Nazism as a system totally foreign to this occidental ideal actually helped justify the liberal position: opposition to Hitler that was organized and systemic and thoroughly political would have had to have been as systemic and total as Nazism itself. The only opposition worth the name, then, was to come from noble individuals and their deeds, not their political philosophies or systems.[36] The military power it took finally to defeat Nazi Germany thus was seen as an extension of these individual liberal virtues—the forceful arm, so to speak, of human goodness—and not as a matter of military and counter-imperialist violence.

The marriage between military violence and individualism was already being consummated in this silence. Thus, even CIA attempts to support modernism or subvert communist culture proposals would not explain why a variant of liberalism was being promoted and accepted in postwar Germany or why a certain kind of modern art accompanied cultural restoration.[37] OMGUS-ECR Div.'s role in this situation deserves comment, however, in part because OMGUS-ECR Div. possessed virtually no agenda for contemporary art, yet played an important practical role in disseminating faith in individualism and freedom—the foundations for a supposed new *Menschenbild*—and in facilitating contacts between individuals and organizations.

In October 1947, OMGUS began initiating steps toward a "Visiting Artists" program;[38] the artists in question, however, were not visual artists, but writers such as Thornton Wilder, Robert Sherwood, and others. As the memo from Gordon E. Textor, Colonel, CE, Director of Information Control Division, put it:

> The problem here, since the War Department staff can be of no help, is to persuade not only the artists of the importance of their appearance in Germany, but also to persuade sponsoring organizations, such as the Carnegie Foundation, of the desirability of their sponsorship and financial support for the travel of these artists to Germany.[39]

Of particular interest here is the emphasis given to private, not government, sources of support for cultural exchanges. This point is repeated explicitly: "There is also for consideration the possibility of establishing a committee, either in New York or Washington, of prominent citizens which would itself contact the foundations and the artists and represent the nucleus with which we would carry on normal liason [sic] and administration."[40] This was a strategy that came to serve OMGUS-ECR Div. when it finally, in 1949, proceeded to address the issue of the visual arts in Germany.[41]

OMGUS was staffed with and endeavored to recruit people with the best democratic intentions, and when the visual arts finally got their assessment in 1949, a young curator of painting at Boston's Museum of Fine Arts, William G. Constable, was chosen for the job. That Constable, though almost exclusively oriented to museums and not to the situation of contemporary art in Germany, upheld democratic ideals is clear from his assessment of German museums' firm patriarchal stance:

> In my enquiries into the present condition of museums in Germany, I have found no disposition to allow women a larger share in their operation and control. There are many capable women in German museums, well trained as art historians. Sometimes, indeed, the main burden of the work falls on them; but I know of no woman director of German museums, and when I have raised the possibility the reply has been the equivalent of "ausgeschlossen" ["absolutely not"]. An example is the museum at Darmstadt, where the director has retired and the work has for some time been in the hands of a capable woman curator. But there seems no thought of her becoming director.
>
> This situation seems to me most regrettable:
>
> (1) It is contrary to the whole spirit of democracy.
>
> (2) It deprives the museum field of valuable reinforcements. As is [sic] other professions, museum personnel consists largely of the old and inert, or of the young and ignorant. War and Nazi activity have affected women in museums less than men; and there are competent and energetic women of middle age who could be given more opportunity then [sic] they now receive.[42]

As for contemporary artists, the absence of an active middle generation was perceived as problematic, along with the lack of access to international art:

> The older painters and sculptors for the most part produce a feebler, more mechanical version of the expressionism of the twenties; the

younger either follow in their footsteps, or experiment with abstract painting of a somewhat elementary type. Here and there, a more vigorous and personal art, with a realistic basis, appears, but everywhere, artists are out of the main current of European development. They have seen nothing of the best contemporary work of other countries, while even today, few examples of old masters are accessible. Berlin, perhaps the liveliest centre of the arts in the country, is especially badly placed to [sic] the blockade.[43]

Thus, as late as 1949, works from abroad were still not seen, and Constable was quick to dismiss the derivative styles practiced by many.[44] Recall also that Grohmann emphasized the importance of *Cahiers d'Art* for access to French and other international art, and that it was not until 1949/50 that German artists began participating in the pages of *Cahiers d'Art*.

Constable advocated greater OMGUS involvement, particularly to counter a perceived French monopoly:

I suggest that an early putting into operations of an art exhibitions programme is very desirable. U.S. Military Government has won a deservedly high reputation for its handling of the restitution of works of art. But it has come to be regarded in Germany as an honest broker interested in property, rather than interested in the arts themselves. Meanwhile, the French, operating in the American Zone through the Museum at Karlsruhe, have suggested the idea that they are the people who minister to spiritual welfare. A programme of exhibitions would be of great value in widening the outlook of the Germans, and helping to correct nationalist bias, apart from helping to restore German morale.[45]

His recommendations included three types of programs.

The first was a series of exhibitions within the US Zone of: old masters, especially non-German ones to wean Germans from their nationalist bias; contemporary German art, but judiciously chosen, as much of it was of inferior quality (these exhibitions would be important as "a valuable help and stimulus to artists, especially young artists");[46] non-German applied art; and contemporary applied art. The second type of program would entail circulating into the US Zone art exhibitions already circulating in the French and British Zones. And the third type would include exhibitions from the United States, including: contemporary American painting and graphic arts (Constable suggested the Whitney Museum, New York, and the Chicago Art Institute as sources); American applied art (he suggested the Museum

of Modern Art, New York); American architecture (MoMA); and American masterpieces from the eighteenth century onward (he noted that this would be, logistically, the most difficult to arrange).[47] For Constable, museums—and in particular democratic access to their holdings via "intelligent choice of subject, arrangement and labelling"—should serve as institutions of democratization. They would "help break down the prevalent idea in Germany that art is something for an instructed elite and not for the people at large."[48]

While Constable saw the old masters and the applied arts as central, he also recognized the potential value of sending American contemporary art to Germany. Because, however, this area was so fraught with emotion at home, particularly in the Congress, where Right-wing representatives were willing to make fools of themselves by suspecting modern art of pro-Soviet espionage,[49] Constable, in order to defend the Schlesinger-type liberal agenda seemingly endorsed by OMGUS staffers, had to seek recourse to the now tried and true device of securing private, not government, support for such exhibitions. After stressing that the exhibitions at the Amerika-Häuser were embarrassingly crude,[50] and that effective exhibitions must be of the highest quality in every respect, Constable noted:

All this emphasizes the importance of having the exhibitions designed and organized by highly competent people in the United States. An offer by the Field Office in New York to do the work should be firmly rejected; likewise that of well-meaning private individuals or dealers who have an interest in Germany. The idea of "picking up" exhibitions wandering about the United States should also be regarded with suspicion. The exhibitions should be organized *ad hoc* by such institutions as the Whitney Museum, New York (Painting, sculpture, graphic arts); The Museum of Modern Art (architecture, painting, sculpture and applied arts); the Institute of Contemporary Art, Boston (applied arts); and the American Federation of Arts, Washington. Such institutions are used to assembling, labelling, and packing exhibitions for circulation, and could be relied on to choose well and to prepare a good catalogue. Also, if criticism of choice was made in Congress or elsewhere (as in the case of the State Department collection of pictures) the fact that the choice was made by an established and reputable institution would be an effective answer. If adequate preliminary explanation were given of the purpose of the exhibitions, and of their importance from the national viewpoint, I believe the institutions mentioned, as well as others, would cooperate to the full. But a bald official letter from Civil Affairs Division would certainly not meet the case.[51]

In other words, not any private individual—with possibly pecuniary interests—but the elite of America's leading private institutions should be encouraged to apply.

In the United States, the arts successfully served as a building block of liberalism and of the middle class, and Constable wanted to see art play a similar role in Germany:

> The teaching of the arts, in the form both of practical instruction and of art history, has for a long time held a considerable place in German education. For some time, however, it has been becoming more and more formalized and arid. In manual work, technical proficiency has been over-emphasized; in art history, names, dates, categories and theories have played an undue part. Moreover, under the Nazis art history was deliberately distorted to serve nationalist ends, by overemphasizing the importance and influence of German art.
>
> The value of the arts as a means of emotional release, of developing individual character by stimulating and controlling [sic!] the imagination, of providing a large number of people with means to greater understanding and enjoyment of life, and of breaking down narrow nationalism, and building up an international outlook, has been overlooked; and consequently their importance as a factor in a liberal education and all that that implies is lost. Meanwhile, in the United States and elsewhere, the value of the arts in this respect has been increasingly recognized and exploited.[52]

Thus, art could be a "gentle" tool with which to teach people to become middle class, provided it was set up properly, i.e., institutionally. Furthermore, arts training should be broad and general; if too narrow and specialized, it could create a caste of unemployables, who may easily come to form "a disgruntled intelligentsia open to various types of political propaganda."[53] Constable provides us with much information about OMGUS policies and philosophy, but it is also clear that both he and OMGUS preferred their art in museums, not on the streets, and hence there was usually a fine disregard for contemporary art. Putting into play the ideal of individualism—the "de-massification" of the German populace—did however provide a new framework of "freedom" for contemporary art.

Not until 1951, however, was American art shown in Germany on the scale envisioned by Constable. In 1949, OMGUS-ECR Div.'s "Cumulative Report of Cultural Affairs Covering the Period 1 May 1948–30 April 1949"[54] stated: "There have been practically no art exhibi-

tions, or arts and crafts exhibitions exchanged with the United States or other foreign countries."[55] In 1951, the exhibition "Amerikanische Malerei, Werden und Gegenwart" opened in Berlin's Rathaus Schöneberg and Schloss Charlottenburg; it was the first exhibition of American art in Berlin.[56] The exhibition included ten paintings by eighteenth- and nineteenth-century artists, and 55 paintings by contemporary, twentieth century artists, along with 65 works of graphic art. The selection committee reflected Constable's vision of an elite: David Finley, National Gallery, Washington; William Milliken, Cleveland Museum of Art; Lloyd Goodrich, Whitney Museum; Bartlett H. Hayes, Jr., Addison Gallery of American Art, Andover, Mass.; Charles Nagel, Jr., Brooklyn Museum; and Charles H. Sawyer, Yale University. Funding came from the Oberlaender Trusts. Besides including a representative selection of early twentieth-century American modernists (Demuth, Hartley, Dove, et al.), the exhibition also included the complete spectrum of post-1940s contemporary painters, from Hyman Bloom and Philip Evergood to Jackson Pollock and Mark Rothko.[57]

OMGUS and its staffers and experts usually pursued as democratic a policy as possible, without coercion or undue manipulation; they saw no reason to persuade the German populace into accepting anything they would not have willingly embraced themselves. Germans in turn were anxious to study foreign models, insofar as these could provide counterproposals to "massification" and totalitarianism and provide them with a blueprint for reconstituting institutions—such as museums, universities, schools—but not, however, with a blueprint for how to paint. Abstract art was already being made anyway; the point now was that a set of terms for art's reception was being given general social approval. Faced with opposition from the orthodox communist, as well as the conservative reactionary camp, it is small wonder that most modern art bolted for the liberal camp.

This general truth, however, should not blind us to the differences —and the significance of these differences—between various kinds of abstract painting and their relation to the issue of expression. If we consider the critiques made of the American cultural contribution, it is clear that one of the main objections was to American optimism. Americans were seen as irritatingly naive, and uninformed by the larger experiences of the Europeans. The Swiss writer Max Frisch, who gained European-wide recognition during the 1950s and 1960s, while in Paris made the following observations in a July 1948 journal entry:

In Thornton Wilder's second play there's a passage that unsurpassedly illustrates the process; Mr. Antrobus, the father, has just invented the wheel, the wheel itself, and barely has the boy played with it for a minute that he makes a suggestion to his father: Dad, one could attach a seat to this! The father invents, the son will "appropriate" ["*besitzen*", which plays also on "occupy"] the invention. Sure, hollers Mr. Antrobus, now any idiot can play with it, but I had the idea first! What's at work here is less an hierarchy, I believe, but rather a phenomenon, a process. Younger nerves, lack of historical experiences, of scepticism, these are of course the prerequisites for appropriating the paternal wheel and for ruling the world. Lack of scepticism, lack of irony: that's what it is, after all, that from the first makes their physiognomy appear strange to us. I've noticed several times in Paris that the Germans, yesterday's oppressors, are here less hated than the Americans, the liberators, which doesn't speak for oppression and against liberation, but rather only expresses, I believe, the feeling of strangeness: the Germans were, despite everything, Europeans.[58]

Many European intellectuals found the Americans irritating.[59] They were often perceived as too naive and too oriented to pragmatism; they intruded too boisterously on the tattered self-conception that European intellectuals were trying to preserve and heal.

Their popular culture—as opposed to the finer institutional culture represented, for example, by William Constable—was perceived as overly aggressive by European intellectuals. American popular or low-brow culture's aggressiveness was one of surface allure, of "seeming" versus "substance":

> Punctually, on the first of the month, the issue of the new American magazine was on display at the newspaper kiosks. The four-color cover shone appetizingly, the smoothness of the spine shimmered seductively. It was the exact same sheen that surrounds the sparkling automobiles of America—lacquered steel, chrome armatures, molded plastics that shimmer like ivory—it was the shine of the silver or gold cans that contain "sliced bacon" or "grapefruit juice," the sheen of the cellophane in which the tobaccos of Cuba or Virginia tend to appear like the carefully cultivated girls of a New York revue. He who can resist such sparkle, please step forward.[60]

Note the emphasis given to "sparkling," "shining"— *schimmern*—to surface effects: packaging appears as the substance, not the product inside. This is a well-entrenched European prejudice: that Americans produce a popular culture that is superficial, while both European

high and folk culture have depth. But the deliberate attempt by the popular American magazine *Reader's Digest* to propagate optimism[61] was critiqued by *Die Gegenwart* as its most objectionable feature, for optimism was seen as the philosophy of packaging, of surfaces, and of "seeming" versus "subtance." According to European intellectuals, empty-headed optimism was specific to the popular culture produced by American capitalism.

> The question is whether, within the bounds of the Marshall Plan, optimism as a way of life is a needed German import article. In Germany, too, there are optimistic and pessimistic systems of philosophy. Those that devote themselves to continuous progress; others that, based on observing morphology, tend to conclude that history is a chain of rises and falls and that basically the same things always recur. It is probable that the belief in a pessimistic interpretation of history, rather than its opposite, is more widespread in Germany today than anywhere else in the world. But this probably is not even the issue. That optimism, which the successfully promoting scholar is seeking to import, is not a philosophical view, but rather a collectively suggested way of life: one must smile when one would rather wail, fear of death is compensated for with comfortably furbished coffins at reasonable prices. The corpse, in the totalitarian East the result of painless liquidation and not the object of human interest, in the West wears make-up. . . . The American optimism which is to be imported could correctly be characterized by proper Marxists as an instrument in the class struggle. For whomever this goes too far should keep in mind that the optimistic character of that surely painfully colonized country is *also* a compulsory character. (Even if rooted in security and riches.) And this with all the consequences. With our parents' old dictum, "stop your whining," begins the universe of neuroses. And in that rich and happy land across the waters, psychiatrists and analysts represent the group that sits most securely in the saddle.[62]

Here in a nutshell we see what is wrong with popular cultural optimism, according to the more worldly-wise European view: it represses reality—namely, awareness of pain—and therefore results in neurotic, compulsive behaviour.

The "collectively suggested individualist way of life" was seen as a (low-brow) national character trait of the Americans, and hence potentially destructive of, or in competition with, the deep but endangered national character of the Germans—and the Europeans. The problem, of course, was that the terms in which the German character could be defined were highly unstable, often undesirable, and much

contested in this period, and hence in a weaker position than the American one. What was identified as an American national character trait by German critics was something furthermore in competition with the ways of expression of the discredited German national character. The encroachment of American popular culture and its ideology of optimism must thus also be seen as inflecting the possibility of expression: it would preclude or at least discredit the expression of pain, disharmony, and strife; it would modulate expression into something innocuous or superficial; and it would feed the postwar rage for order.

It is not the case, of course, that the optimism of the Americans was entirely without resonance among German intellectuals. Faced with the debris of twelve years of National Socialist rule, many writers and critics believed, optimistically, that freedom in itself would lead to a new world order, and that freedom implied the absence of strife or conflict. Clearly, such a paradigm was compatible with the new American imports, whether the (low-brow) *Reader's Digest* or the (high-brow) Congress for Cultural Freedom. The optimism necessary for believing that freedom is the absence of conflict was expressed, for example, by the editors of a 1946 almanach dedicated to cultural renewal.[63] As the introduction put it:

> By confessing to belong with those who are here named—and the many like-minded who are still to be named—we not only make up for a twelve-year injustice, we also raise a claim. The claim, namely, to comprehend man as a being who distinguishes himself from all the other creatures of this earth by his possibility for freedom: the freedom of thought and the freedom of creating, the freedom of character and of vocation. The world shows itself to us in pictures, in the books of poets, in the thoughts of scientists. The spiritual man who remains true to thought, and who does not adhere to its tenets only on paper but also in the reality of his life and deeds and who does not shy the consequences, is and must be a man of freedom. They may differ from one another in the undertones and halftones. They are all unified in one thing: that a culture is only possible where freedom is the prerequisite in thought and deed. Unity lies in the harmonious agreement of many separate voices. Leadership and the highest rank be given to him who has thought the deepest or has created the most deeply affecting work.[64]

A "catch-22" is established here, perhaps against the editors' own best intentions: if the artist is deemed necessary because he is the

embodiment of freedom and his work is the expression of freedom, and freedom is ultimately defined not as a discursive formation but an essential thing-in-itself, as well as a function of harmony—note how freedom is the common good, and this commonality is expressed in the "harmonic agreement" that freedom is the common good (a tautology)—then the artist cannot express freedom by deviating from the expression of unity ("*Einheit*"). The artist cannot dissent.

This is a problem posed by the rhetoric of freedom, a problem that grew as this rhetoric became the rallying cry of the West in the Cold War. Another problem is that abstract art could easily be labelled the expression of freedom, without thought to how it might instead express difference from the tautology of "freedom." That is, if one establishes a rhetorical conception of freedom that becomes instrumental in ideological battles, and if one co-opts "abstract" art into this rhetoric because it is a style the opposition tends to denigrate, then it becomes difficult for this co-opted abstraction to dissent. Differences between abstract styles thus become impossible to discern. A public that dislikes abstraction will be informed that it represents "our" freedom, and a critic who champions abstraction will perhaps at best write about line or color, but not about the content of abstract art. Content gives way to allusions to how abstract art in general represents "our" time, "our" goals (freedom, humanism).[65] There is only a monolithic "we" here; every "them" is on the other side, far away and not within "our" own ranks. In this way, the avant-garde lost all meaning in the postwar period, and a "spearhead school" of abstraction instead became the new establishment.

Optimism demands ontology to help channel and restrict dissent, to ossify it in accord with the requirements of restoration. At the very least, the demands of optimism strengthen ontology's grip. This happens in three ways. First, by denying the reality of disharmony optimism denies the reality of objective existence—and of objective *resistance* to subjective desire: optimism helps strengthen the subject's self-apotheosis as *Geist* (identification with a kind of omnipotence). Second, the apotheosis of *Geist* denies the reality of the bodily or creaturely. And third, the denial of the creaturely is in turn a massive restriction of expression, since expression is now limited even further to "spirituality" or *Geist*.

The key to the link between optimism and a retreat to ontology is that objective existence (and resistance) is denied in favor of the subject's self-apotheosis. We have encountered this already in Adorno's

characterization of ontology's "boastful affirmation of the way it is," which is not an affirmation of objective existence at all, but rather the claim, on the part of the thinking subject, to create identity and to eliminate difference, to affirm itself (the subject) as the locus of identity. Absolute abstraction—the style advocated by Roh (among other critics) and executed to varying degrees by ZEN49 painters such as Winter, Werner, and Baumeister—functions in just this manner. There is no need to villify it as mere wallpaper decoration—as Günter Grass has done in the past[66]—in order to point to its links to the 1950s when Germany had completed its restoration as a remilitarized, conservative-ruled bastion of conformity. Nor is this painting "optimistic" per se, in contrast to something more "authentic" searched for by Grass—perhaps in the form of a kind of crypto-Social Realism.

Its form, rather, is a sometimes sophisticated, sometimes banal, illustration of *Geist*, of the subject's illusory harmony with the world. In this way, it claims identity and erases difference, and in this way it marches hand in hand with the conformist requirements of the Federal Republic of Germany's early years. Material resistance is banished from the floating shapes of the absolute abstraction propagated by Winter, Werner, et al. And this program was not challenged by the major modernist critics of the day (Roh, Grohmann); it was actually encouraged, at least by Roh: the painters, opposed by totalitarians and reactionaries, but purchased by a new industrial middle class, could be assured that they indeed best expressed the spirit of 1950s West Germany.

The "harmony" conveyed in works such as Theodor Werner's *Annunciation*, 1952 (pl. II), is based on a facile simplification. The painter wills the work's forms into harmony, but the work leaves no record or trace of labor, or of the painter's fundamental lack of identity or harmony. The painter supposedly is the locus of unity, harmony, or "the universal," when in fact he is not and can never be: he is always the site of difference. Absolute abstraction, however, paints over this fundamental lack of subjective coherence.

This might be better seen in comparison with several works by Nay from the same period: *Figurine*, 1951 (fig. 23); *In Black Bars*, 1952 (fig. 24); and *Oasis*, 1952 (pl. VIII). By his own admission, Nay, too, strove for harmony, yet the process—as well as the results—differs significantly from the ZEN49 agenda. *Figurine*, *In Black Bars*, and *Oasis* represent a fairly clear sequence of orchestration, dissolution, and renewed orchestration, each time predicated on a willful analysis of—

and struggle with—the medium at hand. This is why Nay's work never looks the same for long periods of time (something that cannot be claimed for the work of Baumeister, Werner, or Winter).

In *Figurine*, from the so-called "fugue" phase or period, quasi-geometric forms are orchestrated rhythmically in a bid for harmonic formal distribution. But note how this is not accomplished at the material reality's expense: the first reality of a painting is that the painting is executed on a flat surface. Hence the refusal to let the forms "float," to create an illusion of space unencumbered by physical or material constraints. In Theodor Werner's painting, on the other hand, the clever deployment of "flat" ciphers depends entirely on a kind of metaphysical illusion of space created by the floating layers of color. Nay avoids this, instead going so far as to make his forms look cut out, especially around the edges of the black shapes where the white ground is allowed to show through. The result is not an ungrounded "floating" of forms, but rather an accentuation of the flat material support. The colored paint is also never deliberately dematerialized as in Werner's transparent layers. Instead, surface effects, especially scumbling in the dark red areas, are deliberately left showing, to remind the viewer that this is nothing but paint on a surface.

At least one other key aspect separates this work from the illusionism of ZEN49-type abstraction, and ties its commitment to a subject-object dynamic: securing the "figure"—a female figure is always Nay's point of reference—is of course the painter's subjective desire, his expressed aim, but his will to depict the figure is undercut constantly by the objective demands of the material, which dictates its terms: flatness, limits of the frame, opacity of surface. And of course the sheer impossibility of achieving desire. Hence, the figure is bound into a struggle with those terms that manifests itself most obviously in the all-over quality of the image. Nay's "figures" are rarely contained by boundaries of the kind that both set the figure on top of the picture-ground as a thing apart from that ground and enframe the form with the canvas's edge. Nay's figures extend and interact with the ground from edge to edge, underscoring the material surface's primary claim on the picture. This illusion—of "figure," of "harmony" —occurs on the flat, and the figure's play across the surface is the result of this primacy of the surface. Again, note the difference to Werner's work (or to the cited examples by Winter): the "floating" quality of these works is there first as a "transcendence" of the objec-

tive materiality of surface flatness, and second as a kind of boundary
—versus all-over quality—of the figure. The resulting abstract illu-
sionism reinforces the painter's primacy over such material aspects as
flatness; it denies the material's incommensurability to the desire for
primacy.

In the next two works by Nay, which belong to the so-called "rhyth-
mic" phase, we can trace the painter's deliberate destruction of *Figu-
rine*'s (relative) facility: in *Figurine* he had "figured out" how to play
out the utmost tension, including spatial tension, of geometric forms.
In Black Bars (fig. 24) destroys this formal syntax; it is a deliberate
return to "ugliness," as in *Woman's Head* of 1946 (fig. 12). *In Black Bars*
retains a measure of the sharp outlines of *Figurine* (fig. 23), but now no
longer enclosing decoratively patterned shapes. Instead, these lines,
in a sweep of dramatic gesture, are cut loose from the underlying
shapes laid on in interlocking patterns and contrasting, jarring colors
of brown, gray, red, green, and yellow. But even this deliberate, rag-
ing chaos is pitched against the objective reality of the canvas—
manifestly not a work by Wols or of *art informel*. In this style, the
"figure" deliberately is made to stand as an affront to traditional con-
siderations and the limitations of aesthetics and form; see Wols' *Com-
position* of 1946 (fig. 25). The figure often appears as the trace of an
"event," or a sign of activity beyond rational, conscious calculation: it
instead asks to be seen as a direct transcription.[67]

Nay's approach is neither a direct transcription, nor a turning away
from painting, and his point of departure is not just his subjective will
to mark the canvas with the event of painting. Note instead how Nay
acknowledges the reality of his materials: the "figure," here discom-
bobulated taken apart, is however not allowed the total freedom of
going where it will, nor is it "immediate." There is no illusionistic
space, and by filling the canvas from edge to edge, it affirms rather
than denies the material priority of the support.

Oasis, from 1952 (pl. VIII), offers a similar strategy of discombobula-
tion. This time, however, Nay does not rely on lines to convey an
undisciplined gesture, but on the riven abundance of paint-saturated
shapes. In this work he is again risking *Figurine*'s relative closure and
stylistic safety, present in most of his works of 1950 and 1951. The
roughness, the dissolution of forms, and a further disintegration of
the figure are similar to *In Black Bars*, but *Oasis* offers even less legi-
bility in terms of deciphering those shapes that signify "figure." Note
the difference between *Figurine*, where circles, heart shapes, and
elongations can all signify breasts, umbilici, buttocks, and limbs, and

Oasis, where the impossibility of creating identity between desire and representation is the painting's keynote.

This kind of work, in its working of a subject-object dynamic, kept alive an expressive potential that was increasingly stifled in the postwar framework of reception. Which is not to say that Nay was therefore unpopular or unsuccessful with the new postwar modern art patron class; quite the contrary: he was bought and honoured.

Yet the differences in abstract art are nonetheless profound. As Adorno's critique in *Negative Dialektik* showed, "identity" is an idealistic wish-fulfilment, since thought itself is different from the one who thinks it.[68] In the insistence on this postulate lies a recognition of the impossibility of identity in art—an insistence on difference—based on a recognition of the somatic aspects, those unreconciled, non-identical elements, that expression belabors. With the grip "absolute" abstraction had on the postwar scene, however, work such as Nay's was not seen as expressive, even though non-identity and the somatic or creaturely was always the subtext of and resistance in his work. Very few painters tried to keep alive a relationship to these unreconciled, non-identical elements that resist formulation as well as to the modernist tradition—tradition of course is also an objective resistance to subjective willing.[69] Nay consistently incorporated this aspect of tradition: his work, for example, refers in complex and varied ways to Cubism and Picasso's painting, particularly the Picasso of the interwar period. "Absolute" abstraction appears bereft of any such referents. With "absolute" abstraction's grip, the somatic (and material) unreconciled aspects could only become manifest in tachist or *art informel* painting, but this style of painting in turn was cut off from tradition. It is this lack of an articulated relationship to tradition that makes tachism ultimately an extreme form of Romanticism.

Another difference between "absolute" abstraction, Nay's work, and tachism is their use of rhetoric. In Adorno's analysis, rhetoric is the inextinguishable sign of language, or rather philosophy's reminder that its form, its material, is language (despite philosophy's claim to *logos*, *Geist*, or transparency):

> In its dependence—patent or latent—on texts, philosophy admits its linguistic nature which the ideal of the method leads it to deny in vain. Like tradition, this nature has been tabooed in recent philosophical history, as rhetoric.[70]

In "absolute" abstraction, the rhetorical moment is ignored or denied in favor of an idealism based on a supposed transcendence of the

facticity of language as form. As in philosophy, the claim is then on a "pure language" based on the absolute identity between, to use familiar terms, signifier and signified, versus a recognition of the difference between the two. The more the cognized is reduced to and functionalized into a product of cognition by the cognizing subject, the more the thinking subject appropriates the independent life of the cognized object. Notions of "pure language" claim an immediacy that does not exist in language—and thus, whether cloaked as "metaphysical transcendence" or "unfettered spontaneity," represent an extreme subjectivism. "Absolute" abstraction wants to absent itself from the subject-object dichotomy; it seeks safety in the realm of *Geist*—and like all idealisms it remains subjective, despite its extirpation of expression.

In western philosophy, rhetoric, reduced to a means or an effect, has been degraded as the carrier of lies,[71] not truth. But the "rhetorical moment," according to Adorno, is one in which expression redeems itself so as to continue existing in thought/philosophy: "In philosophy, rhetoric represents that which cannot be thought except in language."[72] This is a moment of melding, however, not one of unbridled claims on the part of rhetoric: "It [rhetoric] asserts itself in the postulates of representation"—the new formal devices or strategies, so to speak—"through which philosophy differentiates itself from communication."[73] And: "The fact that all approved traditional philosophy from Plato down to the semanticists has been allergic to expression, this fact accords with a propensity of all Enlightenment: to punish undisciplined gestures. It is a basic trait extending all the way to logic, a defense mechanism of the materialized [in original: reified] consciousness."[74] The dialectics proposed by Adorno, on the other hand, "would be the attempt critically to rescue the rhetorical moment: to bring thing and expression into mutual proximity, to the point of non-difference."[75]

Nay's work never jettisons the objective laws of the medium—or tradition. Neither, however, is the rhetorical moment—expression, "the undisciplinedness of mimic action"[76]—ever snuffed out. The work is often uneven, sometimes too rhetorical (as in the self-degrading returns to "ugly" forms),[77] sometimes too philosophical (as in the smooth harmonies of the "disc" pictures from 1954–1962 [fig. 22]): not every work is a dialectical masterpiece! But efforts in this direction are made consistently. This sets Nay's work apart from that of most practitioners of tachism or *art informel*, where the rhetorical

element is marshalled as an attack on the traditions of painting, some-thing perhaps most poignantly noticeable in the work of Wols. Nay's work was generally not perceived, however, by publics or critics as significantly differentiating itself from "pure" or "absolute" abstrac-tion of West German modernism, and its relation—or difference from—*art informel* was also not clearly perceived.

By 1952, the year of heated debates on German re-armament, at least one critic did remark in a charged way on Nay's distinctive style. The distinction is not drawn between German abstractions, however; it is drawn "nationally," between "Germanic" and "Romance" styles:

> As much as Nay's pictures belong, in terms of their stature, to Eu-ropean modernism, they just as much differentiate themselves from the pictures of important painters of Romance origins, for example from Magnelli and Soulage. Nay fills his pictures right up to the edges, as if only the activity of his forms and colors actually brought about the existence of the picture surface. From this derives the amplified, in-tense, and expressive quality of his pictures: all traits apparently indic-ative of specifically German, north European characteristics.
>
> If it is possible to differentiate between German and Romance heri-tage in abstract painting, one is tempted to interpret this continuity [of being able to "type" art] as proof of the originality and appropriateness of modern art; and at the same time to interpret it as indicative that the European community, at least in this respect, is more intact than we generally tend to believe.[78]

The most striking aspects of this commentary are the writer's attempt to place Nay in a German tradition; to analyze his art as being differ-ent from "Romance" tradition; to ignore differences between "Ger-man" artists such as Nay and the other abstractionists; and finally to make national differences a productive sign of the health of the Eu-ropean mosaic. But while this should have been an interesting start for a public discussion of abstract art, the article seemed to produce no resonance. And while the eventual reception of French *art informel* might be seen as a necessary corrective to the monolithic view of Ger-man abstraction, the above-quoted article is prescient in discussing differences between national styles, but not the differences between domestic ones.[79] Perhaps this was due to the fact that, like Heideg-gerian ontology and French existentialism, "absolute" abstraction and *art informel* were in many ways two sides of the same idealist coin.

As the example of Edwin Redslob's career, described at the outset of this chapter, helps demonstrate, positive aspects of American ideology

—individualism versus collectivism, pragmatism versus impracticality—were disseminated in a climate of restoration in Germany that tended to stifle any signs of dissent or rupture. Redslob's career, which was remarkable primarily for its typicality, traded on the affinity between Nazi anti-communism and Cold War anti-communism—both of which were saturated with the deep-seated anti-Eastern European prejudice of a traditionally dominant Western Europe. The American ideology of "can-do" optimism helped renovate the battered foundations of Western European dominance, and, as a manifestation of subjectivism over objectively existing obstacles, it proved beneficial to the different forms of European, specifically German, idealist subjectivisms. The latter occurs in a pronounced form in ontological metaphysics: the "boastful affirmation of the way it is,"[80] which, far from being a just consideration of objective reality, is the blind and undialectical display of subjective will. Metaphysics is, and this is the vexing paradox, as subjective as is a one-sided emphasis on rhetoric—on gesture, "pure" expression—in painting: in both instances, the rights of that against which the subjective will is asserting itself are subsumed to the demands of the artist's agenda, and an illusion of plenitude and identity (versus lack) takes form. Pragmatism is no guarantee of registering the full spectrum of subject-object relations, nor is a positive optimism or a lugubrious ontology: they remain mired in idealism.

The subjectivism of ontology, often misrecognized as objectivity, is of course inimical to expression.[81] It is an extreme subjectivism that denies the corrosive aspect of expression that serves to recall *Geist's* ties to the body and man's dependence on nature—versus his "successful" dominance over it. By itself, however, the gestural remains impoverished and without relation to its Other, which in painting would be form; we see that Nay's expressed desire for a synthesis between "vitalism" and "form" refers to this problem. The purely rhetorical strategy of *art informel* was initially rejected on the German scene, I would argue, because after twelve years of Nazi order, culminating in unprecedented social chaos by 1944/45, postwar Germany in the late 1940s and 1950s was characterized by the search for compelling restraints. In art, communist critics sought restraints such as "realism" and "social engagement." The absolute abstractionists sought restraints in metaphysics. In both instances, the subjective desire for dominance over, and freedom from, that which stubbornly refuses assimilation to the subject's will—namely the creaturely, na-

ture, Otherness—extinguishes a dialectical relationship with objective reality. Nay in many ways differs from all of the above.

Finally, of great importance in the American ideology was its promise of social management of violence. Individualism and a variant of liberalism that promised, optimistically, that violence need never be anything but a repressed, unseen factor in social life, were the ideologically compelling offerings of postwar American influence in Germany. It was a compelling mix because it seemed the most reasonable, particularly to a middle class in the process of reconstituting itself. But it had an ennervating effect on the already precarious situation of expression in art, contributing to a restriction of the disharmonious, the somatic, and the disruptive. The pervasive desire for a smooth continuum and the abhorrence of rupture contributed to paving over important differences in art. These were differences that existed not just between "realist" (often socially engaged) art and "abstraction," but also beween the different kinds of abstraction—whether "absolute," tachist, or the protean changes plotted by E. W. Nay.

NOTES

INTRODUCTION

1. This inability to differentiate tends to dominate the literature to this day: researchers look for the common, unifying links, rather than the differences. This is in part determined by the overriding perception that the key postwar art struggle was realism versus abstraction. Thus, all abstraction is arrayed on one side, all realism on the other. Often this is then divided along state lines, with West Germany garnering all the (presumably unified) abstractionists, while East Germany has only realists. See for example Karin Thomas, *Zweimal deutsche Kunst nach 1945: 40 Jahre Nähe und Ferne* (Cologne: DuMont Dokumente, 1985). See also Jost Hermand, "Modernism Restored: West German Painting in the 1950s," *New German Critique* 11 (spring/summer 1984): 23–41.

Other approaches seek to identify a common "theme," such as the return to classicism or the exploitation of primitivism, as the unifying link that explains all postwar art; see for example Klaus Herding, "Humanismus und Primitivismus; Probleme früher Nachkriegskunst in Deutschland," *Jahrbuch des Kunsthistorischen Instituts* 4 (1989).

2. The resonance of this phrase—in German *Menschenbild*—will be discussed in detail in chapter 1. In 1950, the city of Darmstadt hosted a symposium on the subject, "Das Menschenbild in unserer Zeit."

3. See Jochen Poetter, ed., *ZEN 49; Die ersten zehn Jahre—Orientierungen*, Baden-Baden, Staatliche Kunsthalle, 6 December 1986—15 February 1987 for an overview of this group.

4. See Stuttgart, Will Grohmann Archiv, letter from Grohmann to Martin Heidegger, dated 25 January 1966.

5. Founding members were the painters Willi Baumeister, Rolf Cavael, Gerhard Fietz, Rupprecht Geiger, Willy Hempel, and Fritz Winter, and—one of the few recognized women artists on the scene—the sculptor Brigitte Meier-Denninghoff. By the mid-1950s, the group included, among others: Max Ackermann, Hubert Berke, Julius Bissier, Fathwinter (Franz Alfred Theophil Winter), Karl Otto Götz, Otto Ritschl, Fred Thieler, Hann Trier, Theodor Werner, and Woty Werner.

6. He was persuaded to participate in only one of their group shows, as a guest, at the relatively late date of 1955.

7. This was not only the opinion of the Allied forces, in particular of the Americans who instituted de-Nazification and re-education, but also of older Germans themselves. Many postwar editorials and articles in the popular press addressed this topic; see for example B. R., "Deutschlands verstummen," *Die Gegenwart* 1, Nr.4/5 (1946):7–9; Bert Brecht, "Die Jugend und das Dritte Reich," *Die Fähre* 2, Nr.3 (1947):138; Adolf Grimme, "Jugend und Demokratie," *Die Sammlung* 1 (1945/46):411–21; Werner Krauss, "Über den Zu-

stand unserer Sprache," *Die Gegenwart* 2, Nr.2/3 (1947):29–32; Hermann Nohl, "Die Erziehung in der Kulturkrise," *Die Sammlung* 3 (1948):645–52; Hannah Vogt, "Zum Problem der deutschen Jugend," *Die Sammlung* 1 (1945/46):592–600. The magazine *Frankfurter Hefte* also frequently addressed this problem.

8. See Fritz Winter, quoted in Poetter, *ZEN49*, 275.

9. Rupprecht Geiger, quoted in *ibid.*, 258.

10. Gerhard Fietz, quoted in *ibid.*, 252.

11. Rolf Cavael, quoted in *ibid.*, 248.

12. The archives I consulted included the Archiv für Bildende Kunst in Nürnberg (for files on E. W. Nay, Georg Meistermann, Otto Dix, Werner Heldt, Kurt Martin, Edwin Redslob, and Franz Roh); the Will Grohmann Archiv in the Staatsgalerie, Stuttgart; the Haus am Waldsee archive in Berlin; the Berlin Landesarchiv; the Bundesarchiv in Koblenz; and the Office of Military Government for Germany, United States (OMGUS) files in the National Archives, Washington, D.C.

13. In this vein, I also cite as formative for my approach the essays by Max Horkheimer, written in the early 1940s and published in the Frankfurt School's journal, *Studies in Philosophy and Social Science*. See Max Horkheimer, "Art and Mass Culture" and "The End of Reason," in *Studies in Philosophy and Social Science* 9 (1941): 290–304 and 366–88. The 1941 volume was the final volume, and the only one published in English; previous volumes, already produced in New York exile, were still primarily in German.

14. This was first published in German in 1969, in a volume of Adorno's writings entitled *Stichworte*; it is available in English translation in *The Essential Frankfurt School Reader*, ed. Andrew Arato and Eike Gerhardt (New York: Urizen Books, 1978), 497–511.

15. Theodor W. Adorno, *Negative Dialektik* (Frankfurt: Suhrkamp Verlag, 1966). I use the suhrkamp taschenbuch wissenschaft (paperback) edition of 1975. *Negative Dialektik* is available in English translation: *Negative Dialectics*, trans. E.B. Ashton (New York: The Continuum Publishing Company, 1990). A caveat to the English reader: the translation of *Dialektik der Aufklärung* is inadequate, but the translation of *Negative Dialektik* is quite good.

16. See for example George J. Eliasberg, "Marx und die totalitäre Idee," *Amerikanische Rundschau* 4, Nr.18 (1948): 91–100.

17. There are relatively few secondary sources in art history, particularly in English; beyond my field, in history, there are many studies of this period. I refer the reader to the bibliography.

CHAPTER I

1. The painting is in the private collection of Sophie Franke in Munich; Franke is the widow of the art dealer Günther Franke, whom Nay met in 1931 and who showed Nay's newest works annually beginning in 1946. *Sibylle* was

first shown by Franke in 1946, and subsequently in Hannover (1950), Freiburg (1953), Düsseldorf (1959), and throughout the 1960s in German, Swiss, and Austrian cities. It is reproduced in *50 Jahre Galerie Günther Franke; Nay; Bilder Aquarelle Gouachen Zeichnungen: Graphik aus Sammlung und Galerie Günther Franke* (Munich: Verlag Günther Franke, 1973) and in *E. W. Nay; A Retrospective*, Museum Ludwig and Josef-Haubrich-Kunsthalle (Cologne, 1990).

2. Several excellent studies on this subject exist, most of which center on the canonical figures of French nineteenth-century painting, in particular, Courbet and Manet. See T. J. Clark, *Image of the People; Gustave Courbet and the 1848 Revolution* (London: Thames and Hudson Ltd., 1973); idem, *The Absolute Bourgeois; Artists and Politics in France 1848–1851* (London: Thames and Hudson, 1973); idem, *The Painting of Modern Life; Paris in the Art of Manet and His Followers* (New York: Alfred A. Knopf, 1985); *Courbet Reconsidered*, Brooklyn Museum (1988), particular the essay by Michael Fried.

3. The literature on Expressionism is vast, albeit uneven. Several recent English-language publications tackle the issue: Donald E. Gordon, *Expressionism: Art and Idea* (New Haven and London: Yale University Press, 1987); Stephen Eric Bronner and Douglas Kellner, eds., *Passion and Rebellion: The Expressionist Heritage* (New York: Columbia University Press, 1988); Joan Weinstein, *The End of Expressionism: Art and the November Revolution in Germany, 1918–19* (Chicago and London: University of Chicago Press, 1990). A superb study of German Expressionist prints can be found in *German Expressionist Prints from the Collection of Ruth and Jacob Kainen*, Washington, National Gallery, 22 September 1985—9 February 1986 (1985). For a particular social context, see also Yule F. Heibel, " 'They Danced on Volcanoes': Kandinsky's Breakthrough to Abstraction, the German Avant-Garde and the Eve of the First World War," *Art History* 12, no.3 (September 1989):342–61.

4. As perusal of Nay's papers and letters in the Archiv für Bildende Kunst in the Germanisches Nationalmuseum, Nürnberg, shows, Nay assiduously avoided—and in fact resented—academic titles. If someone addressed him as "Herr Professor," hoping that this would flatter the painter, he or she instead provoked Nay's wrath. He prided himself on avoiding all titles as well as membership in professional organizations.

5. Nay attended the Gymnasium at Schulpforta in Thuringia. See Nürnberg, Archiv für Bildende Kunst am Germanischen Nationalmuseum, *E. W. Nay; Bilder und Dokumente* (Munich: Prestel-Verlag, 1980) for much published documentation on the painter.

6. Ibid., 53.

7. Ibid.

8. See ibid., 53–71, for an overview of the period 1925–1936/38. In 1925 Nay gained access, through Carl Hofer, to the Berlin Art Academy, where he stayed until 1928. Around 1932 he briefly painted in a surrealist manner, which, a propos of his painting *Muschel und Fisch* (1932), he commented on as follows in 1958: "There is the bright, masculine world, there the dark, femi-

nine. A horizontal line in the picture's middle, white above, made palpable in the material—black below. Down there swims a fish (penis) without a head!—vertically a brown conch-form—vagina—above, a diagonal bar—penis—with it a spiral conch-vagina, meaning: definition of the masculine universal world and the possibility (diagonal-spiral) to unite with one another. Cute, that the man-fish hasn't got a head!!! Irony still has its place, the city-dweller expresses himself nevertheless—still!" (Ibid., 58, including illustration of *Muschel und Fisch*.)

By 1936 Nay was frequently called to the National Socialist Reichskulturkammer and asked if he had co-ordinated his painting yet; which he had not. As a result, he was forbidden to exhibit and was designated a "degenerate artist," which entailed considerable financial hardship.

9. Ibid., 65–71 in particular, for a detailed discussion of this visit to Norway and the work produced there.

10. Ibid., 78–87, for Hans Lühdorf's account of his meeting with Nay. Lühdorf, trained in law, came into contact with Nay's pictures in 1939 (at the collector Carl Hagemann's house in Frankfurt). Around December 1941, Lühdorf, himself in the German Wehrmacht, tried to convince Nay's superiors to transfer him to a posting that would allow him time to paint (albeit secretly, since he was still "degenerate"). Lühdorf's 1941 petitions were to no avail, but a string of coincidences did bring about Nay's transfer after all: in early 1942, Lühdorf's group lost its cartographer; needing a new one, Lühdorf suggested Nay. The suggestion was accepted, and Nay transferred to Le Mans just as his division was about to be transferred to the Russian front.

11. Ibid. Once in Le Mans, and through Lühdorf's contacts, Nay met a French amateur sculptor, Pierre Térouanne, who lent him the use of his atelier; he also came into contact with the local antiquities dealer and rare book seller. All of these individuals seem to have been eager to support Nay's secret painting activity. In 1943 Ernst Jünger, the controversial author, came to Le Mans to visit Nay.

12. Ibid., 83, letter from Nay to Günther Franke, 17 August 1943, which expresses this elitism and contempt for totalitarian collectivization: "All concerned are aware and conscious that, to the degree that the disappearance of individualism [*Vermassung*, literally: "massification"] increases, the importance of the smallest spiritual cells also is amplified. And it is in this way that our circle here is understood by its members." Note the use of the word "*Vermassung*," a key term in the postwar era to designate both Nazism and Soviet-style Communism; note as well the suggestion of a secret coterie, a select avant-garde, that actually grows in significance the more the rest of the world degenerates.

13. Set free in May 1945, Nay arrived in Hofheim near Frankfurt, where he was acquainted with Hanna Bekker vom Rath, an art collector and dealer. She provided him a small studio in which he worked and lived.

14. *E. W. Nay: Bilder und Dokumente*, 90.

15. Ibid. Erich Meyer (1897–1967) was director of the Museum for Arts and Crafts in Hamburg from 1947–1962. During the Nazi period, he and Nay met in Berlin through Carl-Georg Heise, director of the Lübeck Museum until 1933, then director of the Hamburg Kunsthalle from 1945–1955. Meyer bought Nay's work and became an avid collector of his art.

16. Ibid., 87.

17. The "Lofoten" series, discussed in *E. W. Nay: Bilder und Dokumente*, 65–71, in many ways established Nay's early reputation.

18. See Terry Smith, "A State of Seeing, Unsighted: Notes on the Visual in Nazi War Culture," *Block* 12 (winter 1986/87):50–70, as well as Susan Buck-Morss, "Aesthetics and Anaesthetics: Walter Benjamin's Artwork Essay Reconsidered," *October* 62 (fall 1992):3–41. Buck-Morss' article in this issue of *October* is immediately followed by Brigitte Werneburg's "Ernst Jünger and the Transformed World," 43–64, an analysis of the writer's extremist—and rightwing—philosophy of brinkmanship, his attempt to theorize danger, not security, as the essential component of modern human life, and his desire to radicalize perception in accordance with these views. Nay admired Jünger, yet clearly, as Wernerburg's article makes clear, Jünger's ideas would have been precisely the sort viewed with suspicion if not outright fear in the years after World War II.

19. The symposium, which was accompanied by an exhibition of contemporary art, was held from 15 to 17 July 1950 at the Stadthalle in Darmstadt. The speakers included Johannes Itten, Hans Sedlmayr, Alfred Weber, Alexander Mitscherlisch, Willi Baumeister, and others. Aside from posing the problem of the "image of man" in such programmatic terms, and subsequently drawing a great deal of professional and general interest, the conference was not marked by any outstanding theoretical discussions, with the exception of Hans Seldmayr's contribution, which was extremely conservative and reactionary, but which put its finger directly on the problem of cultural dissolution and bankruptcy, and the audience response of Theodor Adorno. The entire proceedings are published in Hans Gerhard Evers, ed., *Darmstädter Gespräch; Das Menschenbild in unserer Zeit* (Darmstadt: Neue Darmstädter Verlagsanstalt GmbH [1950]).

20. The genesis of National Socialism and its rise to power was the subject of an extremely interesting and well-organized exhibition and symposium, "Konzentrationslager Buchenwald," at the Martin-Gropius-Bau in Berlin, 10 April through 4 June 1990. The exhibition was preceded by several excellent publications, including *Topographie des Terrors*, edited by Reinhard Rürup, professor of history at the Technische Universität, Berlin. The discussion series, which lasted from 25 April to 23 May 1990, included historians from both East and West Germany specializing in this period: Hans Mommsen, Manfred Weissbecker, Ulrich Herbert, Kurt Pätzold, Klaus Drobisch, Eberhard Kolb, Kurt Finker, Peter Steinbach, Rolf Badstübner, Wolfgang Benz, Wolfgang

Meinicke, and Lutz Niethammer. The five discussion evenings were chaired by Reinhard Rürup.

One of the things the exhibition made clear was the extent to which National Socialism was the business of young men; few were born in the nineteenth century, most of the high-ranking leadership was born in the twentieth century, making them in their twenties and early thirties at the start of the regime. In contrast, Social Democratic and Communist leadership was considerably older, indeed part of the establishment. It seems clear that the National Socialist movement was thus capable of capturing the anti-traditional and radical enthusiasm of otherwise disaffected Weimar youth.

21. The Nazis also used brute force to ensure compliance with the new rules of conduct. The system of concentration and death camps exemplifies this well. As discussed by scholars from both former East and West Germany at the "Konzentrationslager Buchenwald" symposium, 9 May 1990 in Berlin, the camp system was the mainstay of Nazi power. Symposium participants Klaus Drobisch and Eberhard Kolb elaborated the following: the first concentration camp was not at Dachau, but at Nohra, west of Weimar, and the pupils of the Führerschule (a Hitler-Youth school) were its first guards; a total of 19 camps already existed prior to Dachau. From 1933–34, the concentration camp system was established, and from 1934–36, the SS took over its perfection. The period from 1936–39 was essentially one of preparing for war (1939–42 is but an extension). In 1942–44, death camps were instituted and mass murder began taking place on an industrial scale; from 1944–45 there was a period of chaos, evacuation, and "final solution."

The concentration camps (or "KZ"s) were the Nazis' most significant means of power over the citizenry. The basic right of sovereignty of the person had been abolished at the start of the Nazi regime, which meant among other things that individuals could be arrested and held without charge or trial for an indefinite period of time (the so-called *Schutzhaft*). The KZs initially were filled with "political prisoners," i.e., opponents of the Nazi regime. By March/April 1933 there were between 46,000 to 49,000 prisoners in KZs; by 1936 the number was up to over 100,000. At the beginning, all the KZs were manned at least in part by local police, and were financed by state money. Around 1935, a new type of KZ was developed, one that was expandable; this is explained by the increasing mobilization for war: while the Nazis had extensive lists of potential oppositionists to their regime, not all of them had yet been locked up, but with the outbreak of war, the people on these lists could immediately be rounded up and shipped to the new, expandable camps (Sachsenhausen was one of the first examples). Between 1936–39 there was also an upswing of camp construction on the Eastern border, in preparation for imperialist expansion. By 1937–38, the so-called "asocials" (homosexuals, prostitutes, etc.) were locked up, and by 1938–39, KZ inmates were used for industrial labor. Every major capitalist business in Germany employed slave

labor from the KZs, and continued to do so through 1944. Mass murder started around 1938–39.

The KZs were never meant to be temporary; they were the Nazis' best way of disabling opponents via the "administrative route." They imply a fundamental systematic and structural change from anything that existed previously; their potential for intimidation initially depended on their ubiquity coupled with their invisibility—not until 1942, when KZ inmates were used on a massive scale for slave labor (by which time they were primarily foreigners), did the inmates become visible to the general populace. But everyone knew about the KZs—which, however, were initially different from death camps: a concentration camp is not a death camp, even though in the second half of 1942 alone, for example, c. 57,000 of 100,000 KZ inmates died due to overwork and malnutrition. By the end of the war, 18 million persons were imprisoned in concentration and death camps, and c. 11–12 million persons had perished in concentration and death camps (including the "inmates" of enforced ghettos). These are estimates, as it is practically impossible to ascertain exact numbers. Also, by war's end, c. 90 percent of inmates were foreigners.

A brief note on postwar camp historiography: according to Drobisch and Kolb, the topic was taboo, especially in the West, from 1945 into the 1960s. In May 1945, Bergen-Belsen was razed by the British (due to plague fears). Almost all other camps were maintained, at least initially; Dachau was used as a refugee camp, until the 1960s, when it was razed (and was later rebuilt as an example of a death camp, which it never in reality was, thus feeding neo-Nazi charges that the death camps are merely an "invention"). Only around 1955 did camp survivors begin calling for a remembrance of the sites. In the 1970s and 1980s, a more persistent, constant interest developed.

22. Very few visual artists were émigrés. As for women artists, only a very small number were recognized or discussed in the press; the two most noteworthy are Hannah Höch, who had already established a reputation before the war, and the sculptor Brigitte Matschinsky-Denninghoff (alternately Meier-Denninghoff), who was the only woman to represent the younger postwar modernist generation.

23. See *Flugblätter des Nationalkomitees Freies Deutschland*, Berlin, Staatsbibliothek Preussischer Kulturbesitz, 29 September—2 November 1989 (1989). The National Komitee Freies Deutschland (NKFD) was a large group of high-ranking, generally ultra-conservative army officers who had turned against Hitler; with Soviet support, they were waging a propaganda war against the Nazi leadership from within Russia.

24. Ibid., 281–82.

25. Ibid., 282.

26. This aspect of "clichéd-ness," of pre-fabrication of human response, thought, emotion (a legacy of Nazi "co-ordination" or *Gleichschaltung*) is also

analyzed in a number of postwar magazine articles, notably by Werner Krauss, "Über den Zustand unserer Sprache," *Die Gegenwart* 2, nr.2/3 (1947): 29–32.

27. Walter Gropius, invited to visit Frankfurt on the Cultural Exchange Program in the summer of 1947, had a depressing assessment of this younger generation: "My impressions were devastating. For someone who has not seen the current realities in Germany, it is unimaginable how deeply, spiritually and physically, destruction has struck. I found it particularly difficult to put myself in a frame of mind that would enable me to say something encouraging and positive. My only hope I place in the spirit of the older generation that finished school before Hitler. The younger generation that grew up under Hitler is cynical, and relations with them are very difficult; the recommendations I made to General Clay reflected this." (Unfortunately, those recommendations were not accessible to me.) This passage is cited in Hermann Glaser, Lutz von Pufendorf, and Michael Schöneich, eds., *Soviel Anfang war nie; Deutsche Städte 1945–1949* (Berlin: Wolf Jobst Siedler Verlag GmbH, 1989), 221.

28. Thomas Mann, *Doktor Faustus*, first published in 1947. I am quoting from the English translation by H.T. Lowe-Porter (New York: Alfred A. Knopf, 1948), 481.

29. "Dies ist eure Schuld" in the sense also of "this is your sin." See Glaser *et al.*, eds., *Soviel Anfang war nie*, 311. This aspect of Allied attempts to deal with responsibility for the death camps was also treated in installations for the exhibition "Soviel Anfang war nie; Kultur aus Trümmern," at the Hamburger Bahnhof, Berlin, 13 October 1989—15 January 1990. This exhibition, accompanied by the above cited publication, was also the site of weekly films, discussions by *Zeitzeugen* (contemporaries of the Nazi and postwar period), and performances (music as well as poetry readings).

30. Ibid., treated as well in the exhibition. Another attempt that apparently failed to elicit the appropriate remorse was the screening, soon after the war ended, of the film "Die Todesmühlen," a frank and necessarily brutal depiction of the death camps.

31. This aspect was discussed from a conservative as well as a progressive point of view. Max Picard, taking the conservative position, found a great deal of resonance with his book *Hitler in uns Selbst*, which initially was published in 1946 and was in its third edition by 1949. See Max Picard, *Hitler in uns Selbst* (Erlenbach-Zürich: Eugen Rentsch Verlag, [1949]). In a related (conservative) vein, Hans Sedlmayr's *Verlust der Mitte; Die bildende Kunst des 19. und 20. Jahrhunderts als Symptom und Symbol der Zeit* (Salzburg: Otto Müller Verlag, 1948) stirred up a great deal of popular and critical response.

32. As I noted in the footnote on the system of concentration and death camps, by one estimate, c. 11 to 12 million people died in these camps during the course of the Nazi period.

33. This quote, dated 1944, was installed on a wall at the exhibition "Soviet Anfang war nie," Berlin, Hamburger Bahnhof, and was reprinted in a small brochure accompanying the exhibition.

34. Many journals existed only briefly, perhaps due in part to the 1948 currency reform's "pruning" of non-essential cultural services (i.e., with the currency reform, prices for magazines or for theater tickets once again became expensive, while simultaneously workers at magazines or actors in theaters were once again paid a living wage). The following is a short list of general interest magazines, as well as several specialized art journals: *Aussaat* (Stuttgart), 1946/47–1947/48; *Bildende Kunst* (Berlin [East]), 1947–1949; *Die Gegenwart* (Frankfurt), 1945/46–1958; *Geist und Tat* (Frankfurt), 1949–1971; *Kunstchronik* (Nürnberg), 1948–1985; *Das Kunstwerk* (Baden-Baden), 1946/47–present; *Die Fähre* (Munich), 1946–1947; *Neues Abendland* (Munich), 1946/47–1958; *Die Sammlung* (Göttingen), 1945/46–1960; *Der Ulenspiegel* (Berlin), 1945/46–1950. *Die Quelle* was the French-sponsored magazine (Konstanz, 1947–1948) and *Die Amerikanische Rundschau* its American counterpart (Munich), 1945–1949/50). In the US sector, applicants for newspaper licenses were screened primarily for their National Socialist or anti-National Socialist past. Only those who had never belonged to the National Socialist party and had, if possible, actively resisted Nazism were able to get a license. Licensing also usually went to a group of people, not single individuals. On the other hand, the Americans were the first to abolish censorship of the papers that were produced by their German licensees: from 4 September 1945 on, production of newspapers and their content was in German hands in the US sector. The Americans felt able to do this in part due to rigorous pre-licensing screening; they set up "screening centers" where applicants had to submit to IQ tests and Rorschach tests, had to partake in discussions, and were psychiatrically evaluated. As a result of these procedures, professionals were often disqualified and approximately one fourth of all licensees were without any previous journalistic experience. The Americans also insisted on "objective" news reporting, i.e., news and commentary were henceforth to be strictly and rigorously separated. (The British, on the other hand, allowed their combination.) The French situation was different: they arrived on the scene after the Americans had already established their policies in the regions they had liberated, and the French took over from there. They also hoped to ameliorate the Germans' resentment over the partition of their country, which was in France's interest, by offering them re-entry into a "community" of nations: the idea was to influence public opinion. As for licenses, these were usually (in contrast to US policy) given to a single individual, and the criteria rested with the local French official (i.e., the applicant's past did not play as significant a role with the French). The French could afford this in part because they maintained strict censorship of all publications until the end of 1946. See Glaser et al., eds., "Soviel Anfang war nie," 272–74.

35. Cited above.

36. I am thinking particularly of Max Horkheimer's, Theodor Adorno's, and other Frankfurt School members' writings in their journal, *Studies in Philosophy and Social Science*, particularly volume 9 (1941).

"Co-ordination"—*Gleichschaltung*—is a highly resonant Nazi slogan which refers to the practical and philosophical eliminaton of difference and opposition.

37. Picard, *Hitler in uns Selbst*, 58.

38. Ibid., 61.

39. Theodor W. Adorno, *Negative Dialektik*, 5th ed. (Frankfurt: Suhrkamp, 1988), 54. The book was first published by Suhrkamp in 1966. *Negative Dialectics*, trans. E. B. Ashton (New York: The Continuum Publishing Company, 1990), 44.

40. Ibid., 54–55; Ashton, trans., *Negative Dialectics*, 44–45.

41. This conception of quality has nothing whatsoever to do with "standards" or with the demand for "quality" coming from the New Right.

42. Juliane Bartsch, "Konstanz; Kunstwoche 1946," *Aussaat* 1, nr.4 (1946): 33; Juliane Bartsch, a young art historian, married Franz Roh, one of the older generation modernist critics, who along with Will Grohmann constituted the established modernist continuity in postwar Germany.

43. See bibliography for full references to articles by Ernst Cassirer, Hans Hennecke, Ulrich Klug, Werner Kraft, Werner Krauss, Dr. Hanns Mayer, Johann Wilhelm Naumann, Friedrich Sieburg, th., Carl August Weber, Dr. Friedrich Zoepfl.

44. One of the most striking examples of this is Theodor Adorno and Hans Sedlmayr at the "Darmstädter Gespräch" in 1950; see Evers, *Darmstädter Gespräch*, 215, for Adorno's comment on Franz Roh's attempt to seek "harmony" in art, as well as Roh's thesis that great art always leaps ahead of audience comprehension and is only understood by subsequent generations: "I find myself in a rather curious position in this discussion. I identify, as I probably need not point out, with the cause of modern art in its extreme form. But I have the feeling that in this discussion the modern artists somewhat damage their own cause, that they proceed apologetically. The basic tenor is that things aren't actually so bad. In this way art makes itself harmless. Compared to this, the Sedlmayrian thesis—and Herr Sedlmayr has himself stressed that our positions are as such diametrically opposed—that the element of negativity is intrinsic to modern art, seems to me to contain something true. We shouldn't be content—and here I differ from Herr Roh—to say: just give us enough time, and then it will become apparent that we, too, are Raphaels and Beethovens and all that. That's not what we are, that's not what we can be, and it's not even what we want to be [audience applause], because the idea of authenticity, which they incarnate, has become problematic."

45. Ernst Cassirer, "Der Mythos als politische Waffe," *Amerikanische Rundschau* 3, nr.11 (1947): 30–41.

46. Ibid., 32.

47. Ibid., 32–33.

48. Ibid., 33.

49. Ibid., 33–34.

50. Ibid., 34–35.

51. The files for OMGUS, now declassified, are in the National Archives, Washington, D.C., branch location Suitland, Maryland. The Bundesarchiv, Koblenz, Germany, has microfiched a portion of the National Archives' holdings, and has also compiled an overview.

52. National Archives, OMGUS ECR Div., miscellaneous papers (official), file #5 299 2 (38).

53. Ibid.

54. Insofar as this whole issue is still unresolved and unstable, the teaching of German history—i.e., how it is taught and transmitted in Germany—still remains a volatile issue in that country.

55. In general, art, versus literature or theater, was very low on the priorities list of most magazines.

56. H.E.F. [Hans Eberhard Friedrich], "Die künstlerische Fragestellung der Gegenwart," *Prisma* 1, nr.10 (1947): 18.

57. *La peinture française moderne*, Berlin, Königliches Schloss, 22 October–6 November 1946 (1946), n.p.

58. See Evers, *Darmstädter Gespräch*, 215–16, for Adorno's comments on the question of harmony and tradition: "Herr Roh a moment ago objected that I had neglected the moment of harmony in the new art and the new music. Well, in a formal sense it is certainly correct that every late quartet by Schönberg and every picture by Picasso is in itself as meaningfully organized, that every part is in the same sense a function of the whole and vice versa, as it has been the case in traditional art. Understood in this way, the concept of harmony doubtlessly signifies something generally valid. But I believe that, should we proceed too hastily to this level, we will as it were neglect that characteristic moment of negativity. As much as I object to the cultural pessimism Sedlmayr brings to bear, he does on this point quite correctly define something otherwise neglected by a too unbroken and naive belief in progress. Speaking dialectically, I would say that the harmony of an artwork consists in its bringing the riven, itself unreconciled, to unmisplaced expression, and that it withstand the riven. And that in this standing-up-to, in this finding-words-for that which is otherwise without words, lies the sole element of reconciliation; while every attempt, say in reference to the idea of the cosmic, to enforce this harmony immediately in modern art ends, after all, by making us ashamed of our own exposure [self-exposure in art], and thus in this way makes us want to build the bridge to the past which it now is imperative to burn. That is, I think that the statements by the esteemed Herr Roh should be reflected and sharpened in just this sense, that one shouldn't sim-

ply deny those moments Sedlmayr has broached, but rather that we incorporate them into the consciousness of our own art. We shouldn't deny them by constructing against them the ideal of an immediate, positive, cosmic, and harmonious art, but rather actually should see the positivity in this negativity. I believe that every artist who has seriously worked on [his] material knows that when he operates with dissonances, these dissonances don't just appear as a nice euphony. But they also don't just appear as a mirror of how hideous our world is. Both theses are in their limitedness wrong. A very peculiar relationship, which one should want to describe very subtly and very precisely, is to be found here: a being-pulled-into, a peculiar attraction that emanates precisely from those non-harmonious elements, a being-enticed-by-adventure, by the not-yet-experienced. But at the same time a willingness to stand up to suffering by helping it to adopt a sign. Only if one—to distil from Herr Evers's words—grasps the multiple resonances of modern art and if one perhaps articulates what actually all resonates in a dissonance, in a work of music, what all is there concentrated by way of initially unreconcilable historical experiences: only if one were capable of grasping all that in its rich entirety would one 'save' modern art without recurring to apologetics and without reducing it to harmlessness and bringing it to the same level of traditional art. This is exactly what we shouldn't do. If there is a preservation of tradition at all, a rescuing of tradition—I here cite Juan Gris *verbatim*—then it could only have its place where one no longer has anything directly to do with tradition, while everywhere in modern art where one does refer to tradition, precisely those moments that are salient to modern art are obscured and levelled to certain categories of timeless universal beauty that have become deeply suspect to us all [audience applause]."

59. E. W. Nay: *Bilder und Dokumente*, 88.

60. Ibid., 81, emphasis added.

61. Ibid., 79.

62. Ibid., 82. Ernst Jünger, an author Nay had read, visited the painter in LeMans, and clearly Nay's language in these passages reflects the "steely romanticism" of Jünger's rightwing radicalism. Nay's later observation that he "masked" himself to avoid becoming cynical might well be the legacy of his 1940s courtship of Jünger's philosophy. Politically, Nay, like his friend Adolf Arndt, was a Social Democrat. Philosophically, he was fascinated by Martin Heidegger. Elisabeth Nay-Scheibler, E. W. Nay's widow, told me that Adorno visited them in their Cologne home once, but the Nays found Adorno difficult, somewhat opaque and against the grain. Adorno for his part found Nay's work interesting and complex. See his comments in *Wird die moderne Kunst "gemanagt"?* (Baden-Baden: Agis-Verlag, 1959), 37–45.

63. E. W. Nay; *Bilder und Dokumente*, 80.

64. Ibid., 86.

65. Nay's postwar stylistic periods have been characterized by his widow

Elisabeth Nay-Scheibler and the staff that worked on the oeuvre catalog (1991) as follows: Hekate-pictures, 1945–48; Fugues, 1949–51; Rhythms, 1952–53; Discs, 1954–62; Eyes, 1963–64; Late Works, 1965–68.

66. See Nürnberg, Archiv für Bildende Kunst, file on E. W. Nay, letter from Erich Meyer to Nay, 17 February 1946; Meyer put quote marks around "peace" because inter-zonal travel was practically impossible. Meyer is speaking here as a personal friend using private correspondence. Nay's works were never discussed in these lively terms in any published criticism.

67. Ibid.

68. See Weinstein, *The End of Expressionism*.

69. Nürnberg, Archiv für Bildende Kunst.

70. See Nürnberg, Archiv für Bildende Kunst, E. W. Nay file, letter from Nay to Herr Voigt, dated 19 September 1948.

71. Nürnberg, Archiv für Bildende Kunst, clippings file, E. W. Nay.

72. Ottomar Domnick, *Die schöpferischen Kräfte in der abstrakten Malerei; Ein Zyklus* (Bergen: Müller & Kiepenheuer Verlag, 1947).

73. See Stuttgart, Will Grohmann Archiv, letter from Grohmann to Hans Hartung, dated 16 February 1949.

74. For extensive documentation on the genesis and development of ZEN49, see Baden-Baden, *ZEN49*.

75. Stuttgart, Will Grohmann Archiv (see n. 73 above); Grohmann wants to suggest that Domnick is just a dabbler, and that his interest in abstract art is fueled by pet theories about the unconscious.

76. The *Neue Zeitung* was a US-licensed newspaper; it seems likely that Grohmann got his first contact with it through the writer Erich Kästner, who in February 1946 was working for the Munich *Neue Zeitung*, while Grohmann was still living in Dresden (in the Soviet zone). Grohmann had written to Kästner on 19 January 1946 from Dresden, in response to one of Kästner's articles, and asked, among other things, if it would be possible to subscribe to the *Neue Zeitung* in Dresden. Kästner replied that this would not be possible as the paper could not be delivered in the Soviet zone. He however asked Grohmann to contribute an article on modern art to the paper, and this could have been the start of Grohmann's relationship with it. Grohmann moved to Berlin soon after. See Stuttgart, Will Grohmann Archiv, letter from Erich Kästner to Will Grohmann, dated 2 February 1946.

77. See Stuttgart, Will Grohmann Archiv, letters from Ottomar Domnick to Grohmann, dated 15 March and 6 October 1948.

78. Kurt Leonhard, "Abstrakte und Subjektive Franzosen in Stuttgart," *Das Kunstwerk* 3, nr.3 (1949): 54.

79. Ibid.; immediately after this passage, Leonhard proceeds to defend expression once more.

80. There is a significant disagreement between two camps of Adorno interpreters, which in turn also reflects two different views of interpreting mod-

ernism and modernity. On the one hand there is Jürgen Habermas' reading of Adorno, which attempts to delete from his thinking contradictory and paradoxical elements in the name of "rescuing" the project of rationality. Another Adorno student from the 1960s, Elisabeth Lenk, has received far less attention (particularly in the extremely patriarchal world of German scholarship), despite her perceptive reading of Adorno's theory. The feminine and the body, aspects that are usually denied in Habermas' readings, are given the significance they have in Adorno's work. Lenk is a professor in Hannover; she spoke at a symposium, "Die Neugier des Neuen; Das unerhört Moderne in der Musik, Prosa und Theorie Theodor W. Adornos," held at the Hochschule der Künste, Freie Universität, and the Literaturhaus, Berlin, 2–5 November 1989. Her paper was entitled "Adorno gegen seine Liebhaber verteidigt" (published in the *Tageszeitung* [Berlin], 3 January 1990). The emphasis was on the "unerhört Moderne," the radically new in Adorno's thinking: this of necessity constantly escapes the parameters set by modernity and modernism-as-classicism.

81. See for example Adorno, *Negative Dialektik*, 48–52, where Hegel's ideas on the subject-object relation are queried and critiqued, showing that Hegel's treatment of the subject was an apotheosis of *Geist* that also denies individual subjectivity ("Of course, all his statements to the contrary notwithstanding, Hegel left the subject's primacy over the object unchallenged. It is disguised merely by the semi-theological word 'spirit' with its indelible memories of individual subjectivity" [Ashton, trans., *Negative Dialectic*, 38]). At the same time: "In sharp contrast to the usual ideal of science, the objectivity of dialectical cognition needs not less subjectivity, but more. Philosophical experience withers otherwise" (Adorno, 50; Ashton, trans., 40). Which in turn brings us to the problem of communication—whether it will be "democratic" (mass-consumption oriented) or "elitist" (hermetic): "Direct communication to everyone is not a criterion of truth. We must resist the all but universal compulsion to confuse the communication of knowledge with knowledge itself, and to rate it higher, if possible—whereas at present each communicative step is falsifying truth and selling it out" (Adorno, 51–52; Ashton, trans., 41).

82. Ibid., 190: "Preponderance of the object is a thought of which any pretentious philosophy will be suspicious. Since Fichte, aversion to it has been institutionalized. Protestations to the contrary, reiterated and varied a thousandfold, seek to drown out the festering suspicion that heteronomy may be mightier than the autonomy of which Kant had already taught that it cannot be conquered by that superior power. [i.e., autonomy should not be conquerable by heteronomy] Such philosophical subjectivism is the ideological accompaniment of the emancipation of the bourgeois I. It furnishes reasons for that emancipation" (Ashton, trans., 189).

83. Ibid., 193; Ashton, trans., 192: "It is by passing to the object's prepon-

derance that dialectics is rendered materialistic. The object, the positive expression of non-identity, is a terminological mask. Once the object becomes an object of cognition, its physical side [*das Leibliche*, literally "the bodily"] is spiritualized from the outset by translation into epistemology, by a reduction of the sort which in the end, in general, was methodologically prescribed by the phenomenology of Husserl."

84. Ibid., 194; Ashton, trans., 193–94.

85. At least not a body worth having, judging by the derogatory designation of "vegetable" for someone who has lost mental control over his or her body.

86. Ibid.

87. Ibid., 227; Ashton, trans., 228. Ashton translates *das Hinzutretende* as "the addendum."

88. Ibid., 228; Ashton, trans., 229.

89. Ibid.

90. Ibid.

91. Ibid., 221 (Ashton, trans., 221–22); the idea of freedom itself derives, historically, out of impulses given to it by the bodily, by its appetites: "The dawning sense of freedom feeds upon the memory of the archaic impulse not yet steered by any solid I. The more the I curbs that impulse, the more chaotic and thus questionable will it find the pre-temporal freedom. Without an anamnesis of the untamed impulse that precedes the ego—an impulse later banished to the zone of unfree bondage to nature—it would be impossible to derive the idea of freedom, although that idea in turn ends up reinforcing the ego. In spontaneity, the philosophical concept that does most to exalt freedom as a mode of conduct above empirical existence, there resounds the echo of that by whose control and ultimate destruction the I of idealistic philosophy means to prove its freedom. Through an apologia for its perverted form, society encourages the individuals to hypostasize their individuality and thus their freedom."

92. Ibid., 240; Ashton, trans., 242.

93. Ibid., 240; Ashton, trans., 242.

94. Although both would resonate with similar themes (bankruptcy of reason, for example). There was also some mutual interest between Nay and Adorno; the latter on at least one public occasion expressed admiration for Nay's work (see note 62).

95. See in particular Heidegger's "The Age of the World Picture," in *The Question Concerning Technology and Other Essays*, trans. and intro. William Lovitt (New York and London: Garland Publishing, Inc., 1977). This essay was first given as a lecture in 1938 and published in 1952.

96. During my research at the Nürnberg, Archiv für Bildende Kunst, of the E. W. Nay and Otto Dix files, as well as during research at the Stuttgart, Will Grohmann Archiv, I came across references in the letters of E. W. Nay, Will

Grohmann, and Dix's biographer, Conzelmann, that indicate without any doubt that Heidegger's hold on the imagination of artists and writers as diverse as Nay and Dix (or Dix and Theodor Werner, another devotee of Heidegger, as Grohmann's letter indicates) and Grohmann and Conzelmann was deep and lasting. Nay wrote to Heidegger on 23 October 1963, apologizing for Günther Grass' attacks on the philosopher. Grohmann wrote to Heidegger on 25 January 1966 asking him to contribute a text to a publication honoring their "mutual friend," the painter Theodor Werner on his 80th birthday. Conzelmann wrote to Dix on 25 July 1952, inquiring about Dix's progress with the "Heidegger portrait" and informing him of a recent reading of the philosopher's work. Of interest is the lateness of interest in Heidegger on the part of Nay, Grohmann, et al., which does not preclude an earlier (1940s) interest, but which does speak of Heidegger's triumph (versus Adorno's) in postwar German philosophy in the 1950s and 1960s.

97. Adorno, *Negative Dialektik*, 86–87 (Ashton, trans. 79–80).

98. As Heidegger put it, the subject's willing is "for the purpose of gaining mastery over that which is as a whole." Heidegger, "The Age of the World Picture," 132.

99. Heidegger, "The Word of Nietzsche: 'God is Dead,'" based on lectures from 1936–40, presented 1943, published 1952, trans. Lovitt, *The Question Concerning Technology*, 58–59.

100. Quoted in Evers, *Darmstädt Gespräch*, 222.

101. Ibid., 223.

102. Heidegger, "The Word of Nietzsche," 71.

103. See for example Erwin Petermann, "Das war verfemte Kunst; IV. George Grosz," *Aussaat* 1, nr.4 (1946): 20–24.

104. See especially Martin Heidegger, "Brief über den 'Humanismus,'" in *Gesamtausgabe; Band 9: Wegmarken* (Frankfurt: Vittorio Klostermann, 1979).

CHAPTER II

1. Even Otto Dix, whose immediate post-World War I works might suggest specific political commitments, held himself aloof from all political parties in the postwar period. See Nürnberg, Archiv für Bildende Kunst. As late as November 1960, Dix's biographer, Conzelmann, was at pains to write to art critics who mistakenly labeled Dix a communist or a leftist, pointing out that Dix had *never* been a communist, and that it is even debatable whether one should call him a pacifist. It is of course also a measure of the German postwar paranoid attitude toward communism in general that such exchanges between Dix's supporters and his critics had to take place at all.

2. Werner Gilles, born 1894 in Rheydt, died 1961 in Essen. Publications on Gilles include the exhibition catalog *Werner Gilles 1894–1961—Ein Rückblick*, Bonn, Rheinisches Landesmuseum, 1973 (intro. Carl Linfert).

3. Werner Heldt, born 1904 in Berlin, died 1954 in Sant'Angelo on Ischia. A recent publication on Heldt is *Werner Heldt*, Nürnberg, Kunsthalle, 2 December 1989–11 February 1990, ed. by Lucius Grisebach.

4. Nürnberg, Archiv für Bildende Kunst, file on Werner Heldt, letter from Werner Gilles to Heldt, dated 13 June 1946.

5. Gilles' prewar work was not particularly remarkable. After the war, his work increasingly turned to pseudo-surrealist visions, a not unexpected development given the above description of his postwar life.

6. This is the only work I know of that has a direct reference to his homosexuality, except perhaps the very early "Das Klistier" (*The Enema*), where male interest in anal penetration is doubly disguised, first as medical genre, then, second, as heterosexual by using a woman as the "patient."

7. Michel Foucault, "Regieren—eine späte Erfindung," trans. Thierry Cherval, *Tageszeitung*, Berlin, 13 October 1989, 33–35, a translation of a lecture Foucault delivered at the College de France in 1978.

8. Ibid., 34–35.

9. This is from Adolf Hitler's *Mein Kampf*, reprinted in *1.9.39—Ein Versuch über den Umgang mit Erinnerung an den Zweiten Weltkrieg*, 4, a publication in conjunction with an exhibition at the Deutsches Historisches Museum, Berlin, 1 September—1 October 1989.

10. See ibid., Hitler's secret speech, 3 February 1933 (four days after being appointed Reich chancellor), to the commanders of the army and navy, which exposes his desire to circumvent any and all pacifist desires on the part of the German populace.

11. See *Flugblätter des Nationalkomitees Freies Deutschland*, Berlin, Staatsbibliothek, 305; as Ruth Andreas-Fischer put it in a diary entry, 26 June 1944: "That's the tragedy of our situation. When we speak, plan, attract confederates, we are hanged. For amidst ten, there'll be at least one who is treacherous or talkative. If we keep silent and only rebel within the quiet of our four walls, we keep the Nazis . . . For can a small group of ten or twenty resolute ones make the Third Reich totter? And we are only small groups . . . in Berlin . . . in Munich . . . in Breslau . . . who never consolidate."

12. See, for example, Peter Weiss, *Die Ästhetik des Widerstands*, 3 vols. (Frankfurt: Suhrkamp Verlag, 1983) for descriptions of the resistance's difficulties communicating with one another.

13. This was discussed in the previously cited discussion series, "Konzentrationslager Buchenwald; Vom Umgang mit einem Erbe: Der Nationalsozialismus in der deutschen Geschichte und Gegenwart," at the Martin-Gropius-Bau, Berlin, 25 April—23 May 1990, particularly the 9 May 1990 session with Klaus Drobisch and Eberhard Kolb on the system of concentration camps and the institution of the police state.

14. See *Flugblätter*, 118. Also of interest is the class resentment at work here: the Nazis, predominantly petit bourgeois, vented their anger at the

"high-born" *Junker* traitors who had, presumably through generations of overrefinement, lost their sense of commitment to the fatherland. This mobilization of resentment (Goebbels used it especially) would appeal to the frustrations of the soldiers serving under the high-born officers who now were suspected of treason.

15. Ibid., 165 ff.; this was of course especially the case if these groups were communist.

16. The *Dolchstosslegende*—literally "legend of the dagger thrust"—refers to the "explanation" that gained currency soon after World War I, which held that the German army was stabbed in the back or betrayed, and not allowed to fight to its full potential, by the inept politicians back home, and that this is why Germany lost the war. Such a "theory" was well capable of mobilizing resentment and could be used by the Nazis who promised to "avenge" this betrayal and to prevent anything like it from ever occuring again.

17. See *Flugblätter*, 18.

18. Ibid., 354–55; as this publication points out, "these articles raised the question, 'who is to be considered a war criminal?,' with which Lieutenant-Colonel Walter Lehwess-Litzmann (BDO) dealt in the FD [*Freies Deutschland*] of 22 October 1943." Lehwess-Litzmann notes that this is not a matter of "debased individuals" acting out perverted fantasies, but rather "a planned, at Hitler's behest, organized system for the extermination of entire peoples, for example, the Jews." The entire government and Nazi leadership, as well as "the gentlemen of monopoly capitalism and the armaments industry," must be held responsible. This last indictment again makes clear why the Anglo-American alliance would not look kindly on this resistance group.

19. Ibid.

20. Ibid.

21. See ibid.: When Alexander Werth tried to submit his detailed report on Maidanek to BBC-London in August 1944 it was rejected as a "masterpiece of Russian propaganda." And everything the NKFD did was also immediately interpreted in terms of whether or not it was good for "our side," whatever that side might be.

22. Ibid., 16; the Nazi leadership was apparently even more shocked by this development and instituted what was known as *Sippenhaft* of all NKFD members' families (i.e., the policy of imprisoning the family was meant to act as a deterrent for further "acts of treason").

23. Ibid., 157.

24. Ibid.; the SPD also detested the Communist Party (KPD), a rivalry that reached ferocious peaks during the Weimar Republic.

25. Ibid.: One example is the *Frankfurter Zeitung*, Nr.447, of October 1943, which was deliberately made up to look like the traditionalist Frankfurt paper shut down by the Nazis in August 1943. It was put together by the American

group led by Allen Dulles, chief of Office of Strategic Services and Office of War Information, based in Bern, Switzerland. The OSS distributed its propaganda material primarily in southern and south-western Germany. The main article in the paper discusses the National Kommitee Freies Deutschland's directing body, the Bund Deutscher Offiziere, and accuses the organization of wanting to rescue the Wehrmacht, on which Churchill had declared war. It also characterizes the generals as anachronistic and backward, and a detriment to the development of Germany.

26. Ibid., 41. Also, Peter Steinbach, speaking at the 16 May 1990 discussion evening at the Martin-Gropius-Bau in Berlin (cited previously), noted that by 1952 the resistance became defamed as "*Landesverrat*" (treason) in the Federal Republic of Germany; workers' resistance in particular, as linked to communism, was defamed.

27. Although the doctrine of unqualified capitulation was meant to prevent the formation of a *Dolchstosslegende*, one does wonder whether the defamation of the resistance groups was in itself a kind of *Dolchstosslegende* insofar as in the West it "explains" the birth of the German Democratic Republic.

28. *Flugblätter*, 165 ff.

29. Ibid.

30. Ibid.; the magazine existed from October 1941—June 1946, and had a readership of 20,000. It maintained close Moscow contact.

31. Ibid.

32. Ibid.

33. Ibid., 180–181.

34. This was first exposed in the wake of the fall of the Berlin Wall by the Berlin *Tageszeitung* in the winter of 1989/90.

35. *Amerikanische Rundschau* 3, nr.11 (1947): 123–24.

36. See the documentation in Klaus-Jörg Ruhl, ed., *"Mein Gott, was soll aus Deutschland werden?" Die Adenauer-Ära 1949–1963* (Munich: Deutscher Taschenbuch Verlag GmbH & Co. KG., 1985).

37. Franklin L. Ford, "Der zwanzigste Juli," *Amerikanische Rundschau* 3, nr.11 (1947): 12–13, quoted from pages 619–626 of Ford's original English version, "The Twentieth of July in the History of the German Resistance," *American Historical Review* 51, nr.4 (July 1946):609–26 (emphasis added).

38. Ibid., 13.

39. Ibid., 16–17.

40. Ibid., 12.

41. In 1949, Karl Thieme reviewed Max Horkheimer's and Theodor W. Adorno's *Dialektik der Aufklärung* in the *Frankfurter Hefte* 4, nr.8 (1949): 716–17, and picked out the following statement as characteristic of Horkheimer's and Adorno's distrust of choosing sides: "Whether a citizen opts for the communist or the fascist ticket already depends on whether he is willing to be more impressed by Red Army or by the laboratories of the West" (716).

42. Washington, D.C., National Archives, OMGUS-ECR Div., file # 5 299 2 (38).

43. Ibid.

44. Ibid.

45. Ibid.

46. Ibid.

47. Ibid.

48. Ibid.

49. Conversely, this of course holds true for re-education in the Soviet zone as well.

50. Washington, National Archives, OMGUS-ECR Div., file # 5 307—3 (1). Emphasis added.

51. Ibid.

52. How women were actually treated in the postwar period is quite a different matter: they were the ones who most definitively were "returned" to a prewar model of virtue, docility, and "femininity," presumably to make the transition to male citizenship easier for their "partners." Some of the most appalling discursive examples of this reconstitution of patriarchy can be found in *Die Sammlung*, particularly by its editor, Hermann Nohl (e.g., "Die heutige Aufgabe der Frau," *Die Sammlung* 2 [1946/47]: 353–58), as well as by the token woman who wrote on the subject, Hannah Vogt (e.g., "Der Auftrag der Frau in Haus und Beruf," *Die Sammlung* 2 [1946/47]: 358–66). Both Nohl and Vogt continued to hold forth on the topic in later issues. The full force of restoration and restriction of personal freedom hit women the hardest.

53. This is a main point of friction between the communist-oriented Berlin *Magistrat* (city-government) and its social democrat critics; the *Magistrat* tried immediately to lay claim to a strategy of re-education that downplayed or eliminated any emphasis on the individual, and instead emphasized the institutional factors involved. Thus, a city government section for *Volksbildung* (adult education, people's education) was formed immediately at the end of the war, and by 11 June 1945 the *Kammer der Kunstschaffenden* (chamber of art workers) was created as part of the *Volksbildung* division. While this was laudable, it also indicated the quick incorporation of "art" into administration, and it conflicted with the views of the communists' opponents in the *Magistrat*. See the publication, Berlin, Senat, *Berlin; Quellen und Dokumente 1945–1951*, vols.1 and 2 (Berlin: Heinz Spitzing Verlag, 1964), particularly vol.1, document, nr.285, 473 f.

54. This was an exhibition entitled "Maler der Gegenwart," held in the Schäzler Palais, Augsburg, December 1945.

55. Article by Erich Kästner, *Neue Zeitung* (7 January 46): 3, quoted in *Soviel Anfang war nie*, 60.

56. Ibid.

57. By 1953 the role of the modern art critic as a kind of pope had become

offensive to the opponents of modern art, who suspected a kind of conspiracy that applied only in Germany and who were convinced that in every other western country abstract art had already fallen out of favor and was no longer taken seriously. See Nürnberg, Archiv für Bildende Kunst, file on Otto Dix, for a letter and paper by Alfred Leithäusler, who corresponded with Dix, and who is representative of this position. In his talk, he notes that "I believe that the mountains will still stand in the exact same way in a thousand years as they do today, and this is why I, for my part, don't want to be involved in prematurely twisting the visual organs of my fellow man." And further down he warns that "if however we fully depart from the basis of objecthood, we enter into an alliance with the snobs, and I can tell you that they can be damned capricious and unreliable."

Leithäusler sees that the connection between "man" and modern life is lost, but not due to social, economic, or historical factors, but solely due to the artists themselves and in particular their cohorts, the modernist critic-pope: it is the critics' fault that a gap exists between art and the public.

Leithäusler has an answer to the problem, however: "But it is in our hands to change these for us so devastating conditions, or better: to undo them altogether. It is up to us to take down the barriers between us and the public, and to create another, wholly new, relationship with the public." He closes with a call to action, to badger the government, and to write protests against the abstract artists and their "pacemakers": "Let's be confident about unleasing a storm in the public sphere. Let's put up posters on the doors to our exhibitions: 'Critics not desired! Whoever writes anyway, does it for our and our public's amusement.'"

With "reaction" such as Leithäusler's—and he spoke to rapt audiences in the suburbs of Munich—it is no wonder that abstract artists and modernist critics could speak of a "reactionary" mood in Germany, particularly as it was coupled with a weird populism.

58. Washington, National Archives, OMGUS-ECR Div., file # 5 334–1 (38).

59. Ibid.

60. I believe it is significant that this German youth is the generation that grew up to become the parents of most of the generation of the Red Army Faction, which protested against the fossilized and dishonest life of postwar society.

61. Published in *Berlin; Quellen und Dokumente*, 1:772–75.

62. Ibid.

63. Both speak dishonestly—as does the capitalist side—about the issue of power. The Nazi and the Soviet model attempted to further an art that would serve a collective, versus an individual, subject, namely the *Volk*, the people. Carl-Ernst Matthias, one of the editors of *Bildende Kunst*, was an astute observer of the modern art scene, but he, too, could not solve the problem of art's autonomy versus its role as servant of a collective subject. In his report

on the "Künstlerkongress in Dresden," *Bildende Kunst* 1, nr.1 (1947): 3–11, he called for the autonomy of art—that it no longer served the interests of Nazis or of a corrupt ruling class (of power, in other words). Art is supposed to be free. But at the same time, as a good communist, he could not help but define that autonomy as "serving the people," which immediately presupposes that it is no longer autonomous. For Matthias (11), "It [art] should serve the people, for the first time in history, and no longer its tyrants, exploiters, and taskmasters. . . . For the first time it is the people who form and shape their lives, who celebrate and enjoy their existence as the cause of all values, who decorate and glorify their daily life, and who want meaningfully to weave their independent existence into history." This, however, presupposes that the *Volk* really have and exercise power: only then does a collective subject— which replaces the "patron" of old (namely, the tyrant, king, pope, or rich merchant—the one with power)—come into being. But as long as a power elite is formed (as it was under Soviet communism), art will continue to express the deformations encountered in its contradictory situation of striving for autonomy and being in relation to power. The collective subject is thus as much a mirage as is the discreet, intact "free" individual of the West. In both instances, the question of who or what wields power remains a factor beyond the control of the ideal.

64. *Bildende Kunst* 2, nr.1, opening editorial, 1.

65. Ibid.; a reader of *Bildende Kunst* expressed, in reverse form, the same reactionary attitude to modern art as Alfred Leithäusler (cited above) when he maintained that Western modernism is an intolerable dictatorship from which the average person wants to escape, and that in the Soviet Union, people are "free" to paint nice pictures that everyone likes. See ibid., letters to the editor section, 27–28, letter from Fritz Werner.

However, in the same section, another reader writes to say that it is time to stop demanding of art that it adapt to the people's taste when the people are lazy and unwilling to learn; he cites the example of Käthe Kollwitz, who, while championing the workers' cause, would not have cared about "accomodating" her work to that audience's taste. See ibid., letter from Kurt König.

66. Adolf Behne was born in 1885 and studied art history in Berlin, where he received his Ph.D. in 1911. Already prior to World War I, he published articles on modern architecture and art in leftist, sometimes social democratic, magazines (for example, *Sozialistische Monatshefte*). He was a founding member of the 1918 Berlin *Arbeitsrat für Kunst* ("Working Council for Art"), and, together with Bruno Taut and Walter Gropius, co-authored its program. In 1923 he spent some time in the USSR, as a founder of the group *Gesellschaft der Freunde des neuen Russland* ("Society of Friends of the New Russia"). He developed theoretical differences with a number of other proletarian art critics and art workers (notably John Heartfield, in 1926), defending his social-

utopian views of constructivism against a view of art he considered too restrictive in its attempts to make art exclusively into a weapon of class struggle. As late as 1947, he defended his notion that constructive work on the "pure" form and work on "social" art had to complement one another.

67. Adolf Behne, "Was will die moderne Kunst?" *Bildende Kunst* 2, nr.1 (1948): 3. In the summer of 1948 Behne died of tuberculosis.

68. Ibid.

69. Ibid.

70. Ibid., 4.

71. Ibid.

72. Ibid., 6.

73. Ibid.

74. Ibid., 4–5.

75. While this predicates the appreciation of Impressionism, it expresses a particularly German lesson, namely one informed by Expressionism and German early twentieth-century ideas; for example, the ideas expressed in the work of Carl Einstein.

76. Behne, "Was will die moderne Kunst?," 6.

77. Again, see Carl-Ernst Matthias's articles in *Bildende Kunst*, especially the above cited report on the "Künstlerkongress in Dresden," *Bildende Kunst* 1, nr.1 (1947): 3–11.

78. Ibid., 5.

79. Ibid., 6.

80. I hesitate to use the word "humanity" as *Menschentum* is not necessarily a humanism.

81. Adorno, *Negative Dialectic*, 127.

82. Recall Adorno's critique of communication, discussed in chapter 1.

83. Adorno, *Negative Dialectic*, 127–128.

84. Note that this has resonance to the Foucaultian critique cited earlier in this chapter: difference/differentiation, while it can be critical, is also necessary to the efficient functioning of a modern capitalist state—when difference/differentiation is denied and imperialism/homogenization is instead (re)instantiated, the modern capitalist society withers, becomes enervated, and (soft or hard) fascism or totalitarianism takes over. The dilemma expresses the essential pessimism—the aporias—of critical thinking.

85. *ZEN49*, 347.

86. Ibid., 346.

87. Ibid.

88. Ibid., 333.

89. Ibid., 334.

90. Adorno, *Negative Dialectic*, 127.

91. Teresa de Lauretis, *Technologies of Gender; Essays on Theory, Film, and Fiction* (Bloomington and Indianapolis: Indiana University Press, 1987), 65,

discusses Umberto Eco's critique of the structuralist question "who speaks," a philosophical question that could only be asked by a class freed from labor. Eco instead asks "who dies," as the following quote, from his *La struttura assente: Introduzione alla ricerca semiologica* (Milan: Bompiani, 1968), 357–58, elaborates:

> Let us suppose there is another question, an even more constitutive one, that is asked not by the free man who can afford "contemplation," but *by the slave* who cannot: for the slave the question *"Who dies?"* is a more urgent question than "Who speaks." . . . For the slave *the proximity of being* is not the most radical kinship: *the proximity of his own body and the bodies of others* comes first. And in perceiving this other kinship, the slave does not leave the domain of ontology to regress (or to remain without consciousness) in the realm of matter: rather, he accedes to thought from another, equally worthy, pre-categorical situation.
>
> By asking "Who dies?" we have not entered an empirical dimension in which all philosophies are worthless, but rather we have set out from another pre-philosophical presupposition in order to found another philosophy.

92. Nürnberg, Archiv für Bildende Kunst, file on E. W. Nay, letter from Nay to Herr Voigt, dated 19 September 1948.

93. See, for example, Daniel-Henri Kahnweiler's numerous books and articles on cubism, in which he interprets it as writing: *Der Weg zum Kubismus* (Munich: Delphin-Verlag, 1920); *Juan Gris; His Life and Work* (New York: Curt Valentin, 1947), and others.

94. Individual action is also severely curtailed in late commodity capitalism, with its logic of "ever-the-same" and ex- and inter-changeable goods and relationships.

95. Joseph Fink, "Das griechische Antlitz," *Aussaat* 1, nr.10/11 (1947): 36–39.

96. Ibid., 39; this sort of text is the perfect target for Martin Bernal's massive critique of Greek studies in the West, *Black Athena: The Afroasiatic Roots of Classical Civilization* (New Brunswick, N.J.: Rutgers University Press, 1987).

97. Werner Krauss, "Über den Zustand unserer Sprache," *Die Gegenwart* 2, nr.2/3 (1947): 29–32.

98. Ibid., 30. Here is the original: "Wenn der Flieger eine Notlandung baut, setzt er sich einfach hin oder rotzt die Mühle hin, wenn er dabei Bruch macht . . . Emil schiebt die Pulle rein und zischt los. Ein Jäger setzt sich hinter ihn, schiesst aus allen Knopflöchern und rotzt ihm den Laden voll. Als ein eigener Jäger kommt, saust dem Tommy der Frack. Er nimmt des Schwänzchen hoch und geht türmen, um nicht abgeknipst zu werden. Wir haben inzwischen unsere Eier gelegt und fahren nach Hause. Da meckert der rechte Motor, dann kotzt und schliesslich verreckt er."

The German reader will note the frequent, almost untranslatable references to bodily fluids and involuntary functions.

99. Ibid.

100. Ibid.

101. Ibid.

102. Ibid.

103. Ibid., 31; what is also interesting here is that Krauss shows argot to be directly related to the bodily and creaturely oriented aspects of existence: it is metaphoric, concrete, and *bildlich*. Yet on the other hand, it is hermetic, inaccessible.

On the importance of the (M)other's (obscene) body in this period, see Klaus Theweleit, *Male Fantasies*, trans. Stephan Conway, Erica Carter, and Chris Turner (Minneapolis: University of Minnesota Press, 1987–1989).

104. *Deutscher Künstlerbund 1950; Erste Ausstellung Berlin 1951*, Berlin, Hochschule für Bildende Künste [1951]; a copy of this catalog can be found in Nürnberg, Archiv für Bildende Kunst, file on Werner Heldt. The catalog published commentary by the artists ("*Künstlerstimmen*"), including statements by Baumeister, Geitlinger, Meistermann, Münter, Nay, Scharff, and Winter (in that order); the catalog is not paginated.

105. Ibid.

106. Ibid.

107. Johann Albrecht von Rantzau, "Geschichte und Politik im deutschen Denken," *Die Sammlung* 1 (1945/46): 544–54.

108. Ibid., 545.

109. But, and Rantzau conveniently ignores this, Kant came from Königsberg, at that time Germany's Eastern-most outpost.

110. Hermann Nohl, " 'Vom Sinn der Kunst' Vortrag bei der Eröffnung der Kunstwoche 'Befreite Kunst' im Celler Schloss am 3.März 1946, der auf vielfachen Wunsch hier noch einmal aus dem 'Forum' [Verlag Adolf Sponholtz, Hannover] abgedruckt wird," *Die Sammlung* 2 (1946/47): 415–16.

111. Wilhelm Worringer, *Abstraktion und Einfühlung* (Munich, 1908).

112. Leopold Zahn, "Apologie der malerischen Malerei," *Das Kunstwerk* 1, nr.7 (1946/47): 3–4.

113. Ibid., 3, emphasis added.

114. Ibid.

115. Ibid., 4.

116. Ibid.

117. Ibid., 3–4.

118. Egon Vietta, "Kreuzzug der Ausstellungen," *Das Kunstwerk* 2, nr.1/2 (1948): 79.

119. Ibid.

120. See Nürnberg, Archiv für Bildende Kunst, file on Otto Dix, Dix-Conzelmann correspondence.

121. Ibid.

122. Nay did exhibit once, as a guest, with ZEN49 in 1955.

123. As discussed in chapter 1.

124. Willi Baumeister, *Das Unbekannte in der Kunst* (Stuttgart: Curt E. Schwab Verlagsgesellschaft, 1947).

125. Nürnberg, Archiv für Bildende Kunst, file on E.W. Nay, letter from Nay to Herr Voigt, dated 19 September 1948.

126. H. T. [Heinz Trökes], "Ausstellungen; Deutsche Kunstreise," *Das Kunstwerk* 2, nr.8 (1948): 44; Hanna Bekker vom Rath was an old acquaintance of Nay.

127. Ibid.

128. Frederick S. Wight, "Amerikanische Malerei der Gegenwart," *Amerikanische Rundschau* 5, nr.24 (1949): 61–72.

129. Egon Vietta, "Die Olympischen Spiele der Europäischen Malerei," *Das Kunstwerk* 2, nr.10 (1948): 45.

130. Ibid.

131. See Clement Greenberg, "The Present Prospects of American Painting and Sculpture," *Horizon* 93–94 (October 1947):20–30.

132. R. Wankmüller-Freyh, "Das kubistische Stilleben," *Das Kunstwerk* 2, nr.5/6 (1948): 15.

133. See *E. W. Nay; Bilder und Dokumente*, 206; the quote is from a text Nay wrote in June 1965 while vacationing on Crete; he read this text at an opening of his latest works at the Galerie Günther Franke, Munich, in 1965.

134. Anton Henze, "Abstrakt-Absolut-Konkret?" *Das Kunstwerk* 2, nr.1/2 (1948): 37.

135. See, for example, L., "Berliner Ausstellung," *Bildende Kunst* 2, nr.10 (1948): 43–46; and Heinz Lüdecke, "Über das Grundübel unserer Welt," *Bildende Kunst* 3, nr.6 (1949): 180.

136. Recall Adorno, *Negative Dialektik*, 133.

137. Again, see Henze, cited above. The artists of ZEN49 made similar arguments; see *ZEN49, passim*, documentation section.

CHAPTER III

1. Berlin, Senat, *Berlin; Quellen und Dokumente 1945–1951*, vol.1, doc.nr. 285, 473.

2. In the Soviet sector, the Communist Party of Germany (*Kommunistische Partei Deutschland*—KPD) was renamed the Socialist Unity Party of Germany (*Sozialistische Einheitspartei Deutschland*—SED) soon after the war—in 1946— when the Social Democratic Party of Germany (*Sozialdemokratische Partei Deutschland*—SPD) was forcibly fused with the KPD. In the remaining zones of Germany and in West Berlin, the SPD could not be "amalgamated" to the KPD; there was no SED, and the KPD eventually became illegal.

3. See *Berlin; Quellen und Dokumente*, vol.1, doc.nr. 644, 1139–1140. The number of registered voters was 2,307,122, of which 2,128,677 voted. 97% (2,085,338) of the votes cast were valid votes, 2.04% (43,449) were invalid.

The SPD won in every district, albeit not with a majority of over 50%. For all of Berlin, the distribution was: 48.7% SPD; 19.8% SED; 22.2% CDU (Christian Democratic Union); 9.3% LPD (liberals). For the Soviet sector: 43.6% SPD; 29.9% SED; 18.7% CDU; 7.8% LPD. And for the West sector: 51.76% SPD; 14.76% SED; 23.6% CDU; 9.66% LPD.

4. Ibid.

5. Ibid.

6. Ibid.; see note 2 above concerning the genesis of the SED and its relation to the SPD in the West.

7. Arthur Schlesinger, Jr., *The Vital Center: The Politics of Freedom* (Boston: Riverside Press, 1962).

8. *Berlin; Quellen und Dokumente*, vol.1, doc.nr. 645, 1140.

9. Ibid. While as a slogan "neither Right nor Left, but Vital Center" sounds ideal, it is also idealistic insofar as its defenders did get caught up in defending one of the two, even as they did so in the name of the vital center. The latter was simply co-opted to the West's interests, despite the fact that in Germany these interests in the Fifties were overtly conservative and even reactionary.

10. Ibid., doc.nr.3, 2.

11. Ibid., doc.nr. 26, 23–24.

12. In addition, it is of course also the case that Winston Churchill's top secret telegram of 12 May 1945 to President Truman reiterated this East-West division, albeit without the National Socialist rhetoric that summarily dressed the Soviets up as "Asians." See ibid., doc.nr.51, 71–73:

1. I am profoundly concerned about the European situation as outlined in my [telegram] number 41. I learn that half the American air force in Europe has already begun to move to the Pacific Theatre. The newspapers are full of the great movements of the American armies out of Europe. Our armies also are under previous arrangements likely to undergo a marked reduction. The Canadian Army will certainly leave. The French are weak and difficult to deal with. Anyone can see that in a very short space of time our armed power on the Continent will have vanished except for moderate forces to hold down Germany.

2. Meanwhile what is to happen about Russia? I have always worked for friendship with Russia, but like you, I feel deep anxiety because of their misinterpretation of the Yalta decisions, their attitude towards Poland, their overwhelming influence in the Balkans excepting Greece, the difficulties they make about Vienna, the combination of Russian power and the territories under their control or occupied, coupled with the Communist technique in so many other countries, and above all their power to maintain very large armies in the field for a long time. What will be the position in a year or two, when the British and American armies have melted and the French has not yet been formed on any major scale, when we may have

a handful of divisions mostly French, and when Russia may choose to keep two or three hundred on active service?

3. An iron curtain is drawn down upon their front. We do not know what is going on behind. There seems little doubt that the whole of the regions east of the line Lübeck-Trieste-Corfu will soon be completely in their hands. To this must be added the further enormous area conquered by the American armies between Eisenach and (the) Elbe, which will I suppose in a few weeks be occupied, when the Americans retreat, by the Russian power. All kinds of arrangements will have to be made by General Eisenhower to prevent another immense flight of the German population westward as this enormous Muscovite advance into the centre of Europe takes place. And then the curtain will descend again to a very large extent if not entirely. Thus a broad band of many hundreds of miles of Russian-occupied territory will isolate us from Poland.

4. Meanwhile the attention of our peoples will be occupied in inflicting severities upon Germany, which is ruined and prostrate, and it would be open to the Russians in a very short time to advance if they chose to the waters of the North Sea and the Atlantic.

5. Surely it is vital now to come to an understanding with Russia, or see where we are with her, before we weaken our armies mortally or retire to the zones of occupation. This can only be done by a personal meeting. I should be most grateful for your opinion and advice. Of course we may take the view that Russia will behave imspeccably [sic] and no doubt that offers the most convenient solution. To sum up, this issue of settlement with Russia before our strength has gone seems to me do [sic] dwarf all others."

13. Ibid., 237. The *Magistrat* was dominated by the communists. Prior to the forced union of SPD and KPD in the Soviet-ruled sectors of Berlin, as well as of the Soviet Zone in Germany, this meant that the *Magistrat* was dominated by the KPD; after their fusion, the SED dominated.

14. Ibid., doc.nr. 148, 242–43.

15. Late capitalism has increasingly tended to rid itself of the necessity of individuals and of individual action—the corporation can get along without these factors—and hence we see periodic crises of "the individual" in our postwar society.

16. *Berlin; Quellen und Dokumente*, vol.1, doc.nr. 285, 473.

17. Ibid., 474.

18. Ibid. The *Kulturbund* was formed on 4 July 1945, less than one month after the *Magistrat* formed the *Kammer der Kunstschaffenden*.

19. The exhibition "Soviel Anfang war nie," at the Hamburger Bahnhof in Berlin (accompanying publication edited by Herman Glaser et al., 1989), was accompanied by a series of symposia dealing with the so-called "*Umbruchs-*

jahre," the years 1945–1949, with speakers who had witnessed the period under discussion. On 5 November 1989, the topic was post-war theatre and discussants included Heinrich Goertz, Friedrich Luft, Wolfgang Harich, and Roman Weyl. All the participants, but in particular Harich, who was a young journalist in the Soviet zone of Berlin after the war, stressed the intense interest that the Soviet cultural officers showed for German culture and the value they placed on putting it on stage. Interestingly, Harich pointed out that several of them—Fratkin and Dymshitz, for example—were Soviet Jews who felt nonetheless that Germans should not put on plays thematizing the Holocaust because the topic would be too painful for *German* audiences to deal with. Perhaps this is an evasion of the bad past in favor of the "good" one.

In a different vein, one can also point to oppressed groups—racial or sexual minorities, for example—following the same strategy of seeking a "good" or "heroic" past in which to ground their projection for the future.

20. I believe this accounts for the Janus-face of "nationalism" in both reactionary as well as communist social proposals.

21. Washington, National Archives, OMGUS-ECR Div., file # 5 307 3.

22. As Walter Ulbricht put it at the III. Party Congress of the SED on 22 July 1950, "during the Weimar period, building complexes were built in many of our cities that in their architectural style did not meet the population's wishes, did not conform to the national features, but rather conformed to the formalist thoughts of a number of architects who transposed the primitivity of certain factory buildings to residential buildings. Under Hitler-fascism, this barracks style was further developed. Some architects, especially in the architecture division of the Berlin Magistrate, wanted to prettify Germany's capital city by building low-rise houses, and they wanted to build in the city center using guidelines for suburbs. The basic mistake of these architects is that they did not relate to the structure and architecture of Berlin, but rather that in their cosmopolitan fantasies they believed that one should build houses in Berlin that could just as well fit into the south African landscape." Cited in *Berlin; Quellen und Dokumente,* vol.2, doc.nr. 1063, 1869.

This is the rhetoric; what the GDR actually did to the cities can be seen in centers as different in scale as Frankfurt a.d. Oder (on the Polish border) and East Berlin: razed city centers, huge towers "dedicated" to "socialism," and plazas—usually replete with an oversized fountain—set between inhuman, overscaled concrete facades.

23. Washington, National Archives, OMGUS-ECR Div., file # 5 333 3 (2).

24. Ibid., 67.

25. Ibid., 71.

26. Quoted in Glaser et al., eds., *Soviel Anfang war nie,* 206.

27. Ibid.

28. Ibid., 208.

29. Ibid., 209.

30. See Victor Farias, *Heidegger und der Nationalsozialismus* (Frankfurt a.Main: S. Fischer Verlag GmbH, 1989) for an account of how thoroughly conservative the majority of academic youth were in the late 1940s and 50s. Farias wrote his book in Spanish and it was originally published in French (*Heidegger et le nazisme*) in 1987; the German translation is an expanded and revised version of the Spanish original.

31. Glaser et al., *Soviel Anfang warnie*, 209.

32. In the early 1950s, a struggle arose over policy-setting in an organization called the "Deutscher Künstlerbund 1950." The struggle crystallized in 1952 around the figures of its president, Carl Hofer, and Will Grohmann and several abstract artists (Winter, Werner, Baumeister, Uhlmann). The "Deutscher Künstlerbund 1950" was the revived postwar version of a prewar artists' organization that had been banned by the Nazis; it did not have any real membership criteria, according to Grohmann and his side, who were embarassed by the hodge-podge exhibitions this organization put together— exhibitions that simultaneously laid claim to representing Germany abroad. Grohmann had in mind something more defined and definitive, particularly in terms of competing at international exhibitions in Venice or Sao Paolo. The struggle between Hofer and Grohmann is beyond the time-frame set by my text here, but I would like to point out that the way the struggle has been bowdlerized in most art historical accounts as one between the "realists" (Hofer) and the "abstracts" (Grohmann and cohorts) is absolutely wrong. The point for Grohmann—actually a much more serious and potentially insidiuous one—was over control of policy-setting and standards: Grohmann wanted an elite, "lean and mean" avant-garde which would not embarass Germany in the international field, while Hofer and the "Deutscher Künstlerbund 1950" tried to hang on to an "inclusive" policy—one that did not pay any attention to the international scope of modern art—of selecting and exhibiting artists.

See Nürnberg, Archiv für Bildende Kunst, file on Georg Meistermann; also see, Stuttgart, Will Grohmann Archiv; and *Deutscher Künstlerbund 1950; Erste Ausstellung*, Berlin, Charlottenburg (1951).

33. Which is not to downplay the very stong "Italian" component—the classicism—in Hofer's art.

34. See *Hommage à Günther Franke*, Munich, Museum Villa Stuck, 1 July– 18 September (1983).

35. See Berlin, Landesarchiv, laz 11880.

36. Hofer also found support amongst the SPD: he was after all an individualist (which eventually got him into trouble with the SED side) and a contemporary artist.

See Berlin, Landesarchiv, laz 11587 for more statistical information: 80% of all Berlin artists lived in the Western sectors of the city; money was extremely

scarce, especially in 1948, but SPD policy at least upheld the ideal of supporting contemporary artists.

37. Ibid. In 1948, the worst year for Berlin, the city did not even have the funds to pay for a commissioned plaque.

38. See Berlin-Zehlendorf, Haus am Waldsee, Archives.

39. See Berlin, Landesarchiv, Rep.14, Acc.2323 for the sometimes heated struggles (via letters) that surrounded attempts to keep the Haus am Waldsee viable as a cutting-edge exhibition space, as well as for the connections to SPD city government.

40. Reprinted in Glaser et al., *Soviel Anfang war nie*,17.

41. Like an amputation carried out on a living being is how the process was characterized by B.R. [Benno Reifenberg], "Am lebenden Objekt," *Die Gegenwart* 2, nr.21/22 (1947): 7–8.

42. F. Adama von Scheltema, "Ist der Expressionismus noch 'junge Kunst'?" *Prisma* 1, nr.2 (1946), 18.

43. See also Hans Grundig, "Berichte und Berechtigungen; Dresdener Bilanz; Betrachtungen zur ersten allgemeinen deutschen Kunstausstellung," *Prisma* 1, nr.2 (1946): 33–34. Grundig was the *Rektor* of the Staatliche Kunsthochschule in Dresden at the time he wrote this article.

His opening comments suggest that Expressionism is really the most meaningful style of German art, and that it is in this sense a carrier of national unity. But he immediately goes on to describe the generational problem at hand: that the older generation represents the "new" art (including "dynamic," "protesting," "tense" Expressionism), while the generation born between 1918 and 1930 seems entirely ruined by twelve years of Nazi art indoctrination. But the implication is of course also that "dynamic," "protesting" Expressionism is inextricably linked to the failures of this pre-1918 generation—which after all had produced not only Expressionism, but Nazism, too. At the height of Nazi power, almost all top and middle-ranking Nazis were young men, born after 1900, and hence in their early and mid-30s throughout the height of the National Socialist period: Nazism itself had been a "dynamic," "protesting," and "tense" movement, led not by old men, but by young ones.

44. "le Reich," *Die Gegenwart* 3, nr.23 (1948): 1.

45. André Gide, "Über den Klassizismus," trans. Friedhelm Kemp, *Prisma* 1, nr.3 (1947): 18–19.

46. Ibid., 18.

47. Heinz Lüdecke, "Der denkende Künstler," *Bildende Kunst* 2, nr.8 (1948): 3–9.

48. Ibid., 4.

49. Ibid.

50. Ibid., 3.

51. Ibid.

52. See Elisabeth Lenk, *Die unbewusste Gesellschaft; Über die mimetische Grundstruktur in der Literatur und im Traum* (Munich: Matthes & Seitz Verlag, 1983).

53. See Karl-Heinz Bohrer, *Die Kritik der Romantik; der Verdacht der Philosophie gegen die literarische Moderne* (Frankfurt: edition suhrkamp 1551, 1989).

54. Lüdecke, "Der denkende Künstler," 6.

55. Ibid.

56. Lüdecke never clarifies what it is, in his opinion, that the constructivists did wrong, except to note that their art was not liked or accepted by the people.

57. Lüdecke, "Der denkende Künstler," 6.

58. Cited in *ZEN49*, 240.

59. Ibid.

60. See chapter 2 for a discussion of Behne's arguments about *Anschaulichkeit*.

61. Cited in *Zen49*, 240.

62. See Bohrer, *Die Kritik der Romantik*, 292f.

63. Ibid., 292: "that is to say, the aesthetic is the real enemy of ontological reconstruction."

64. Ibid.

65. Adorno, *Negative Dialektik*, 231–32.

66. Ibid., 44; see trans. Ashton, 31–32, "Vertiginousness."

67. Ibid., 325.

68. See, for example, Gunter Groll, "Realisten und Romantiker," *Prisma* 1, nr.10 (1947): 17–18; see also Franz Roh's many postwar ruminations on the inevitability of synthesis (e.g., "Zur Diskussion um die gegenstandslose Kunst," *Prisma* 1, nr.10 (1947): 26–28.).

69. See Adorno, *Negative Dialectic*, trans. E.B. Ashton, 172.

70. Ibid.

71. Ibid., 175.

72. Ibid.

73. Ibid.

74. Ibid., 175–76.

75. Although Adorno was not an invited speaker at the 1950 Darmstadt symposium "Das Menschenbild in unserer Zeit," he did speak from the audience and his comments are reprinted in full in Evers, *Darmstädter Gespräch*.

76. See Kurt Leonhard, "Picasso," *Das Kunstwerk* 1, nr.8/9 (1946/47): 18–29.

77. Ibid., 18.

78. The literary style most closely associated with this is *nouveau roman* (the work of Nathalie Sarraute, for example), and two different, but key, theorists are Roland Barthes and Michel Foucault.

79. Groll, "Realisten und Romantiker," 17.

80. Ibid.

81. Ibid.

82. In the original, *"geistigen vitalen Tendenzen"*; Nürnberg, Archiv für Bildende Kunst, file on E. W. Nay, letter from Nay to Herr Voigt, dated 19 September 1948.

83. Washington, National Archives, OMGUS-ECR Div., file # 5 333–3 (2).

84. The polemics regarding Carl Hofer in the pages of *Bildende Kunst* notwithstanding.

85. *Das Kunstwerk*, for example, seems to have accepted only contract work, not unsolicited papers.

86. The contents of this issue, vol.1,, nr.8/9 (1946/47) included: L. Zahn, "Abkehr von der 'Natur'"; A. Henze, "Zum Verständnis abstrakter Malerei"; E. Strassner, "Abstrakte und gegenständliche Malerei"; K. Leonhard, "Picasso"; H. Trökes, "Der Surrealismus"; H. Hildebrandt, "Oskar Schlemmer"; A. Rannit, "M. K. Ciurlionis"; Hanns Theodor Flemming, "Moore und Sutherland"; H. Trökes, "Moderne Kunst in Deutschland"; C. Weiler, "Bilder und Publikum." Also included were book reviews and a short lexicon of abstract artists.

87. Ibid., 73–75.

88. Ibid., 73 (emphasis added).

89. Ibid.

90. Ibid., 74.

91. Ibid., 75.

92. See, for example, Stuttgart, Will Grohmann Archiv, Grohmann's letter in French to Christian Zervos, dated 22 February 1949: "the work consoles me a bit for the scant light we have—two hours per day—and the difficulties of heating. Despite these difficult restrictions, I love Berlin, and I would not want to live anywhere else in Germany but here. Berlin is and remains the most lively and active city. all the other cities are more or less 'the provinces.'"

93. See, for example, Washington, National Archives, OMGUS-ECR Div., file # 5 307–3 (1), Berlin 28 October 1947:

RESTRICTED ALLIED CONTROL AUTHORITY CONTROL COUNCIL DIRECTIVE NO. 56 *Basic Principles for Adult Education in Germany*
The Control Council approves the following principles and transmits them to the Zone Commanders and to the Allied Kommandatura, Berlin, for their guidance: . . .
 2. *Organization of Adult Education*
 (a) Education of adults should be achieved through institutions and agencies specially created for the purpose which may be sponsored or promoted by public and private organizations.
 (b) The radio, cinema, press, libraries, and museums should also be used as media of adult education."

Also, see:

SECRET *28 February 1947* [COPY NO. 91] STATE-WAR-NAVY COORDINATING COMMITTEE DECISION ON SWNCC 269/10 LONG-RANGE POLICY STATEMENT FOR GERMAN RE-EDUCATION

28 February 1947 (revised): Appendix A, on private non-commercial interchange [pp. 41 ff] . . . the United States Government will permit and encourage the interchange, on a non-commercial (gift or exchange) basis, of cultural, informational and educational materials between individuals and institutions in the United States Zone of Germany and in member nations of the International Postal Union (excluding Japan and Spain) subject to provisions stated below.

2. The United States Government will assist in this private interchange of cultural material by:

(a) Encouraging the establishment or, when desirable, the reestablishment within the United States Zone of Germany, of such responsible German agencies as are competent to act for German cultural groups, including agencies designed to operate on a national scale.

(b) Permitting the use within the United States Zone of Germany of such governmental communication and transportation facilities as may be authorized and made available by OMGUS for the furtherance of the cultural purposes set forth in this paper.

In another crucial program, put forth in October 1946 (see ibid., STATE-WAR-NAVY COORDINATING COMMITTEE, decision 269/8, Appendix A, "UNITED STATES POLICY ON VISITS OF GERMAN NATIONALS TO THE UNITED STATES, AND OF PERSONS FROM THE UNITED STATES TO GERMANY, IN FURTHERANCE OF DEMOCRATIC REORIENTATION OF THE GERMAN PEOPLE") United States policy again reiterated the desirability of finding private sponsors for such cultural exchanges.

William Constable's report, cited above, the first to deal exclusively with the visual arts, also enforced the idea that support should be encouraged from private sources such as the important museums in the United States.

Those institutions that did rely almost exclusively on US Government support, such as the Amerika-Häuser and the US Information Centers, were by 1953 in fiscal trouble due to the cutbacks proposed by Eisenhower. See Ursula Bluhm's witty remark to Grohmann, apropos of her job security with the Americans in Frankfurt (she held a job with the US Information Center there): "Surely we're all going to be unemployed by 1 July 1953—it's already 'Eisenhowering-showering' quite heavily!!" (Stuttgart, Will Grohmann Archiv).

94. See Stuttgart, Will Grohmann Archiv, letter from Grohmann to Stephan Hirzel, dated 1 May 1951, as well as letters from Franz Roh to Grohmann, dated 12 January 1953 and 10 September 1953.

95. Ibid., letter from Grohmann to E. W. Nay, dated 10 December 1952.

96. Grohmann was always willing to speak his mind disapprovingly of the

propagandistic strategies implemented in Berlin by the East-sector communists in their bid to gain adherents. See his letters, Will Grohmann Archiv, Stuttgart.

97. Ibid., letter from Grohmann to Ursula Bluhm, dated 17 July 1952; in this same letter he also complains about having been once again passed up by the Cultural Exchange program (run by OMGUS-ECR Div.) for a trip to the United States.

98. Ibid., letter from Grohmann to E. W. Nay, dated 8 January 1953.

99. Grohmann's first contact with Barr might have come about through Herbert Read, who wrote to Grohmann on 22 December 1938, apropos of a book on Klee Grohmann was writing, "it would be best to have a single edition for the two countries, but the publishers would be distinct. For America I think it would probably be best to approach in the first place Alfred Barr, of the Museum of Modern Art (11 West 53rd Street, N.Y.) and ask him to cooperate with an English publisher. Here in London the most likely would be Faber & Faber (24 Russell Square, W.C.1), with whom I am very intimate. I would prefer not to approach Barr myself, but if you find he is interested in the proposal, then I will do my best with Faber or some other London publisher. . . . The situation is not very good here—a greater indifference than ever towards all questions of art. People think only of the threatening future." (Stuttgart, Will Grohmann Archiv)

100. Christian Zervos, the editor of *Cahiers d'Art*, and Will Grohmann had been in contact since well before World War II.

101. Stuttgart, Will Grohmann Archiv, letter from Zervos to Grohmann, dated 23 July 1949.

102. Ibid., letter from Grohmann to Zervos, dated 12 September 1949.

103. Ibid.

104. Ibid., letter from Grohmann to Zervos, dated 23 May 1949.

105. See, for example, ibid., the letter from Alfred H. Barr Jr. to Grohmann, 13 August 1947: "I am delighted to know that you are active and preparing a book on 20th century art to be published in Stuttgart. Won't you let me know if we can help you. Please note the catalog of the Museum of Modern Art Collection which I enclose; it is not quite up to date even with the supplement, for we have since added several very important cubist works by Picasso, Braque, Duchamp, La Fresnaye and Gris. We could provide you with a few photographs if you need to have them for publication in your book." While the possibility for general interest in German art was held open, it is also clear that MoMA was still primarily focusing on French modernists.

106. It should be noted that *Das Kunstwerk* was not up to par here; it did not have an international readership.

107. Stuttgart, Will Grohmann Archiv, letter from Grohmann to Günther Franke, dated 10 December 1952.

108. Indicative of Grohmann's relationship to official recognition is his

comment, ibid., to E. W. Nay, after Nay won an award in 1952: "You again have a prize, and I'm glad that you have received DM 2,500.00 for a nice trip. As to the prize itself, I always think of the art dealer who at the time telegraphed Beckmann after he had just won the Carnegie Prize: Don't worry, you are a good painter!" Letter from Grohmann to E. W. Nay, dated 21 July 1952.

109. True, Grohmann's contacts and allegiances ran with the SPD, as did those of his friends and supporters. But the new purchasing class—the audience for modern art slowly being built up—belonged to an industrial elite best served by the restorative, unabashedly pro-American, anti-Soviet CDU.

110. See Stuttgart, Will Grohmann Archiv, Grohmann-Ströher correspondence, May to July 1952.

111. Ibid., letter from Karl Ströher to Grohmann, dated 26 June 1952.

112. Ibid.

113. See ibid., letter from Ströher to Grohmann, dated 18 July 1952.

114. There was a period of intense strife over the role of the *Künstlerbund*, an umbrella organization of visual artists that took it upon itself to represent Germany on the international scene. Grohmann, using the *Künstlerbund*'s president, Carl Hofer, as his straw man, put himself at the center of a bitter dispute that was popularly represented as being about realism (Hofer) versus abstraction. I would argue, however, that the issue was really over who should have the right to "represent" Germany abroad: an avant-garde elite, or—to use a current political expression—a "rainbow coalition" of various interests which would always fail, in Grohmann's view, to add up to an incisive wedge capable of making an international mark.

115. As Ursula Bluhm wrote Grohmann on 12 January 1953: "We recently had American museum guests here who searched for books on the 'post-Baumeister' generation—but there's nothing there. That's always too bad."

And on 4 May 1954 she wrote to Grohmann apropos of the retardataire hold the now old-guard abstractionists had on the German scene: "We've just read in *Kunstwerk*, nr.3–4 Thwaites's essay on 'Notes on 3 Painters of the New Style' (Hartung, Werner, & Winter). He speaks here of things which you have long thought about and discussed with us and others—I'm thinking for eg. of our discussion over Christmas in Berlin when we spoke about the new view of nature in B's [Bernard Schultze's] pictures. Tw. [Thwaites] has connected thoughts with Werner & Winter that don't belong there at all, respectively totally ignored the really new stylistic means, namely the 'structures,' the renunciation of illusionistic space, and the logical following upon another of the planes (all of which is still present with the 3 named painters—but which, beginning with Pollock, Wols, was given up) I justed wanted to touch on this & think that it would be of great significance if you should write a *fundamental article* in a competent place on this topic, before things are gotten off on the completely wrong track again in Germany. And the truly contemporary striv-

ing of the younger ones (it isn't even possible to say 'young' anymore— Bernard is turning 39 now & the other two aren't any 'younger'!!) should also be explained sometime, the way M. Tapié has often done in Paris. If you don't do it, no one will do it right & there's no one oriented as you are & would only do it clumsily. Döry can't assert himself here; he is, despite his truly excellent knowledge of the contemporary developments in Europe, too unknown, *Das Kunstwerk* wouldn't accept anything by him, ditto for the other large newspapers or journals. Maybe you can do this after all upon your return from the US—there'll surely be many articles due then!!"

Abstract Expressionism did not begin to gain currency until 1954 in Germany, as Ursula Bluhm's letter dated 20 August 1954 suggests. Here she expressed to Grohmann chagrin over Karl Otto Götz's apparently successful self-aggrandizement; Götz was to show at the Springer Gallery in Berlin and "it would only be irritating if he again shows up with his Paris text, which absolutely falsifies the facts (that he is the initiator of this abstract-expressive style in Germany, & he's only been painting like this for 1/2 a year, while [Otto] Greis & Bernard [Schultze] have been doing it for over 2 years!)" — Stuttgart, Will Grohmann Archiv.

116. See ibid., letter from Grohmann to Franz Roh, dated 26 August 1954.

CHAPTER IV

1. Bernhard Lakebrink, "Der abendländische Mensch," *Neues Abendland* 2, nr.10 (1947): 289.

2. See Nürnberg, Archiv für Bildende Kunst, file on Edwin Redslob.

3. Ibid., letter from Redslob to the Arbeitsamt, Potsdam, dated 15 March 1943.

4. Ibid., letter from Hans Rosenberg to Redslob, dated 5 October 1949.

5. Ibid., letter from Maxwell D. Taylor to Redslob, dated 22 November 1949.

6. Ibid., letter from Hans Rosenberg to Mr. Elkinton, dated 1 October 1949. This is from a carbon copy of Rosenberg's letter, which he must have sent along to Redslob to keep him up to date on the funding search for his US trip.

7. Ibid., from the talk, "Education in Germany Today and Tomorrow," The FU Berlin, address by Dr. Edwin Redslob, President of the Free University of Berlin, at the General Session of the National Conference on the Occupied Countries, 9–10 December 1949, Washington, D.C.

8. Ibid., see the letter from Dr. Günther Birkenfeld of the Congress for Cultural Freedom to Redslob, January 1954.

9. The CCF in part derived from the United State's perceived need to counter the USSR's peace congress—the one to which Carl Hofer signed a greeting, earning him the wrath of West German students; see chapter Three.

10. Quoted in *ZEN49*, 19. Unfortunately, the catalog does not analyze the

ideological function of the CCF nor of Jaspers' statement, preferring to use the information given as a general socio-political backdrop for modern art's "development" in this period.

11. While I object to the racist as well as uncritical terminology in which Redslob et al. formulated anti-communism, I do not want to downplay the real danger of the German orthodox communists' restriction and finally extirpation of freedom in their domain.

12. Hans Eberhard Friedrich ["Editorial"], *Prisma* 1, nr.2 (1946): 1.

13. George J. Eliasberg, "Marx und die totalitäre Idee," *Amerikanische Rundschau* 4, nr.18 (1948):91–100. Eliasberg was born in Wiesbaden in 1906; he studied at the universities of Hamburg and Berlin. Active opposition to the National Socialist-regime brought him a sentence, in 1935, of four and one half years in prison. From 1941 on Eliasberg lived in the United States. According to the biographical information on the author, supplied by the *Amerikanische Rundschau* as a matter of course on all its contributors, we are also informed that in the United States, a book was published during the war dealing with the German underground, and that Eliasberg was "decisively" involved in its writing, albeit under a pseudonymn. Neither the book nor Eliasberg's alias are identified by the magazine.

14. Ibid., 91. The article is identified as being taken from a book in progress on the history of the Communist International.

15. Ibid., 93.

16. Ibid., 97.

17. Ibid., 98.

18. Ibid., 100.

19. Ibid., 94.

20. Arthur M. Schlesinger, Jr., "Über die Zukunft des Sozialismus," *Amerikanische Rundschau* 4, nr.17 (1948): 72–84. The article is identified as being from *Partisan Review*; it was published as, "The Future of Socialism: III; The Perspective Now," 14, nr.13 (May-June 1947): 220–242.

21. Ibid., 72; from the original, 229; this is a criticism Adorno would have endorsed.

22. Ibid., 73, from the original, 230.

23. Ibid., 74, from the original, 231.

24. See for example Max Horkheimer's articles in the Frankfurt School's "house organ," *Studies in Philosophy and Social Science*, especially volume 9 (1941), "Art and Mass Culture," 290–304 and "The End of Reason" 366–388.

25. Schlesinger, "Über die," 831, from the original, 240.

26. Ibid.

27. Ibid., 83–84; from the original, 242; the last clause—that the communist revolution is winning over the fascist one—is not, however, included in the German version.

28. Ibid., 84.

29. See for example Friedrich Krause, ed., *Dokumente des Anderen Deutschland*, vol.4: "Deutsche Innere Emigration," collected and commentated by Karl O. Paetel, with contributions by Carl Zuckmayer and Dorothy Thompson (New York: Verlag Friedrich Krause, 1946).

30. See Hans Eberhard Friedrich, "Von der reziproken Freiheit des Einzelnen," *Prisma* 1, nr.10 (1947): 1–3.

31. H.E.F. [Hans Eberhard Friedrich], "Die künstlerische Fragestellung der Gegenwart," *Prisma* 1, nr.10 (1947): 18.

32. Ibid. Note the similarity in some respects between Friedrich's argument about conventionalism and Behne's, quoted in chapter Two.

33. Eric H. Boehm, *We Survived: The Stories of Fourteen of the Hidden and the Hunted of Nazi Germany, as Told to E.H. Boehm* (New Haven: Yale University Press, 1949).

34. The magazine folded, two issues into the year, in 1950. Its demise might be linked to the birth of Melvin J. Lasky's *Der Monat*, the newly founded CCF's house organ.

35. Frank, review of Eric H. Boehm, *We Survived, Amerikanische Rundschau* 6, nr.29 (1950): 126.

36. See also Robert Haerdter's analysis of the situation, "Kollektivschuld," *Die Gegenwart* 1, nr.2/3 (1946): 11: "The reproach no German can be spared may be formulated quite broadly and without any psychological nuance as follows: namely, that while one is co-responsible for the existence of the 'Third Realm' because he voted for Hitler, the other is also responsible because, despite being an opponent of the regime, he did not do enough to prevent the 'seizure of power'; this formulation, in its simplicity, gets to the heart of the question. In the final analysis, however, it must be reiterated: once Hitler had succeeded in acquiring undivided power and forcing the German people under his 'leadership,' there no longer existed any possibility of breaking up the terror with revolutionary means, that is, collectively. Two dates from Germany's National Socialist history should have made this irrefutably apparent to any doubter, no matter where he stands: 30 June 1934 and 20 July 1944. Whoever stepped out of the silent shadow of opposition became a martyr, but not a saviour. He brought death or imprisonment on himself, but did not bring freedom to others, which alone would have justified his individual sacrifice before the collective of the people."

I believe that this could be another reason why communist opposition to Nazism is so discredited or at best left unmentioned, for communism is as systemic as the Nazi system it opposed.

37. And it would tell us nothing about why the audience for abstract art failed to differentiate between the different kinds of abstraction practiced by, for example, Nay and Werner.

One CIA-funded attempt to support Western European and Anglo-American economic and cultural interests and concurrently to counter communist cul-

tural influence is exemplified by the Congress for Cultural Freedom. The CCF drew many intellectuals into its orbit, who, for the most part, remained unaware of the CIA connection. See Christopher Lasch, "The Cultural Cold War," in *The Agony of the American Left* (New York: Random House, 1968).

38. See Washington, National Archives, OMGUS file # 5 301–2 (31), "Visiting Artists," 15 October 1947.

39. Ibid.; the two key people involved in getting this program off the ground were Benno Frank of Information Control Division and Dr. McClaskey of Education and Cultural Relations Division. In June 1948, the Cultural Exchange Branch became the Cultural Affairs Branch and in the process absorbed parts of the Information Services Division, formerly the Information Control Division. The files from Information Services Division were transferred to Education and Cultural Relations Division in September 1949. See the Bundesarchiv, Koblenz, "Overview" by archivist Josef Henke, of the OMGUS files. The Bundesarchiv microfiched substantial portions of the National Archives, Washington OMGUS files for its own archives and simultaneously tried to provide a systematic overview of the holdings, something entirely lacking in the U.S. archive where the files are numbered not according to department or subject matter, but rather according to the order in which shipment of the files was received by the National Archives. This makes it impossible, for instance, to access the ICD files if one does not know the batch or shipment number, which in turn is completely independent of the file's content. An inventory that would correlate file numbers with content has never been made.

40. Ibid.

41. The great reliance on individual personalities is stressed from the first. Thus, the Greater Hesse file # 5 298–3 (31) contains exchanges between Dr. Fritz Karsen, Chief, Higher Education and Teacher Training, OMGUS, Internal Affairs and Communications Division, Education & Religious Affairs Branch, and Max Horkheimer of the Frankfurt School, dated November and December 1946. The gist of the matter is that Karsen, in an influential position in OMGUS, and a personal acquaintance of Horkheimer, Adorno, Friedrich Pollock, and Felix Weil, was trying to do everything he could to facilitate Horkheimer's and the others' acceptance of the University of Frankfurt's offer to the *Institut* to return to its home city. As Karsen's letter, dated 24 December 1946, also notes: "The longer I stay in this country getting acquainted with the situation in various universities, the more I feel the necessity that people with a world-wide horizon should come to this country and teach here at least for a while. It is simply lamentable to see how many of the scientific institutions have gradually slipped down from the high standards which they were used to hold previously. [sic] There are mostly only very old men who can still claim to have some standing in the international world of science. Even those complain that they had been shut off from the currents of scientific life

outside of Germany." Of his own work in Berlin ("building up a school of advanced studies on the basis of scientific institutions of Berlin") he notes "The great problem with which we are faced is to find men of international reputation in the different fields here in this country. We are firmly decided not to let any institute of this new school come into existence until we have found the right personality to head it."

42. Washington, National Archives, OMGUS-ECR Div. file # 5 333–3 (2), William Constable, letter to Mrs. Woodsmall, dated 10 May 1949.

43. Ibid., "The Arts in Germany Today," Constable's report, October 1949.

44. It is hard to tell whether Constable's hope for some form of realism is widely shared by the staffers of Education and Cultural Relations Division, or whether it reflects the personal preference of the Boston-based curator. Recall that Boston's galleries and museums, unlike New York's, did not embrace Abstract Expressionism in the postwar period, and that they generally hung behind modern art developments. See *Dissent: The Issue of Modern Art in Boston*, Boston, The Institute for Contemporary Art, 1985.

45. "Washington, National Archives, OMGUS-ECR Div. file 5333–3 (2), William Constable, "Notes on a Programme of Art Exhibitions," memo dated 1 April 1949.

46. Ibid.

47. Ibid. Again, possibly a reflection of Constable's Bostonian tastes: note that he chooses New York's Museum of Modern Art for the relatively minor category of applied art, not for contemporary painting and sculpture. Constable, however, did consider applied art an important category in itself.

48. Ibid., "Art and Reorientation," Autumn 1949; it is slightly ironic that this Fluxus and Beuysian notion should here be propagated by someone so interested in the institution, while in the 1960s and '70s it was taken up as an original idea by opponents of the institution.

49. For a good general account of some of these aspects, see Jane de Hart Mathews, "Art and Politics in Cold War America," *American Historical Review* 81 (October 1976): 762–87.

50. Constable, "Art and Reorientation"; this reference was struck out in pencil, presumably by Constable's "editor," Dr. Alonzo G. Grace, Director of ECR Div. Subsequent criticisms by Constable of the Amerika-Häuser exhibitions can be found in his final report (p. 39): "The admirable work done by the Amerika Haeuser in many directions, should not be allowed to obscure the fact that the art exhibitions at most of them are lamentable. This is due to (a) the material supplied being poor and badly set up (b) ineffective arrangement and ineffective labelling. There are notable exceptions e.g. Frankfurt, where the director has pursued an independent policy in organizing exhibitions; and Regensburg, where satisfactory installations have been made." The Amerika-Häuser were part of Information Services Division.

51. Ibid., 32.

52. Ibid., 52.

53. Ibid., 63.

54. Washington, National Archives, OMGUS-ECR Div. file # 5 335–3 (1).

55. Ibid.

56. Berlin, Rathaus Schöneberg, Berliner Festwochen 1951, Senator für Volks-bildung, *Amerikanische Malerei; Werden und Gegenwart*, 20 September—5 October 1951, Rathaus Schöneberg; 10—24 October 1951, Schloss Charlottenburg.

57. The paintings by the latter two all came from the Betty Parsons Gallery.

58. Max Frisch, *Tagebuch 1946–1949* (Frankfurt: suhrkamp taschenbuch, 1985), 249–250; the journal was also published in hardcover by Suhrkamp in 1950.

59. French intellectuals more vehemently and unabashedly than German ones, whose views, after what they had been implicated in for the last twelve years, tended to be more moderate if not subdued.

60. th., "Optimismus auf der Einfuhrliste; An den Rand eines ameri-kanischen Monatsheftes notiert," *Die Gegenwart* 3, nr.19 (1948): 19.

61. Ibid.; the magazine in question is *Das Beste*, the German-language version of *Reader's Digest*.

62. Ibid.; the author goes on to say that instead of optimism and propa-ganda, Germany needs real, actual help: "Next to the scholarly promoter of American optimism, that business-administration educated importer of a commodity not easily sold in Germany, the general who imports food and raw materials, machines and wagons into our country appears like a miracle of enlightenment."

63. Josef K. Witsch and Max Bense, eds., *Almanach der Unvergessenen; Ein Gedenkbüchlein erstmalig erschienen im Jahre 1946* (Thüringen: Der Greifenverlag zu Rudolstadt, 1946). The editors hoped to publish the almanach annually, but never moved beyond the first and only issue.

64. Ibid., vii.

65. German art criticism of this period is almost exclusively devoted to one of these two modes: reading a newspaper article about an exhibition, one either gets nothing but a general report on line and color, or an endorsement of idealism. Interestingly, in neither case did I ever come away from such articles with a sense of how the art looked to the reviewer. There was, I thought, always a strong sense of eliminating subjective response in favor of high-minded "objective" reporting.

66. See for example Günter Grass, "Geschenkte Freiheit; Versagen, Schuld, vertane Chancen," *Die Zeit* 40, nr.20 (17 May 1985), 14–15.

67. Ursula Bluhm, in a letter to Will Grohmann, dated 27 March 1954 (see Grohmann-Archiv, Stuttgart), recounts an interesting encounter with the widow of the painter Wols, whom she and her husband Bernard Schultze had just visited in Paris. According to Mme. Wols, Wols knew precisely, before ever putting paint to canvas, how the painting was going to look when it was

finished. He saw each work before his "inner eye" first, sometimes spending hours lying on his bed, playing one of his nine musical instruments, waiting for the image to appear. Sometimes he would tell his wife that he saw the complete painting on his right eye, but had to wait a little longer before it became clear on his left (or vice versa). Once the image was clear, he would get up and start to paint, knowing exactly where each spot had to go.

This anecdote would seem to suggest that Wols' automatism operated with some notion of direct transcription, i.e., that Wols' art, too, is arch-subjective in that it strives for pure language or immediacy (the equation of mind's eye vision and painting). Painting is not that immediate, however.

On the French postwar art scene, see also my "New Unravellings of the Real? *Autre* Art's Threadbare Subject Meets the New Universalism," *Rutgers Art Review* 7 (1986):75–103. See also the collection of essays in *Reconstructing Modernism: Art in New York, Paris, and Montreal 1945–1964*, ed. Serge Guilbaut (Cambridge, MA: MIT Press, 1990).

68. See Adorno, *Negative Dialektik*, 174, 176, and 177, but also especially the section entitled "Das Schwindelerregende" (p. 44). In E. B. Ashton's translation this section ("Vertiginousness") starts on page 31 and is continued on page 33 under the heading "Fragility of Truth."

69. Werner Heldt, discussed briefly in chapter Two, is perhaps another example of a painter of this period still operating with a complex set of referents.

70. Adorno, *Negative Dialektik*, 65; Ashton translation, 55.

71. Ibid.

72. Ibid.

73. Ibid.; own translation. In Ashton translation (p. 55), the last clause is deleted: "It holds a place among the postulates of contents already known and fixed."

74. Ibid.; Ashton translation, 55–56.

75. Ibid., 66, own translation. Ashton's translation, (p. 56): "would mean to attempt a critical rescue of the rhetorical element, a mutual approximation of thing and expression, to the point where the difference fades."

76. In the original, "das undisziplinierte der Gebärde"; this is the phrase translated by Ashton simply as "undisciplined gestures" (p. 56).

77. While on Crete in 1965, Nay wrote down lengthy observations on his art, the artworld, and himself; they were published in part in *Ernst Wilhelm Nay; Die Druckgraphik*, ed. C. G. Heise and K. H. Gabler (Stuttgart: Belser Verlag, 1975); the following excerpt, reprinted in *E. W. Nay; Bilder und Dokumente* (p. 211), illuminates Nay's views on the importance of (self-)degradation: "Only degradation pushes art on. And—without this being of psychoanalytical use—I value degradation. The degraded and insulted of this earth interest me—and I don't help them, for they have an advantage. Even if they don't understand it and don't know how to use it for their own good. I hide this

desire for degradation from others; it propels me, and others would not understand this or would interpret it as masochism. Yet my I oscillates between saying yes and saying no to itself. And the no usually dominates, that pushes me on. I don't want anything—I don't want anything—no utopic world improvements, no threats of a moral, ethical, or idealistic type, but to be as I am and to paint as this 'I am' liberates itself out of me. For I live all out, out of every pore, and nothing in me [no part of me] has the upper hand."

78. See Nürnberg, Archiv für Bildende Kunst, file on E. W. Nay, newspaper clipping of an article by C. Meyer (corrected in margin as C. Weyer), "Der Maler Nay erhielt Kölner Kunstpreis," *Hannoverscher Presse* (8 August 1952).

79. Although Meyer/Weyer refers to Soulages, *informel* was not widely received in Germany until after 1952, and Soulages' work does not represent it as much as Wols'. See Stuttgart, Will Grohmann Archiv, letter from Ursula Bluhm to Grohmann, dated 4 May 1954, in which she critiques an article by Anthony Thwaites, an English art critic resident in Munich, which appeared in *Das Kunstwerk* and in which Thwaites, according to Bluhm, blunderingly misinterprets Werner, Winter, and Hartung as pursuing stylistic strategies that are proper to *informel*, when in fact the work of the three painters discussed by Thwaites is still caught in the logic of illusionism. Bluhm cites Wols and Pollock as the "starting point" of the dissolution of the illusionistic space in the abstract picture.

80. Adorno, *Negative Dialektik*, 133.

81. In an interview with Dr. Greta Domnick, the widow of Dr. Ottomar Domnick, on 3 September 1990, Dr. Domnick made it very clear that she and her husband were quite uninterested in collecting any works of *art informel*, with the exception of Hans Hartung, whom they did not interpret as in any way an automatist. They also did not make a point of collecting Nay.

BIBLIOGRAPHY

ARCHIVES

Berlin. Haus am Waldsee Archiv. Internal files on immediate postwar exhibition activities.

Berlin. Landesarchiv. Files on Berlin cultural activities in immediate postwar period.

Koblenz. Bundesarchiv. OMGUS files (microfiched copies).

Nürnberg. Archiv für Bildende Kunst. Files on E. W. Nay, Georg Meistermann, Otto Dix, Werner Heldt, Kurt Martin, Edwin Redslob, and Franz Roh.

Stuttgart. Will Grohmann Archiv. Correspondence and personal papers from pre- and post-World War II period relating to modern art.

Washington, D.C. National Archives. Office of Military Government for Germany, United States (OMGUS) files.

INTERVIEWS

Elisabeth Nay-Scheibler, 27 August 1988; 20 December 1989.

Sophie Franke, 28 January 1990.

Dr. Greta Domnick, 3 September 1990.

BOOKS AND ARTICLES

"Abgrund ohne Gesicht; Der 20. Juli 1944—gefilmt." *Die Gegenwart* 3, nr.13 (1948):19–20.

Adama von Scheltema, F. "Ist der Expressionismus noch 'Junge Kunst'?" *Prisma* 1, nr.2 (1946):17–18.

Adorno, Theodor W. *Ästhetische Theorie.* Ed. Gretel Adorno and Rolf Tiedemann. 3rd ed. Frankfurt a.M.: Suhrkamp Taschenbuch Verlag, 1977.

———. "Auferstehung der Kultur in Deutschland?" *Frankfurter Hefte* 5 (May 1950):469–77.

———. *Negative Dialektik.* 5th ed. Frankfurt a.M.: Suhrkamp-Taschenbuch Wissenschaft, 1988.

———. "Subject and Object." In *The Essential Frankfurt School Reader.* Ed. Andrew Arato and Eike Gerhardt. New York: Urizen Books, 1978.

Adorno, Theodor W., and Max Horkheimer. *Dialektik der Aufklärung: Philosophische Fragmente.* Amsterdam, 1947. Repr. ed. Frankfurt a.M.: S. Fischer Verlag, 1969.

Andersch, Rudolf. "Vom Sinn der Malerei." *Frankfurter Hefte* 3 (February 1948):183.

Adriani, Götz, ed. *Baumeister: Dokumente, Texte, Gemälde*. Cologne: Verlag M.DuMont Schauberg, 1971.

"Aus dem Notizbuch der Redaktion." *Das Kunstwerk* 2, nr.3/4 (1948):73; nr.7 (1948):47–48; nr.9 (1948):55–56; nr.10 (1948):49–50; *Das Kunstwerk* 3, nr.4 (1949):51; nr.6 (1949):61–62; nr.8 (1949):54; *Das Kunstwerk* 4, nr.1 (1950): 50–52.

B.R. [Benno Reifenberg]. "Am lebenden Objekt." *Die Gegenwart* 2, nr.21/22 (1947):7–8.

———. "Bücher von heute; Befreiendes Schreiben." *Die Gegenwart* 3, nr.22 (1948):18–19.

———. "Deutschlands Verstummen." *Die Gegenwart* 1, nr.4/5 (1946):7–9.

———. "Die schwerste Sorge." *Die Gegenwart* 1, nr.10/11 (1946):9–11.

Baden-Baden. Staatliche Kunsthalle. *Berliner Neue Gruppe 1954*. Exh.Cat. 1954.

Baden-Baden. Staatliche Kunsthalle. *ZEN 49*. See under Poetter, Jochen.

Balzer, Wolfgang. "Die allgemeine deutsche Kunstausstellung in Dresden 1946." *Zeitschrift für Kunst* 1, nr.1 (1947):56–66.

Barthel, Gustav. "Deutsche Kunsthistorikertagung in München." *Das Kunstwerk* 3, nr.8 (1949):55.

Barthes, Roland. "Myth Today." In *A Barthes Reader*. ed. Susan Sontag. New York: Hill and Wang, 1982.

Bartsch, Juliane. "Augsburg; Extreme Malerei." *Aussaat* 1, nr.10/11 (1947): 56–57.

———. "Konstanz; Kunstwoche 1946." *Aussaat* 1, nr.4 (1946):33–34.

———. "München; Bildende Kunst." *Aussaat* 1, nr.8/9 (1946/47):62–63.

———. "München; Gegenwartstheater." *Aussaat* 1, nr.10/11 (1947):60–61.

Bauer, Arnold. "Buchkritik; Das gute Recht des letzten Zivilisten; Anmerkungen zu zwei zeitgenössischen Selbstbekenntnissen." *Die Fähre* 2, nr.4 (1947):251–54.

———. "Buchkritik; Stimmen des nationalen Wissens; Bücher zur deutschen Katastrophe." *Die Fähre* 2, nr.3 (1947):184–88.

Baumeister, Willi. *Das Unbekannte in der Kunst*. Stuttgart: Curt E. Schwab Verlagsgesellschaft, 1947.

———. *Magie der Form*. Intro. Franz Roh. Baden-Baden: Woldemar Klein, 1954.

———. "Offener Brief an André Malraux." *Das Kunstwerk* 1, nr.8/9 (1946/47):79.

Behne, Adolf. "Was will die moderne Kunst?" *Bildende Kunst* 2, nr.1 (1948):3–6. 3–6.

Berglar-Schröer, Hans-Peter. "Die Vertrauenskrise der Jugend." *Frankfurter Hefte* 2 (July 1947):693–701.

Berlin. Charlottenburg. *Deutscher Künstlerbund 1950; Erste Ausstellung*. Exh.Cat. 1951.

Berlin. Charlottenburg. *Berliner Neue Gruppe 1952; Als Gäste die Mittlere Generation der Zeitgenössischen Maler Frankreichs.* Exh.Cat. 1952.

Berlin. Deutsches Historisches Museum. *1.9.39—Ein Versuch über den Umgang mit Erinnerung an den Zweiten Weltkrieg,* 1 September—1 October 1989. Exh.Cat.

Berlin. Direction Générale des Affaires Culturelles, Service des Relations Artistiques, Mainz. *Französische Malerei und Plastik 1938–1948,* May—June 1950. Exh.Cat.

Berlin. Galerie Franz. *Zone 5; Karl Hartung, Jeanne Mammen, Hans Thiemen, Heinz Trökes, Hans Uhlmann, Mac Zimmermann,* 4 September—20 October 1948. Exh.Cat.

Berlin. Galerie Gerd Rosen. *Almanach 1947.*

Berlin. Galerie Gerd Rosen. *Sammelband der Faltblätter.* Exh.Cat. 1946.

Berlin. Hochschule für Bildende Künste. *Werke Französischer Meister der Gegenwart,* 11 September-12 October 1952. Exh.Cat.

Berlin. Hochschule fr Bildende Knste. *Werke Französischer Meister der Gegenwart,* 11 September-12 October 1952. Exh.Cat.

Berlin. Kammer der Kunstschaffenden. *1. Kunstausstellung,* July—August 1945. Exh.Cat.

Berlin. Königliches Schloss. *La Peinture Française Moderne,* 22 October—6 November 1946. Exh.Cat.

Berlin. Neue Gruppe. *Berliner Neue Gruppe 1950.* Exh.Cat. 1950.

Berlin. Rathaus Schöneberg. Berliner Festwochen 1951. Senator für Volksbildung. *Amerikanische Malerei; Werden und Gegenwart,* 20 September—5 October 1951 (Rathaus Schöneberg), 10—24 October 1951 (Schloss Charlottenburg). Exh.Cat.

Berlin. Schloss Charlottenburg. *Berliner Neue Gruppe 1950.* Exh.Cat. 1950.

Berlin. Schloss Charlottenburg. *Berliner Kunstausstellungen,* December 1950. Exh.Cat.

Berlin. Senat. *Berlin: Quellen und Dokumente 1945–1951.* 2 vols. Berlin: Heinz Spitzing Verlag, 1964.

Berlin. Staatsbibiliothek Preussischer Kulturbesitz. *Flugblätter des Nationalkomitees Freies Deutschland,* 29 September—2 November 1989. Exh.Cat.

Berlin-East. Staatliches Museum am Kupfergraben; Verband Bildender Künstler im Kulturbund zur demokratischen Erneuerung Deutschlands. *Künstler schaffen für den Frieden,* 1 December 1951—31 January 1952. Exh.Cat.

Berlin-Lichterfelde. Volksbildungsamt Steglitz. *Nach 12 Jahren.* Exh.Cat. 1945.

Berlin-Zehlendorf. Haus am Waldsee. *Berliner Neue Gruppe; Erste Ausstellung,* June—July 1949. Exh.Cat.

Berlin and Stuttgart. Herbert Rund. Sammlung Zeitgenössischer Kunst. *Berliner Künstler; Wanderaus stellung 1949.* Exh.Cat. 1949.

"Berlin oder Frankfurt?" *Neues Abendland* 1, nr.4 (1946): 23–28.

Bernal, Martin. *Black Athena: The Afroasiatic Roots of Classical Civilization*. Vol.1: *The Fabrication of Ancient Greece 1785–1985*. New Brunswick, N.J.: Rutgers University Press, 1987.

Besser, Joachim. "Neuwertung der Vergangenheit; Die deutschen Zeitschriften im Kampf um ein neues Geschichtsbild." *Die Sammlung* 2 (1946/47):574–84.

Blackbourn, David, and Geoff Eley. *The Peculiarities of German History: Bourgeois Society and Politics in Nineteenth-Century Germany*. Oxford and New York: Oxford University Press, 1984.

Blücher, Heinrich. "Nationalsozialismus und Neo-nationalismus." *Amerikanische Rundschau* 5, nr.24 (1949):110–17.

Bodensiek, K.H. "Vom Expressionismus zur neuen Wirklichkeit." *Die Sammlung* 2 (1946/47):263–67.

Boeck, Wilhelm. "Bilderverfolgung." *Das Kunstwerk* 1, nr.8/9 (1946/47):65–68.

Böttcher, Karl Wilhelm. "Die junge Generation und die Parteien; Bericht über ein Gespräch." *Frankfurter Hefte* 3 (August 1948):756–61.

Bohrer, Karl Heinz. *Die Kritik der Romantik: Der Verdacht der Philosophie gegen die literarische Moderne*. Frankfurt: edition suhrkamp 1551, 1989.

Bonn. Münsterschule. *Berliner Künstler; Malerei, Grafik, Plastik*, 27 July—27 August 1950. Exh.Cat.

Bonn. Rheinisches Landesmuseum. *Werner Gilles 1894–1961— Ein Rückblick*. Exh.Cat. 1973.

Bourniquel, Camille. "Magie, surréalisme et liberté." *Esprit* 15 (November 1947):775–82.

Brecht, Bert. "Die Jugend und das Dritte Reich." *Die Fähre* 2, nr.3 (1947):138.

Broch, Hermann. "Geschichtsmystik und künstlerisches Symbol." *Die Fähre* 1, nr.1 (1946):41–47.

Buck-Morss, Susan. "Aesthetics and Anaesthetics: Walter Benjamin's Artwork Essay Reconsidered," *October* 62 (fall 1992):3–41

Burgmüller, Herbert. "Buchkritik; Bilanz." *Die Fähre* 2, nr.5 (1947):316–17.

———. "Buchkritik; Schriften zur Zeit." *Die Fähre* 2, nr.11 (1947):701–2.

Busch, G. "Bremen; Bremer Kunsthalle." *Aussaat* 1, nr.10/11 (1947):57–58.

Cassirer, Ernst. "Der Mythos als politische Waffe." *Amerikanische Rundschau* 3, nr.11 (1947):30–41.

Christoffel, Ulrich. "Nature Morte." *Das Kunstwerk* 2, nr.7 (1948):5–12.

Clark, T. J. *The Absolute Bourgeois: Artists and Politics in France 1848–1851*. London: Thames and Hudson Ltd., 1973.

———. *Image of the People: Gustave Courbet and the 1848 Revolution*. London: Thames and Hudson Ltd., 1973.

———. *The Painting of Modern Life: Paris in the Art of Manet and His Followers*. New York: Alfred A. Knopf, 1985.

Cockcroft, Eva. "Abstract Expressionism, Weapon of the Cold War." *Artforum* 12 (June 1974):39–41.

Cologne. Josef-Haubrich Kunsthalle. *Retrospektive E. W. Nay/ E. W. Nay: A Retrospective*, 17 November 1990—20 January 1991. Exh.Cat.

Consulat Générale de France à Düsseldorf. *La Réalité Quotidienne des Echange Franco-Allemands*. Strassbourg: Istra, 1970.

Corino, Karl. *Intellektuelle im Bann des Nationalsozialismus*. Hamburg: Hoffmann und Campe, 1980.

Craig, Gordon A. *The Germans*. New York: G.P. Putnam's Sons, 1982.

Dean, Carolyn J. *The Self and Its Pleasures: Bataille, Lacan, and the History of the Decentered Subject*. Ithaca and London: Cornell University Press, 1992.

Dirks, Walter. "Das Abendland und der Sozialismus." *Frankfurter Hefte* 1 (June 1946):67–76.

———. "Die Krise der Mitte." *Frankfurter Hefte* 3 (July 1948):591–96.

———. "Rechts und Links." *Frankfurter Hefte* 1 (September 1946):24–37.

———. "Der Weg zur Freiheit; Ein Beitrag zur deutschen Selbsterkenntnis." *Frankfurter Hefte* 1 (July 1946):50–60.

———. "Die zweite Republik; Zum Ziel und zum Weg der deutschen Demokratie." *Frankfurter Hefte* 1 (April 1946):12–24.

Domnick, Ottomar. *Die schöpferischen Kräfte in der abstrakten Malerei; Ein Zyklus*. Bergen: Müller & Kiepenheuer Verlag, 1947.

Ebel, Lilo. "Deutsche Kunst der Gegenwart." *Frankfurter Hefte* 3 (May 1948): 476–79.

"Ein Brief aus Amerika und sein europäisches Echo." *Das Kunstwerk* 4, nr.8/9 (1950):105–6.

Einem, Herbert von. "Gedanken zur Geschichte der deutschen bildenden Kunst des 19. und 20. Jahrhunderts." *Die Sammlung* 1 (1945/46):169–79.

Eliasberg, George J. "Marx und die totalitäre Idee." *Amerikanische Rundschau* 4, nr.18 (1948):91–100.

1.9.39—Ein Versuch über den Umgang mit Erinnerung an den Zweiten Weltkrieg. Berlin: Deutsches Historisches Museum, 1989.

es. "Antike als Bild und Vorbild." *Frankfurter Hefte* 4 (July 1949):626–28.

Evers, Hans Gerhard, ed. *Darmstädter Gespräch; Das Menschenbild in unserer Zeit*. Darmstadt: Neue Darmstädter Verlagsanstalt GmbH [1950].

Farías, Victor. *Heidegger und der Nationalsozialismus*. Trans. Klaus Laermann. Frankfurt a.M.: S. Fischer Verlag, 1989.

Fink, Joseph. "Das griechische Antlitz." *Aussaat* 1, nr.10/11 (1947):36–39.

Flake, Otto. "Friedrich Nietzsche." *Prisma* 1, nr.9 (1947):21–26.

Ford, Franklin L. "Der zwanzigste Juli." *Amerikanische Rundschau* 3, nr.11 (1947):5–17.

Foucault, Michel. "Regieren—eine späte Erfindung." Trans. Thierry Cherval. *Tageszeitung* (13 October 1989): 33–35.

Freiburg i.B. Kunstverein. *Deutsche Gegenstandslose Malerei und Plastik der Gegenwart*, 4—27 June 1950. Exh.Cat.

Fried, Michael. "Courbet's 'Femininity.'" In *Courbet Reconsidered*. Ed. Sarah Faunce and Linda Nochlin. Brooklyn: The Brooklyn Museum, November 1988. Exh.Cat.

Friedländer, Saul. *Kitsch und Tod; Der Widerschein des Nazismus*. Trans. Michael Grendacher. Munich: Carl Hanser Verlag, 1984.

Friedrich, Hans Eberhard. ["Editorial."] *Prisma* 1, nr.2 (1946):1–3.

———. "Von der reziproken Freiheit des Einzelnen." *Prisma* 1, nr.10 (1947): 1–3.

Frisch, Max. *Tagebuch 1946–1949*. Frankfurt a.M.: suhrkamp taschenbuch, 1985.

50 Jahre Galerie Günther Franke; Nay; Bilder Aquarelle Gouachen Zeichnungen: Graphik aus Sammlung und Galerie Günther Franke. Munich: Verlag Günther Franke, 1973.

"Für Deutschlands Einheit." *Bildende Kunst* 2, nr.2 (1948): 28.

Gadamer, Hans Georg. *Hegel's Dialectic: Five Hermeneutical Studies*. Trans. P. Christopher Smith. New Haven and London: Yale University Press, 1976.

"Getreues Spiegelbild; Querschnitt durch die Buchverlags-Produktion (II)." *Die Gegenwart* 3, nr.1/2 (1948):19–27.

Gide, André. "Über den Klassizismus." Trans. Friedhelm Kemp. *Prisma* 1, nr.3 (1947):18–19.

Glaser, Hermann, Lutz von Pufendorf, and Michael Schöneich, eds. *Soviel Anfang war nie; Deutsche Städte 1945–1949*. Berlin: Wolf Jobst Siedler Verlag GmbH, 1989.

Gowans, Alan. "A-Humanism, Primitivism, and the Art of the Future." *College Art Journal* 11 (summer 1952):226–39.

Grass, Günter. "Geschenkte Freiheit; Versagen, Schuld, vertane Chancen." *Die Zeit* 40, nr.20 [Overseas Edition] (17 May 1985): 14–15.

Greenberg, Clement. "The Present Prospects of American Painting and Sculpture." *Horizon* 93–94 (October 1947):20–30.

Grimme, Adolf. "Jugend und Demokratie." *Die Sammlung* 1 (1945/46):411–21.

Groll, Gunter. "Realisten und Romantiker." *Prisma* 1, nr.10 (1947):17–18.

Grosser, Alfred. *The Federal Republic of Germany: A Concise History*. Trans. Nelson Aldrich. New York: Frederick A. Praeger, Publishers, 1964.

———. *The Western Alliance: European-American Relations Since 1945*. Trans. Michael Shaw. New York: Vintage Books, 1982.

Grundig, Hans. "Berichte und Berechtigungen; Dresdener Bilanz; Betrachtungen zur ersten allgemeinen deutschen Kunstausstellung." *Prisma* 1, nr.2 (1946):33–34.

Gu [Bernhard Guttmann]. "Der Wert des Einzelnen." *Die Gegenwart* 1, nr.14/15 (1946):9–10.

Guérard, Albert. "Thomas Mann und unsere Zeit." *Amerikanische Rundschau* 3, nr.11 (1947):56–62.

Guilbaut, Serge. *How New York Stole the Idea of Modern Art; Abstract Expressionism, Freedom, and the Cold War.* Trans. Arthur Goldhammer. Chicago: University of Chicago Press, 1983.

———. *Reconstructing Modernism: Art in New York, Paris, and Montreal 1945–1964.* Cambridge, MA: MIT Press, 1990.

Guttmann, Bernhard. "Die Funktion des Widerstandes." *Die Gegenwart* 4, nr.6 (1949):7–9.

H.E.F. [Hans Eberhard Friedrich]. "Die künstlerische Fragestellung der Gegenwart." *Prisma* 1, nr.10 (1947): 18–19.

H.L. [Heinz Lüdecke]. "Die ersten Berliner Herbstaus stellungen." *Bildende Kunst* 1, nr.7 (1947):27.

———. "Marc Chagall und der 'psychische Formalismus.'" *Bildende Kunst* 1, nr.8 (1947):11.

———. "Rückblick auf die Berliner Frühjahrsaus stellungen." *Bildende Kunst* 2, nr.5 (1948):27, 30.

H.T. "Ausstellungen; Deutsche Kunstreise." *Das Kunstwerk* 2, nr.8 (1948): 43–44.

Habermas, Jürgen. *Politik, Kunst, Religion: Essays über zeitgenössische Philosophen.* Stuttgart: Philipp Reclam jun., 1978.

———. *Der philosophische Diskurs der Moderne: Zwölf Vorlesungen.* Frankfurt a.M.: Suhrkamp Verlag, 1985.

Heeg-Erasmus, Fritz. "Einführung in die moderne Malerei." *Aussaat* 2, nr.1/2 (1947):23–27.

Hegel, Georg Wilhelm Friedrich. *Vorlesungen über die Ästhetik.* Intro. Rüdiger Bubner. 2 vols. Stuttgart: Philipp Reclam jun., 1971.

Heibel, Yule. "New Unravellings of the Real? *Autre* Art's Threadbare Subject Meets the New Universalism," *Rutgers Art Review* 7 (1986):75–103.

Heidegger, Martin. "Brief über den Humanismus." In *Gesamtausgabe; Band 9: Wegmarken.* Frankfurt: Vittorio Klostermann, 1979.

———. *The Question Concerning Technology and Other Essays.* Trans. William Lovitt. New York and London: Garland Publishing, Inc., 1977.

———. *Der Ursprung des Kunstwerkes.* Intro. Hans-Georg Gadamer. Stuttgart: Philipp Reclam jun., 1960.

Heilbut, Anthony. *Exiled in Paradise: German Refugee Artists and Intellectuals in America, from the 1930s to the Present.* Boston: Beacon Press, 1984.

Heise, Carl Georg, and Karl Heinz Gabler, eds. *E. W. Nay: Die Druckgraphik.* Stuttgart: Belser Verlag, 1975.

Held, Jutta. *Kunst und Kunstpolitik 1945–49: Kulturaufbau in Deutschland nach dem 2. Weltkrieg.* Berlin: Verlag für Ausbildung und Studium in der Elefanten Presse, 1981.

Heller, Thomas C., Morton Sonsa, and David E. Wellbery, eds. *Reconstructing Individualism: Autonomy, Individuality, and the Self in Western Thought.* Stanford: Stanford University Press, 1986.

Hennecke, Hans. "Deutsche Lyrik—Heute." *Die Fähre* 2, nr.5 (1947):269–78.

Henze, Anton. "Absolute Malerei in Amerika." *Das Kunstwerk* 2, nr.5/6 (1948): 66–68.

———. "Abstrakt—Absolut—Konkret?" *Das Kunstwerk* 2, nr.1/2 (1948):37–38.

———. "Zum Verständnis abstrakter Malerei." *Das Kunstwerk* 1, nr.8/9 (1946/47): 8–9.

Herding, Klaus. "Humanismus und Primitivismus; Probleme früher Nach-kriegskunst in Deutschland." *Jahrbuch des Kunsthistorischen Instituts* 4 (1989).

Hermand, Jost. "Modernism Restored: West German Painting in the 1950s." *New German Critique* 11 (spring/summer 1984):23–41.

Hildebrandt, Hans. "Impressionisten; II. Edgar Degas." *Aussaat* 1, nr.2 (1946):12–17.

Hilldring, John H. "Amerikas Absichten in Deutschland." *Amerikanische Rundschau* 4, nr.19 (1948):3–9.

Hippel, Fritz von. "Nationalsozialistische Herrschafts ordnung als Warnung und Lehre; Eine juristische Betrachtung." *Die Sammlung* 1 (1945/46):285–96; 351–63; 394–404.

Hofer, Carl. "Kunst und Politik." *Bildende Kunst* 2, nr.10 (1948):20–22.

Holz, Hans Heinz. "Marburg-Wiesbaden; Bildende Kunst." *Aussaat* 1, nr.8/9 (1946/47):61–62.

Horkheimer, Max. "Art and Mass Culture." *Studies in Philosophy and Social Science* 9 (1941):290–304.

———. "The End of Reason." *Studies in Philosophy and Social Science* 9 (1941): 366–88.

Huyghe, René. "Das Zeitalter des Absurden." *Die Quelle* 1, nr.1 (1947):6–19.

Iggers, George G. *The German Conception of History: The National Tradition of Historical Thought from Herder to the Present.* Middletown, Conn., 1968.

Imperialismus und Kultur. Institut für Gesellschafts wissenschaften beim ZK der SED, Lehrstuhl für marxistisch-leninistische Kultur-und Kunstwissen-schaften. Munich: Damnitz Verlag, 1975.

"Ins zweite Jahr." *Bildende Kunst* 2, nr.1 (1948):1.

Jay, Martin. *Marxism and Totality: The Adventures of a Concept from Lukács to Habermas.* Berkeley and Los Angeles: University of California Press, 1984.

K.P. "Deutsche Kunst der Gegenwart in Baden-Baden." *Bildende Kunst* 1, nr.8 (1947):19.

Kahnweiler, Daniel-Henri. *Der Weg zum Kubismus.* Munich: Delphin-Verlag, 1920.

———. *Juan Gris: His Life and Work.* New York: Curt Valentin, 1947.

Karlsruhe. Staatliche Kunsthalle. *Gegenstandslose Malerei in Amerika,* March/April 1948. Exh.Cat.

Karlsruhe. Staatliche Kunsthalle. *Kunst unserer Zeit in Neuerwerbungen der Staatlichen Kunsthalle Karlsruhe 1948–1955.* Baden-Baden: Woldemar Klein Verlag, 1955.

Kassel. *Dokumenta: Kunst des XX. Jahrhunderts*. Munich: Prestel Verlag, 1955.

Kecskemeti, Paul. "Existentialismus." *Amerikanische Rundschau* 3, nr.13 (1947): 80–96.

Kinkel, Hans. "Zweite Deutsche Kunstausstellung Dresden 1950." *Das Kunstwerk* 4, nr.1 (1950):44–45.

Klein, Woldemar, and Leopold Zahn. [Editorial]. *Das Kunstwerk* 1, nr.6 (1946/47):1.

Klug, Ulrich. "Universalität und Totalität; Zum drei hundertsten Geburtstag von Gottfried Wilhelm Lessing." *Die Fähre* 1, nr.4 (1946):201–8.

Kogon, Eugen. "Deutschland von heute." *Frankfurter Hefte* 4 (July 1949):569–82.

———. "Demokratie und Föderalismus." *Frankfurter Hefte* 1 (September 1946): 66–78.

———. "Gericht und Gewissen." *Frankfurter Hefte* 1 (April 1946):25–37.

———. "Nürnberg und die Geschichte." *Frankfurter Hefte* 1 (April 1946):3–5.

Kolko, Gabriel. *Main Currents in Modern American History*. Repr. ed. New York: Pantheon Books, 1984.

Kraft, Werner. "Karl Kraus und die Sprache." *Die Fähre* 1, nr.6 (1946):373–79.

Krause, Friedrich, ed. *Dokumente des Anderen Deutschland*. Vol.4: *Deutsche Innere Emigration: Anti-Nationalistische Zeugnisse aus Deutschland*. Compiled by Karl O. Paetel. New York: Verlag Friedrich Krause, 1946.

Krauss, Werner. "Über den Zustand unserer Sprache." *Die Gegenwart* 2, nr.2/3 (1947):29–32.

Kristol, Irving. "Was die Leichenschau zeigt." *Amerikanische Rundschau* 4, nr.22 (1948):26–43.

Kühn, Herbert. "Moderne Kunst und Kunst der Vorzeit." *Das Kunstwerk* 4, nr.8/9 (1950):6–9.

"Das kulturelle Leben." *Die Quelle* 1, nr.2 (1947):116–28.

Kupffer, Heinrich. *Der Faschismus und das Menschenbild in der deutschen Pädagogik*. Frankfurt: Fischer Tachenbuch Verlag, GmbH, 1984.

Kurtz, Waldemar. "Elementare Kunst." *Prisma* 1, nr.10 (1947):19–20.

Kusenberg, Kurt. "Über den Surrealismus." *Das Kunstwerk* 4, nr.5 (1950):5–9.

Lakebrink, Bernhard. "Der abendländische Mensch." *Neues Abendland* 2, nr.10 (1947):289–92.

Lasch, Christopher. *The Agony of the American Left*. New York: Random House, 1968.

Lauretis, Teresa de. *Technologies of Gender: Essays on Theory, Film, and Fiction*. Bloomington and Indianapolis: Indiana University Press, 1987.

"le Reich." *Die Gegenwart* 3, nr.23 (1948):1–2.

Lenk, Elisabeth. *Die unbewusste Gesellschaft: Über die mimetische Grundstruktur in der Literatur und im Traum*. Munich: Matthes & Seitz Verlag, 1983.

Leonhard, Kurt. "Abstrakte und Subjektive Franzosen in Stuttgart." *Das Kunstwerk* 3, nr.3 (1949):54.

———. "Kunstgespräche; In Darmstadt." *Das Kunstwerk* 4, nr.8/9 (1950):103.

———. "Picasso." *Das Kunstwerk* 1, nr.8/9 (1946/47):18–29.

Leuteritz, Gustav. "Französische Malerei in Berlin." *Bildende Kunst* 1, nr.1 (1947):16–19.

Leverkusen. Städtisches Museum. *Thema Informel*, February/March 1973. Exh.Cat.

Lex, Alice. "Die Kunst im Werden eines neuen Weltbildes." *Bildende Kunst* 2, nr.4 (1948):18–20.

Lindemann, Dr. "Junge französische Malerei in Düsseldorf." *Das Kunstwerk* 4, nr.3 (1950):64–66.

Lipman, Jean. "Primitives Sehen und modernes Gestalten; Zwei Perioden der amerikanischen Malerei." *Amerikanische Rundschau* 1, nr.3 (1945):45–52.

Loeper, Charlotte von. "Wo steht die Frauenbewegung heute? Gedanken zur Frauentagung in Bad Pyrmont." *Die Sammlung* 2 (1946/47):398–401.

Lüdecke, Heinz. "Die Bezüglichkeit des Beziehungslosen." *Bildende Kunst* 1, nr.7 (1947):9–13.

———. "Der denkende Künstler." *Bildende Kunst* 2, nr.8 (1948):3–9.

———. "Kunst in allen Sektoren und Zonen." *Bildende Kunst* 1, nr.6 (1947): 24–28.

———. "Rückblick und Fazit zum Jahresschluss." *Bildende Kunst* 2, nr.1 (1948):22–24.

———. "Über das Grundübel unserer Welt." *Bildende Kunst* 3, nr.6 (1949):180.

———. "Wie kann den Künstlern geholfen werden?" *Bildende Kunst* 3, nr.1 (1949):14–15.

Ludwigsburg. Deutsch-Französisches Institut. *Deutschland-Frankreich: Ludwigsburger Beiträge zum Problem der Deutsch-Französischen Beziehungen.* Stuttgart: Deutsche Verlags Anstalt, 1966.

Lyotard, Jean-François. "Nés en 1925." *Les Temps Modernes* 3 (1948):2052–7.

M.v.B. "Die Sphinx ist nicht tot." *Die Gegenwart* 3, nr.24 (1948):17–19.

Machui, Artur von. "Dem Gedächtnis Adolf Reichweins." *Die Sammlung* 1 (1945/46):1–11.

Maier, Charles S, ed. *The Origins of the Cold War and Contemporary Europe.* New York and London: New Viewpoints, 1978.

Mann, Anthony. *Comeback: Germany 1945–1952.* London: Macmillan London Limited, 1980.

Mann, Thomas. *Doktor Faustus.* Frankfurt a.M.: Fischer Taschenbuch, 1990.

Martin, Kurt. "Abschiedsworte zu zwei von uns scheidenden Kunstfreunde." *Das Kunstwerk* 3, nr.7 (1949):[53].

———. *Erinnerungen an die französische Kulturpolitik in Freiburg i. Br. nach dem Kriege.* Siegmaringen: Jan Thorbecke Verlag KG, 1974.

Mathews, Jane de Hart. "Art and Politics in Cold War America." *American Historical Review* 81 (October 1976):762–87.

Matthias, Carl-Ernst. "Künstlerkongress in Dresden." *Bildende Kunst* 1, nr.1 (1947):3–11.

Mayer, Dr. Hanns. "Deutscher Existenzialismus vor zwanzig Jahren; Hans Henny Jahn, Perrudja erscheint neu im Willi Weismann Verlag, München." *Die Fähre* 2, nr.9 (1947):572–73.

Mehring, Walter. "Kunst und Ideologie; Eine Betrachtung." *Amerikanische Rundschau* 4, nr.20 (1948):115–20.

Mertens, Christian. "'Abstrakte Malerei'; Aus Anlass einer Ausstellung." *Frankfurter Hefte* 3 (February 1948):185–87.

Minssen, Friedrich. "Der Widerstand gegen den Widerstand." *Frankfurter Hefte* 4 (October 1949):884–88.

Mitscherlisch, Alexander. "Die schwersten Stunden; Über schlag eines Jahres." *Die Fähre* 1, nr.3 (1946):131–38.

"Die moderne Kunst auf der Nymphenburger Kunsthistoriker tagung." *Das Kunstwerk* 3, nr.9 (1949):56.

Mörchen, Hermann. *Macht und Herrschaft im Denken von Heidegger und Adorno.* Stuttgart: Klett-Cotta, 1980.

Münster, Clemens. "Deutsche Malerei und Plastik der Gegenwart." *Frankfurter Hefte* 4 (July 1949):625–26.

———. "Versuch über moderne Malerei." *Frankfurter Hefte* 1 (June 1946): 33–43.

Munich. Museum Villa Stuck. *Hommage à Günther Franke,* 1 July—18 September 1983. Exh.Cat.

Munich. Stadtmuseum. *Zwischen Kaltem Krieg und Wirtschaftswunder: Deutsche und europäische Plakate,* 22 October 1982—9 January 1983. Exh.Cat.

Munsterberg, Hugo. "Art in Berlin: Summer, 1951." *College Art Journal* 11 (Winter 1951/52):110–14.

Naumann, Johann Wilhelm. "'Neues Abendland.'" *Neues Abend land* 1, nr.1 (1946):1–3.

Nemitz, F. "Gebilde aus Handschrift." *Das Kunstwerk* 2, nr.5/6 (1948):49–51.

New York. The Museum of Modern Art. *German Art of the Twentieth Century.* Texts Werner Haftmann, Alfred Hentzen, and William S. Liebermann. Ed. Andrew Carduff Ritchie. 1957.

New York. The Museum of Modern Art. *The New Decade: 22 European Painters and Sculptors.* Ed. Andrew Carduff Ritchie. 1955.

Nitzschke, Bernd. *Sexualität und Männlichkeit: Zwischen Symbiosewunsch und Gewalt.* Reinbek b.Hamburg: Rowohlt Taschenbuch Verlag GmbH, 1988.

Nohl, Hermann. "Das Ende der Kunst?" *Die Sammlung* 1 (1945/46):179–83.

———. "Die Erziehung in der Kulturkrise." *Die Sammlung* 3 (1948):645–52.

———. "Die geistige Lage im gegenwärtigen Deutschland." [Lecture held at GER.-Conference, Bedford College, London, 18 July 1947.] *Die Sammlung* 2 (1946/47):601–6.

———. "Die heutige Aufgabe der Frau." *Die Sammlung* 2 (1946/47):353–58.

———. "Vom Sinn der Kunst." *Die Sammlung* 2 (1946/47): 412–18.

Nürnberg. Archiv für Bildende Kunst am Germanischen Nationalmuseum. *E. W. Nay: Bilder und Dokumente.* Munich: Prestel-Verlag, 1980.

Nürnberg. Kunsthalle. Ed. Lucius Grisebach. *Werner Heldt*, 2 December 1989—11 February 1990. Exh.Cat.

Ortmeier, Martin. *Der Primitivismus moderner Malerei; Eine Gattungs- und rezeptionstheoretische Studie*. Munich: Verlag Holler, 1983.

P. L. "Berliner Ausstellungen." *Bildende Kunst* 2, nr.10 (1948):43–46.

Pasolini, Pier Paolo. *Ketzererfahrungen "Empirismo eretico": Schriften zu Sprache, Literatur und Film*. Trans. Reimar Klein. Frankfurt a.M.: Ullstein Materialien, 1982.

Peiffer-Watenphul, Max. "Biennale die Venezia." *Das Kunstwerk* 2, nr.8 (1948): 35–36.

Petermann, Erwin. "Das war verfemte Kunst; IV. George Grosz." *Aussaat* 1, nr.4 (1946):20–24.

Peterson, Edward N. *The American Occupation of Germany: Retreat to Victory*. Detroit: Wayne State University Press, 1977.

Pfeiffer-Belli, Wolfgang. "Deutschland nach dem Kriege; Buchkritik." *Die Fähre* 1, nr.4 (1946):253–54.

Picard, Max. *Die Atomisierung in der modernen Kunst*. Hamburg: Furche-Verlag, 1954.

———. *Hitler in uns Selbst*. 3rd ed. Erlenberg-Zurich: Eugen Rentsch Verlag. [1949].

———. *Ist Freiheit Heute überhaupt möglich? Einbruch in die Kinderseele*. Hamburg: Im Furche-Verlag, 1955.

Pirker, Theo. *Die SPD nach Hitler: Die Geschichte der Sozialdemokratischen Partei Deutschlands 1945–1964*. Munich: Rütten & Loenig Verlag GmbH, 1965.

Platen-Hallermund, Alice. "Der deutsche Widerstand." *Frankfurter Hefte* 3 (March 1948):280–82.

Plivier, Theodor. "Entscheidung für Europa." *Die Gegenwart* 4, nr.1 (1949):8.

Poetter, Jochen, ed. *Zen 49: Die ersten zehn Jahre— Orientierungen*. Baden-Baden: Staatliche Kunsthalle, 1986.

Pommeranz-Liedtke, G. "Mensch und Arbeit; Zu einem Grund thema der Kunst in unserer Zeit." *Bildende Kunst* 3, nr.6 (1949):182–87.

Proske, Rüdiger, and Walter Weymann-Weyhe. "Wir aus dem Kriege; Der Weg der jüngeren Generation." *Frankfurter Hefte* 3 (September 1948):792–803.

"Das Publikum sagt seine Meinung." [Letters to the editor.] *Bildende Kunst* 2, nr.1 (1948):27–29.

R.H. [Robert Haerdter]. "Kollektivschuld." *Die Gegenwart* 1, nr.2/3 (1946): 10–12.

Rannit, Aleksis. "Erster Weltkongress der Kunstkritiker." *Das Kunstwerk* 2, nr.10 (1948):46–47.

Rantzau, Johann Albrecht von. "Geschichte und Politik im deutschen Denken." *Die Sammlung* 1 (1945/46):544–54.

Rathke, Christian, ed. *Die 50er Jahre: Aspekte und Tendenzen*. Wuppertal: Kunst- und Museumsverein, 1977.

Rein, F. H. "De-Nazification and Science." Trans. OMGUS. *Göttinger Universitäts-Zeitung* 1, nr. 1 (11 December 1945).

Reindl, L.E. "Moderne Kunst in Konstanz." *Das Kunstwerk* 1, nr.2 (1946/47): 32–33.

Renner, Paul. "Psychoanalyse und moderne Malerei." *Zeitschrift für Kunst* 1, nr.4 (1947):68–71.

Reynaud, Henri. *Les Relations Universitaires entre la France et la République d'Allemagne de 1945 à 1978*. Reims: Matot-Braine, 1979.

Roh, Franz. *German Painting in the 20th Century*. Additions by Juliane Roh. Trans. Catherine Hutter. Ed. Julia Phelps. Greenwich, Conn.: New York Graphic Society Ltd., 1968.

———. "Zur Diskussion um die gegenstandslose Kunst." *Prisma* 1, nr.10 (1947):26–28.

Ruhl, Klaus-Jörg, ed. *"Mein Gott, was soll aus Deutschland werden?" Die Adenauer-Ära 1949–1963*. Munich: Deutscher Taschenbuch Verlag GmbH & Co.KG., 1985.

Rupp, Hans Karl. *Ausserparlamentarische Opposition in der Ära Adenauer: Der Kampf gegen die Atombewaffnung in den fünfziger Jahren; Eine Studie zur innenpolitischen Entwicklung der BRD*. Cologne: Pahl-Rugenstein Verlag, 1970.

Sachs, Nelly. "Chor der Geretteten." *Die Fähre* 2, nr.12 (1947):742.

St. Louis. Art Museum. Ed. Jack Cowart. *Expressions: New Art from Germany—Georg Baselitz, Jörg Immendorff, Anselm Kiefer, Markus Lüpertz, A.R. Penck*, June—August 1983. Exh.Cat.

Sauerländer, Willibald. "Ein heimlicher Moderner; Zum Tod von Hans Sedlmayr." *Die Zeit* 39 (27 July 1984):11.

Schlesinger, Jr., Arthur M. "Über die Zukunft des Sozialismus." *Amerikanische Rundschau* 4, nr.17 (1948):72–84.

———. *The Vital Center: The Politics of Freedom*. Boston: Riverside Press, 1962.

Schmädecke, Jürgen and Peter Steinbach, eds. *Der Widerstand gegen den Nationalsozialismus: Die deutsche Gesellschaft und der Widerstand gegen Hitler*. Munich: R. Piper GmbH & Co. KG, 1985.

Schmidt, Eberhard. *Die verhinderte Neuordnung 1945–1952: Zu einer Auseinandersetzung um die Demokratisierung der Wirtschaft in den westlichen Besatzungszonen und in der Bundesrepublik Deutschland*. Frankfurt: Europäische Verlagsanstalt, 1970.

Schmidt, P.F. "Klassizismus einst und jetzt." *Das Kunstwerk* 4, nr.4 (1950): 5–11.

Schmücker, Irma. "Das Wesen des Griechentums und das Wesen der griechischen Philosophie." *Aussaat* 1, nr.2 (1946):5–8.

Schneider, Reinhold. "Der Mensch vor dem Gericht der Geschichte." *Neues Abendland* 1, nr.1 (1946):12–20.

Schneider-Lengyel, J. "Vom Impressionismus zum Surrealismus." *Prisma* 1, nr.10 (1947):37–39.

Schön, Gerhard. "Junge Künstler—Junge Kunst." *Aussaat* 2, nr.1/2 (1947):66.

Schüling, Hermann. *Zur Geschichte der ästhetischen Wertung: Bibliographie über den Kitsch*. Giessen: Universitäts bibliothek Giessen, 1971.

Sedlmayr, Hans. *Verlust der Mitte: Die bildende Kunst des 19. und 20. Jahrhunderts als Symptom und Symbol der Zeit*. Salzburg: Otto Müller Verlag, 1948.

Seelmann-Eggebert, Ulrich. "Heidelberg-Mannheim; Das Ja zum Leben (Gedanken zur Uraufführung zweier amerikanischer Dramen, 'Galgenfrist' und 'Biographie und Liebe.'" *Aussaat* 1, nr.10/11 (1947):58–59.

Sieburg, Friedrich. "Der Schrei nach Literatur." *Die Gegenwart* 3, nr.21 (1948):15–17.

Smith, Terry. "A State of Seeing, Unsighted: Notes on the Visual in Nazi War Culture," *Block* 12 (winter 1986/87):50–70.

Spaeth, Eloise A. "America's Cultural Responsibilities Abroad." *College Art Journal* 11 (winter 1951/52):115–20.

"Stimmen der Künstler." *Das Kunstwerk* 4, nr.8/9 (1950):11–24.

"Stimmen über die abstrakte Malerei." *Bildende Kunst* 2, nr.4 (1948):28.

Strassner, Ernst. "Abstrakte und gegenständliche Malerei." *Das Kunstwerk* 1, nr.8/9 (1946/47):13–14.

Stumfohl, Helmut. "Ein Brief an die Redaktion" [Reply to Irving Kristol]. *Amerikanische Rundschau* 5, nr.24 (1948):105–9.

Tagg, John. "American Power and American Painting: The Development of Vanguard Painting in the United States since 1945." *Praxis* 1, nr.2 (winter 1976):59–78.

Tapié, Michel. *Un art autre: où il s'agit de nouveaux dévidages du réel*. Paris: Gabriel-Giraud et Fils, 1952.

Th. "Optimismus auf der Einfuhrliste; An den Rand eines amerikanischen Monatsheftes notiert." *Die Gegenwart* 3, nr.19 (1948):19–20.

Theweleit, Klaus. *Male Fantasies*. Trans. Stephan Conway, Erica Carter, and Chris Turner. Minneapolis: University of Minnesota Press, c.1987-c.1989.

Thieme, Karl. "Entzauberte Entzauberung." *Frankfurter Hefte* 4, nr.8 (1949): 716–17.

Thompson, Dorothy. "An meine deutschen Freunde." *Amerikanische Rundschau* 4, nr.21 (1948):3–10.

Töwe, Christian. "Das war verfemte Kunst; XVI. Karl Schmidt-Rottluff." *Aussaat* 1, nr.12 (1947):26–29.

Thomas, Karin. *Zweimal deutsche Kunst nach 1945: 40 Jahre Nähe und Ferne*. Cologne: DuMont Dokumente, 1985.

Trökes, Heinz. "Moderne Kunst und Zeitbewusstsein." *Bildende Kunst* 2, nr.3 (1948):17–19.

———. "Der Surrealismus." *Das Kunstwerk* 1, nr.8/9 (1946/47):30–36.

Vietta, Egon. "Kreuzzug der Ausstellungen." *Das Kunstwerk* 2, nr.1/2 (1948):79.

———. "Die olympischen Spiele der Europäischen Malerei." *Das Kunstwerk* 2, nr.10 (1948):40–46.

Vogt, Hannah. "Der Auftrag der Frau in Haus und Beruf." *Die Sammlung* 2 (1946/47):358–66.

———. "Zum Problem der deutschen Jugend." *Die Sammlung* 1 (1945/46): 592–600.

Voss, Hermann. "Hans Sedlmayr, Verlust der Mitte." *Zeitschrift für Kunst* 4, nr.1 (1950):78–83.

Wankmüller-Freyh, R. "Das kubistische Stilleben." *Das Kunstwerk* 2, nr.5/6 (1948):15–29.

Weber, Carl August. "Besorgnis um die junge Dichtung." *Die Fähre* 2, nr.6 (1947):323–24.

———. "Der Existenzialismus." *Prisma* 1, nr.6 (1947):37–38.

———. "Neue Wege der Literatur in Frankreich." *Die Fähre* 1, nr.9 (1946):545–49.

Weischedel, Wilhelm. "Wesen und Grenzen der Existenzphilosophie." *Frankfurter Hefte* 3 (August 1948):726–35.

Weisenborn, Günther. "Es gab einen deutschen Widerstand." *Frankfurter Hefte* 2 (June 1947):531–32.

Weiss, Peter. *Die Ästhetik des Widerstands*. 3 vols. Frankfurt a.M.: Suhrkamp Verlag, 1983.

Werneburg, Brigitte. "Ernst Jünger and the Transformed World." *October* 62 (fall 1992):43–64.

Westheim, Paul. "Die Rebellion gegen den Kubismus." *Das Kunstwerk* 2, nr.7 (1948):20–22.

Westphal, Conrad. " 'Entartete' Kunst." *Aussaat* 2, nr.1/2 (1947):47–48.

———. "Zu Lithographien von E. W. Nay." *Das Kunstwerk* 4, nr.8/9 (1950): 38–41.

———. "Zur abstrakten Kunst." *Aussaat* 2, nr.3/4 (1947):118–20.

Weyl, Stefan. "Wie Amerika während des Kriegs über Deutschland dachte." *Amerikanische Rundschau* 3, nr.13 (1947):117–26.

Weymann-Weyhe, Walter and Rüdiger Proske. "Die Lage der Intellektuellen in Deutschland." *Frankfurter Hefte* 3 (June 1948):526–41.

Wight, Fredrick S. "Amerikanische Malerei der Gegenwart." *Amerikanische Rundschau* 5, nr.24 (1949):61–72.

Witsch, Josef K., and Max Bense, eds. *Almanach der Unvergessenen: Ein Gedenkbüchlein erstmalig erschienen im Jahre 1946*. Thüringen: Der Greifenverlag zu Rudolfstadt, 1946.

Zahn, Leopold. "Abkehr von der 'Natur'." *Das Kunstwerk* 1, nr.8/9 (1946/47):3–6.

———. "Der abstrakten Malerei gewidmet." *Das Kunstwerk* 2, nr.5/6 (1948): 57–61.

———. "Apologie der malerischen Malerei." *Das Kunstwerk* 1, nr.7 (1946/47): 3–4.

———. "Deutsche Kunst der Gegenwart." *Das Kunstwerk* 2, nr.1/2 (1948): 55–65.

———. "3x abstrakte Kunst." *Das Kunstwerk* 1, nr.3 (1946/47):27–31.

———. "Einführung in die moderne französische Malerei." *Das Kunstwerk* 4, nr.3 (1950).

———. "Die moderne Kunst und ihre jüngsten Gegner." *Das Kunstwerk* 4, nr.1 (1950):47–48.

———. "Schminken und Schmücken." *Das Kunstwerk* 3, nr.9 (1949):5.

———. "Verlust der Mitte." *Das Kunstwerk* 4, nr.2 (1950):55–56.

———. "Die XXV. Biennale in Venedig." *Das Kunstwerk* 4, nr.6 (1950):60–64.

"Zeitschriftenspiegel." *Das Kunstwerk* 1, nr.3 (1946/47):44–45.

Zervos, Christian. "Notes sur Willi Baumeister." *Cahiers d'Art* 24 (1949): 342–44.

Zoepfl, Dr. Friedrich. "Die deutsche Kultur der Zukunft." *Neues Abendland* 1, nr.11 (1947):1–4.

"Die Zukunft der abendländischen Kultur." *Neues Abendland* 2, nr.7 (1947): 220–21.

"Zur Diskussion über die abstrakte Kunst." *Bildende Kunst* 2, nr.2 (1948): 23–24.

"Zur Signatur des Zeitalters." *Das Kunstwerk* 4, nr.8/9 (1950).

"Zweimal Emigration." *Die Gegenwart* 1, nr.2/3 (1946):37–38.

INDEX